Rambling Prose

Rambling Prose

ESSAYS

STEVEN G. KELLMAN

TRINITY UNIVERSITY PRESS

San Antonio

Published by Trinity University Press
San Antonio, Texas 78212
Copyright © 2020 by Steven G. Kellman

Book design by BookMatters
Cover design by Elyse Andrews
Author photo by Calvin Hoovestol

Cover: *Carr residence in Pasadena, now Carmelita Park, ca. 1895*. Digitally
reproduced by the USC Digital Library. From the California Historical
Society Collection at the University of Southern California.

ISBN 978-1-59534-934-7 paperback
ISBN 978-1-59534-945-0 ebook

Trinity University Press strives to produce its books using methods and
materials in an environmentally sensitive manner. We favor working
with manufacturers that practice sustainable management of all natural
resources, produce paper using recycled stock, and manage forests with
the best possible practices for people, biodiversity, and sustainability.
The press is a member of the Green Press Initiative, a nonprofit pro-
gram dedicated to supporting publishers in their efforts to reduce their
impacts on endangered forests, climate change, and forest-dependent
communities.

The paper used in this publication meets the minimum requirements
of the American National Standard for Information Sciences—
Permanence of Paper for Printed Library Materials, ANSI 39.48–1992.

CIP data on file at the Library of Congress

24 23 22 21 20 | 5 4 3 2 1

Contents

Preface

A century ago, Virginia Woolf, echoing Samuel Johnson, announced that she was writing her essays for "the common reader." But one of the recurring themes in this collection is that a seismic cataclysm has shifted the tectonic plates of contemporary culture. On or about December 2010 human character changed. Booksellers became almost as rare as shoemakers, and the term "antiquarian bookstore" turned into a redundancy. When not preempted entirely by viewing images, reading migrated to electronic devices. An essayist can hope to reach only the uncommon reader, since anyone engaged in the sustained, isolating activity of reading a printed book is as uncommon today as a snow leopard.

The fact that this collection begins with meditations on silence and marginality and concludes with reflections on final words is only partly because essayists, like poets and serious novelists, cannot count on committed readers. Dismissing the term "famous novelist" as an oxymoron, Gore Vidal once asked: "How can a novelist be famous—no matter how well known he may be personally to the press?—if the novel itself is of little consequence to the civilized, much less to the generality?" However, more fundamental to the arc of this book is the realization that, at root, all writing confronts the fact that we are born and die without knowing why. Only suicides and those convicted of capital crimes have the privilege of choosing final words.

But these essays are not unusually morbid. If not especially infused with *joie de vivre*, they are at least driven by *mystère de vivre*, powerful curiosity about the odd ways in which we exhaust our mortality. Their diverse subjects include literature, education, and movies. Like the rambling rose, a shrub that spreads over fences, trees, and other objects it encounters, this volume sprouts blossoms along the way. *Rambling Prose* is a miscellany collected over the course of two decades. Although I have tweaked a few obvious anachronisms

here and there, I have resisted the temptation to rewrite the essays. The collection remains a record of my thoughts in particular times and places. Some of the essays were written on assignment for particular publications; others were thrown over the transom, into the hands of receptive editors. I am grateful for their encouragement, for the hospitality of Trinity University Press (especially its director, Tom Payton, its managing editor, Sarah Nawrocki, and its senior acquisitions editor, Marguerite Avery), for the vigilance of keen-eyed copyeditor Emily Jerman Schuster, and, most essentially, for the unwavering support of my uncommon first reader, my wife, Wendy Barker.

Silence of the Limens

That Goes without Saying

A Treatise on Silence

2010

> Music is the cup that holds the wine of silence.
> Sound is the cup, empty; noise is the cup, broken.
> —Robert Fripp

My mother was a literalist of the imagination. A dirty mouth, she knew, demanded scouring. She was also the empress of congealed cream: a sultana of soap. When I repeated a filthy word overheard at the playground, she straightaway grabbed her four-year-old son by the neck, marched him into the bathroom, held him over the sink, and washed his mouth. Though Ivory bars were $99^{44}/_{100}$ percent pure, the caustic taste of that chalky cake might have been enough to make a young boy swear off speech, even speech devoid of swear words. Yet other children have had more telling reasons to go mum. Raped at seven, Maya Angelou went mute for the next five years. Separated from his parents at six, Jerzy Kosinski claimed not to have spoken throughout his ordeal of surviving the Nazi devastation of eastern Europe. At fifteen, the Little Mermaid sacrificed her tongue for the chance to be loved by a mortal prince.

"Will you please be quiet, please" demands a character in the Raymond Carver story. For most of us, quiet abides in the ethereal expanses beyond twenty thousand hertz or in the nether realm beneath twenty hertz. What we do not or cannot hear might, like Bishop Berkeley's tree falling in the forest, not even exist. Auditory range contracts with age, which is why classroom teachers tend to be oblivious to "The Mosquito," a cell phone ring tone whose frequency, set as high as seventeen kilohertz, is nevertheless heard by youthful students more attentive to messages from peers than from pedagogues. Senescence: the contraction into soundlessness. The parameters of silence vary among bats and elephants (who register ultrasonic vibrations), whales and rhea (intimate with infrasonic vibrations), and middling humans (proud

arbiters of what is infra and ultra). Alternative universes collide in houses where dogs scamper about alert to sounds unheard by the masters' ears.

Whatever the sound of silence, it is for one lyricist, Paul Simon, pathological. "Silence," he sings, "like a cancer grows." For another, Joseph Mohr, it is sacred. Mohr's familiar "Stille Nacht, Heilige Nacht" equates the silence of the night before Christmas with its holiness. The silence of serenity is not identical with the silence of despair, any more than the silence of the lambs ought to be confused with the silence of the tapeworms or the owls. Reflecting a taxonomy of silences, the standard system of musical notation employs several different marks to punctuate the intervals between performance, including the caesura (//), general pause (-), fermata (^), and breath mark ('). Silences resonate differently for us depending on age, personality, and philosophy. Renouncing speech is a way for ascetics to purge themselves of worldly impurities. But if culture is, in Lionel Trilling's resonant phrase, "the buzz and hum of implication," then silence is antisocial, a rude refusal to participate in the raucous human comedy. "Hasn't art been the human creature's rebellion against silence?" asks composer Toru Takemitsu, as if succumbing to silence is a repudiation of humanity.[1] And Lennard J. Davis seized on sound as a way of rebelling against his deaf parents and the hushed household in which they brought him up: "The only way I knew to exist against the silence was to make noise. Whimpers, sniffs, throat-clearings, song—these sounds let me know I was there."[2]

Silence can be plenitude, a state that renders any sound superfluous, or it can be utter vacancy, a symptom of the cosmic void. It can be active, something that we create and embrace, or passive, something we endure and that, according to Maurice Maeterlinck, is "the shadow of sleep, of death or nonexistence."[3] "Ask me about my vow of silence," quips the bumper sticker, summing up the culture's ambivalence toward quiet. Honk if you don't like noise.

2

Cave tibi a cane muto et aqua silenti (Beware of a dog that does not speak to you and of silent waters).
—Latin proverb

My parents belonged to a world that still believed in part that children should be seen and not heard (the part they denied was that children should be seen). Speech is strength, which is why grievances of the weak remain by definition unvoiced; breaking silence is seizing power. Richard Nixon presumed

to speak for what he called "the silent majority"—Americans who shared his political beliefs but lacked effective means to express them. It requires uncommon mettle for those denied a voice to speak up on their own behalf. There are many reasons to believe that silence is golden, but when it betokens repression, neglect, and negation, the metal is leaden. William of Orange, who led the forces for Dutch independence, acquired the epithet William the Silent not for heroic stoicism but for calculated circumspection. Although monastic vows of silence signify and facilitate spiritual purification, the Mafia's omertà is an instrument of criminal concealment—deceit through radical meiosis. Like mushrooms, injustice and atrocity thrive in the dark, and conspiracies of silence are strategies to erase the shame of rape, incest, alcoholism, and other behavior that a culture deems unspeakable. So, when the emperor has no clothes, few dare call it nudity. "In the end," said Martin Luther King Jr., speaking for the cause of civil rights, "we will remember not the words of our enemies, but the silence of our friends."[4] And it is not a fond memory. *Qui tacet consentit*; the mute concur—don't you agree?

Although some find transcendent harmony in the music of the spheres, Blaise Pascal, gazing into the abyss, was terrified by the absolute lack of sound. "*Le silence éternel de ces espaces infinis m'effraie*" (The eternal silence of the infinite spaces frightens me), he wrote.[5] Franz Kafka, too, dreaded eternal silence. Reimagining Odysseus's voyage in "Das Schweigen der Sirenen," he writes that the silence of the Sirens is more fearful than anything they might have sung. Not for him the reassuring claim, in "Ode on a Grecian Urn," that "heard melodies are sweet, but those unheard / Are sweeter" or Stendhal's observation that the best music is the kind that becomes inaudible after a few bars. The benign void of John Cage's "4′ 33″"—four minutes thirty-three seconds in which, though the pianist does *not* strike the keys, the audience is all ears—would be unimaginable for Pascal. Yet Cage insisted that: "There is no such thing as silence. Something is always happening that makes a sound."[6] He noted that even when he entered an anechoic chamber at Harvard, he could not escape the sound of blood coursing through his body. In the sonnet "Rest," Christina Rossetti evokes a "Silence more musical than any song,"[7] but for Kafka it is closer to the starkness of Schönberg's compositions than the euphony of Mozart's.

"*Aber Schweigen ist Wohnort der Opfer*" (But silence is where the victims dwell), observes Nelly Sachs,[8] who survived the Holocaust and gave poetic voice to those who did not. Breaking the silence is a metaphor commonly employed by blacks, Latinos, gays, the indigenous, the indigent, the disabled, and

others who reject the marginal position they were historically consigned to. "Let those who have a voice speak for the voiceless," proclaimed Archbishop Oscar Romero, who was assassinated for his efforts to champion the peasants of Nicaragua. "If nothing else is left one must scream," declared Nadezhda Mandelstam, who lived to bear witness to Stalinist oppression. "Silence is the real crime against humanity."[9]

Increasingly vocal about their own experiences, women often speak of dispelling the silence imposed on them by a patriarchy that enforces reticence as a feminine virtue, as if, like children, they should be seen and not heard. "The history of most women is hidden, either by silence, or by flourishes and ornaments that amount to silence," declared Virginia Woolf. The sentiment was echoed by Adrienne Rich, in her book *On Lies, Secrets, and Silence*: "The entire history of women's struggle for self-determination has been muffled in silence over and over."[10] *Silences* is the title Tillie Olsen gave a 1978 collection of essays about women writers who were discouraged or ignored. Philomela, whose brother-in-law, Tereus, ripped out her tongue after assaulting her, became a totem of the movement to empower women. "The problem lay buried, unspoken, for many years in the minds of American women"[11] is the way Betty Friedan begins *The Feminine Mystique*, her manifesto for conquering that problem, by enabling women to speak up and assume control of their own lives.

Yet, despite—or because of—a history of stifling their voices, women are popularly associated with loquacity. Telephone operator, office receptionist, and other occupations requiring continual talk were long the exclusive province of women. One of the definitions that, in his impudent *Dictionary of the English Language*, Samuel Johnson assigned to "gossip" was "one who runs about tattling like women at a lying-in."[12] In the 1959 pop song "You Talk Too Much," the imaginary interlocutor is female, like most of the species' other troubling chatterboxes from Eve to Barbara Walters and Oprah Winfrey. However, the word *omertà* is thought to be derived from the Sicilian *omu* and Italian *uomo*, suggesting that manliness expresses itself in reticence. Hollywood and much of the rest of the world are drawn to strong, silent men such as Gary Cooper, Henry Fonda, and Clint Eastwood, as though silence is strength itself. Stoicism is traditionally masculine, and stiff upper lips do not facilitate speech. Women, though, are assigned the role of consolers, conveyers of bedtime tales and lullabies for whom silence is no solace. The world's most famous mime, Marcel Marceau, was a man, but celebrity tattling—the otiose activity of harpies such as Louella Parsons, Hedda Hopper,

Rona Barrett, and Liz Smith—has long been seen as women's work. In fact, the Greeks conceived of Harpies as loathsome, voracious, and female. The transgendering wit behind the graffito "Marcel Proust is a yenta" derives from knowing that yentas are verbose women. *À la recherche du temps perdu* is seven volumes long, and the novel's gay author hardly conformed to the category of strong, silent man.

Nevertheless, what Lord Alfred Douglas, Oscar Wilde's companion, called "the love that dare not speak its name" has long since revealed its name and much else, publicly and prolifically. The "play" button is more popular than the "mute." In 1968, Norman Mailer proclaimed that "true liberty...consisted of his right to say shit in the *New Yorker*."[13] But within thirty years, the infamous fecal term and others like it were appearing regularly in that fastidious magazine. In June 2004, the vice president of the United States was even heard to utter "fuck" on the floor of the Senate. No one hauled him into the congressional washroom to douse his mouth with soap. Although the Federal Communications Commission still pounces on broadcast profanity and vestiges of Victorianism linger among legionnaires of decency, Western cultures are more apt to celebrate than denigrate the shattering of silence. Free citizens eschew the quaint gymnastic clinch of holding their tongues.

3

Seul le silence est grand, tout le reste est faiblesse.
(Only silence is great, all else is weakness.)
 —Alfred de Vigny, "La Mort du loup"

However, for all the negative qualities ascribed to silence, it also means safety. *En boca cerrada no entran moscas.* According to the Spanish proverb, if you keep your mouth shut, you keep out the flies. But silence also kept the Pentagon from discharging uniformed gays and lesbians. According to the "Don't Ask, Don't Tell" policy of the US military, homosexuals were tolerated in the ranks as long as they remained mum about their sexual orientation. And although it is not necessarily true that tight lips float ships, the conviction that loose ones can sink them is dogma during war. Silence is the white flag that stands apart from combat. It offers sanctuary from a garrulous, perilous world of percussive brute force. "Words are like leaves," wrote Alexander Pope, a poet often terse but rarely taciturn, "and where they most abound, / Much fruit of sense beneath is rarely found."[14]

However, more than merely a negative tactic, a refusal to commit clamor,

silence can be a value in itself. Although Benjamin Franklin chose the ludicrous name "Silence Dogood" for the loquacious, self-righteous narrator of his early satirical essays, a formic aphorism he included in *Poor Richard's Almanack*—"None preaches better than the ant, and she says nothing"—suggests a genuine respect for reticence. And his *Autobiography* assigns Silence a paramount position in its catalogue of moral virtues. Listing Silence second, just after Temperance, among the thirteen virtues that "occurr'd to me as necessary or desirable," Franklin advises: "Speak not but what may benefit others or yourself. Avoid trifling Conversation." A belief that all conversation is trifling quickened the Symbolists of the late nineteenth century, who favored suggestion over assertion—"It is idle to think that, by means of words, any real communication can pass from one man to another," asserted the playwright Maeterlinck.[15] The Talmudic sage Shammai also counseled verbal restraint: "*Emor mi'at vi'asey harbey*" (Say little but do much).[16] Taoist enlightenment, too, is wordless. According to Lao Tzu: "Those who know don't talk. Those who talk don't know."[17]

Moreover, silence can even surpass mere virtue or enlightenment. If, as J. D. Salinger's Seymour Glass contends, "The human voice conspires to desecrate everything on earth,"[18] then the pre-vocal state is sacred. A vow of cleansing silence—the verbal analogue of fasting—is common to much monastic life, and societies cope with profound communal grief by invoking a collective moment of silence. Contemplative silence permits and marks a return to the still center of being, and it is the foundation upon which Quakers meet in worship. Quietism is the term for a condition of beatific serenity, and in the mystical traditions of many religions and cultures, quiet signals ultimate accord with the ineffable Absolute. "Words failed me," says the visionary about the final moment of inexplicable rapture. After attaining enlightenment during a night of the full moon, the Buddha went silent for seven days. Apollonius of Tyana, the first-century ascetic sage, refrained from speech for five years. The Trappist Thomas Merton contended that what he called "elected silence" is essential to spiritual clarity: "In silence we learn to make distinctions. Those who fly silence, fly also from distinctions. They do not want to see too clearly. They prefer confusion. A man who loves God necessarily loves silence also, because he fears to lose his sense of discernment."[19]

"Silence itself had become my teacher," writes Karen Armstrong, recounting her personal progress in a spiritual memoir, *The Spiral Staircase: My Climb out of Darkness*. "After a time I found that I could almost listen to the silence, which had a dimension all of its own. I started to attend to its strange and

beautiful texture, which, of course, it was impossible to express in words. I discovered that I felt at home and alive in the silence, which compelled me to enter my interior world and walk around there."[20] A scholar of world religions, Armstrong situates her enlightenment within the context of monotheistic theology, but explorer Richard Byrd, drawing his inspiration from the stark Antarctic void, experiences a pantheistic delirium. Amid the noiseless expanse that surrounded him during the winter of 1934, Byrd feels himself in harmony with a cosmic soundless symphony:

> I paused to listen to the silence. My breath crystallized as it passed my cheeks. Drifted on a breeze gentler than a whisper. The wind vane pointed toward the South Pole. Presently the wind cups ceased their gentle turning as the cold killed the breeze. My frozen breath hung like a cloud overhead. The day was dying, the night was being born—but with great peace. Here were the imponderable processes and forces of the cosmos, harmonious and soundless. Harmony, that was it! That was what came out of the silence—gentle rhythm. The train of a perfect chord, the music of the spheres perhaps. It was enough to catch that rhythm momentarily to be myself a part of it.[21]

"Stout Cortez," as imagined by John Keats, encountered a very different landscape when he (or rather, Vasco Núñez de Balboa) ventured across the Isthmus of Panama. Attempting to convey the ecstasy he experienced on first reading George Chapman's translation of the Homeric epics, Keats likens himself to Spanish explorers in the Western Hemisphere who suddenly beheld the vast Pacific Ocean. What can one say about such an extraordinary event without being oafish and banal? Wow?!? Keats concludes his famous sonnet by leaving his awestruck conquistadores mute: "Silent, upon a peak in Darien."

The poem stops, admitting that it has nothing left to say. And what *could* it say that is not a desecration of the silence that it posits as the only proper response? Convinced that words are meager means to convey his ecstatic state, Keats devises a verbal structure that deftly undercuts itself. The first thirteen lines of his Petrarchan sonnet are written in conventional iambic pentameter. However, the final line is hypostressed. It contains only four—rather than five—accented syllables, and even a casual reader will sense something missing at the end. The poet has managed to use language to intimate something that transcends language. "On First Looking into Chapman's Homer" assembles its own words to convey how the words of Homer refracted through the words of Chapman leave Keats speechless.

4

*Qui veut se donner à la peinture doit commencer par se
faire couper la langue.* (Whoever wishes to devote himself
to painting must begin by cutting out his tongue.)
 —Henri Matisse[22]

A mathematical equation has afflicted the most ambitious literature of the past two centuries. If a picture is worth a thousand words, then economics, if not aesthetics, demands that those who work with words be more efficient. Why fill page after page with phrases describing a haystack when a painting or a photograph can do the job more efficiently and effectively? For Flaubert, James, Chekhov, and Hemingway, economy of expression demanded frugal narratives that show rather than tell, that emulate the immediacy of pictures. In "Ars Poetica," Archibald MacLeish, declaiming against poems that declaim, demands, through a series of paradoxes, literature that denies its own medium—poems that are "mute," "dumb," "silent," and "wordless." Instead of statements, he called for images: "An empty doorway and a maple leaf" or "The leaning grasses and two lights above the sea." The development of photography during the nineteenth century precipitated a crisis not only for painting; the new technology was able to produce more accurate images more rapidly and inexpensively than the old. But it also induced in authors the anxiety of flatulence. Words seemed such a crude instrument for interpreting the music of the spheres.

For some uneasy writers, music became the paradigm. "*De la musique avant toute chose*" (Music before everything else), demands Paul Verlaine in his 1885 verse manifesto "Art poétique." Wary of verbal wiles, he demands: "*Prends l'éloquence et tords-lui son cou!*" (Take eloquence and wring its neck!), as if it were possible to beat speech into silence. Verlaine concludes his poem by dismissing all writing that has not attained the condition of music, that remains stubbornly, irremediably verbal: "*Et tout le reste est littérature*" (And everything else is literature). The line oozes contempt, as if writing were unworthy of the most talented writers.

Stephen Dedalus's "silence, exile, and cunning" supplanted "faith, hope, and charity" as the modernist credo, and the greatest of those is silence. In the valedictory poems that he composed as death approached, in 1941, Rabindranath Tagore casts aside the chimera of words. "Human beings, with their self-drawn lines," he writes, "forget the epochs' message." In the final line of "Sickbed 30," that message is: "silence flows within earth's womb, mocking."[23] The aspiration toward erasure can be found not only

in much of modern literature, but perhaps most emphatically in Elbert G. Hubbard's 1905 *Essay on Silence*, a book of fifty-six pages that are so blank they are not even numbered (Hubbard's text was copied verbatim in 1974 in Bruce Harris's *The Nothing Book*). However, the monochromatic canvases of Kasimir Malevich and Mark Rothko, like Cage's soundless score (anticipated in 1897 by Alphonse Allais's *Marche funèbre composée pour les funérailles d'un grand homme sourd*, a funeral march consisting of twenty-four empty bars), also posit vacancy as verity.

"The art of our time is noisy with appeals for silence," proclaimed Susan Sontag, who, in her essay "The Aesthetics of Silence,"[24] brought sound thoughts to the subject. Along with Roland Barthes, Maurice Blanchot, Ihab Hassan, Jacques Derrida, and George Steiner, she was a leading aesthetician of silence, of vacancy as the zero degree of human expression. Philosophical and theological underpinnings to self-effacing art can be traced to Plato, Gnosticism, Sufism, Quakerism, Zen, and the Kabbalah, among other sources. In a sense, though, all modern philosophy culminates in Ludwig Wittgenstein's terse tautology that "*Wovon man nicht sprechen kann, darüber muss man schweigen*" (Whereof one cannot speak, thereof one must be silent).[25] However, the preeminent virtuoso of wordlessness is surely Samuel Beckett, who lamented that "I could not have gone through the awful wretched mess of life without having left a stain upon the silence."[26]

He left an indelible stain. But Beckett's long literary career, in English and in French, constituted an extended quarrel with language. According to his narrator Moran, who cancels his opening statement in *Molloy* ("It is midnight. The rain is beating on the windows") with his conclusion ("It was not midnight. It was not raining"), any discourse is dispensable: "It seemed to me that all language was an excess of language."[27] Desperate to find fit words to recount "the inenarrable contraption I called my existence,"[28] Moran, like every other Beckett narrator, is baffled by the gap between mute reality and clangorous language. In Beckett's first novel, *Dream of Fair to Middling Women* (1932), the protagonist, Belacqua, proclaims an ambition that presages the author's own: "I shall state silences more competently than ever a better man spangled the butterflies of vertigo."[29] Increasingly, Beckett pared his luxuriant, playful prose to the threshold of nullity, so that his 1965 film *Film* is a single character study in mime and his 1967 play *Come and Go* contains but 121 words. All of his oeuvre covets the title *Acte sans paroles* (Act without words) (1957). It is constructed on the premise that truth is preverbal, that the only reason to break the primal silence is to try to articulate the futility and mendacity of all speech. Molloy advises that "you would do better, at least

no worse, to obliterate texts than to blacken margins, to fill in the holes of words till all is blank and flat and the whole ghastly business looks like what it is, senseless, speechless, issueless misery."[30] The Unnamable is the label applied to the ultimate narrator of Beckett's novelistic trilogy, but the word could apply to anyone and anything within his ineffable universe. Moran explains that: "Not one person in a hundred knows how to be silent and listen, no, nor even to conceive what such a thing means. Yet only then can you detect, beyond the fatuous clamour, the silence of which the universe is made."[31]

5

All artists dream of a silence which they must enter,
as some creatures return to the sea to spawn.
 —Iris Murdoch[32]

No whoosh is heard beyond the ionosphere, and it is only by cinematic convention that melodies by Richard Strauss or John Williams serenade travelers through outer space. If any of our species ever sounded the depths of the cosmos, it would be a silent flight. However, it is impossible to stifle the songs of the earth. There are few places on this planet where it is possible to wander for hours without audible evidence of another living being. The Galápagos Islands, a Pacific archipelago formed by volcanic eruption, seemed unearthly to Charles Darwin when he came upon them in 1835. In a diary entry about Isla San Cristóbal, he noted that "the whole is black Lava, *completely* covered by small leafless brushwood & low trees.—The fragments of Lava where most porous are reddish & like cinders; the stunted trees show little signs of life. The black rocks heated by the rays of the vertical sun like a stove give to the air a close & sultry feeling. The plants also smell unpleasantly. The country was compared to what we might imagine the cultivated parts of the Infernal regions to be."[33]

 Today, the human population of the Galápagos numbers about 30,000, and neither they nor the thousands of ecotourists who scramble across the petrified lava beds take a vow of silence. Yet the youngest of the islands, Fernandina, which rose from the sea a mere 700,000 years ago, remains uninhabited by *Homo sapiens*. Darwin never stopped at Fernandina, but when I did, 171 years after the voyage of the *Beagle*, no din from cars or planes disturbed the primal peace. However, indigenous creatures, including sea lions, marine iguanas, penguins, boobies, and a few of the thirteen species of songbird that have come to be called Darwin's finches, emit their own distinctive

tones. The decibel level in the Galápagos is surely lower than in Mexico City, Cairo, or Kuala Lumpur, but, like Prospero's remote domain, these isles, too, are "full of noises, / Sounds and sweet airs, that give delight, and hurt not."[34]

Even amid the desolate pale expanses of Antarctica, Sir Ernest Shackleton was haunted by the presentiment of a phantom companion. "Who is the third who walks always beside you?" asks T. S. Eliot in *The Waste Land*, echoing the testimonies of Shackleton, Thomas Crean, and Frank Worsley that they sensed a stranger escorting them during their arduous trek across the mountains and glaciers of South Georgia.

For a nineteenth-century European, Abyssinia, untamed and unmapped, was—as much as the South Pole, the Galápagos, or the dark side of the moon—ultima Thule. And it was there that, after renouncing poetry at age nineteen, Arthur Rimbaud made his way, growing the tumor that would kill him at thirty-seven. During his last ten years of life, Rimbaud did not quit speaking or writing letters, but his unwritten poems, like those of Sor Juana Inés de la Cruz submitting to the muzzle of her archbishop, constitute a kind of "silence" that thunders through the pages of literary history. Artistic abdications—seventeen-year-old Thomas Chatterton choosing arsenic over poetry, Glenn Gould withdrawing from public performance, Greta Garbo wanting to be alone instead of on camera—invite and defy interpretation precisely because silence from the eloquent is a provocation. "What really knocks me out," says Holden Caulfield, "is a book that, when you're all done reading it, you wish the author that wrote it was a terrific friend of yours and you could call him up on the phone whenever you felt like it."[35] Many felt that way about *The Catcher in the Rye*, and when, in 1965, J. D. Salinger himself retreated to the fastness of Cornish, New Hampshire, and terminated all contact with the public, devoted readers felt betrayed.

In 1964, when *Call It Sleep* was rediscovered as a forgotten masterpiece, thirty years after its initial publication, astonished critics made their way to a duck farm in Maine to interrogate the Rip Van Winkle of modern American literature. They tried to assimilate the fact that Henry Roth had published little during the interim. It would take Roth another thirty years to publish his second novel, *A Star Shines over Mt. Morris Park* (1994). His prolonged (sixty-year) residence on writer's block might be the most sustained case of mogigraphia among major American writers, but, at his death in 1994, Ralph Ellison was still working on the second novel (published posthumously in 1999 as *Juneteenth*) that he began after *Invisible Man* in 1952. Just as mathematicians differentiate among orders of infinity (Aleph1, Aleph2, Aleph3, ad

infinitum), it is possible to parse disparate sorts of literary silence. And the silence from a hiatus in creativity sounds different from the kind produced by Harper Lee and Arthur Golden, who declined to follow up on their first novels, *To Kill a Mockingbird* and *Memoirs of a Geisha*, respectively. (*Go Set a Watchman*, which Lee allowed to be published in the final months of her life, is not so much a follow-up to *Mockingbird* as an early, abandoned draft of it.) They defy the convention of literature as a calling; once the silence is broken, the writer feels compelled to keep on calling.

Yet another kind of silence ensues when an author such as Elena Ferrante, Cormac McCarthy, Thomas Pynchon, B. Traven, or William Wharton writes and publishes but spurns interviews, blurbs, readings, workshops, and most of the other promotional activities expected of successful contemporary authors. The taunting figure of the reclusive and/or reluctant writer who becomes famous by repudiating the trappings of fame shows up in contemporary fiction as a way of contesting the sentimental tenet that art is self-expression. In *Mao II* (1991), Don DeLillo, himself notoriously elusive, offers as protagonist Bill Gray, who has been living in seclusion for the past twenty-three years while writing the novel he refuses to release into the culture. Gray is a variation on Bucky Wunderlick, once the world's most famous rock star, who, in DeLillo's *Great Jones Street* (1973), retreats from clamorous public appearances to anonymous, ascetic solitude in a bare New York apartment.

In *The Book of Illusions* (2002), Paul Auster tells the story of David Zimmer, a scholar who tracks down Hector Mann, a great filmmaker who disappeared in 1929. Early in the novel, we are told that Zimmer is the author of something called *The Road to Abyssinia*—"a book about writers who had given up writing, a meditation on silence. Rimbaud, Dashiell Hammett, Laura Riding, J. D. Salinger, and others—poets and novelists of uncommon brilliance who, for one reason or another, had stopped."[36] When he finds Mann, in New Mexico, Zimmer discovers that, in addition to the early work for which he gained renown, the director secretly made fourteen later films. Mann intends to destroy them at his death, and he now lies on his deathbed. Zimmer struggles to get a glimpse at films made not for viewing, created by "the first artist to make his work with the conscious, premeditated intention of destroying it."[37]

That claim of primacy is hyperbolic, not just fictional. Tibetan sand paintings—intricate, arduous designs obliterated at the moment of their completion—are a humbling exercise in aesthetic effacement. Kafka's dying request, of his friend Max Brod, to burn all his manuscripts, is another precedent, as are Yves Tinguely's self-destructing sculptures.

But the most striking case of willful literary muffling might be that of Bob Kaufman, sometimes called "the black Rimbaud." Kaufman (1925–1986), who inspired Herb Caen to coin the term "beatnik," produced two classic Beat documents—*Abomunist Manifesto* (1959) and *Solitudes Crowded with Loneliness* (1964)—that, like his poetry, deploy words to express mistrust of language. Born in New Orleans to an African American mother and an Orthodox Jewish father, Kaufman settled in San Francisco after twenty years in the merchant marine. His writing was strongly influenced by Buddhism and jazz, both of which disdain the merely verbal. But what, within the tradition of literary silence, is most remarkable about Kaufman is that for the ten years following the 1963 assassination of John F. Kennedy not only did he cease publishing or writing; he chose not even to speak.

Qui tacet conturbat; silence is disturbing—to readers, who crave sequels, and critics, who are trained to interpret everything, even and especially blankness. The hermeneutics of silence is the revenge of scholarship on the uncooperative artist. See Myles Weber's *Consuming Silences: How We Read Authors Who Don't Publish* (2005) for a tenacious attempt to interpret the muteness of Tillie Olsen, Henry Roth, J. D. Salinger, and Ralph Ellison. In *Stone Reader* (2003), filmmaker Mark Moskowitz testifies to his own inability to accept silence from a gifted writer. The film documents Moskowitz's attempt to track down Dow Mossman, whose first and only novel, *The Stones of Summer* (1972), had fascinated him thirty years before. *Stone Reader* becomes a meditation on squandered talent and the discontinuities of an individual life. Few literary lives have been as discontinuous—if symmetrical—as that of Friedrich Hölderlin (1770–1843). By age thirty-six, Hölderlin had established himself as one of the greatest of German poets, before succumbing to inarticulate insanity for his final thirty-six years. "*Ich verstand die Stille des Aethers*" (I understood the stillness of the ether), wrote Hölderlin before losing his command of language. "*Der Menschen Worte verstand ich nie*" (I never understood the words of men).[38]

6

How imagine a silent world.
—Hannah Merker, *Listening*[39]

Who better to comprehend silence than those who cannot hear? Although Cage insisted that the rumbles of his own organs were audible even in an anechoic chamber, might he have apprehended pure silence if he had lacked the physical capacity for audition? If a tree falls in a forest and you simply cannot

hear it, you experience hush in a way that most people, even with the aid of earplugs, cannot. The memoirs of the deaf abound with details about the loss of hearing, the ordeal of education, encounters with bigotry, and the relative advantages of signing and oralism. Some authors use their personal histories to demonstrate that "Deaf Is Dandy," that the non-hearing constitute a self-sufficient community with a complex culture of its own. The accounts of the prelingual deaf, those who were born without hearing or who lost their hearing before acquiring language, naturally differ from those of the postlingual deaf, those who learned to speak before losing their ability to hear. But none provides a description of silence that could satisfy the curiosity of those who never cease to hear something.

Despite the title of her memoir, *The Feel of Silence*, Bonnie Poitras Tucker is more intent on sussing out the feel of sound. "I know that the rain makes noise: the heavier the rain the louder the noise," she writes. "I know that because many people have told me so. But no one has told me when—or how— the rain makes noise. Is it the fall of rain itself that carries sound, or does the sound come only when the rain hits something, such as the ground or the windowpane?"[40] A resolute oralist who rejects deaf separatism, Tucker insists on seeing her condition as a handicap ("I would gladly grab any opportunity to fix my deafness")[41] and attends to sound rather than silence.

If deaf writers provide no privileged access to silence, it might be due to the limitations of written language, which evolved as a surrogate for speech. To publish a book on the deaf experience, Tucker, like Pierre Desloges, Helen Keller, Henry Kisor, or Hannah Merker, has to resort to English, French, or another semiotic system that ultimately derives from sounds. Within such a system, absolute silence is inconceivable because it cannot be represented. Perhaps the only accurate way to express silence is through signing, through one of the purely visual languages that are entirely autonomous and that empower the deaf to communicate without recourse to spoken languages. Benny Sidransky's view of American Sign Language resembles the utopianism of those who have advocated Hebrew, Latin, Esperanto, or Volapük as perfect conduits of thought and antidotes to linguistic muddle after Babel. Using ASL, Sidransky assured his hearing daughter Ruth: "Not need to speak to know language. I late to learn my language, never really learn hearing language, to speak with tongue well, but sign language is real language, separate from English, separate from tongue language. It is first language from God, before man talk with mouth."[42]

However, David Wright, a South African poet who lost his hearing at

age seven, contends that the deaf are no closer than anyone else to silence. Insisting, like Cage, that "no one inhabits a world of total silence," Wright describes the "phantasmal voices" that he, remembering sound, continued to "hear."[43] Hospitalized with the scarlet fever that destroyed his auditory nerve, he had no trouble continuing to understand the people he knew:

> My mother spent most of the day beside me and I understood everything she said. Why not? Without knowing it, I had been reading her mouth all my life. When she spoke I seemed to hear her voice. It was an illusion which persisted even after I knew it was an illusion. My father, my cousin, everyone I had known, retained phantasmal voices. That they were imaginary, the projections of habit and memory, did not come home to me until I had left the hospital. One day I was talking with my cousin and he, in a moment of inspiration, covered his mouth with his hand as he spoke. Silence! Once and for all I understood that when I could not see I could not hear.[44]

Yet Wright sees much, feelingly. Ludwig van Beethoven and Gabriel Fauré famously continued to compose after losing their hearing, and Wright and others report that the deaf indeed "hear" music, by feeling the vibrations it produces. In a room with a wooden floor, he "listened" to the instruments of an orchestra through his feet. So, though silence functions as a modernist metaphor for the absolute, a kind of magnetic north for situating purity in art, it does not exist—or, at least as soon as we try to experience it, the very act of observation stirs up the stillness. "It is not necessary to be able to hear in order to hear," says Wright, who, experiencing music as tactile, suggests synesthesia as a universal condition. Though we and other species are attentive to differing frequencies, everything leaves an impression, in one sense or another.

7

Speech is of Time, Silence is of Eternity.
 —Thomas Carlyle, *Sartor Resartus*[45]

Moving to Tel-Aviv in August 1973, I realized shortly after signing a lease that I had bungled my choice of residence. I rented an apartment that was conveniently located—beside both the main coastal highway to Haifa and the small but busy Sde Dov Airport. You might say that the unrelenting tumult of traffic was so abrasive that I could not even hear myself think—except that my thoughts were loud and frantic. Sleeping *under* the pillow did not help,

because under those conditions sleep was as elusive as sanity. Had I been selected by the Mossad to be a subject for some experiment in aural torture?

Relief arrived a few weeks later, with the outbreak of war. Many of my neighbors were mobilized, sent off to hold the fragile lines against the Syrian and Egyptian armies. Commercial aviation was grounded, and the six-lane highway was transformed into a virtual promenade. Except for an occasional air-raid siren, my apartment was as quiet as the reading room in the Gallaudet University library. While the massive violence and suffering left me stunned, dismayed, and grieved, I experienced the Yom Kippur War as an oasis of calm. However, even without gunpowder, bombs, and missiles, the battlefield in the *Iliad* is a very noisy place. And frontline service in the infantry has become ever more cacophonous during recent centuries. If hell is war, damnation means being sentenced to eternal clamor. John Milton named the capital of his hell, the raucous place where all the demons congregate, Pandemonium. Those who raise hell do not speak softly.

World War II concluded in 1945, but the bellicose ambient clangor has gotten only shriller. It is harder and harder to find a place to live that is free of noise pollution that is not within earshot of the grating, jarring, strident sounds of planes, cars, trucks, motorcycles, lawnmowers, leaf blowers, boom boxes, power saws, and power drills. "Nothing has changed the nature of man so much as the loss of silence," wrote Max Picard,[46] and in the fifty years since he made that observation nothing confirms it so much as the fact that we take the perpetually elevated level of sound for granted. If repeated exposure to volumes greater than eighty-five decibels causes physiological as well as psychological damage, the species has been subjected to profound stress.

Until the advent of recording less than a century ago, sound was a singular phenomenon. One might cherish for an entire lifetime the memory of having heard the Philadelphia Orchestra perform a Schubert symphony or William Jennings Bryan deliver a campaign speech. Now it is impossible to escape endless reiterations of the same sounds, and a dental appointment, a telephone hold, or a visit to a shopping mall means serving as captive audience to sounds selected by an invisible agent. Though released as late as 1936, nine years after *The Jazz Singer* made talk seem indispensable to cinema, Charlie Chaplin's *Modern Times* is still a silent film, except when Charlie's boss barks orders at him. For Chaplin, sound, which threatened his art and his livelihood, is ominous. We can always close our eyes to unpleasantness, but ears are not equipped with lids, and nothing is as tyrannous as forcing

sound on someone else. In George Orwell's *Nineteen Eighty-Four*, the voice of Big Brother, in fluent Newspeak, booms out from ubiquitous speakers.

Muzak, the company that pioneered the commercial distribution of melodic wallpaper, has become more sophisticated than it was when clients needed only to upholster their elevators with a faintly recognizable upbeat tune. Its repertoire is much larger, and it faces competition. But, according to an official in Muzak's marketing department: "Our biggest competitor is silence."[47] Yet that competitor seems teetering on the brink of bankruptcy. Weary of all the sound and the fury and the sound of fury, I yearn to listen to the lesson of the cosmos, the silence of ineffable truth. I use my mother tongue to long for moments when all goes mum. Amid the enervating din of speeches, beats, and screeches, I dream of tender mothers armed with bars of soap scouring discord from a raucous world. The rest of course is silence.

Life in the Margins

From Brooklyn to Bulgaria

2002

If doughnuts are nothing but sweet empty calories, their centers are nothing but nothing. Centers, held Yeats, cannot hold, but neither can distinctions between inside and outside, up and down, center and circumference. The double helix, on which life is built, is a Möbius strip that makes a mockery of centrality and finality. By almost any measure, save the esteem of its citizens, the Brooklyn I grew up in was a major urban center. If the borough had been an independent municipality, as it was until incorporation into New York City in 1898, its population of three million would have made it the fourth largest city in the United States. Its schools, libraries, medical institutions, recreational facilities, and transportation system were outstanding and accessible. George Washington had slept in Brooklyn, and so, more frequently and soundly, had Walt Whitman, George Gershwin, Ben Shahn, Marianne Moore, Spike Lee, and Arthur Miller. Unique among geographical jurisdictions smaller than a city, Brooklyn even had its own major league baseball team, something not even metropolitan upstart Los Angeles could claim, until 1957.

Yet Brooklyn, along with the Bronx, Queens, and Staten Island, was and is known as one of the "outer boroughs," a mere foyer and foil to glamorous Manhattan. "New York, New York, it's a wonderful town," explain three furloughed sailors, functioning as singing cartographers, in the musical *On the Town*. "The Bronx is up and the Battery's down." Down south below even the Battery, the tip of Manhattan, lies invisible Brooklyn. George M. Cohan crooned, "Give my regards to Broadway," but neglected to offer his respects to Brooklyn, which occupies all of what, in a gesture of specious majesty, is called Kings County. When someone from my native borough states, "I'm going to the City," there is no ambiguity about which city or about the fact that, though its citizens cast decisive votes in New York City elections, Kings County is a dispensable stem on the Big Apple. "One of the longest journeys

in the world is the journey from Brooklyn to Manhattan," observed Norman Podhoretz, aware that it takes more than a subway token to move from margin to center.

When I left Brooklyn I moved west, far past the last stop of the New York Metropolitan Transit Authority, to lands where egg creams and bialys are more exotic than guanabana. Saul Steinberg's infamous Gothamocentric *New Yorker* cartoon would suggest that venturing beyond the Hudson is like sailing off the edge of the world. So moving beyond the Mississippi took me beyond beyond the pale. I have lived in Bemidji, Minnesota, which registers on Americans' radar, if at all, during winter mornings when it is the coldest spot in the lower forty-eight, and in Irvine, California, a freeway exit amid Orange County's formless sprawl. For most of the past three decades, I have lived deep in the heart of Texas, in a metropolis that is neither Dallas nor Houston. If one measure of centrality is how a place is identified, consider that whenever the nation's seventh largest city is mentioned in news reports, it is always San Antonio, Texas. Neither Cleveland nor Milwaukee nor Pittsburgh needs to be cited with its state.

If all the world's a stage, some nations stand, by chance or choice, in the wings, playing the role of supernumerary to the superpower. It is a lighter burden to carry the spears than to have to hurl them. Those who lurk on the periphery gain an edge over centrists, who lack a corner in which to hide. Consider Canada: an entire nation dedicated to the principle that it is not the United States. Vancouver is not San Francisco, Windsor is not Detroit, and Toronto is not New York, though it is pleased to serve as its cinematic doppelgänger for frugal moviemakers who stay within budget by disguising Yonge Street as Sixth Avenue. For Canadians, stretched along a long southern border, skirting the center is, more than slapping a hockey puck, the national pastime. Why would a country call its states provinces if it did not embrace provincialism? The second largest sovereignty in the world, Canada is small time in a big way.

In 1980, I spent five months in Tbilisi, Georgia, teaching at a university in what was then the hinterlands of the Soviet Union. Though more people live in Tbilisi than in Tallahassee or Trenton, the capitals of Florida and New Jersey are more recognizable to outsiders—which is to say insiders, those who occupy the spheres of greatest earthly influence. CNN broadcasts to the world from Atlanta, Georgia; the other Georgia is a feebler transmitter. Georgians, who speak a language unrelated to any other in the world, pride themselves on their rich ancient culture, which they deem superior to that

of the barbarian Russian interlopers who whitewashed the murals of their churches and attempted to outlaw Georgian from the classrooms of the Caucasus. But even during the Soviet era, children in Tbilisi grew up knowing long passages of Shota Rustaveli's medieval *Knight in Panther's Skin* by heart and assuming that their national epic was as renowned a contribution to world literature as works by Homer, Dante, Shakespeare, Goethe, Tolstoy, and Proust. They were mistaken. Rustaveli would not even figure in a list of the ten thousand most famous authors, though he should, and, if he had lived closer to the centers of cultural power, he would.

A verdant corridor between Europe and Asia, Georgia has been host and hostage to wave after wave of travelers, plunderers, and usurpers. While resenting the Soviet interregnum that ended in 1991, Georgians tend to regard their former Kremlin overlords as yet another horde of failed invaders. Having survived the Mongols, Arabs, Saracens, Persians, and Turks, Georgians knew they would outlast the Russians. In the process, they reaffirmed their carrefour consciousness, their pride in enduring as a distinct and vibrant culture despite being placed in medias res. Like Lebanon, Poland, and Vietnam, Georgia takes heart from the thought that it is a crossroads enriched rather than destroyed by countless crossings. For all the world, these are the boondocks, but crossroad cultures like that of Georgia are also situated at the center. By contrast, efforts to determine the imaginary demographic midpoint of the United States often lead to an empty prairie acre. Tbilisi demonstrates that it is possible to be a center without being the focus.

Over in the Balkans, at once the epicenter of history and its distant periphery, there is a calm at the eye of the storm, a blind spot where all the gazes cross. It is not Belgrade or Sarajevo or Srebrenica, cynosures of ethnic strife. In September 2000, I traveled to Sofia, which, though located at the midpoint of the Balkan Peninsula, almost equidistant between the Adriatic and Black Seas, is a forgotten metropolis of about 1.3 million. Named from the Greek word for wisdom, Sofia is Europe's unknown capital, an uncertain redoubt against the Enlightenment. Unlike Jerusalem, Athens, Alexandria, Vienna, and London, "unreal" cities cited by T. S. Eliot in *The Waste Land*, Sofia is a real city, one that inhabits the imagination of few but its own inhabitants. Bulgaria's charming second-largest city and its former capital, Plovdiv (population 500,000), is too obscure even for the inventory of TV quiz show savants.

Now that Albania has exploded into international awareness with political revolution and economic collapse, and Slovenia and Croatia stepped away

from Yugoslavia to take their separate bows, Bulgaria is probably the continent's most unfamiliar country. It, too, is a carrefour nation, one that has withstood incursions and appropriations by numerous interlopers. "When you come to a fork in the road," declared Yogi Berra, "take it." Thracians, Romans, Khazars, Celts, Goths, Huns, Byzantines, Tatars, Greeks, Turks, Germans, and Russians have taken roads into and through Bulgaria. Yet no one can take the Balkans for granted, even by confusing them with the Baltics. Although it is the nexus between Europe and Asia, Christianity and Islam, modernity and antiquity, ill-paved Bulgaria is off the beaten track, a country in which not even Canada bothers to maintain an embassy. Simeon II—who governed under the mufti moniker Simeon Saxecoburggotski—was at once the heir to the abandoned Bulgarian throne and, during my sojourn there, the nation's newly elected prime minister. Though a Balkan equivalent of both Prince Charles and Tony Blair, he could probably ice-skate at Rockefeller Center without arousing a single paparazzo.

Despite the return of its royal pretender from a fifty-five-year exile, Bulgaria is hemorrhaging Bulgarians, losing many of the best and brightest of its residents (8.2 million and counting down) to the lure of Western centers. Its youngest have been scraped away by curettes; from 1995 to 1998, abortions outnumbered births in Bulgaria. A connoisseur of margins, I sipped the Bulgarian backwaters during a semester at the University of Sofia, where English, the language of Shakespeare and Melville but also of the dollar bill, is a popular subject. It was a season in both paradise and perdition. According to Greek legend, Orpheus, master of the enchanted lyre, inhabited what is now Bulgaria, but, attempting to retrieve his beloved Eurydice, went to hell. An American who visits Bulgaria must cross the Stygian borders, must move from the metropolis into the sticks.

Casual travelers to ultima Thule who expect to discover the there that is there must settle for specters of themselves. A Texan at Masada sees shadows of the Alamo. Bulgarians speak a Slavic tongue that, while also kin to Croatian, Czech, and Polish, is, like Russian, Serbian, and Ukrainian, written in the thirty-letter alphabet derived from the forty-eight characters concocted by Saints Cyril and Methodius in the ninth century to accommodate their translation of the Bible. Bulgarian is said to be closer to the primal Slavic language, Old Church Slavonic, than any of its cousins. But even major universities in the United States that teach Polish, Russian, and Ukrainian rarely offer courses in Bulgarian. I knew enough Russian to read Sofia street signs in Cyrillic, but because I never became fluent or even comfortable in Bulgarian, whatever I

encountered in the Balkans had to be refracted through the syntax of prosperous America. And it was hard to translate the quiet desperation of a society where the average monthly income is barely $100 and the (official) unemployment rate is 15 percent into the sanguine language of Ralph Waldo Emerson, Horatio Alger, and Dallas Cowboys cheerleaders. In Bulgaria, nodding one's head means no; shaking it means yes. A newcomer unfamiliar with the contrary way in which Bulgarians use their heads to approve and refuse could easily run into trouble. It would be like innocently scratching your own earwax at an auction and discovering you owed $20,000 for an urn you did not want.

While cheerfulness is a particularly American obsession, as if we feel forever compelled to test whether national buoyancy really does float, it is not just compatriots of Walt Whitman and Norman Vincent Peale who nod. Moving the noggin up and down is near universal as a mark of assent. I know of no country other than Bulgaria where the semiotics of head signals are so dramatically reversed. Bulgarians I queried in a cafe were as puzzled by the phenomenon as I—inclined to shake my head in disbelief, except that the waiter might interpret that as affirmation and bring me an unwanted shot of rakia. Of course, Bulgarians who have been exposed to foreigners know how to transpose their head movements, which only adds to the confusion, since you can never be certain whether they are trying to accommodate a visitor's comprehension when they nod, or are using their heads as they ordinarily do.

Acknowledging the influence of the carrefour culture, one theory holds that Bulgarians are deliberately perverse, perhaps in order to set themselves apart from all the nations that have tried to dominate, absorb, or destroy them. It is worth noting that their southern—sometimes hostile—neighbors, the Greeks, say *da* when they mean no, and that Bulgarians, and other Slavic speakers, say *da* when they mean yes. They say *kartof*, and I say *potato*, but divergence over whether something affirms or denies is much more fundamental than a mere difference in vocabulary. It probably does not encourage concord within the contentious Balkans.

The lands beyond the western coast of the Black Sea have long been both the black hole of geopolitics, sucking in global energies, and a vast volcanic operation grinding things down and spewing them outward. The Balkans are a laboratory for gauging the operations of both centripetal and centrifugal force. Throughout recent history—including the Russo-Turkish War of 1878, the Great War triggered at Sarajevo in August 1914, and the NATO bombings of Serbia in 1998—the outside world has been drawn violently into the peninsula, at the same time that the area's proclivity toward fragmentation

has given the world the verb "to balkanize." Splintering off along with the rest of Croatia, Split, a lovely town on the Dalmatian Coast, has lived up to its fractious name. When I visited the Federal Republic of Yugoslavia in 1990, a year before that hybrid concoction began to come undone, citizens were vaunting their success at maintaining interethnic amity—harmony among disparate languages, religions, and cultures. Today the former Yugoslavia lies in shatters, and Belgrade, its Serbian center, cannot hold even Montenegro much longer. At the margins, Ljubljana, Zagreb, and Sarajevo provide alternative hubs; though, in the incessant cotillion from center to margin back to center, Slovenia, Croatia, and Bosnia all seek entry back into the middle, as members of the European Union.

Bulgaria does not seem on the verge of disintegration, though it, too, boasts of harmonious heterogeneity. In the case of the Jews, it has just cause. During World War II, Bulgaria, alone of all the European countries under German domination, saved virtually its entire Jewish population, which numbered about 50,000. Though formally aligned with Berlin against the Allies, Bulgaria's Tsar Boris, the grandson of a German aristocrat, refused to deport native Bulgarian Jews to the death camps in Poland. Could anti-anti-Semitism have succeeded in Bulgaria when it failed in Holland and Hungary, because, after slyly nodding its collective head to plans for the Final Solution, Bulgaria of course did nothing?

However, another marginal group, 550,000 Roma, or Gypsies, live on the perimeters of respectable society, in largely squalid quarters, excluded from opportunities for education, health care, and employment. Outsiders to their outcast community most often see the Roma begging on the streets of larger cities. Even educated Bulgarians, who would never disparage any other group, feel no compunction about reviling the pariah Roma. Nor are about 800,000 ethnic Turks integrated into Bulgarian society. Although the ancien régime of the Stalinist ruler Todor Zhivkov—who, until toppled in 1989, held power for thirty-five years—did promote assimilation, the terms were both callous and coercive. In 1985, when Turks were ordered to adopt Bulgarian names and to cease speaking Turkish in public, about 350,000 fled to Turkey. Many have since returned, but, though male Muslim circumcision is no longer forbidden, election to parliament of members of the Turkish Movement for Rights and Freedoms testifies both to the community's new clout and to a continuing need to defend its interests.

Wariness toward the large Turkish presence, concentrated in the northeast and east, is a legacy of almost six centuries in which Bulgaria served as

an involuntary outpost of the Ottoman Empire. So, too, is mistrust of the 250,000 Pomaks, descendants of Bulgarians who converted to Islam under Ottoman control. Yet majority Bulgarians themselves remain the Pomaks of European culture, shunned and stigmatized. Until 2001, most of their neighbors demanded special visas from Bulgarian travelers, and the derivation of the word *bugger* from Bulgaria—dating from a time when the nation harbored heretic Bogomils, ostracized from the heart of Christendom—is a continuing linguistic mark of Cain. More recently, Bulgaria was, without proof, widely believed to be complicit in the shooting of Pope John Paul II. The fact that Bulgaria was once itself a mighty empire has left as its residue a nation of ironists. In 1014, after decisive defeat by Byzantium at the Battle of Belasitsa, 15,000 Bulgarian soldiers had their eyes put out. Can any Bulgarian gaze at the historical pageant of momentary dominions without a tinge of brutal melancholy?

During Slobodan Milosevic's attempts to create a "Greater Serbia," Bulgaria—the Nebraska of the Balkans—willingly served as a flyover zone for NATO bombers. The loss of Yugoslavia as a trading partner and the general leeriness of foreign investors toward the entire region devastated the Bulgarian economy. Massive investment has been promised to help rebuild Serbia, but Bulgaria, still ignored by outside powers, sees itself as the victim of a victory that, hoping to propitiate wealthy Western nations, it supported. An editorial in a Sofia newspaper jested that Bulgaria might attract preemptive foreign aid if it simply declared war against Romania, with whom it squabbles across the Danube. But Bulgaria chose the wrong side in both World War I and World War II, and fighting for itself, even against a depleted neighbor, would not be a prudent option.

Russia fought, successfully, to free Bulgaria from Turkish rule in 1878. In Sofia, a huge white sandstone obelisk, called Ruski Pametnik, memorializes the two hundred thousand Russian soldiers who died liberating fellow Slavs; and, fourteen meters above the street outside Bulgaria's National Assembly, a statue of Tsar Alexander II, the Russian monarch who led the liberation, sits astride his horse. Though it follows the rites not of Russian Orthodoxy but of Bulgarian Orthodoxy, an independent and indigenous church, Sofia's monumental Alexander Nevsky Cathedral was built and named to honor the Russian "Tsar Liberator" and his patron saint. One of the country's most impressive structures, the neo-Byzantine cathedral proclaims Bulgaria's religious autonomy at the same time that it concedes subservience. No one would imagine naming Philadelphia's Independence Hall after the Marquis

de Lafayette, for all his help during the American Revolution. Things are done differently in nations on the margins.

For most of the Cold War, Bulgaria, devoid of those occasional rowdy episodes that thrust Czechoslovakia, Hungary, and Poland into the spotlight, was the most reliable member of the Warsaw Pact. When the Soviet empire crumbled and glasnost spread even to Sofia, the first fair elections returned the Communists—elected as the Bulgarian Socialist Party—to power in 1990. Unlike Romania's Nicolae Ceausescu and Yugoslavia's Josip Broz Tito, Georgi Dimitrov and then Todor Zhivkov followed the Kremlin line, a sturdy streetcar for carrying Bulgaria to the fringes of international attention. Though it is now defaced by graffiti and ignored or reviled by passersby, the bronze *Monument to the Soviet Army* still commands the edge of Borissova Gradina, Sofia's version of Central Park.

Central heating is a Western frill that I did not expect to encounter at Europe's southeastern extremities. However, temperatures within buildings are indeed centrally regulated, for the entire city of Sofia. On October 26, 2000, radiators in every apartment and office in Sofia began to vent heat for the first time since the end of winter. The region was still basking in what Bulgarians, oblivious to the ethnic slur, call "Gypsy summer," and the only alternative to communal hyperthermia was to open the windows and keep them open for several weeks, until frigid weather finally justified the municipal decision. With central heating, as with the value of their lev on the world's currency markets, Bulgarians have reason to believe outside forces are driving their lives.

Because ownership of a private car exceeds the means of most Bulgarians, Sofia should be a pedestrian's paradise, except that motorists are more rash than they are rare, and sidewalks seem to have been designed by cobblers, to drum up more trade. Within two days of setting foot in Sofia, I had mangled a shoe on its broken pavements. And what cars there are get parked on the sidewalks, forcing walkers to squeeze along beside them. To save their mortal soles, pilgrims in Bulgaria must tread warily, past feral dogs, pugnacious beggars, and street signs tagged for poets. In the North American metropolis, buildings, roads, and bridges tend to be designated with the names of politicians (Emily Dickinson and Wallace Stevens will never overtake John F. Kennedy and Ronald Reagan in the competition to claim airports, high schools, and boulevards), but street maps for liminal cities are a literary pantheon. In Sofia's case, cherished poets were also political heroes, indeed martyrs to the cause of nationhood. Hristo Botev died during the anti-Ottoman

insurrection of 1876. Dimcho Debelyanov was killed in combat in Macedonia in 1916. And police abducted and murdered Geo Milev in 1925. These are not household names beyond the Balkans. The only Bulgarian to have won the Nobel Prize for literature was Elias Canetti, but when I mentioned the renowned name, even educated Bulgarians did not recognize it, perhaps because, though born in Ruse, on the border below Romania, to a family of Sephardic Jews, Canetti spent most of his life in England, writing in German. Among contemporary Bulgarian authors, Julia Kristeva and Tzvetan Todorov have the widest reputations in the outside world, but each lives in France and writes in French.

Because he was born in colonial Ireland, George Bernard Shaw might have been expected to write with sympathy for the periphery, yet in *Arms and the Man* he ridicules Bulgaria as an unhappy land burdened by the illusions of war and love. In act 1, Raina boasts about her aristocratic family's library, "the only one in Bulgaria," but we learn in act 3 that "it is not much of a library. Its literary equipment consists of a single fixed shelf stocked with old paper covered novels, broken backed, coffee stained, torn and thumbed; and a couple of little hanging shelves with a few gift books on them." Scholars who visit contemporary Bulgaria discover that its bibliographical resources have not much improved during the past hundred years. In 1759, four centuries after the fall of the Second Bulgarian Empire, when Voltaire was incensed by incessant wars between the Prussians and the French, he found it more politic to use Bulgars and Avars as satirical surrogates. Brutish Bulgar soldiers in *Candide* abduct the title character into their foolish and ferocious war against the Avars, and they rape and disembowel his beloved Cunégonde. It is all too easy to mock the hinterlands as outlandish, as Alfred Jarry did when, in *Ubu Roi*, he assigned one absurd character to be the entire army of Poland, a nation that did not even exist in 1896, when he wrote his play. But a worse indignity is to be too obscure to be mocked at all. The vast, nasty repertoire of Polish jokes might instead have been Bulgarian jokes, except that jokers usually do not know Bulgaria from Burkina Faso.

Virtually every Bulgarian I know has a friend or family member who has abandoned Bulgaria, convinced that psychic suffocation is the fate of those who remain in the thin of things. In Bulgarian, *bolka* means pain, and, though the word comes from a different root, the Balkans are a zone of woe. "What do you like about this country?" asks an affable taxi driver, on the chance that a stranger might find reasons to dispel the gloom. Despite the vitality of Sofia's theaters and concert halls, the city appears to be wrapped in a permanent pall. "Only the Dead Know Brooklyn" is how Thomas Wolfe, who moved

to the outer borough from Asheville, titled a famous short story, and there is a posthumous feeling to living on the periphery, whether of the Big Apple or the Continent. Catastrophic derailment is often the fate of those who ramble off the beaten track. Humans are giddy migrant creatures, programmed to move to where it's at, even if "it" is the inane ritual of lowering a gaudy sphere on Times Square to mark the start of a new millennium. The only way to keep 'em down on the farm after they've seen Paree is to give the farmers full citizenship in the global village, through Coca-Cola, cable, and the Internet. Bulgaria longed to lose itself in the European Union, the agent that it hoped would rescue it from oblivion. Those hopes might have appeared fulfilled in 2018, when, after being accepted into the European Union in 2007, Bulgaria hosted the rotating presidency of the Council of the EU. "Unhappy the land that needs a hero," wrote Bertolt Brecht. Pining for a champion—even Simeon II, who returned in 1996 from the Spanish exile he began at nine, in 1946—to redeem its afflictions, Bulgaria is an unhappy land.

And yet divergence is a force as powerful as convergence. A yearning to be far from the madding crowd burns within members of the crowd itself. "Nobody goes there anymore," observed Yogi Berra about a restaurant that had lost its cachet but not its liquor license. "It's too crowded." Grand Central Terminal, in the heart of Manhattan, is the site of both connection and dispersion. Planetary conglomeration—through corporate mega-mergers, NATO's absorption of its former antagonists, and near-universal membership in the United Nations—accelerates even as centrifugal force propels separatist movements in Abkhazia, Aceh, Catalonia, Chechnya, Corsica, East Timor, Eritrea, Irian Jaya, Kashmir, Montenegro, Nigeria, and Quebec. New York City makes occasional noises about separating from New York State, and some Brooklynites even plot secession from the City. Greta Garbo famously wanted to be alone, but fascination with such factoids from popular culture brings us all together. We measure out our days between the tumult of the Big Time and the stillness of the small time.

During Thanksgiving, the most American of holidays, I found myself back on what is, legally, American soil, at the official residence of the United States ambassador to Bulgaria. If representing Washington at the Court of Saint James's is the plum position for a foreign service officer, assignment to Sofia must be a prune. Nearing retirement, Ambassador Richard Miles, a veteran of the diplomatic corps, was not visibly pining for a final commission to Tokyo or Berlin. In fact, whether or not he would be eased into early retirement was, in November 2000, still hanging on a few disputed presidential votes in some distant Florida precincts. But after dinner, instead of watching

football, Miles recounted to his guests how he and his wife had evacuated their previous residence, in Belgrade, just ahead of angry mobs that sacked the building. The week before Thanksgiving, they had returned to Serbia for the first time, to hoist the same American flag they had lowered during their hasty, hazardous exit. People living in the periphery can safely count their blessings, even if they cannot savor them.

My departure from Bulgaria demanded a readjustment of norms. Emerging from the Balkan haze into a Texas glare, I found that American cars seemed too long, American grocery shelves too copious, American torsos too stout. I also found myself thinking about Dante's geometry of desire, a series of concentric circles that constitute hell. A conviction that she is trapped out in the circumference is what poisons Emma Bovary's existence; a rural girl with centripetal dreams of big-time glamour, she moves from her father's farm to Tostes to Yonville to Rouen, but never quite makes it to Paris. Urbanization, one of the most powerful forces in the modern world—propelled by the universal intuition that genuine life is elsewhere—has made Cairo, Calcutta, Kuala Lumpur, Lagos, Lima, and Mexico City almost unlivable.

Franz Kafka spent almost his entire life in Prague, the provincial capital of a disintegrating empire. By 1924, the year he died in exemplary obscurity, the United States had emerged as the strongest economic and military power on earth, yet Kafka never set foot beyond middle Europe. When he wrote *Amerika* (in German, the imperial language of Vienna, not the patois of either Prague or the shtetls of his own scattered people), he was so far out of the loop that he imagined Oklahoma lying beside the Pacific. But Kafka built a better mousetrap than any other author of his era, and the world, whose conscience his oeuvre catches, has beaten a path to his secluded doorstep. Kafka is the central icon of a shattered age.

Decentering became a crucial industry in Paris, New Haven, and other capitals of postmodernism, a radical church that denies privilege, as if every soul is equally aswim in the holy sea. Postmodernists insist on deconstructing the metaphor of nucleus and circumference, as if the Pomo Indians of the Pacific Northwest were as pivotal to civilization as Wall Street magnates. Though millions of hajis make their pilgrimage to magnetic Mecca, when Muhammad himself stood his ground, the mountain came to Muhammad. The lesson of a season in a Bulgarian city named for wisdom is ambiguous. The only certainty is that wherever I choose to plant my feet, they grow toenails. Even Sofia, Tbilisi, or Brooklyn can be Mecca. It can also be Mudville.

Out of Sight

2019

Beneath it all, the desire for oblivion runs.
—Philip Larkin, "Wants"

In 1956, when T. S. Eliot spoke at the University of Minnesota, the event had to be held in the university's Williams Arena, aka "The Barn," in order to accommodate the fourteen thousand people drawn to see the famous author in person. Wallace Stevens wrote that "the poet is the priest of the invisible"; Eliot was enough of a celebrity to convince the editors of *Time* to place him on the cover of their weekly magazine. However, in his best-known essay, "Tradition and the Individual Talent," he champions self-effacement. According to Eliot, the creative act is for the artist "a continual surrender of himself as he is at the moment to something which is more valuable. The progress of an artist is a continual self-sacrifice, a continual extinction of personality." The reader, accordingly, should resist chatter about the author but instead concentrate exclusively on the text: "Honest criticism and sensitive appreciation are directed not upon the poet but upon the poetry."

Eliot belonged to an age that, in retrospect, seems more demure than the present. In footage of baseball games before World War II, fans in the stands wear jackets and ties, even during the height of the summer and the depths of the Depression. Hollywood's Motion Picture Production Code refused to countenance profanity, nudity, or sacrilege. Though some actors, politicians, and athletes certainly engaged in questionable behavior, few outsiders raised questions, because the behavior was kept out of sight. Journalists generally colluded in concealing the private lives of prominent people. Racial injustice was rampant, but not discussed in polite company. Eliot's aesthetics of impersonality, which D. H. Lawrence reduced to the admonition "Never trust the teller, trust the tale," was the product of an age in which Jack Benny, a master of self-effacing humor who made mockery of his limitations as a violinist and his image as a miser, declared: "Modesty is my best quality."

By contrast, much of contemporary culture is not a negation, but a

celebration, of the individual ego, epitomized by the popularity of the sel-fie. The industrial machinery of commercial publicity demands self-promotion rather than self-effacement from authors. Though humility, anonymity, and penury were long considered the appropriate lot of the translator, Lawrence Venuti, a leading theorist of translation studies and author of *The Translator's Invisibility*, urges literary translators to abandon their invisibility and *foreignize* their texts, i.e., not try to pass them off as written in the target language, but rather make it apparent that they *are* translations. When Scott Moncrieff gave his rendition of À *la recherche du temps perdu* the title *Remembrance of Things Past*, he was offering a shout-out to Shakespeare, not Proust, and thereby signaling his own presence.

No publisher today would let Emily Dickinson provide "I'm nobody! Who are you?" as an excuse for avoiding book signings and interviews. The first-person pronoun—used even by the #MeToo movement that arose to protest sexual abuse, in reaction against rampant predation by callous egotists—has preempted everything else. "I am, with or without you / I am, breathing without you / I am, somebody without you," proclaims Leona Lewis, in one of more than twenty-five recent pop tunes by various songwriters that all bear the title "I Am." The blusterous forty-fifth president of the United States, who regularly proclaims that he knows more than generals, scientists, economists, and other experts and who boasted that "I alone can fix it," is the most obstreperous specimen of the culture of aggressive self-assertion.

Amid a culture in which everyone is unmasked and in your face, in which privacy is abandoned and everything is bared in social media, how tempting it is to follow the example of John Keats, who tells his nightingale he wishes he could "leave the world unseen / And with thee fade away into the forest dim." In a world of perpetual surveillance, not just in banks, airports, and department stores, but also city streets and even private homes, the universal extension of Jeremy Bentham's Panopticon in which there is no place to hide from the all-seeing eye, who would not covet the Invisibility Cloak of J. K. Rowling's Wizardkind? At the outset of *How to Disappear: Notes on Invisibility in a Time of Transparency*, Akiko Busch cultivates stillness. Motionless and silent in a forest, she makes herself inconspicuous to the wildlife around her. Ignored by the squirrels, crows, and deer, she notes: "I am reminded of the grace of reticence, the power of discretion, and the possibility of being utterly private."

Busch teaches at the School of Visual Arts, the New York institution

whose very name belies blindness, though perhaps it is the function of art to make the unseen manifest. A connoisseur of abnegation, she describes her book as "a field guide to invisibility, one to reacquaint us with the possibilities of the unseen world." Early in her often lyrical meditations on the meanings and possibilities of invisibility, Busch discusses Plato's treatment, in Book II of *The Republic*, of the Ring of Gyges. According to myth, Gyges was able to become king of Lydia because one of his ancestors had acquired a magical ring that rendered him invisible. Unseen, he was able to murder the unsuspecting legitimate monarch and usurp his throne. Although Busch diagnoses what she calls her invisiphilia, she acknowledges the ethical complexities of not being seen. Since invisibility enables one to evade personal responsibility, who would resist the temptation to use the Ring of Gyges to murder one's rivals or enemies, loot banks, or merely shoplift a copy of Busch's book? Is visibility necessary to ensure morality? *The Republic* posits that a rational person is inherently virtuous, regardless of convenient chances to transgress. However, prisons are filled with irrational people who thought they could get away with murder or a lesser crime. If they were invisible, they in fact could, and they would surely seize the opportunity. Voyeurism is the offense of illicitly gawking at someone else while remaining unseen oneself. Moral responsibility—in Plato's Republic or the American Republic—demands visibility, an honest reply to the question: "Who goes there?"

In nature, though, species have evolved to survive by concealment, making themselves difficult to be seen—through stripes, spots, ambient colors, and other means—by their predators or their prey. Busch is fascinated by crypsis, the camouflage or mimicry that enables organisms to obtain food and avoid becoming food. She recalls noticing—barely—a green tree snake in Costa Rica that was able to surprise and devour a small toad after "spiraling down through the leaves and bark of a palm tree, its vivid jade color and delicately scalloped pattern of scale mimicking both the decoration of bark and the leaves of the palm tree behind it." Among other species that trick the eye through features that enable them to disappear into the environment, Busch cites "arctic foxes that turn white before snowfall, glamorous Indonesian crabs with baroque patterning on their shells that mimic the coral in which they live, octopi with cells beneath their skin that can change color to simulate that of the surrounding marine life." Musing on the pebble plant, which evolved to resemble the African rocks among which it grew, she concludes: "Its botanical ingenuity revealed something about the beauty, valor, and imagination of going unseen."

Of course, blending in can also be a survival strategy for human beings. Odysseus survives the wrath of the cyclops he has blinded by affecting anonymity. When fleeing Polyphemus's cave, he is asked by the giant the name of the intruder who poked out his solitary eye, and Odysseus replies: "No Man." And he lives to return to Ithaca. A Jew in Nazi Germany would not want to call attention to himself by walking down the street in a skullcap. Urban tailors prosper because those who hope to make a killing in the corporate world adopt the uniform that lets them fit in.

Busch also turns her eye to the use of camouflage for military purposes, the design of planes, ships, and other instruments of war to avoid detection. And she examines the physics of invisibility, the new technologies that are making things disappear, at the same that facial recognition technology and other engineering innovations are making it harder to remain unseen. Yet she exults in the anonymity of crowds. Walking through Grand Central Terminal, she marvels at what, echoing Gerald Stanley Lee, she calls "the gorgeous multitude," how "some 750,000 people a day manage to maintain their sense of momentum and direction as they pass through." It is not by asserting 750,000 separate identities. Trying to understand how an entire economy might supersede the conflicting desires of individual consumers and producers, Adam Smith, in The Wealth of Nations, posited "an invisible hand." Smith regarded it as a benign force, but invisibility also makes it easier for a hand to molest.

During a visit to Hafnarfjörður, Iceland, Busch learns about the Huldufólk, the invisible people believed to inhabit the volcanic rocks that surround the town. Her account of supernatural unseen presences verges on mysticism but, surprisingly, never mentions the concept of an invisible being that most dominates Western culture—God. According to the book of Exodus, not even Moses could catch a glimpse of the Deity except as manifested in a burning bush. Though Busch discusses how, in a white patriarchy, women, blacks, and others are often made to feel invisible, she neglects to note how oppressive being seen can be for women subjected to the male gaze. Marilyn Monroe was certainly not invisible, but the torment she felt was in part a consequence of how she was seen.

In "Elegy Written in a Country Churchyard," Thomas Gray, the champion of "mute Miltons," waxes sentimental over anonymity, regretting that: "Full many a flower is born to blush unseen, / And waste its sweetness in the desert air." Yet, exposed to the hooves of the madding crowd, many flowers would be crushed. Busch recognizes that human beings possess a primal longing to

melt, thaw, and resolve ourselves into an unseen dew, what she calls a "fundamental human need for obscurity that has gone unrecognized in recent years." But she also acknowledges a contrary urge to thrust ourselves into the line of sight; "we live to see and be seen," she notes. To be alive is to navigate a dialectic between the two opposing vectors. Though *How to Disappear* is largely a paean to evanescence, its author does not disappear. The book is signed with the distinctive byline of Akiko Busch.

Ain't We Got Fun?

2003

Are you having fun? Is there a more oppressive question? The interrogator is the simpering superintendent of amusements on a Caribbean cruise. To answer yes, you must try somehow to make yourself into the very model of mirth, contorting a grimace into a goofy grin and embracing salvation through shuffleboard and cha-cha-cha. To answer no, you confess to a fundamental moral failing. The ingrate who, offered all the advantages of contemporary diversion, still refuses to have a good time must be an enemy of the human race. "Dost thou think, because thou art virtuous, there shall be no more cakes and ale?" Sir Toby Belch interrogates Malvolio. In the fast-food court that is America, those who prefer to fast are force-fed cakes and ale. No Puritan parson was ever more severe than the current enforcers of fun.

"Fun is fun," observed Anita Loos, "but no girl wants to laugh all the time." Sometime between 1925, when Loos published that quip, in *Gentlemen Prefer Blondes*, and 1983, when Cyndi Lauper laughed all the way to the bank singing "Girls Just Want to Have Fun," human nature changed. Though life once seemed a vale of tears, it had become a barrel of fun. Today only a sourpuss insists that the best use for barrels is to accommodate pickles.

"Double your pleasure, double your fun" is the exhortation that for many years sold Doublemint gum. Even more emphatic was the Beach Boys' triadic hit tune "Fun, Fun, Fun." Who will bid four times fun? The noun "fun" shows up so often now in everyday speech that an alien observer might be tempted to impute very merry lives to the speakers. It is the rationale people give for starting a new business, having a baby, and joining the Navy. By the time the word metastasized into a popular adjective, about fifty years ago, fun had become the guiding principle of Western civilization. "It was a fun time" might serve as epitaph for the age of Madonna, O.J., and Monica, an era in which fun people did fun things in fun places. "Most people get a fair amount of fun

out of their lives, but on balance life is suffering, and only the very young or the very foolish imagine otherwise," wrote George Orwell in 1946. Already, the young and the foolish were shredding the confetti with which to usher in New Year's Day 1984, and to think of life as suffering became unimaginable under the Sign of the Smiley Face.

Even before 1965, when Fred Gastoff invented the vinyl pompom, cheerleaders began to outnumber philosophers at leading universities in the United States. Despite rampant crime, labor unrest, racial turmoil, and municipal insolvency, John V. Lindsay dubbed New York, the unruly metropolis whose mayor he became in 1966, "Fun City." The epithet might seem more appropriate to Fort Lauderdale or Las Vegas, but its application to Gotham marks a dramatic departure from Augustine's aspirations for the City of God or Jesus's for the City on a Hill. Did Pericles have a fun time ruling Athens? "We had fun. We got some positive things done for Texas. We worked hard. And it was the memories that I'll never forget" is how, on January 4, 2002, President George W. Bush recalled his six years as governor. It is unlikely that William Gladstone, Otto von Bismarck, and Charles de Gaulle would have characterized their public service in quite those terms. "People must not do things for fun," contended Sir Alan Patrick Herbert in 1935. "We are not here for fun. There is no reference to fun in any act of Parliament." Within less than thirty years, the injunction to have a fun time became enshrined in oral law.

Can bare facts be fun? "Facts alone are wanted in life," proclaimed Mr. Gradgrind in Charles Dickens's *Hard Times* in 1854, and a century later, when *Dragnet* premiered in 1952, Jack Webb's Sergeant Joe Friday was still demanding: "Just the facts, ma'am, nothing but the facts." Yet gloomy Friday did not fit the emerging mood of Mardi Gras, a universal Fat Tuesday that felt compelled to package facts as jolly. Hundreds of institutions now entice readers to peruse their documents by promising information that is entertaining. Internet surfers are lured to websites by icons promising "fun facts" about vitamin B2, the Sheraton Anchorage Hotel, ancient Egypt, United States currency, pygmy sperm whales, Kool-Aid, the California Gold Rush, the Microbial Genome Program, Grover Cleveland, Kwanzaa, Leonardo da Vinci, and figs. Additional fun facts will soon no doubt be made available about Immanuel Kant, turnips, North Dakota, psoriasis, Edvard Munch, and Idi Amin. Reading information about Ritz crackers is not my idea of a fun time, but a website operated by Nabisco promises "fun facts" about their product, and it is hard not to bite.

"Work is much more fun than fun," asserted Noel Coward, who probably never experienced what Marxists call the alienation of labor, which is not only the fact that workers lack control over goods and services they spend their lives producing but also that their essential lives seem disconnected from how they make a living. For a man of Coward's prodigious artistic talent, it is easier to have fun writing plays and songs than working in a coal mine or on an automotive assembly line. But for the mass of men and women whom modern industrialism forced into lives of quiet desperation, fun was what they dreamed of having during the breaks they never had enough of. It is precisely because work in the developed world ceased to be fun that fun had to be imagined and exalted, as an alternative to the dour reality. The invention of leisure, for those not already in the leisure class, coincided with the elevation of fun into a cardinal virtue and the creation of an industry to promote it. Having ostentatious fun, like sporting a perfect tan, became a way of flaunting—or feigning—emancipation from the tyranny of work. Fleeing the borders of responsibility, seekers of fun became migrants of a sort not widely known in the stable universe of Newtonian tasks, before repeal of the law of gravitas. As much as duty and even salary, fun has become a mighty force in the job market. Larry Ross, a high-powered CEO whom Studs Terkel interviewed for his oral history *Working*, described the relief he felt after selling his large company and becoming a freelance consultant. Despite tempting offers to return to corporate management, Ross explained, "Suddenly I realized what I'm doing is much more fun than going into that jungle again." Would Ralph Waldo Emerson have justified his career move to lecturer and essayist by complaining that being a Unitarian minister had simply ceased being fun? Fun, not profit-taking, was again invoked as justification when Philippe Kahn decided in 1994 to sell off part of his software company, Borland International, for $145 million. "If you're not having fun, it's not worth it," he told reporters. At some point in the last half of the twentieth century, the moment in which a job stopped being fun became the sanctioned point at which to quit.

Fun and games in ancient Rome—gladiator bouts and orgies—are not quite what would pass for fun today. *Jocus*, the closest synonym in classical Latin, is more a matter of moments and actions than the ebullient spirit we associate with fun. Nor do most translations—German *Spass*, French *amusement*, Spanish *diversion*, Dutch *plezier*, Portuguese *divertimento*—capture the cultural calibrations embodied in Ronald McDonald, Kim Kardashian, and Roger Stone. Though the English word is said to be derived from Middle

English *fonne*, fool, its current sense, as the motiveless pursuit of merriment, had to await the historical conditions that made fun possible. Samuel Johnson was a merry old soul, but when, at the end of the Augustan Age, he encountered fun, he dismissed it as "a low cant word." Yet fun is not just crude; it must also be gratuitous. To find fun times, it is not enough to locate an age that rejects high seriousness, as Matthew Arnold—inaccurately—claimed Chaucer did. Fun is a vulgar form of aestheticism; it is fart for fart's sake. It repudiates both purpose and politesse. It is Oscar Wilde in a bowling alley.

The most egalitarian of experiences, fun is available to anyone regardless of age, class, education, race, or sex. Sex is, in fact, one of the most common sources of fun, and it does not require pulchritude, wealth, or even a partner. The *Playboy* empire, dedicated to democratizing the orgasm, arose during the postwar Era of Feeling Good, when fun-loving was conflated with erotic fun. As the Gallic adage notes, *La fouterie est le lyrisme du peuple*, and if screwing is indeed the people's poetry, one hardly needs Mallarmé to have a good time. Whether they are brothels or merely amusement park attractions, fun houses earn their ill repute by defying genteel sensibility and siding with the rogues. Nothing is more characteristic of the spirit of the times than the urge to make fun of stuffed shirts and silk gowns, to mock elites as enemies of fun. The box-office success of grossout comedies, movies such as *Porky's*, *Dumb and Dumber*, *There's Something about Mary*, *Big Daddy*, and *American Pie*, in which it is cool to be uncouth, and belching, farting, nose-picking, and masturbating are sufficient conditions for risibility, testifies to the sovereignty of fun. Boorish comedies such as *Legally Blonde* celebrate the conquest of bastions of solemn privilege by raucous and raunchy fun. To appreciate the subtle, intricate pleasures of a 1924 Mouton Rothschild Bordeaux or a canto from *The Faerie Queene* requires the discipline and background of a connoisseur, but fun brings facile mirth to everyone. It proclaims perpetual carnival, a leveling of all hierarchies to the common merriment. "Ain't we got fun?" ask songwriters Gus Kahn and Raymond B. Egan, in the demotic, raffish English that is the native language of mischief. If they had, instead, phrased their question "Do we not have fun?" the obvious answer would have been "Hell, no!"

Under the dominion of fun, jollity trumps ideology. Glum John Adams would have stood no chance at winning office, and Abraham Lincoln's melancholy would have constituted grounds for impeachment. As fatal to his presidential ambitions in 2000 as a few disputed ballots in Florida was the fact that Albert Gore Jr. was seen as too stiff. In an era when it is more crucial for a

candidate to perform well on *Saturday Night Live* than on *Meet the Press*, Gore failed to convince enough voters that he was a fun guy. Hillary Clinton similarly failed the merriment measure. When O. J. Simpson, a connoisseur of glee, was asked to comment on Donald Trump, Clinton's political opponent in 2016, he replied: "Ain't no doubt about it. The one thing I can say about The Donald is The Donald is fun." American politicians who are not perceived as God-fearing do not get elected; those who come across as fun-loving prevail.

Ronald Reagan earned eight years in the Oval Office through his ability to act, even minutes after being shot, as if life were a box of chocolates and one need never swallow any Brussels sprouts. "It's good to be the king!" exclaims Mel Brooks's King Louis XVI, for whom the secret of successful monarchy is demonstrating that the monarch savors power. To predict the winner in each of the following contests, simply follow the fun: Kennedy-Nixon, Carter-Reagan, Mondale-Reagan, Clinton-Bush, Clinton-Dole, Gore-Bush, Obama-McCain, Obama-Romney, Clinton-Trump. "Are you having fun?" Jay Leno asks his audience, speaking for all broadcasters to all audiences. The mass media reflect, facilitate, and obey the culture of fun. Much of the fun in contemporary life comes from TV sitcoms, bestselling novels, glossy magazines, blockbuster movies, sports spectacles, and rock extravaganzas. And when they cease to be fun things, they cease to be mass media. Every viewer with cable connections and a remote control is sovereign of the video universe, moving on to other offerings as soon as the fun wears thin. The habit of measuring minutes as units of fun time has tainted other experiences. The dramatic increase in divorce since fun became a common adjective is surely due in part to blighted expectations that marriage licenses are a lifetime warranty for fun. Higher education has been lowered by the spurious assumption that college classrooms should be factories for fun.

The events of September 11, 2001, administered a powerful fungicide to the garden of good times. The immediate aftermath of devastation, war, and recession was a sobering of the collective mood. When American Media, a company based in Boca Raton, Florida, that publishes six successful supermarket tabloids, was itself attacked by anthrax, the crisis concentrated even the most giddy of American minds. Intent on tracking terrorists, the American media neglected their hallowed role of covering the sex lives of celebrities. The *New York Daily News* fired one of its three gossip columnists, and pundits were having fun proclaiming "the end of irony," as if Kandahar demanded candor and newly issued field rations allowed no place for cakes and ale. And yet it is difficult to trade a whoopee cushion in for a hair shirt.

Responding to the Financial Panic of 1875, Emily Dickinson, no Funny Girl herself, described: "An Innuendo sear / That makes the Heart put up its Fun / And turn Philosopher." 9/11 was a bit more than an innuendo, but it is hard to believe that even the destruction of the World Trade Center would turn most Americans into philosophers permanently. Within a few weeks of the attacks on Lower Manhattan and the Pentagon, signs were abundant that the collective heart was taking up its fun again. "Can we be funny?" asked executive producer Lorne Michaels during an installment of *Saturday Night Live* broadcast while bodies were still being recovered from the terrorist attacks. "Why start now?" replied New York mayor Rudolph Giuliani, who knew how to time his fun. In December 2001, two CDs of the fun-loving Rat Pack in performance as well as a remake of their movie *Ocean's Eleven* were released, demonstrating that the bibulous clique of entertainers whose parts—including Frank Sinatra, Dean Martin, Sammy Davis Jr., and Peter Lawford—were more talented than the pack's preening whole was still surfing waves of posthumous popularity.

When the Right Reverend George L. Carey announced in January 2002 that he was stepping down as archbishop of Canterbury, the prelate did not conclude: "It's been a lot of fun." But when a group of investors announced plans to start a new daily newspaper, the *Sun*, in New York, media analyst Dave Thompson predicted that it would not survive more than three years. "But it'll be a fun three years!" he exclaimed. When financial pressures eventually forced it to fold in 2008, struggling to keep the paper going had presumably ceased to be fun. And on January 3, 2002, when Greta Van Susteren, a longtime commentator and host at CNN, signed a contract with rival Fox News Network, she justified her desertion by invoking the rule of fun; speaking of her new employers, she told a reporter: "It's the year 2002, it's exciting, and I think they're having fun." One cannot imagine a similar response from Wernher von Braun when, back in 1945, before global fun began to melt the Cold War, he abandoned the German V-2 rocket program and went to work in Texas developing ballistic missiles for the United States. In fall 2001, consumption rather than conservation was being urged by an American president as the antidote to an ailing economy, as if splurging could cure penury and the hair of the dog that bit you did not also carry fleas. All it takes is a few upticks of the Dow Jones average for levity to rise once more. Not even Gulf War II could defeat the spirit of fun. Fun days are here again!

These days it is acceptable to mock almost anything, but those who make fun of fun risk the dreadful stigmas of snob and prig. A scarlet letter

for adultery would, by contrast, be just a joke. The final victims of the Salem witch hunts have been the Puritans, condemned posthumously less for intolerance than austerity, as if the culture that indulged in the exquisite eroticism of bundling was uniformly dreary and their fixation on death did not make them connoisseurs of the cosmic joke. Puritanism is, according to H. L. Mencken, the Baltimore sage with a taste for cakes and ale, "the haunting fear that someone, somewhere, may be happy."

I do not begrudge the happiness of fun-loving people. I merely doubt it. The house of fun does not have many mansions, and it is safer to hoist a piebald tent on its shifting land. Oblivious to grief, fun lacks the tragic sense of life, identified by Miguel de Unamuno in 1913, long before fun reached its apotheosis in Walt Disney World as well as most of the rest of the developed world, as the condition of being torn between irrational hope for immortality and the rational expectation of death. Fun denies the grave—not heroically, by defying it, but witlessly, by ignoring it. "Life is a jest; and all things show it," wrote John Gay for his own epitaph. But the remark would have been but idle fun without the plangent awareness of death that concludes Gay's couplet: "I thought so once, but now I know it." If mortality makes a mockery of earthly amusements, recognition that life is brief transmutes fun into something rich and strange. Fun is shallower than joie de vivre precisely because true joy in life is fueled by the knowledge that life has limits. Dolce far niente is all the sweeter for the awareness that beyond life is nothing. The urgency to savor what you know to be fleeting, "to love that well which thou must leave ere long," as Shakespeare put it in Sonnet 73, tinges earthly happiness with sorrow. Thinking about extinction is not fun.

Though he titled his poem Commedia, Dante's cosmology leaves no room for having fun. The blessed saints who populate Paradiso are inspired by love but are not fun-loving, nor could Purgatorio, with its regimen of expiatory agonies, pass as a medieval franchise of Hooters. The sensualists in the Second Circle of the Inferno are the closest Dante, whose vision is warped by miasmic winds, comes to imagining fun. Nessun maggior dolore che ricordarsi del tempo felice nel la miseria, says Francesca da Rimini—"There is no greater sorrow than to recall our time of joy in wretchedness." Not only is her memory of joy eternally tainted by endless wretchedness, there was little genuine fun about her adulterous encounter with her brother-in-law Paolo in the first place. In a sense, the strict sense of the Italian verb divertirsi, all of Dante's sinners are having a fun time, since all, like the poet himself, who has wandered off the straight way into a dark wood, have strayed. With his impudent amalgam of

high and low, François Rabelais anticipated fun times to come, but to find consistently genuine fun, a reader has to wait six centuries after Dante, for the era of the ersatz Italian gastronomical entertainment called Chuck E. Cheese. For the vast population now living well above subsistence, mere sustenance no longer dictates dining decisions. "Buy a bucket of chicken and have a barrel of fun" is how Kentucky Fried Chicken advertised itself during the 1980s. Of course, to the millions of hens whose drumsticks he fried, Colonel Sanders was not a fun guy.

Sanctimony—virtually worthless among world currencies—is not the only alternative to fun. William Blake was not a dull fellow or even an enemy of fun, but he assigned it an inferior position in the hierarchy of pleasures: "Fun I love," wrote Blake in a letter dated August 23, 1799, "but too much fun is of all things the most loathsome. Mirth is better than fun, and happiness is better than mirth." Blake seems to be faulting fun for lacking both depth and duration. It is a momentary sensation, devoid of the passion, intensity, and commitment of our most cherished experiences. Fun is to happiness as a sandcastle is to the Taj Mahal. French fashion designer Christian Lacroix made fun of his own fickle business, better suited than sculpture to fun, when he declared: "Haute Couture should be fun, foolish, and almost unwearable." But fun itself was unbearable to British *couturière* Vivienne Westwood, who exclaimed: "Every time I hear that word, I cringe. Fun! I think it's disgusting; it's just running around. It's not my idea of pleasure." Inhospitable to any but giddy thoughts, fun is not much of an idea at all.

To the hedonist Sally Bowles, "life is a cabaret," but the fun times of cabaret life expired with the Weimar Republic. The Third Reich was no fun for its millions of victims. While Auschwitz survivor Primo Levi's vision of *l' univers concentrationnaire*, life as the Lager (camp), is no more accurate a metaphor than life as a cabaret, it is more seasoned. It at least recognizes the malignity and mortality of human life that fun is a feeble tactic designed to deny. Jeff Getty, a founder of Survive AIDS in San Francisco, probably suffers more than most. In August 2001, he told a reporter for the *New York Times*: "This morning my back is out again, I have sciatica, I have a herpes shingle going right up my back. I'm just now finishing all my drugs. Yesterday I had to take injections to make my bone marrow grow, and my life is no fun." Despite many—or few—moments of gladness, even for the happiest of mortals, bungee jumping might be dandy, but life is more than fun.

Honor among Scholars

2010

Praising Caesar as a Colossus who "doth bestride the narrow world," Shakespeare's
Cassius tells Brutus that "we petty men...peep about to find ourselves dis-
honorable graves." Of course, it is not the graves that are dishonorable but
the men who end up in those graves, after leading lives tainted by skulldug-
gery. Nevertheless, there can be honor even among thieves, and dishonor even
among scholars, men and women who have been intimate with Shakespeare,
Spinoza, and the Holy Scriptures.

Dishonor in higher education is possible only because honor is so funda-
mental to the idea of a university. Honor is the engine that drives us to make
and share discoveries. We volunteer to cover an ailing colleague's classes or
give a book to an indigent student because it is the honorable thing to do.
And we shudder at revelations that Marc Hauser, a professor of psychology
at Harvard, fudged data in his studies of primate behavior; that several books
by James Twitchell, a professor of English at the University of Florida, ap-
propriated others' words verbatim without attribution; and that Alexander
Kemos, the third-ranking administrator at Texas A&M University, lied
about his doctorate.

So, while we are appalled but not shocked to find fraudulent bankers and
deceitful politicians, disgraceful behavior within a university is especially dis-
tressing. It is a betrayal of the trust that is essential to a community of schol-
ars. "Say it ain't so!" we want to shout at the eminent historian who concocted
sources, the college president who faked his credentials, and the coach who
channeled illicit payments to student-athletes. Discovery that one experi-
ment has been fudged or one manuscript forged can begin to erode the entire
body of collective knowledge.

"The most tragic thing in the world is a man of genius who is not also
a man of honor," notes Sir Colenso Ridgeon in George Bernard Shaw's *The*

Doctor's Dilemma. There is, of course, no necessary correlation between intelligence and virtue, and to find examples of brilliant scoundrels, it is not necessary to look to Nazi doctor Josef Mengele or Superman's nemesis, Lex Luthor. Just look around the nearest university.

"What is honour?" asks Falstaff, who concludes that it is a vacuous abstraction, merely: "A word." Yet, even though John Dryden dismissed it as "but an empty bubble," the word has spread. Particularly on college campuses, honor echoes like a carillon, in honors courses, honors colleges, honor societies, and honor rolls. Graduation ceremonies dispense honorary degrees as well as diplomas inscribed cum laude—with honor. It is true that, in Book Nine of *The Republic*, Plato has Socrates divide humanity into three classes: "lovers of wisdom, lovers of honor, and lovers of gain." And if the categories are mutually exclusive, then the university, while a magnet for lovers of wisdom, would not be a natural home for lovers of honor (or, especially in these lean times, lovers of gain). Nevertheless, the principle that there is honor even among scholars, that the love of wisdom is itself worthy of honor, is proclaimed by the mottoes of the University of Kiev—"Utilitas honor et gloria" (Utility, honor, and glory)—and the United States Military Academy ("Duty, Honor, Country"). The college fraternity Kappa Delta Rho pledges "Honor Super Omnia" (Honor above All Things), and students at Texas A&M University recite by heart the "Aggie Code of Honor": "Aggies do not lie, cheat, or steal nor tolerate those who do." In Boulder, students submit completed exams along with an affirmation that: "On my honor as a University of Colorado student, I have neither given nor received unauthorized assistance." But what is the honor of a University of Colorado student? Members of academic communities are forever avowing their honor, despite and because of contrary evidence.

In *The Honor Code: How Moral Revolutions Happen* (2010), Kwame Anthony Appiah answers Falstaff's question by defining honor as "an entitlement to respect." An entitlement, to be sure, is not the same as respect itself. One can conclude from Appiah's definition that to be honorable is not to subordinate everything to reputation but rather to act so as to be worthy of respect, regardless of whether anyone actually grants it. Appiah distinguishes between two kinds of honor—"positive recognition respect" and "esteem." Positive recognition respect is what we accord individuals simply because they belong to certain peer groups—vintners, dental hygienists, firefighters, knights of the Round Table—regardless of whether they have in fact individually done anything extraordinary to earn our respect. Esteem, by contrast, is a matter of merit, and it is inherently hierarchical. While we might accord

all baseball players positive recognition respect, a batter who hit below .250 would not earn enshrinement in the Hall of Fame. We can respect all violinists but acknowledge that there was only one Heifetz.

To the extent that higher education aspires to be a meritocracy, in which the best students receive the highest grades and the best professors the most illustrious titles, universities are excellent laboratories for the study of honor. Appiah, who was inducted into the American Academy of Arts and Letters, among other honors, is himself among the most esteemed of contemporary academics. But, though he holds a prestigious chair in philosophy at Princeton University, he does not address questions about honor in higher education. Instead, he devotes a chapter to each of three "moral revolutions" whose success he ascribes to the reversal of honor codes. Dueling among English gentlemen, foot-binding in China, and slavery along the Atlantic were each, Appiah argues, initially supported by appeals to honor. In 1829, the Duke of Wellington challenged the Earl of Winchilsea to pistols at twelve paces because it was considered the honorable response to calumny. Until the demise of the Manchu dynasty at the turn of the twentieth century, Chinese women signaled their refinement by contorting their feet into a lovely but painful lotus shape. And until the trade was banned by Britain in 1807, white slaveholders purchased African laborers in part to advertise their own elevated rank. Appiah devotes a fourth chapter to an incomplete revolution, the campaign to end honor killing—the murder of a woman whose sexual activity brings opprobrium on her family—in contemporary Pakistan.

Honor and morality, as he notes, are independent variables. Even as slaveholding was considered a badge of honor by the colonial elite, cogent arguments were made against it as morally repugnant. However, Appiah claims, it was not until honor was recruited to assist morality that the peculiar institution was dismantled on the plantations of the Western Hemisphere. Slavery was—and is—wrong, but what caused the moral revolution against it was the novel conviction that owning human beings was also dishonorable. William Wilberforce's abolitionist movement became a struggle to restore England's national honor. Similarly, opponents of both dueling and foot-binding spelled out their iniquities. Yet those claims were necessary but insufficient without a belief that the practices also violated standards of honor.

When that belief took hold, the conversion was rapid and complete, like a chemical reaction in which the introduction of a trace element instantaneously transforms the entire contents of a test tube. Within decades, dueling was being ridiculed for bringing dishonor to an effete aristocracy, and gentlemen who previously would not have married brides with unbound feet now

considered women with bound feet unworthy mates. In the case of honor killing, Appiah contends that moral suasion in itself will not end the loathsome practice unless it serves to alter the culture's honor code: "Honor killing will only perish when it is seen as dishonorable." If and when that time comes, as it has for dueling, slavery, and foot-binding, earlier attitudes will seem bizarre. People will ask, says Appiah: "What were we thinking? How did we do that for all those years?"

Let's apply to academe Appiah's analysis of how honor and morality can be wed, and of the mayhem that can result when the two are severed. A sense of personal honor motivates individuals to do what is worthy of respect and to avoid doing what induces shame. However, we can talk about national honor—for Americans, it was affirmed when Neil Armstrong walked on the moon and was besmirched by officially sanctioned torture at Guantánamo— because honor is conferred and denied within communities that share a code of honor. To the extent that we identify with a group, our honor is invested in the actions of our cohorts.

Yet, within the grouping called academe, just as I would not take credit for a colleague's discovery of the mechanism behind Alzheimer's, I would not accept blame for another's arrest for arson. Collective dishonor is not the same as collective guilt. When Binghamton University's basketball team became embroiled in scandal, specific Bearcat players arrested for theft and drugs and administrators who covered up were guilty of serious infractions, but the entire community of students, faculty, administrators, and alumni felt the dishonor. On the other hand, the announcement that Roger D. Kornberg would win the Nobel Prize in Chemistry in 2006 brought honor to everyone at Stanford University, which employed him on its medical faculty.

Misdeeds are not necessarily more rampant on college campuses than in brokerage houses, law firms, or shopping malls. But some seem more common: plagiarism; grade-fixing; doctoring sponsored research to please the sponsor; sabotage of rivals; conflict of interest; abuse of laboratory subjects; fabrication of credentials. Most of these are illegal and unethical, as well as dishonorable.

However, echoing the examples that Appiah discusses, a few invidious practices are still considered honorable within certain academic subcultures. Binge drinking is not only widespread; a famous national study conducted by the Harvard School of Public Health in 1997 found that almost half the students surveyed reported downing four or five drinks in rapid succession within the previous two weeks. The practice also distinguishes the "well-rounded" undergraduate from the "nerd" at many institutions. At schools

with high drinking rates, 34 percent of non-bingeing students reported harassment from binge drinkers. Hollywood celebrates college life as a long, merry bender; a poster advertising *College* (2008) shows a hungover student bent over a toilet bowl. In popular culture, the bespectacled grind supplies papers and answers to his less bookish fellows, but, though he gets the grades, it is the smooth—and bibulous—guy who gets the girl. Many consider it more shameful to be seen in the library than at a beer bust and take pride in their alma mater's designation as a "party school."

Though not universal, such attitudes are pernicious. Inebriation endangers physical and psychological health and obstructs learning. Binge drinkers squander educational opportunities that others were denied. Such arguments can and must be made, but they are not likely to end binge drinking unless they are joined to a change in the culture's honor code. If students begin to believe that not only is it not awesome to be soused but that it is dishonorable to put themselves out of commission and into a continuing stupor, declining an additional drink will be deemed worthy of respect. Sobriety will suddenly become the new cool.

Similarly to high percentages of heavy drinking on campuses, 75 percent of American undergraduates admit to cheating during their college careers. In other countries in which I have taught, education is conceived of as communal, and it is honorable to share answers with fellow students, dishonorable to withhold assistance. In the United States, collaborative test taking, when not just a lazy river to a passing grade, is more a matter of flouting fussy rules. But there are sound reasons to discourage cheating. It makes a mockery of individual responsibility and subverts the integrity of academic credentials. It encourages slipshod learning, producing graduates unqualified to teach a class, prepare taxes, or perform surgery. It is inherently dishonest, but the way to reduce its incidence is to make it dishonorable, to convince test takers that relying on themselves is worthy of esteem. The "gentleman's C" is not worthy of a gentleman; true gentility earns its grades. As with dueling, foot-binding, and slaveholding, cheating will end when the honor code is altered, when respect is accorded those whose work is their own.

In cynical, selfish times, honor, like Rodney Dangerfield, gets no respect. Though it is itself founded on a decent respect for the opinions of mankind, honor comes to seem like a foppish posture. However, wisely defined, in universities and elsewhere, it is applied ethics, a standard and strategy for living as we should.

Flesh and Food

Fish, Flesh, and Foul

The Anti-Vegetarian Animus

2000

Giving up flesh is not nearly as traumatic as giving up the ghost. Although thousands have been martyred for their refusal to eat meat, vegetarians today suffer merely a species of social death. Stop eating what George Bernard Shaw, a recovered carnivore, called "scorched corpses of animals" and you become either the pariah or the cynosure of the dinner party, either barred or badgered over culinary preferences. "Tell me what you eat and I will tell you who you are," declared the French gourmet Anthelme Brillat-Savarin, not the first or last to demand a full accounting of a stranger's diet. Determined to minimize suffering, I ate my last hamburger almost fifty years ago, but I still am often grilled about who I think I am.

What about the pain you cause to carrots? Do you get enough protein and vitamin B12? Are you willing to provide sanctuary to endangered cockroaches? In a dog-eat-dog world, why deny yourself the savor of a wiener? Would you be so self-righteous if you were stranded in the Sierras with the Donners?

Sometimes a questioner sincerely seeks to understand, but often the interrogation is flippant or even hostile. "Oh, come!" said Shaw, when asked to explain his abstinence from flesh. "Why should you call me to account for eating decently?" But unless they lead cloistered lives or live off cacti in the desert, vegetarians grow accustomed to the curiosity and animosity of others. In 1791, John Oswald began a pioneering book on animal rights by complaining that he was "fatigued with answering the enquiries, and replying to the objections of his friends, with respect to the singularity of his mode of life." Oswald titled his book *The Cry of Nature; or, an Appeal to Mercy and to Justice on Behalf of the Persecuted Animals,* and one cannot help assigning its kindly author to the category of persecuted animals. Look there, too, for gentle Joseph Ritson, the Englishman whose 1802 work *An Essay on Abstinence from*

Animal Food as a Moral Duty is characterized by the venerable *Dictionary of National Biography* as bearing "marks of incipient insanity."

But diners who, for reasons of ethics, environment, or health, choose not to partake of fish, flesh, or fowl do not solicit pity, and it is odd to speak of them as a class of victims. When the Canadian singer k. d. lang declared on TV that "meat stinks," cattlemen led a campaign to ban and burn her records at more than three dozen radio stations across North America. Telephone threats harassed her mother out of Consort, Alberta, where a sign proclaiming "Home of k. d. lang" was vandalized with the scrawl "Eat beef, dyke." In this instance, at least, some rednecks probably found it harder to swallow dissenting culinary practices than dissenting sexual ones. Yet, instructive as it is about dominant social attitudes, the hassle lang has suffered for her views on food is of a different order from the butchery suffered by gays, blacks, Jews, Indians, Gypsies, Tutsis, and other scapegoats. (Livestock goats, too, are not raised to die of old age.) Middle-class families squabble as much over menus as TV selections, but to find wholesale slaughter over dietary choices, you have to go back to the Inquisition, which originated as a crusade against heretical vegetarians, the Albigensians of southern France.

Vegetarianism has a history, stretching into the Paleolithic mists when, hunting and gathering, *Homo sapiens* distinguished themselves from most other hominids by feeding on flesh. Opportunistic organisms, humans eat everything, though the invention of Alka-Seltzer is a caveat that maybe we should not. Yet, according to the book of Genesis, Adam and Eve never needed flesh and blood to sustain themselves in the Garden of Eden; and Ovid—like Raphael in Milton's *Paradise Lost*—imagined a Golden Age in which butchery would not be a precondition for nutrition. Ambrosia and nectar were sustenance enough for the Greek gods, and in the Homeric "Hymn to Hermes," the messenger of Mount Olympus resisted the temptation to feast on meat, lest it make him mortal. Though it is moot whether Socrates and Plato themselves partook of meat at the banquets they attended, the ideal state imagined in *The Republic* is a vegetopia. Many other ancient writers, including Empedocles, Plotinus, Plutarch, Porphyry, Seneca, and Theophrastus, fixed their canons and appetites against slaughter, and the original Epicurean, Epicurus himself, found pleasure in forgoing flesh. Pythagoras's regimen, which, for obscure reasons, banned beans as well as meat, was so exemplary that for more than two thousand years those who abstained at least from flesh were called Pythagoreans. The word *vegetarian*— from *vegetus*, Latin for sound, whole, vital—was not coined until 1847, at the

founding of the Vegetarian Society of the UK in Ramsgate, England. But shadowing this history, like a fungus on a cantaloupe, is a chronicle of animosity—a persistent record of misunderstanding, mistrust, and misbehavior toward those who refuse to consume fish, flesh, or fowl. Vegephobia blights Greek comedies of the third and fourth centuries that satirize Pythagoras, and it persists in belligerent banter by the dinner-party smart-ass intent on discrediting guests who prefer aubergine in tomato to vitello tonnato. If every creophagist were obliged to kill the calf that ends up veal, the population of Pythagoreans would multiply by pi. On the other hand, "if every person went and killed a chicken each year, the world would be a lot more peaceful place," sneered Ted Nugent, a hard rocker who extols the excellence of bow-and-arrow hunting. But in Shakespeare's *Twelfth Night*, Sir Andrew Aguecheek's assessment of his own dullness skewers Nugent: "I am a great eater of beef and I believe that does harm to my wit."

"Vegetables are interesting," quipped the humorist Fran Lebowitz, "but lack a sense of purpose when unaccompanied by a good cut of meat." Such cracks are merely obnoxious; ridicule is the tribute that carnivores pay Pythagoreans. More genuinely noxious was the mob of butchers and bakers who rioted in Boston in 1837 when Sylvester Graham, Presbyterian minister and the inventor of an eponymous cracker, preached against the evils of abattoirs and white flour. It is one thing to declare—as the senior George Bush (who advertised his populist tastes by munching publicly on fried pork rinds) did in 1986—one's abhorrence of broccoli. (Code for vegephobia, the announcement was greeted with sympathetic mirth by commentators who might have recoiled in horror at the implicit racism had the future president dared, instead, to dis jazz.) But it is quite another matter to crucify those who feed on crucifers.

In AD 276, Mani, founder of the religious movement that bore his name, was tortured and executed by the Sasanian rulers of Persia for trying to convert them to his unorthodox ways, which were meatless. A century later, Timothy, the Patriarch of Alexandria, was so fearful that Manichaeanism might infiltrate Christendom that he exacted taste tests of his clergy; those who refused to eat meat were presumed Manichaean and punished severely. The dualism of the Manichaeans disturbed the early fathers more than their asceticism, but both challenged church dogma and authority, and it was easy to seize on vegetarianism as both a symptom and an assertion of heresy. Despite the best efforts of Augustine, himself a lapsed Manichaean, the doctrine was not entirely eradicated, and when it resurfaced in the eleventh

century with the steak-spurning Bogomils, many were in fact burned at the
stake. When Manichaeanism spread to Asia, so did persecution, as evidenced
by an edict promulgated in China in 1141: "All meat-eschewing demon wor-
shippers and those who meet together at night and disperse at dawn to prac-
tice and propagate evil teachings shall be strangulated." In medieval Provence,
the Cathars, heirs of Mani, whose meatless diet also excluded milk and
cheese, were condemned for doctrinal errancy. Preaching against Catharist
deviancy in 1163, Eckbert of Schonau enumerated ten heresies of which they
were guilty, including: "The second heresy: avoiding meat. Those who have
become full members of their sect avoid all meat. This is not for the same
reason as monks and other followers of the spiritual life abstain from it: they
say that meat must be avoided because all flesh is born of coition, and there-
fore they think it unclean." In 1208, Pope Innocent III declared war, in the
form of the Albigensian Crusade, against the vegetarian infidels, and tens
of thousands were slaughtered in defense of carnivorous Christianity. The
Inquisition was established in 1231, when Pope Gregory IX established courts
in southern France to conduct inquests into the piety of suspected meat-es-
chewing infidels.

Despite centuries of persecution, vegetarianism has survived. Vegetarians,
less vulnerable to heart disease, stroke, cancer, and other ills that flesh eaters
are heir to, have thrived. According to the adage one man's meat is another
man's poison and according to much current research, meat can be toxic to a
man or woman. Though a Jewish proverb insists that "meat, not hay, makes
the lion roar," many humans whom we lionize have disagreed. Vegetarianism
has not impeded the athletic achievements of Hank Aaron, Billie Jean King,
Carl Lewis, Martina Navratilova, Paavo Nurmi, Dave Scott, or Bill Walton.
Although Victor Frankenstein's gentle creature ate no flesh, it is also true
that Adolf Hitler gave up meat shortly after the suspicious death of his niece
Geli Raubal in 1931. Yet so have many finer ethical minds, including Gautama
Buddha, Leonardo da Vinci, John Wesley, Percy Bysshe Shelley, Susan B.
Anthony, Leo Tolstoy, Mohandas Gandhi, Franz Kafka, S. Y. Agnon, Albert
Schweitzer, and Cesar Chavez. Isaac Bashevis Singer explained his own re-
fusal to be complicit in a culinary holocaust by noting that: "I did not become
a vegetarian for my health, I did it for the health of the chickens." Vincent van
Gogh became a vegetarian after visiting a slaughterhouse, and so would many
others if meat were less convenient—or were not packaged in savory patties
and cutlets that obscure their bloody origins.

"Animals are my friends," explained Shaw, "and I don't eat my friends."

Animals are not necessarily my friends, but I do not feast on sentient strangers either. Nor do I exploit them. As a vegan (a word coined in 1944, for a practice that goes back to ancient times), I avoid all animal products, including dairy, eggs, and leather. I chewed my last chop almost fifty years ago, my last omelet about thirty. Though the book of Matthew proclaims that "man shall not live by bread alone," this man lives by broccoli, tempeh, carrots, spinach, honeydew, cashews, and tofu, too. If veganism has not made me a better man, one who refuses to feed off the misery of others, it has made me a healthier one.

"All flesh is grass," declared Isaiah, but surely an envoy of the Deity can distinguish between ribs and rice. Trimming elephant grass is gardening, but harvesting an elephant is butchery. In fact, Isaiah himself equated meat with murder: "He that killeth an ox is as if he slew a man," quoth the prophet in chapter 66, verse 3. The vegetarian movement in nineteenth-century America began with the Bible, in a group that called itself the Bible Christian Church and established itself in Philadelphia in 1817. Abstention from flesh was further spread by the Seventh-Day Adventists. But John Harvey Kellogg, the dynamic evangelist of wholegrain hygiene, embraced vegetarianism for secular salvation, to invigorate the fragile flesh. He made his fortune out of cornflakes, peanut butter, shredded wheat, and other victuals invented to prolong and fortify the lives of mortal bodies. Like his rival C. W. Post, who found riches in Grape-Nuts and Postum, Kellogg based his work in Battle Creek, Michigan, a town that attracted nudists, homeopaths, mesmerists, phrenologists, pacifists, abolitionists, prohibitionists, and feminists, as well as the derision of those who dismissed them all as fakes and crazies.

In *The Road to Wellville*, a 1994 novel by T. Coraghessan Boyle set in Battle Creek in 1907, Will Lightbody, a reluctant patient at the Kellogg sanitarium, resents his wife Eleanor's descent into "the morass of vegetarianism, neurasthenia, frigidity, and quackery." Listing vegetarianism in an inventory of unpopular practices is a standard strategy of scoffers. When, for example, in a 1994 car review, P. J. O'Rourke attacked critics of the internal combustion engine, he indulged in derision by association and alliteration: "They're losers, the three-bong-hit saviors of the earth, lava lamp luddites, global warming dolts, ozone boneheads, peace creeps, tofu twinks, Birkenstock buttinskis, and bedwetting vegetarian bicyclists who bother whales on weekends." When, incensed at fans of the rival New York Mets, Atlanta Braves pitcher John Rocker maligned immigrants, gays, and ethnic minorities, he was fined and suspended. If he had castigated Mets fans as sproutheads and

complained that you cannot find a decent hot dog at Shea Stadium, he would have been adored.

"I want there to be no peasant in my realm so poor that he will not have a chicken in his pot every Sunday," proclaimed Henri IV. If the Bourbon monarch's wish had been their command, every subject would have been conscripted as a carnivore. Echoing Henri IV, Herbert Hoover was elected president of the United States in 1928 with the slogan "A chicken in every pot, a car in every garage." Economic conditions prevented Hoover from keeping that promise, but ethical considerations should have produced the same effect. Turkeys often run for office, but poultry does not vote, and most of those who do go to the polls support the hegemony of the meat culture. Politicians have little to gain and, owing to the corporate clout of those who process and market animal carcasses, much to lose by publicly embracing vegetarianism. Even heavyweight Mike Tyson, a vegan since 2010, cannot match the clout of a lobbyist for the Tyson poultry empire. The ritual demand of any national election is that candidates sample the cuisines of the regions and ethnic groups whose support they are seeking, and they score best by sharing meat: fajitas, kielbasa, gumbo, pastrami, ribs, fried chicken, prosciutto. Iowa's Polk County Steak Fry and South Carolina congressman Jim Clyburn's "World Famous Fish Fry" are mandatory stops for presidential candidates. The road to the White House is paved with the bones of slaughtered beasts. On the quintessential American holiday, Thanksgiving, any national leader who does not devour a turkey may be thought seditious.

In another obligatory ritual, the highest officials from the city or state in which two championship teams compete customarily place wagers with each other in the form of a hamper of local edibles. The offering is almost always meat. After the Saint Louis Rams beat the Tennessee Titans in Super Bowl XXXIV, for example, Tennessee governor Don Sundquist sent Missouri governor Mel Carnahan a supply of Tennessee country ham. In 1999, when the Super Bowl pitted the Atlanta Falcons against the Denver Broncos, Mayor Willington Webb put his Colorado buffalo steaks up against Mayor Bill Campbell's Georgia spare ribs. After the New York Knicks lost the 1999 NBA finals to the San Antonio Spurs, Mayor Rudolph Giuliani lost his bet with Howard Peak and sent the San Antonio mayor a generous supply of Nathan's franks. For millions of ravenous fans, hot dogs, not tofu, are the sacramental substance of sporting rites.

During fifteen terms in the House of Representatives, until 1996, Congressman Andrew Jacobs of Indiana, who sponsored legislation to ease

the plight of farm animals, made no secret of his dietary preferences. But even the Congressional Directory refers to Jacobs as "an eccentric Democrat," a description that many would also apply to former congressman Dennis Kucinich (D-OH), who failed to gain much traction running for the presidency in 2004 and 2008, and to Congresswoman Tulsi Gabbard (D-HI), whose presidential run failed in 2020. If there were a Vegetarian Caucus in Congress, its membership would consist of Senator Cory Booker (D-NJ), Gabbard, Representative Jamie Raskin (D-MD), and Representative Adam Schiff (D-CA), not exactly a horde. Ordinary elected officials are more likely to admit that they are gay than vegetarian. Coming out of the produce locker means facing the fire of creophagist constituents. Bill Clinton was famously, avidly omnivorous, and when his daughter, Chelsea, disclosed that she was a vegetarian, she did it during her father's second term, when her culinary deviancy could no longer affect his electoral prospects. And it was only after leaving the White House that, scared into veganism by heart disease, Clinton himself gave up meat. His vice president, Al Gore, connected his own decision to became a vegan twelve years after retiring from government to his campaign against global warming: "It's absolutely correct that the growing meat intensity of diets around the world is one of the issues connected to this global crisis—not only because of the CO_2 involved, but also because of the water consumed in the process." Vegetarian Patti Reagan Davis was estranged from her father during the years he presided over sanguinary state banquets. Francisco Madero, the president of Mexico from 1911 to 1913, after leading the revolution that overthrew dictator Porfirio Díaz, was assassinated twice—once by his own security forces and once by the *Encyclopaedia Britannica*, whose entry on Madero suggests that his vegetarianism was a defect: "He was an unimpressive man, short, slender, and pale—and a vegetarian, teetotaler, and spiritualist."

There once was an American Vegetarian Party, and it ran candidates for president and vice president four times, in 1948, 1952, 1956, and 1960. Its meager results are usually lumped under "Other," together with the scattered votes received by other token contenders. In politics, where Walter Mondale attacked the shallowness of his opponents' qualifications for the Democratic presidential nomination by asking "Where's the beef?," vegetarian is almost synonymous with lunatic fringe. At a rally in South Carolina during his insurgent run for the Republican presidential nomination in 2008, Senator John McCain invoked vegetarianism to emphasize how widely he was reaching out to scattered, tiny, and unlikely constituencies. "I say to independents,

Democrats, Libertarians, vegetarians," he said, early in his campaign for the presidency, "come on over and vote for me tomorrow." Three days later, McCain repeated the jest in Michigan: "I don't care if you're Republican or Democrat or Libertarian or vegetarian."

Yet vegetarians are not such rare birds. According to the Gallup Poll, 5 percent of American adults—more than 12.5 million Americans—consider themselves vegetarians, which means that they outnumber Ohioans. But who gets more respect? Pennsylvanians slightly outnumber vegetarians, and, according to a proverb of the Pennsylvania Dutch, "A louse in the cabbage is better than no meat at all." But that is a lousy, tasteless claim, refuted by the Odessa mutiny, which began, in 1905, when sailors in the Russian navy refused to eat meat infested with maggots. Actually, ascertaining the number of vegetarians is an imprecise science, since follow-up questions reveal that some who identify themselves as "vegetarian" eat fish or chicken or occasionally even consume red meat. A 1999 poll conducted by the Vegetarian Resource Group asked a random sample of Americans whether, when dining out, they always order a dish without meat, fish, or fowl. Of the total, 5.5 percent said yes—5 percent of the men and 6 percent of the women. But is it possible that Americans are more particular when choosing from a restaurant menu than when reaching into the refrigerator?

In Britain, where the Royal Society for the Prevention of Cruelty to Animals, a model for humane organizations in other countries, was founded in 1824 and where animal rights agitation has a longer and more strident history than anywhere else in the West, vegetarianism is more commonplace. Abstention from meat did not prevent Jeremy Corbyn from becoming leader of the British Labour Party. Even in provincial English village pubs, I have encountered menus that explicitly offer vegan entrees. In Cape Town, by contrast, a restaurant I happened on near the South African Parliament offered nothing for even a lacto-ovo vegetarian. When I explained my dietary requirements to the waitress, she assured me that the soup was vegetarian. But floating in the bowl she brought was some suspicious matter. "Well, it has only a few pieces of chicken," explained the waitress. Traveling in Eastern Europe poses no problem for vegans, as long as they are willing to fast.

A 1998 poll found that 7 percent of Britons agreed with the statement: "I am a vegetarian and eat no meat at all." And since the prospect of pestilence tends to concentrate the mind, incidents of mad cow disease, *E. coli*, and salmonella have provided additional incentives to avoid red meat and poultry. The founding of the Carnivores Club in London in 1996, in the midst

of the European crisis over the incidence of bovine spongiform encephalopathy in British beef, was an act of bravado that defied the patent logic of vegetarianism. So, too, did Auberon Waugh, when, in a 1999 article in the *Daily Telegraph*, he railed against "the vegetarian underground, a worldwide conspiracy of animal sentimentalists working in secret, or under deep cover, using our traditional class and regional animosities to promote its repulsive cause."

"Vegetarian underground" sounds like a mushroom factory, and whatever movement there is to encourage abstention from meat is not nearly as organized or as potent as the culture of carnivorism. Dining on chops is firmly rooted in the patriarchy. "Beefeater" is the name the English apply to the hardy, valiant yeomen of the guard, as if meat were implicit in masculinity. William Cody acquired his manly reputation and his nickname—Buffalo Bill—by slaying thousands of burly beasts. In the sexual ecology of the dinner table, salads are "lady food," unlike steaks and roasts. According to the historian Todd L. Savitt, male slaves in antebellum Virginia were fed twice as much meat as their female counterparts. During World War I, meat was withheld from civilian women in order to provide a steady supply for fighting men. A meat-and-potatoes man is a redundancy, since, echoing cannibalistic cultures in which warriors acquire strength by devouring their foes, males nourish and affirm their virility by consuming flesh. If, like butcher shops, taverns are a man's domain, salad bar is an oxymoron.

Real Men Don't Eat Quiche, announced Bruce Feirstein in a 1982 bestseller that spoofed the culture's paradigm of yahoo machismo. "Real Men," wrote Feirstein, "avoid all members of the wimp food group, including crudites, lemon mousse, crepes, avocado, capons, chives, shrimp dip, and fruit compote." Instead, he claimed, they wolf down steaks, hamburgers, cheeseburgers, bacon cheeseburgers, California burgers, pizza burgers, chili burgers, Big Macs, Whoppers, Kentucky Fried Chicken, and ham and Swiss on rye. In the demographics of vegetarianism there is a notable gender gap. Women constitute a disproportionate share of the population of Pythagoreans. In the survey that found Britain 7 percent vegetarian, the figure was 10 percent for women but only 4 percent for men. In the 2019 Gallup Poll that found 5 percent of Americans identifying themselves as vegetarian, the figure was 6 percent for women and only 4 percent for men. A man who chooses ratatouille over ribs risks aspersions over his sexual identity, as though swallowing compote earned one the derogatory epithet "fruit."

Just as not all vegetarians are saints, not all vegephobes are psychopathic

muttonheads who believe that Whoppers grow in burger patches. Even Mark Twain was not above taking cheap shots at Pythagoreans. "First God created fools, that was for practice," quipped Twain. "Then he created vegetarians." When he created Charles Kinbote, the deranged, homicidal protagonist of *Pale Fire*, Vladimir Nabokov included vegetarianism as one of his aberrations. And though you would expect the author of *Animal Farm* to respect the right to life of barnyard creatures, George Orwell was a persistent scourge of vegetarians. A champion of common sense and the common people, Orwell identified with the working class, believing with Winston Smith in 1984 that "the future belonged to the proles." To Orwell's usually lucid mind, avoiding meat was the jejune indulgence of aristocrats and intellectuals.

For most of European history, meat has been a mark of power and privilege and a rare delicacy for the peasantry. The origins of "pecuniary" in *pecus*, the Latin word for herd, and of "capital" in *capita*, Latin for head (of cattle), are a reminder that meat was long a measure of wealth. Monks renounced flesh to demonstrate their indifference to worldly advantage, and it was not until the twentieth century, when Colonel Sanders catered to the civilian infantry and even soup kitchens put a chicken in the pot, that the implications of flesh for class were reversed. Now the gentry sups on arugula, while plebeians munch meat loaf. "The ordinary human being," proclaimed Orwell, speaking for the working bloke (and for himself), "would sooner starve than live on brown bread and carrots." In *The Road to Wigan Pier*, an account of indigence in the Midlands that was published in 1937, Orwell—who called himself a socialist—takes offense at an application for a socialist summer school that asks candidates whether they prefer vegetarian meals. "This kind of thing is by itself sufficient to alienate plenty of decent people," complains Orwell. "And their instinct is perfectly sound, for the food-crank is by definition a person willing to cut himself off from human society in hopes of adding five years on to the life of his carcase; that is, a person out of touch with common humanity." For Orwell, who sentimentalized the English working class as the salt of the earth, an aversion to salt pork would by definition make someone a "food-crank" and a misanthrope. By a curious act of moral calisthenics, "decent people" are recognized by their willingness to participate in mass slaughter.

Standards of decency change, and arbiters of etiquette have since adopted a more decent respect for the opinions of noncarnivorous mankind. "Dieters and teetotalers should never feel it necessary to eat anything that is injurious to their health or contrary to their moral standards," insists Emily Post. "If

you are, for example, a vegetarian, you need not feel obliged to taste the roast." And Peggy Post, advising hosts, also counsels toleration: "When you're planning a larger party, you needn't ask each guest about food restrictions, but to be on the safe side, make sure you include some 'neutral' dishes such as a vegetable platter, pasta with meatless sauce, and fresh fruit for dessert. That way, everybody will find something he or she enjoys." If every host were required to read the Posts, vegetarianism would be less a matter of social martyrdom.

Manners were not minded in January 1998, when vegetarianism was put on trial in Amarillo, Texas. Oprah Winfrey was charged with violating the state's food defamation law. During one of her TV shows in April 1996, vegetarian activist Howard Lyman had warned about the spread of mad cow disease into American herds. Oprah replied: "It has just stopped me cold from eating another burger." After her statement was aired, the market for cattle dropped by about $36 million. Instead of a posse, angry ranchers organized a lawsuit. But the not-guilty verdict affirmed the rights of Americans, even in Texas, to avow in public their aversion to beef.

In June 1997, two and a half years after it had begun, the longest trial in English legal history concluded with a judgment against David Morris, a former letter carrier, and Helen Steel, a former gardener. They were acquitted on most of the libel charges brought against them for distributing pamphlets proclaiming that, by mass-marketing hamburgers, McDonald's endangers human health, exploits labor, and devastates the environment. The corporation reportedly spent about 10 million pounds to prosecute the two anti-meat crusaders, and though it ultimately succeeded in obtaining a token judgment of forty thousand pounds against them, it will probably never try to collect because the defendants are indigent and McDonald's would have to pay too high a price in public relations. Though the British courts found that Morris and Steel had indeed defamed the burger empire when they claimed its products are poisonous and contribute to starvation and deforestation in developing countries, their charges that McDonald's abuses children in its advertising, is cruel to animals, provides low wages and inadequate working conditions, and heightens the risk of heart disease were all upheld by the judgments.

It has long been easy to dismiss vegetarians as tender, feckless folk—like those who with Bronson Alcott created Fruitlands, the meat-free commune in nineteenth-century Massachusetts that lasted only seven months. They seem as quixotic as Esperantists, who plot world peace by evangelizing for a single artificial language. In fact, some Esperantists and vegetarians have

been making gentle common cause since 1906, when they formed Tutmonda Esperantista Vegetariana Asocio.

Yet vegetarians today are more assertive. Many are no longer willing to settle for celery or gruel in schools, prisons, and restaurants. Airlines report an increase in requests for special meals. Passengers who reserve vegetarian entrees for their trips often draw envious stares from those nearby, who are forced to sate their appetites with standard fare. Airline food has probably done more than Leo Tolstoy to persuade our neighbors to pass up meat. Is there sociological significance to the fact that the best-selling novel of the 1990s, *The Bridges of Madison County*, tells the story of a livestock farmer's wife who falls in love with a Pythagorean stranger?

But if vegetarianism has become more prominent and popular, it has also provoked a new backlash, one that differs from familiar strategies of ridicule and ostracism only in its defensiveness. Like determined smokers who continue to puff long after tobacco has been proved lethal, some meat-eaters protest too much. In *Eat Fat* (1996), for example, Richard Klein attacks what Orwell might call the food police, the voices heard throughout the land that inveigh against pandemic obesity. Faced with the unprecedented cornucopia available to consumers, Klein urges us to dig in: "Even if fat is unhealthy, which it is and it isn't, for the vast majority of people, it's probably healthier than the alternative. The alternative is dieting, compulsive exercise, hypervegetarianism, diet pills." It is not clear just what Klein means by "hyper-vegetarianism," except that, like right-wing zealots who denounce any liberal as "ultra-liberal," he favors gluttony over antimuttony. Jeffrey Steingarten, too, attempts to stigmatize vegetarianism as a derangement. In *The Man Who Ate Everything* (1997), he celebrates his own omnivorousness and declares: "The more I contemplated food phobias, the more I became convinced that people who habitually avoid certifiably delicious foods are at least as troubled as people who avoid sex, or take no pleasure from it, except that the latter will probably seek psychiatric help, while food phobics rationalize their problem in the name of genetic inheritance, allergy, vegetarianism, matters of taste, nutrition, food safety, obesity, or a sensitive nature." Lacking evidence of meat's benefits for physical health, Steingarten and Klein presume that vegetarianism is harmful to mental health. Ignoring the ethical claims of vegetarianism, they can more easily dismiss it as dementia.

Assigned by the muckraking weekly *Appeal to Reason* to investigate working conditions in the Chicago stockyards, Upton Sinclair was converted to vegetarianism—for merely three years, admittedly—by observing the process

by which living animals are transformed into food. "One could not stand and watch very long without becoming philosophical, without beginning to deal in symbols and similes, and to hear the hog squeal of the universe," he wrote in *The Jungle*, the novel that provoked passage of the Pure Food and Drug Act of 1906. But Sinclair, who was more interested in the rights of workers than those of cattle, was disappointed at instigating food reform rather than industrial revolution. "I aimed at the public's heart and by accident I hit it in the stomach," he complained.

Yet the stomach is a more reliable organ. About as virtuous as the penis, the heart can lead us into bloody deeds, but the belly is a moral compass. Haunted by the hog squeal of the world, I will not stomach nourishment that requires processing pigs into pork, calves into veal, and turkeys into drumsticks. Foie gras might be deemed a delicacy, but my conscience is too delicate to countenance any sustenance that is obtained by thrusting a spike down the throat of a living goose. It is an ichthyophagist's self-serving fantasy that, as the Star Kist ad contends, Charlie the Tuna yearns to be hooked, canned, and chewed. Kraft Foods would have us believe that the noblest avatar of a cow is the hot dog: "Oh I wish I was an Oscar Mayer wiener, for that is what I'd really like to be," goes the genial jingle, but the reality is much crueler.

No one wants a kosher Jew at a lobster bake, least of all the kosher Jew. Vegetarians are spoilsports at the banquet, and it is no wonder that they are resented for observing Lent throughout the year. Many seem, and even are, self-righteous about their choices, but they are surely right in insisting that what we eat be a matter of choice, not of habit, and that the choice be based not just on taste. Those who act on their convictions often emit an odor of sanctimony, yet those who do not reek of hypocrisy. The world is a plain of woe, and there often seems little one can do to minimize the pain. But every day, each of us makes decisions that determine life or death for other creatures. Supermarkets and restaurants are arenas for urgent moral combat, and those who opt to abstain from fish, flesh, and fowl ought not to be reviled or ridiculed.

Once, in a remote foreign capital, a dinner was held in my honor. To salute my presence in their country, the hosts set out on my plate a whole roast suckling pig. I stared at the unfortunate creature, a victim of brutal culinary customs, and he stared back. Though the pig was the evening's pièce de résistance, I managed to resist. It was better to risk puzzling or antagonizing my benefactors than to bear forever the guilt of slaying a shoat. No human need eat meat, and we most honor our humanity when we do not.

Green Freedom for the Cockatoo

1991

As far as we know, every other species of the genus to which Homo sapiens belongs has been extinct for at least forty thousand years. Though it is unlikely, it is also conceivable that a specimen of *Homo habilis* or *Homo erectus* could one day wander into a clearing in an African village. More plausible, at least in principle, is the possibility of an experiment in genetic engineering that would back-breed a living cousin, a member of a hominid species akin to our own. Its presence would pose a remarkable challenge to the "human sciences" of anthropology, linguistics, and psychology, not least in defining what is "human." But the most intriguing questions would be ethical and legal: would human beings have authority over this creature—to experiment on, hunt, and eat—as God's commandment in Genesis 1:28, that Adam and Eve "have dominion over the fish of the sea, and over the fowl of the air, and over every living thing that moveth upon the earth," seems to suggest is our divinely sanctioned prerogative?

No other project in Western philosophy since Periclean Athens has been more relentlessly pursued than the quest for a defining characteristic of the human. We are featherless bipeds, but so are kangaroos. We employ language, but so do many others, including Koko, the lowland gorilla who commanded an extensive vocabulary of American Sign Language. We are intelligent, or so the taxonomical designation *sapiens* flatters us into believing, but so too are dolphins and chimpanzees, more so than human babies, anencephalics, and roller derby fans. Man, claims Dostoevsky's Underground Man, is the only species that curses, but he might, as usual, be speaking for himself. To err is human, but nowhere do we demonstrate that human proclivity more than in our presumptions about human exceptionalism.

To the Renaissance humanists, man was the measure of all things, including man's place in the cosmic scheme. "Man is really the vicar of God," proclaimed Marsilio Ficino, a fifteenth-century Florentine who sounds like an ad

man handed the human account, "since he inhabits and cultivates all elements and is present on earth without being absent from the ether. He uses not only the elements, but also all the animals which belong *to* the elements, the animals of the earth, of the water, and of the air, for food, convenience, and pleasure, and the higher, celestial beings for knowledge and the miracles of magic. Not only does he make use of the animals, he also rules them. It is true, with the weapons received from nature some animals may at times attack man or escape his control. But with the weapons he has invented himself man avoids the attacks of wild animals, puts them to flight, and tames them. Who has ever seen any human beings kept under the control of animals, in such a way as we see everywhere herds of both wild and domesticated animals obeying men throughout their lives? Man not only rules the animals by force, he also governs, keeps, and teaches them."

More than *Homo faber* or *Homo ludens*, Man the Lion Tamer might seem the defining epithet of human beings. We differ from every other species because we insist on differing from them. Humans might be the only species intent on asserting and justifying its sovereignty over everything else. However, merely to discuss the relations between humans and animals is to perpetuate a false dichotomy, as though we are not ourselves part of the animal kingdom. Christian fundamentalists attack humanism for the arrogance of displacing the theocentric universe with an anthropocentric one. Biocentrists have an equally strong screed against humanism: Peter Singer attacks it for the arrogance of its blatant speciesism.

Speciesism, a term coined by Richard D. Ryder in *Victims of Science: The Use of Animals in Research*, was popularized by Singer in *Animal Liberation: A New Ethics for Our Treatment of Animals*. Singer's volume, which appeared in 1975, shortly after Ryder's, is, like *The Origin of Species, Uncle Tom's Cabin, The Jungle, Silent Spring*, and *The Feminine Mystique*, one of the very few books that can be said to have reconfigured the world. It awakened many from dogmatic slumber, an ideology that consigned dogs, ducks, and deer to being objects of our convenience. Before *Animal Liberation*, a few isolated voices challenged the dominant tendency to deny other species the moral consideration we routinely grant any member of *Homo sapiens*. Four decades later, Animal Liberation is a formidable movement, and neither its advocates nor its adversaries can make elementary choices about food, clothing, and recreation as unreflectively as they did before. Some people still dine on veal, strut about in mink, and administer shocks to beagles, but they are increasingly obliged to justify their speciesist behavior.

Speciesism is not simply a crucial concept for Singer's argument; it is its very foundation. The first chapter of *Animal Liberation* makes so cogent a case against speciesism that the rest of the book has little to do but document examples and parry anticipated objections. Singer assumes an enlightened modern Western reader who rejects both racism and sexism as benighted relics of barbarism. That is not to say that, *pace* Thomas Jefferson, all human beings are created equal, merely that they are entitled to equal moral consideration. Discrimination on the basis of ethnicity or gender is not always inappropriate; a casting director might have good reason to choose an actor of African origin to play Othello and a woman to play Desdemona. But preferential treatment becomes racist or sexist when the discrimination is arbitrary, when the sole criterion for how we behave toward someone is whether that person belongs to our race or gender. Refusing to allow a woman to attend law school merely because of a prejudice in favor of Y chromosomes is sexist and—most of Singer's readers would likely agree—reprehensible.

By analogy, speciesism is the *arbitrary* discrimination against other species in favor of one's own. Though he titles his first chapter "All Animals Are Equal," Singer is not so indiscriminate as not to notice the differences between grasshoppers and ants. He is not advocating Olympic eligibility for cheetahs or that penguins be granted suffrage. But he does recognize that other species are at least as capable of suffering as we are, and to be indifferent to that suffering simply because they are not *Homo sapiens* is speciesist. "The question," asked Jeremy Bentham, in a passage from *Introduction to the Principles of Morals and Legislation* that Singer quotes twice, "is not, Can they reason? Nor Can they *talk?* but, Can they *suffer?*" Descartes and others have spun rococo theories to rationalize away pain in other animals, but any evidence that leads us to impute pain to other human beings applies as well to other organisms with a nervous system. In fact, with 200 million ethmoidal cells in their noses, German shepherds probably suffer more when something turns rotten than do their "masters," who have only 5 million. Something is rotten in the attitude that a pullet's pain is less agonizing than a person's. Pain is pain, argues Singer, and we ought not to regard it as more acceptable to inflict it on one species than another. The speciesist is someone who, under any circumstance, judges the feelings of other animals as less important than those of a human being.

Singer's governing principle, "the identical consideration of interests," insists that there is no ethical basis for assigning a higher value to the feelings of a particular group. Ours is a culture that conditions us to sanction

excruciating martyrdom for billions of nonhumans in order to provide us with food, clothing, cosmetics, medicine, and entertainment. If we try to determine the criterion that justifies this inequity, we cannot say it is, for example, intelligence. Though most humans are probably more intelligent than most pigs, the newborn, the intellectually disabled, and the senile are not, and unless we are prepared to butcher and vivisect *them*, we are forced to admit that an arbitrary preference for humans merely because they are humans accounts for the differential treatment. The same flaw can be found in any other criterion we might choose—language, appearance, conviviality—to rationalize our insistence on slighting the sufferings of other animals. We will always be able to find some human beings who are inferior to some other animals in these particular respects. If we nevertheless persist in inflicting pain on other species for selfish human gain, we are exposed as speciesist. Singer's test for whether or not to perform an experiment applies as well to any other activity that causes pain: "Since a speciesist bias, like a racist bias, is unjustifiable, an experiment cannot be justifiable unless the experiment is so important that the use of a brain-damaged human would also be justifiable." If we recoil from that prospect, either the experiment is frivolous or we are demonstrating a preference for humans merely because they are humans.

Singer is hesitant to champion "animal rights," because he believes that the concept introduces extraneous issues of jurisprudence and because he is convinced that rights are superfluous to his attack on speciesism as a violation of the *interests* of other sentient creatures. In this, he has been criticized by fellow philosophers and liberationists, most notably Tom Regan. In *The Case for Animal Rights* (1983), Regan defines and defends what he means by the moral rights of animals. He faults the utilitarian basis for Singer's assault on speciesism, warning that the goal of maximizing pleasure and minimizing pain could be, and has been, invoked to justify animal exploitation. But the debate between Singer and Regan remains a family disagreement and has not prevented the two from collaborating as editors of the anthology *Animal Rights and Human Obligations* (1976, revised 1989), a standard text in many philosophy courses. Singer and Regan are both symptoms and instigators of a sea change in academic philosophy during the past fifty years. Ethics has been restored to a central role within the discipline, and professional philosophers are increasingly willing to engage the educated laity on matters of public import, like the justification for killing more than 100 million animals each year in American research labs.

Singer's principle of the equal consideration of interests helps address the

question I posed earlier: Would we be warranted in similarly exploiting an-
other member of the genus *Homo*? While we are certainly under no obliga-
tion to appoint the hominid stranger to the Supreme Court, neither is there
any reason but a speciesist, specious one to regard his or her sufferings as less
worthy of consideration than Osama bin Laden's or Charles Manson's. In
fact, it ought not to matter where the creature is positioned on the taxonomic
charts in order to merit ethical consideration; as long as she or he is capable
of suffering, we must, if we inflict it, conceive some justification more satis-
factory than speciesism. The principle also provides us with a cogent defense
if an extraterrestrial as superior to us in intelligence, eloquence, strength,
and virtue—or any of the qualities that led Hamlet to extol *Homo sapiens* as
"noble in reason, infinite in faculty! In form and moving how express and ad-
mirable! In action how like an angel, in apprehension how like a god!"—ever
attempted to assert dominion over mere human beings. If you prick us, we
might reply, we, too, feel pain, and merely because you *can* does not mean that
you *should* make shoes and steaks out of us.

Chapters 2 and 3 of *Animal Liberation* are case studies in two of the most
widespread and virulent examples of institutionalized speciesism: research
and farming. Singer provides detailed accounts of many of the millions of
animals who are tortured annually in university, military, and industrial lab-
oratories. Because of the trivial objectives of the research, or alternatives to
animal testing such as computer models, tissue samples, cell cultures, epi-
demiological studies, and human volunteers, much of this cruelty is unnec-
essary. The cases of thalidomide, extensively tested on other species before
being authorized, disastrously, for human consumption, and, conversely, pen-
icillin, which, toxic to guinea pigs and hamsters, might never have been re-
leased, are a reminder that nonhumans are an unreliable model for human
biology. But even if there is a reasonable certainty of worthwhile results, and
even if there are no alternatives, opposition to speciesism demands that the
subjects on which we perform our experiments ought not to be chosen merely
because they are nonhumans.

Singer also notes that 100 million cows, pigs, and sheep and 5 billion chick-
ens and turkeys are slaughtered each year in the United States alone. Because
of modern intensive farming in what are virtual factories—an average poultry
warehouse contains 80 thousand birds—most animal food production is un-
tenably brutal; unless we are also prepared to be cannibals, it is all speciesist.
The presence of healthy vegetarians demonstrates that alternatives exist.

Many other books—for example, Orville Schell's *Modern Meat* (1984),

Robert Sharpe's *The Cruel Deception* (1988), and Jonathan Safran Foer's *Eating Animals* (2009)—are devoted entirely to the horrors of laboratories and farms. Singer's purposes are less investigative than philosophical. Once he has convinced us that speciesism is indefensible, everything else is merely application. He might just as well have focused subsequent chapters on the fur industry, bullfighting, zoos, and rodeos as on animal research and factory farming. In fact, in terms of numbers, hunting, a multibillion-dollar industry responsible for 200 million deaths per year in the United States, where 7 percent of the population indulges in it, is probably responsible for more abuse of animals than research is. Perhaps because his readers are likely to be urban, educated, and less inclined to slay a mourning dove than visit a vivarium, Singer does not bother to review what Cleveland Amory's *Man Kind? Our Incredible War on Wildlife* (1980) documents in numbing detail.

Forty-five years after its initial publication, *Animal Liberation* no longer seems such *A New Ethics for Our Treatment of Animals* as the subtitle had suggested, and Singer dropped it from the second edition. He revised the book to take account of the exponential growth in the Animal Liberation movement since 1975 and to provide more current information on the state of animal research and factory farming. At the time of his first edition, when abstaining from meat was still considered aberrant and suspect, Singer provided an appendix of vegetarian recipes, but now he simply lists a few of the many cruelty-free cookbooks published in the interim. On a minor philosophical point, whether it is possible to benefit a nonexistent being, Singer retreats from his earlier certainty. And with regard to his own dietary practices, he reports that, convinced that mollusks also feel pain, he has now added oysters and mussels to the list of organisms he will not eat. But Singer, who has since become both Ira W. DeCamp Professor of Bioethics at Princeton University and a Laureate Professor at the Centre for Applied Philosophy and Public Ethics at the University of Melbourne, still takes essentially the same position as before, when he became the only professor from down under widely known up over. The new edition of *Animal Liberation* responds to criticisms from adversaries and allies, but Singer insists that, in fifteen years of extensive debate, he has come across "nothing that has led me to think that the simple ethical arguments on which the book is based are anything but sound."

To anyone lacking Singer's passion for reason, such intransigence might come across as arrogance. However, *Animal Liberation* is constructed as a sort of algorithm for resolving behavior toward other species, and its architect demands no credit for its clarity and cogency; he cannot imagine any

thoughtful adult persisting in speciesism once the fallacy of its logic is exposed. Singer is notably uncomfortable with appeals to emotion or instinct. Sentimental fustian about "the sanctity of all life" leaves him apprehensive, because mysticism has as often been enlisted to condone or even encourage cruelty as to condemn it. Singer's is the voice of a decent human being speaking to other human beings in full confidence they will share his common sense and compassion.

An increasing number do. An article in the *Village Voice* estimated a membership of more than 10 million in the 7,000 animal rights and welfare organizations spread throughout the United States. Fur has become almost as unfashionable as tobacco, hunters seem as much a dying species as some of their prey, and some of the largest cosmetic companies—among them Amway, Avon, Mary Kay, and Revlon—have declared a moratorium on animal testing. More and more animal tormentors—including experimental psychologists Richard Ryder and Roger Ulrich and primatologist Don Barnes—have experienced their flash of light on the road to Damascus and returned as animal liberationists. A hostile review of Canadian philosopher Michael Allen Fox's 1986 *The Case for Animal Experimentation* was so convincing that Fox publicly recanted his views and became a vegetarian. Turning his back on the Baskin-Robbins ice cream business that had made his family extremely wealthy, John Robbins became a vegan and an outspoken advocate of diets devoid of dairy and meat. Yet Singer, who will not savor blood, is not sanguine.

"As this edition shows only too dearly," he states in the preface to the revised *Animal Liberation*, "the movement has as yet made little impact on the central forms of animal exploitation." Factory farming is more intensive than ever, and despite some reforms in Europe and Australia, virtually nothing has occurred in the United States to prevent a researcher from getting away with murder, or worse. Speciesism remains as embedded within our culture as do the Hellenic, Judaic, and Christian traditions that have fostered it.

Racism has been attacked by a broad coalition of armies, from the NAACP and the Urban League to SNCC, CORE, the Black Panthers, and the Black Lives Matter movement. Similarly, the range of groups that work in defense of animals is vast—from traditional, paternalistic organizations like the Humane Society of the United States and the American Society for the Prevention of Cruelty to Animals, which perpetuate a benign brand of speciesism, to People for the Ethical Treatment of Animals, Trans-Species Unlimited, the Fund for Animals, and the National Anti-Vivisection Society.

The shadowy fringes of the movement are occupied by the Animal Liberation Front and other underground cells that have claimed credit for illegal raids on laboratories, slaughterhouses, and furriers, causing many millions of dollars in damage and the liberation of many thousands of animals. Commando actions against speciesists in Britain have been more militant, even violent.

Again invoking the analogy to human liberation movements, Singer deplores violence as both wrong in itself and counterproductive, and cites the exemplary achievements of Mohandas Gandhi and Martin Luther King Jr. through peaceful tactics. Yet it is also true that, just as Huey Newton and Rap Brown forced racism onto the national agenda and made King seem less extreme by comparison, Singer's own crusade against speciesism benefits from his moderate position between the ASPCA and the ALF. Convinced that the best is enemy of the good, he is a gentle meliorist preaching gradual reform rather than immediate revolution. Himself a vegan (one who refuses any animal product, including eggs and dairy), Singer recognizes that the first and most plausible priority is to convince others to renounce red meat: "If because of an admirable desire to stop all forms of exploitation of animals immediately we convey the impression that unless one gives up milk products one is no better than those who still eat animal flesh, the result may be that many people are deterred from doing anything at all, and the exploitation of animals will continue as before."

Two hundred years ago, Singer could not have assumed the revulsion against racism that most enlightened readers now at least affect. Sexism has more recently entered the compass of moral opprobrium. Speciesism seems an inevitable corollary, as does a book that explores the nexus between women's liberation and animal liberation. "A feminist-vegetarian critical theory begins," declares Carol J. Adams, "with the perception that women and animals are similarly positioned in a patriarchal world, as objects rather than subjects." Like Singer, Adams moves metaphorically, from the brutalization of women to the subjugation of nonhumans and back. *Comparaison n'est pas raison*—comparison is no syllogism—but it does provide Adams with elegant symmetries and trenchant insights. Perhaps it is historical happenstance that modern feminism descends from the Seneca Falls conference of 1848 and that an important 1847 meeting in Ramsgate, England, defined the term *vegetarian*—derived from Latin *vegetus*, meaning whole, sound, fresh, lively, and not from *vegetable* (vegetarians are not all batty over brussels sprouts). But the women dismembered by Jack the Ripper were not just fanciful tropes. "She was ripped open just as you see a dead calf at a butcher's shop," reported

the police surgeon called to the scene of one of Jack's crimes. Though Adams mentions Singer only twice in her book and Betty Friedan not at all, she is the intellectual offspring of both.

The Sexual Politics of Meat: A Feminist-Vegetarian Critical Theory is an ungainly title, and Adams anticipates that a common reaction will be ridicule. If patriarchal culture tends to marginalize feminists and trivialize vegetarians, feminist-vegetarians can count on a snicker from sexist "pigs" who count among their inalienable rights chomping on chitlings and badgering "chicks." The tendency to dismiss vegetarianism as a sentimental fad, as what even Spinoza mocks as "womanish tenderness," is precisely what Adams is intent on exposing. Despite a long and distinguished tradition of vegetarian thinkers, including Pythagoras, Plutarch, Shelley, Gandhi, and Shaw, Adams notes the insidious strategies by which the issue of animal exploitation, like that of sexism, has been excluded from discussion, not "meaty" enough for a virile civilization. Where's the beef?

Like Singer, Adams views vegetarianism as crucial to a nonspeciesist existence. Though she contends that the human anatomy is poorly designed for carnivores, 81.6 percent of the food that Americans consume is provided by animals. For most inhabitants of modern industrialized nations, the principal contact with other species is in the supermarket and at the table, where sanitized, cosmetized viands lull us into forgetting their bloody origins. Comfort in our gluttony is dependent on consigning others to do our butchery. Veal cutlets do not grow on trees; they are reconstituted from fragments of slaughtered anemic calves. The cattle that the USDA euphemizes as "grain-consuming animal units" are in reality sentient beings who deserve our moral consideration as much as the battered, slaughtered women who are the by-products of a culture dedicated to the adoration / oppression of "the fairer sex." Not every man is a rapist, but many learn quite early to dismember women mentally, to view them as an assemblage of genital and other parts offered for male delectation. The cover of *The Sexual Politics of Meat* reproduces the leering design on a beach towel that labels the sections of a naked woman's back (chuck, rib, loin, round, rump) and queries: "What's your cut?" Adams undercuts the assumptions of a society in which other species and human females are customarily treated as objects, whose bodies are divisible and not their own.

A refusal to eat meat is a direct rejection of this system of oppression. Though vegetarianism might well be more nutritious and—since cattle protein can require as much as twenty times the acreage as producing the same amino acids from nonanimal sources—more ecologically efficient, Adams

insists on the moral imperative for not appropriating others' flesh and fluids. Of the two kinds of foods that human beings acquire from other animal species, one involves the kind of butchery common to sexual abuse, and the other entails the exploitation of the female of the other species. Adams labels the first—what we camouflage by the words *meat, beef, veal, pork,* or *mutton,* not *flesh, cow, calf, pig,* or *sheep*—"animalized protein." The second, dairy and eggs, she calls "feminized protein," because it requires treating other female animals as human societies have been known to treat their women: as factories of involuntary pregnancy.

Adams claims a tradition of books by women who reject male violence, identify with nonhumans, and embrace vegetarianism and often pacifism. Mary Wollstonecraft, author of *A Vindication of the Rights of Woman,* bore Mary Shelley, whose gentle Frankenstein monster refuses to eat meat and who drew a connection between violence against women and against animals. So have Aphra Behn, Charlotte Perkins Gilman, Isabel Colegate, Mary McCarthy, Alice Walker, Marge Piercy, Audre Lord, Brigid Brophy, Maxine Kumin, and many other women authors. "From cutting the throat of a young calf to cutting the throat of our brothers and sisters is but a step," claims Isadora Duncan in her autobiography *My Life.* "While we are ourselves the living graves of murdered animals, how can we expect any ideal conditions on the earth?" Such voices, contends Adams, have been muted and marginalized in a society whose dominant principle is the domination of women by men and of everything else by humans. *The Sexual Politics of Meat* is dedicated "In memory of 6 billion each year, 16 million each day, 700,000 each hour, 11,500 each minute," and these largely invisible victims are what Adams repeatedly calls "the absent referent"—the suffering steer behind the hamburger patty, like the woman behind the cheesecake icon.

Early in Volker Schlöndorff's 1990 film version of Margaret Atwood's *The Handmaid's Tale,* Kate (Natasha Richardson) is captured. She is seized by the soldiers of Gilead, a tyrannical patriarchy that is Atwood's nightmare of misogynist fundamentalism triumphant. Along with dozens of other women prisoners, Kate is transported to an indoctrination center—in *a truck designed for livestock.* The image recalls the cattle cars that the Nazis employed to convey their Jewish victims to death camps. But it also suggests a society in which women are chattel, and cattle are, like human sex objects, merely meat. According to Adams, three phases characterize the oppression of both women and other species: objectification, fragmentation, and consumption. We cannot digest a bull until we first think of him as a thing, reduce it to ribs

or chuck, and then swallow. In patriarchal society, women are rendered the Other, atomized as tits and ass, and devoured.

StarKist advertises itself with a curiously masochistic piscine mascot, Charlie the Tuna, who laments that he is not good enough to be hooked, canned, and chewed. A pitiful cartoon creature resembling a hot dog sings of how he would love to be an Oscar Mayer wiener, as though victimization is a noble aspiration. Although its hamburgers are in fact ground-up bovines whose throats were slit by machete or brains bashed in by sledgehammer, McDonald's tries to convince us that they grow in hamburger patches and are eager to be picked. It is an insidious psychology that suggests that these animals invite their destruction and that we should feel no guilt at all for obliging, and it is reminiscent of the tendency for rapists and other felons, and sometimes even our legal system, to blame the human victim, as though she brought her misery upon herself.

In the traditional division of labor, men were the hunters and butchers, just as, in the traditional diet, men demonstrate their sovereignty by carving and eating the meat, consigning to women the less glamorized fare of vegetables, fruits, and grains. Men who go against the grain are stigmatized as quiche-eating "fruits." "Beef eaters" is what the British call an elite military unit. During the rationing of World War II, meat, a symbol of virility and strength, was reserved for men at the front. As women are supposed to be passive, turnips should suffice for them, though female anorexia is epidemic in a society in which men are the ones designated to eat.

Adams seizes on the myth of Meris to embody the point from which she so often digresses, into literary criticism, history, and sociolinguistics. The Sexual Politics of Meat is probably too academic to become the popular manifesto that Singer created or to make of Meris a feminist-vegetarian heroine as memorable as Camus's Sisyphus. As the story is recounted by Hesiod, Meris was seduced and impregnated by the supreme patriarch, Zeus. Fearful that she would bear a child who would grow up to overthrow him, Zeus devoured Meris. Every movement deserves to choose its own originative myths, but feminist-vegetarianism might also give thought to the Greek story of Erysichthon, the Thessalian prince who, because he violated a forest sacred to Demeter, was punished with an unappeasable appetite. To sate his hunger, Erysichthon did not quite eat his daughter Mestra, but he did sell her into slavery—repeatedly, since she kept returning home. In a perfect blend of subject and object, victim and victimizer, Erysichthon, an ecological paradigm of efficient recycling, ended up devouring himself.

Kafka's Plea

2010

One day, during lunch break at the Workers' Accident Insurance Institute in Prague, a colleague offered to share a slice of sausage with Franz Kafka. A strict vegetarian, Kafka is said to have replied: "The only fit food for a man is half a lemon." Nutritionists would probably disagree. However, in "The Hunger Artist," the story of a performer who declines even a piece of lemon, a virtuoso of abstemiousness who flaunts his ability to fast for weeks and months, Kafka elevates refusing to eat into a principle of aesthetics.

A rich tradition exists of literature, film, and painting that celebrate *la joie de table*, the conviviality of convivium, shared delight in pleasures of the palate. However, there is also a countertradition, a line of renegade artists who refuse to eat their peas, who defy proper dining etiquette, through displays of anorexia, bulimia, cannibalism, coprophagy, necrophagia, veganism, starvation, and other culinary aberrations. Modernism arose as an adversarial impulse, a challenge to bourgeois conventions. It often manifested itself in bad table manners. If ritualized ingestion is the most formalized sacrament of the Western middle class, a secular form of the Eucharist, then artists who reject the prix fixe menu assert their claim to the avant-garde. At the risk of sounding like Carry Nation at a beer bust, I offer food for thought about aberrant thoughts on eating.

Sigmund Freud's theory of sublimation explains artistic ambition by recourse to a diverted libido. But François Rabelais locates the impulse for art not in the groin but squarely in the stomach. In *The Fourth Book of the Heroic Deeds and Sayings of the Noble Pantagruel* (1552), he writes: "Sir Belly—is the true master of all the arts....To this chivalrous monarch we are all bound to show reverence, swear obedience, and give honour." And much literature, painting, and film—functioning as a toast to *pain grillé* and more sumptuous fare—does just that. "Food," quipped Fran Lebowitz, "is an important

part of a balanced diet." It is also an essential ingredient in the *Odyssey* and *Beowulf* as well as *In Search of Lost Time* and *To the Lighthouse*. It is celebrated in what is now a familiar canon of culinary films, including *Tampopo* (1985), *Like Water for Chocolate* (1992), *The Wedding Banquet* (1993), *Eat Drink Man Woman* (1994), *Big Night* (1996), *Chocolat* (2000), *Babette's Feast* (2001), *Ratatouille* (2007), *Julie and Julia* (2009), *Eat Pray Love* (2010), *Chef* (2014), and *The Hundred-Foot Journey* (2014). Of course, moviegoing, a pretext for popcorn chomping, has long been an oral experience, and exhibitors find concession stands a more lucrative profit center than their box offices. Visual artists, from the cave painters paying tribute to their prey to Leonardo with his *Last Supper* to Judy Chicago and *The Dinner Party*, have honored the human appetite. "Please, sir, I want some more," pleads Oliver Twist, and no reader would begrudge the hungry orphan another bowl of gruel.

However, when Luis Buñuel wanted to mock middle-class values, he often struck at the stomach. *The Exterminating Angel* (1962) is the story of a formal dinner party that, far from being an occasion for savoring sumptuous dishes in stimulating company, proves to be a prison; its guests find themselves unaccountably trapped for weeks inside an elegant dining room. And the running joke in Buñuel's *The Discreet Charm of the Bourgeoisie* (1972) is that its privileged characters are thwarted every time they begin to share a meal. The film dramatizes the frustrations of what in Latin would be termed *victus interruptus*, an impeded repast. As exposés of the food industry and the unhealthy eating habits of contemporary Americans, both *Super Size Me* (2004) and *Fast Food Nation* (2006) are appetite suppressants, antidotes to the gastronomic gusto of *Babette's Feast*. So, too, is Marco Ferreri's 1973 film *La Grande Bouffe*, in which four wealthy gentlemen gather at a country estate for the purpose of gorging themselves—in splendid style—to death. If I were managing one of those fashionable theaters that serves meals to its audiences, I don't think that I would want to program *La Grande Bouffe* into my schedule. Similarly, films that depict the consumption of human flesh challenge the conventions of feasting our eyes on images of joyous consumption. *Soylent Green* (1973), *Eating Raoul* (1982), *The Cook, the Thief, His Wife, and Her Lover* (1989), *Fried Green Tomatoes* (1991), *The Silence of the Lambs* (1991), *Alive* (1993), and *Sweeney Todd: The Demon Barber of Fleet Street* (2007), like any number of exploitative horror flicks involving dismemberment and ingestion of human bodies, do not encourage hearty appetites. The texts of the Marquis de Sade delight in defying many taboos, particularly in regard to food. While writing *The 120 Days of Sodom*, in 1785, de Sade's body was

ballooning into grotesque proportions, but few who read his depictions of co-prophagy and cannibalism are likely to want to snack while turning the gruesome pages.

The very thought of eating human flesh induces revulsion in most readers, but some, recognizing the continuity of life, refuse to privilege *Homo sapiens* as uniquely capable of suffering. For them, it is morally repugnant to inflict unnecessary pain or death on anyone, and it is therefore inconsistent to refrain from eating slices of a fellow human being while continuing to consume what society calls "meat" and what Ingrid Newkirk, president of PETA, defines as "the antibiotic- and pesticide-laden corpse of a tortured animal." Anyone squeamish about seeing *Sweeney Todd* might also consider the suffering source of the *boeuf en daube* that Mrs. Ramsay revels in in *To the Lighthouse*.

As an alternative to the butchery inherent in conventional diets, vegetarianism has a long and noble history. According to Genesis, Adam and Eve never needed flesh and blood to sustain them in the Garden of Eden, and Ovid—like Raphael in Milton's *Paradise Lost*—imagined a Golden Age in which butchery is not a precondition for nutrition. Ambrosia and nectar were sustenance enough for the Greek gods, and in the Homeric "Hymn to Hermes," the messenger of Mount Olympus resists the temptation to feast on meat, lest it make him mortal. Though it is moot whether Socrates and Plato themselves partook of meat at the banquets they attended, the ideal state imagined in *The Republic* is a vegetopia. Many other ancient writers, including Empedocles, Plotinus, Plutarch, Porphyry, Seneca, and Theophrastus, fixed their canons and appetites against slaughter, and the original Epicurean, Epicurus himself, found pleasure in forgoing flesh. More recent literary vegetarians have included Percy Bysshe Shelley, Leo Tolstoy, George Bernard Shaw, Ted Hughes, V. S. Naipaul, J. M. Coetzee, Margaret Atwood, and Jonathan Safran Foer. "For the animals," wrote Isaac Bashevis Singer, who also abstained from meat, "it is an eternal Treblinka."

However, almost as long as the history of vegetarianism is the history of anti-vegetarian bigotry. Those who lunch on sausage are often dyspeptic toward those who opt for half a lemon. "Don't artichokes have hearts?" they ask. "If you are willing to step on an ant," they sneer, "why not toss a living lobster into a boiling pot?" In his 2002 book *Kill It and Grill It: Ted and Shemane Nugent's Guide to Preparing and Cooking Wild Game and Fish*, hard rocker and bow-hunter Ted Nugent scoffs: "Vegetarians are cool. All I eat are vegetarians—except for the occasional mountain lion steak."

No one ever went broke by taunting vegetarians. In her best-selling memoir, *Going Rogue: An American Life* (2009), Sarah Palin, a former beauty queen intent on showing up the guys, prides herself on her prowess at hunting and butchering. "I love meat," she proclaims. "I eat pork chops, thick bacon burgers, and the seared fatty edges of a medium-well-done steak. But I especially love moose and caribou. I always remind people from outside our state that there's plenty of room for all Alaska's animals—right next to the mashed potatoes." And the quondam governor scoffs at those who do not share her craving for animal flesh: "If any vegans came over for dinner, I could whip them up a salad, then explain my philosophy on being a carnivore: *If God had not intended for us to eat animals, how come He made them out of meat?*" Ridicule is the tribute that carnivores pay to Pythagoreans. The defensiveness of rabid meat-eaters reflects anxiety over their own alimentary preferences.

Literary Seductions

Ut Coitus Lectio

The Poet as Lovemaker

1980

Roland Barthes's anatomy of textual pleasures—Le Plaisir du texte (1973)—
virtually concedes that the term "erotic literature" is a tautology. The poet
and the lover are of imagination compact, and where they come together is in
what they would do with us. The creation of a text is a labor of love, not only
for want of other wages. And reading, like love, aims at dissolving personal
boundaries. Both reading and loving are processes that are betrayed when
reified. That all literature, whether Aretino's *Sonnets* or *The Congressional
Record*, is inherently erotic is the burden of a pervasive trope that maintains
that the experience of literature—and of art in general—is analogous to, or
even a species of, lovemaking.

The category of "pornography" differs in degree but not kind from other
literary forms. Etymologically, of course, pornography means writing about
harlots, and one of the problems with the term is that it has come to be ap-
plied exclusively to the content of works. No longer would anyone want to
argue the historical position that pornography is exclusively whore stories or
that these are perforce pornography. But when a movie has its rating altered
along what is in effect an implicit continuum from inoffensive to luridly por-
nographic simply by including an exposed breast or thigh, it is evident that
criteria of content are being applied. The flaw in such procedure derives from
the fact that the significance of any given content is unstable and culturally
conditioned. Expressions like "the pornography of power" or "the pornog-
raphy of violence" likewise suggest that pornography lacks an intrinsic sub-
ject matter of its own. Not only would there be critical differences in how
the term is applied in Scandinavia, Saudi Arabia, and North America, in the
twelfth century and the twenty-first; but despite the material, Alfred Kinsey's
writings presumably are not pornographic, while Georges Bataille strives to
be erotic in a discussion of hunting.

Clearly, then, eroticism is a quality not of objects but of relationships. Otherwise there would be many more miscreants whom not even their mothers could love. And, though this quality is most conspicuous in the reading of texts conventionally classified as pornography, the fact that *bawd* and *bard* are both definitions of the word *hack* suggests that pornography stands in a synecdochic relationship to literature as a whole. It is remarkable how much of the vocabulary of literary criticism—e.g., anatomy, chaste style, climax, masculine and feminine rhymes, *rime embrassée*, romance, lay—is shared by sexology. Likewise, John Keats, writing to Fanny Brawne (July 8, 1819), points to the recurring image of a text as lover: "I have met with women whom I really think would like to be married to a poem, and to be given away by a novel." According to the liberal platitude, no one was ever ravished by a book; yet the medieval romance *Lancelot du Lac* serves at least as pander to Dante's Paolo and Francesca. The bibliophile, not the least passionate of the world's lovers, has been known to spend hours caressing the spine of his beloved. And the ritual of kissing a book, after taking an oath or participating in worship, affirms reading's blend, like love's, of sacred and sensual.

The erotic and the aesthetic modes are akin in their detachment from practical functions, whether procreation or propaganda. If sexuality divorced from its natural goal of reproduction is patently artifice, then perhaps art freed of its utilitarian origins is no less erotic. Although Aristotle's curiously orgasmic concept of "catharsis" repays scrutiny, it is primarily in the past two centuries, when the West most ardently cultivated the erotic and the aesthetic, that discussions of either have frequently entailed both. A century after Decadence, many still pay lip service to Susan Sontag's proclamation at the conclusion of "Against Interpretation" that: "In place of a hermeneutics we need an erotics of art." Sontag's brilliant polemic—and perhaps all true quarrels are lovers' quarrels—diverts us from the fact that discussions of art have long sounded like anecdotes of seduction. Emily Dickinson's famous definition of poetry, for example, would not be out of place in *The Hite Report*. "If I read a book [and] it makes my whole body so cold no fire can warm me, I know *that* is poetry. If I feel as if the top of my head were taken off, I know *that* is poetry." Similarly, in a preface to her own scholarly study of American film, Marjorie Rosen describes moviegoing as an amorous experience: "Even today, when my consciousness has been raised and my fantasies exorcised, I have a soft spot for the Robert Redfords, Marlon Brandos, and Paul Newmans who make love to me in glorious Technicolor, breathtaking Cinemascope, and stereophonic sound."[1] And Pauline Kael can confess that *I Lost It at the Movies*

(1965) and assume her reader will understand the antecedent of the pronoun, precisely because of the conventionality of the erotics of art.

Music is widely regarded as an aphrodisiac, as if the popular lyric "I'm in the mood for love" were redundant, and all forms were rhapsodies. Arthur Rubinstein has stated that playing the piano is making love, and musicians are regularly instructed to perform *con amore* or *con molta passione*. Samuel Pepys notes that a concert he had just attended was "so sweet that it ravished me; and endeed, in a word, did wrap up my soul so that it made me really sick, just as I have formerly been when in love with my wife." If music be the food of love, then rock criticism is appropriately saturated with orgasmic metaphors, as if all performances aspired to what John Lennon candidly acknowledges in "A Day in the Life"—"I'd love to turn you on."

Surely Pygmalion took more than a professional interest in his work, and it has become formulaic for literary critics to confess being enamored of a fictional character. Simon Karlinsky, for example, even implies that such infatuation is a criterion of excellence when, in the course of reviewing a new edition of Tolstoy, he refers incidentally to *Anna Karenina* as "what many consider the greatest novel ever written, with a heroine with whom any sensitive reader cannot fail to fall in love."[2] John Gardner maintains that love—"a word no aesthetician ought carelessly to drop from his vocabulary"—names the single quality without which true art cannot exist.[3] Gardner argues fervently: "Despite the labors of academic artists and those sophisticates who are embarrassed by emotion, it seems all but self-evident that it is for the pleasure of exercising our capacity to love that we pick up a book at all. Except in the classroom, where we read what is assigned, or study compositions or paintings to pass a course, we read or listen or look at works of art in the hope of experiencing our highest, most selfless emotion, either to reach a sublime communication with the maker sharing his affirmations as common lovers do, or to find, in works of literature, characters we love as we do real people."[4]

Perhaps innumerable, turbid references to Einfühlung or to "identifying with" a protagonist become more intelligible when translated into a metaphor of eros. Certainly no examination of the tenet that art is like love can ignore the cluster of attitudes associated with the name of Sigmund Freud. Freud's theory of art was complex, inconstant, and never fully articulated. However, his concept of sublimation and of the artist as neurotic have made him a popular spokesman for the view that the aesthetic and the erotic are mutually convertible. In one footnote, Freud does take up a preoccupation of traditional aesthetics, the nature of the beautiful. Using the German word *Reiz*, he

asserts that all awareness of beauty derives from sexual attraction. "There is to my mind no doubt that the concept of 'beautiful' has its roots in sexual excitation and that its original meaning was 'sexually stimulating.'"[5] As unlikely an authority as William Wordsworth shares this belief in a bond between poetry and sexuality. Concurring with Coleridge that the immediate object of poetry is pleasure, he announces in the preface to *Lyrical Ballads* that: "The end of poetry is to produce excitement in co-existence with an overbalance of pleasure." And he praises metrical language for "the pleasure which the mind derives from the perception of similitude in dissimilitude. This principle is the great spring of the activity of our minds, and their chief feeder. From this principle the direction of the sexual appetite, and all the passions connected with it, take their origin." Such assertions are designed to restore us to our senses, to the origin of aesthetics.

Though Plato's Socrates could be led to condemn poetry precisely because of its appeal to the passions and because of its mimetic remoteness from the True, the Good, and the Beautiful, in *Phaedrus* 277 he appears to be equating rhetoric with love, contending that through dialectic the speaker can propagate wisdom by planting seeds in his interlocutor. This image is not at odds with Auguste Renoir's lovely but un-Platonic phrase "*Je peins avec ma queue*" (I paint with my penis), a claim that, not issued by a member of the contemporary avant-garde, ought to be taken metaphorically. John Hall Wheelock also points to the sexuality of artistic creation, contending that writing a poem is a form of autoeroticism—"Well, making a poem is like having a love affair with yourself. Artists are, in a sense, communing with the 'anima,' which is the feminine principle in a man, and what is born of this is not a living creature, but a work of art."[6] It is no longer mere sublimation in Robert Frost's familiar description of "The Figure a Poem Makes." Reiterating the analogy between poetry and love, he contends that for both reader and writer: "It begins in delight and ends in wisdom. The figure is the same as for love."[7] And, in *Chimera*, a playful version of the Scheherazade story in which both narrator and auditor are depicted as speculating on the nature of narrative, John Barth makes explicit the sexual character of the literary experience: "The very relation between teller and told was by nature erotic. The teller's role, he felt, regardless of his actual gender, was essentially masculine, the listener's or reader's feminine, and the tale was the medium of their intercourse....Narrative, in short—and here they were again in full agreement—was a love relation, not a rape: its success depended upon the reader's consent and cooperation, which she could withhold or at any moment withdraw."[8]

But it is Walt Whitman, "the caresser of life" in "Song of Myself," who provides the preeminent demonstration that *ut lectio coitus*. Who touches his book embraces a man, one incessantly conscious of self and reader and of the loving fusion he would achieve between the two through his poem. In the 1855 preface to *Leaves of Grass*, Whitman contends that "the known universe has one complete lover and that is the greatest poet." Whitman would be that bard by creating a poem amorous enough to dissolve the boundaries separating I and thou, subject and object, self and cosmos. "Song of Myself" enacts the Transcendentalist, and erotic, paradox of finding the world in the self. Though he begins his celebrated poem by celebrating and singing himself, Whitman immediately invites his reader to merge with that self: "And what I assume you shall assume, / For every atom belonging to me as good belongs to you." Romantic union is announced again when he employs an image suggesting both a spokesman and a carnal lover: "It is you talking just as much as myself, I act as the tongue of you." Whitman's text—"This the touch of my lips to yours, this the murmur of yearning"—does not simply develop the theme of love, but is itself a potent act of liaison between creator and reader. "On women fit for conception I start bigger and nimbler babes / (This day I am jetting the stuff of far more arrogant republics)." Beginning with the creation of a distinctive, hirsute persona named "Walt," "Song of Myself" (as much as *Story of O*) dramatizes the surrender of isolate personality: "Behold, I do not give lectures or a little charity / When I give I give myself."

At times, as when "I turn the bridegroom out of bed and stay with the bride myself," Whitman portrays himself as inseminator, while at other times he ebbs with the ocean of life. While his poetry is consistently an act of love, the reader's role varies from active to passive as the style ranges from what is traditionally termed "masculine" to what is traditionally termed "feminine." *Leaves of Grass* attempts a loving fusion of these, and other, polarities. In an analysis of "the orgasmic rhythms" of *Women in Love*, Garrett Stewart argues not only that Lawrence, too, depicts an erotic transcendence of male and female, but that the very grammar of his text provides the reader with this ultimate sexual experience: "The intercourse described, this 'communication,' is in the punning sense 'unspeakable' not because of shame this time, but because of its 'intolerable' perfection—beyond the reach, and beyond the necessity, of words, except those of the narrator, whose language is so engaged as to fall into the rhythms of simulation. This we will have to call Lawrence's post-orgastic style, the prose not of fictional rush to climax, but of the poise and reciprocal peace that ensues. Otherness must be grammatically respected,

avoiding the strict subject and object relationship in sexuality, with mutuality and balance made syntactically evident."[9]

On the other hand, Jean-Paul Sartre sees Jean Genet's writing as "an art feminine in its nature." He contends that the reader must assume a masculine role in order to undergo the sexual experience that Genet's text creates: "His literary adventure is not unlike an amorous adventure: while seeking to arouse horror, Genet writes in order to be loved. I refer here to an infernal love that aims at subjugating a freedom in order to take shelter in it from the world. To win love, to subdue a mind to make it want to be dependent, inessential, to become for it, with its complicity, the sovereign object: is not this what wicked love and Genet desire? The mind of the reader will oddly resemble that of a lover: it forgets itself, it loses itself so that the Thief may appear. Under the effect of poetic philters, the reader treats himself as an inessential means."[10]

Similarly, Valéry Larbaud's "Le Masque" is an apostrophe to the reader to assume an active role and embrace the poet:

> Oh qu'un lecteur, mon frère, à qui je parle
> A travers ce masque pâle et brillant
> Y vienne déposer un baiser lourd et lent
> Sur ce front déprimé et cette joue si pâle,
> Afin d'appuyer plus fortement sur ma figure
> Cette autre figure creuse et parfumée.[11]

A study of the gender of real and implied audiences would have to come to terms with "masculine" and "feminine" styles and with the variety of literary/sexual experiences available to the reader.

Of course, all equations of literature with love—whether by Saint Augustine, Guilhem de Peitieus, or Sigmund Freud—remain reductive and vacuous if neither term is defined except by the other. Both reading and rogering are conventional activities, and both have a history. Denis de Rougemont, C. S. Lewis, and others have popularized the thesis that love is a convention, not merely in the convenient sense of a coming together, but as a system of contingent and culturally acquired gestures and attitudes. It is thus that we read La Rochefoucauld's witticism that some would never love if they had never heard the word—"Il y a des gens qui n'auraient jamais été amoureux, s'ils n'avaient jamais entendu parler de l'amour"—or Pascal's observation that we fall in love by speaking of love—"A force de parler d'amour, on devient amoureux."[12] So, too, with reading. The Noble Savage does not read Rousseau.

Erotic and literary experiences vary significantly according to period, culture, and participant. And if literature is not simply a love offering, or even frequently about love, but by nature a facsimile of loving, then a correlation should exist between styles in reading and in making love. It is common to speak of styles that are chaste and those that are ravishing, of texts that are barren and seminal, of tones that are seductive and ironic. Perhaps this last corresponds to the detachment of men who count sheep in order to delay ejaculation. Numerous medieval palinodes testify to the author's guilt over a joyful transaction with his reader, and it is possible that eras in which sex is utilitarian, in which pleasure in it for its own sake is discouraged, are also periods of exclusively functional art. The ideal of celibacy, the endorsement of only one conjugal position, the institution of *la chemise cagoule* (a thick nightshirt with an aperture positioned so that a husband could impregnate his wife while avoiding any superfluous contact)—perhaps these are akin to Puritan discomfort over jubilation that a thing of beauty is a joy forever or over our temptation to be attracted by works of art devoid of doctrine. The sumptuous pornographic underground of the Victorians should caution us against too simplistic an equation of literary and sexual fashions. But if all reading is ravishment, then of course the genuinely chaste poem is unread, even unreadable. And perhaps the Victorian notion of personal "purity" bears some comparison to the forbidding style of Symbolist "pure" poetry.

An age that extols the ideal of chastity would assume a far different relationship between reader and text than would, for example, the Jazz Age, however reluctant it might be to acknowledge the nonmusical sense of the verb "to jazz." "For jazz is orgasm, it is the music of orgasm, good orgasm and bad," impudently declares Norman Mailer.[13] The erotically suggestive lyrics and rhythms of rock music proclaim both a sexual and an artistic revolution. Is it mere coincidence that *The Dynamics of Literary Response* (1968) appeared within two years of *Human Sexual Response* (1966)? In her demand for a new, living theater, Judith Malina invokes the simile of sexuality. Her claim that both theater and sex free us from convention is simply consistent with contemporary conventions for both activities: "Now we are getting to a theatre where the audience is treated as individualized, as in a sex relationship. A sex relationship must free us from convention. This nakedness and trust in bed is what the actor must come to when we break through and personalize the audience.[14]

If an *ars poetica* can also reflect its age's art of love, we can no doubt learn something about contemporary aesthetic fashions by consulting sex manuals.

In one of the most popular, *The Joy of Sex: A Gourmet Guide to Love Making* (1972), Alex Comfort makes use throughout of an analogy between *ars amandi* and the art of gastronomy. But, in his opening remarks, he shifts the terms of comparison to the arts of dance and song. It is to justify the careful study of lovemaking that Comfort presumably likens it to an artistic discipline, yet the arts he chooses as exemplary are, curiously, those he conceives of as instinctive activities: "All of us who are not disabled or dumb are able to dance and sing—after a fashion. This, if you think about it, summarizes the justification for learning to make love. Love, like singing, is something to be taken spontaneously."[15]

Contemporary art and sexuality—as well as nutrition—share a cult of nature, and it is no wonder that casual, colloquial styles, found poetry, improvisational theater, aleatory and country music, and pop art coexist with guides that preach the values of spontaneity and openness in sexual relationships.

If the literary experience is a version of the prurient, then our alphabet is an assemblage of love letters. In *After Babel: Aspects of Language and Translation*, George Steiner in fact argues that all communication is amatory: "Sex is a profoundly semantic act. Like language, it is subject to the shaping force of social convention, rules of proceeding, and accumulated precedent. To speak and to make love is to enact a distinctive twofold universality: both forms of communication are universals of human physiology as well as of social evolution. It is likely that human sexuality and speech developed in close-knit reciprocity."[16]

Perhaps we are back at the nagging suspicion that all tyro linguists are cautioned against harboring—that there is a connection between sexuality and either the gender of nouns or the conjugation of verbs. Although writing is a still, solitary act, it is also a breach of solitude. And all language is erotic because all language is a joining of tongues. Viola suggests to Feste in *Twelfth Night* that "They that dally nicely with words may quickly make them wanton."[17] And though Humbert Humbert is in the prison by himself, and of himself, he can still manage a facsimile of love, as in his pathetic ejaculation: "Oh, my Lolita, I have only words to play with!"[18]

Yet Dante's ineffable vision of heaven and Réage's mystical notion of the ultimate orgasm argue that love is an alphabetic ecstasy, though (as in the Annunciation) a word can be the instrument of its conception. The modernist literary experience is particularly apocalyptic, aspiring to a breathless marriage of true minds when, dissolving the boundaries separating author and reader, all passion is spent. Beyond Joyce's verbal luxuriance, he longs for the

reader with an ideal insomnia willing to share a blissful night. Admittedly, reading is not lovemaking, and those who wield words to reason that it is are being self-indulgent. Yet many, many have solemnly engaged in this fanciful yoking. To explore its range and history is to come close to embracing the literary experience itself. The attempt is exhilarating, but the outcome is tragic, postcoital grief. As with the final punctuation of an overwhelming narrative—whether *Alice's Adventures in Wonderland*, *Paradise Lost*, *Gone with the Wind*, or "The Rime of the Ancient Mariner"—we are forlorn, no longer touched by the power of another's word.

Books and Ballots

2016

> If only Russia had been founded
> by Anna Akhmatova, if only
> Mandelstam had made the laws
> —Adam Zagajewski, "If Only Russia"

Two hundred eleven members of the 113th Congress listed law as their occupation. Congress also includes numerous entrepreneurs, physicians, engineers, clergy, teachers, farmers, and accountants, as well as solitary examples of a rodeo announcer, a vintner, a comedian, a firefighter, a welder, a fruit picker, a football player, a fisherman, and a mortician.[1] No one claims a literary calling. Many members of the Senate and the House of Representatives—as well as presidents, governors, and mayors—have written, or pretend to have written, books. Ghostwritten memoirs published to coincide with campaigns are the tribute that ambitious yahoos pay to literate Houyhnhnms. But the office that a professional writer seeks is most often merely a space in which to write.

Despite the fact that the Bureau of Labor Statistics estimated 123,200 writers in the United States in 2018 (easily exceeding the number of rodeo announcers and vintners),[2] it is an extraordinary event when a writer becomes a candidate, and it is almost apocalyptic when one succeeds. Especially in the United States, where Adlai Stevenson was mocked as an "egghead" for being seen with a book and where Sarah Palin's apparent indifference to reading embellished her credentials as a populist foe of "elitism," being "bookish" is usually not an asset, but a liability. So alien are books and reading to American notions of political power that Henry Kissinger, an intellectual courtier who himself never ran for office, was astonished to find books not only bursting out of the shelves of Mao Zedong's study but piled onto a table and the floor as well. "It looked more the retreat of a scholar than the audience room of the all-powerful leader of the world's most populous nation," he recalled.[3] According to a survey conducted by the National Endowment for the Arts, fewer than half of Americans of voting age read any literature; and they apparently do not like to read the names of writers on their ballots.[4]

In *America the Philosophical*, Carlin Romano makes the hyperbolic claim that "America in the early twenty-first century towers as the most philosophical culture in the history of the world, an unprecedented marketplace of truth and argument that far surpasses ancient Greece, Cartesian France, nineteenth-century Germany, or any other place one can name over the past three millennia."[5] As part of his panegyric, Romano hails Barack Obama as "our most cosmopolitan, philosopher-in-chief president since Woodrow Wilson."[6] Obama's *Dreams from My Father*, which Obama published in 1995, a year before running successfully for the Illinois State Senate, and which won the 2009 Galaxy British Book Award for biography, is indeed written with extraordinary passion and grace. Like Thomas Jefferson, James Madison, Abraham Lincoln, and Theodore Roosevelt, Obama is an anomaly among American politicians in his gift for composing powerful English prose. Nevertheless, although the forty-fourth president might, in another life, have become an important literary figure, he is still, however, an officeholder who writes, not primarily a writer who ran for office. The forty-fifth president, who hires ghostwriters to compose volumes published under his name, does not read books. Jimmy Carter produced poetry and fiction after leaving the White House, and, despite their published novels, no one considers "author" as the primary identity of Barbara Boxer, William Cohen, Newt Gingrich, Gary Hart, Barbara Mikulski, James Webb, and William Weld. Though Calvin Coolidge in fact translated Dante's *Inferno* during his honeymoon, he is better known for the philistine declaration that "the chief business of the American people is business." No American writer approximating the stature of Victor Hugo, who was elected to the French Senate in 1876, has ever run for public office. The United States may or may not be the "most philosophical culture" in history, but its political and literary cultures are kept quite distinct. The congressional bibliography abounds with memoirs, histories, and policy studies, but, in this country, composing poetry is a disqualification for election to public office.

"The only thing I've ever really wanted in my life was to be President,"[7] Gore Vidal, whose grandfather, Thomas P. Gore, was a senator from Oklahoma and who considered politics "the family business,"[8] told an interviewer in 1976. Despite more than two dozen novels, eight plays, and two political campaigns—for Congress from New York in 1962 and for the Senate from California in 1982—Vidal's ambition remained unfulfilled. Norman Mailer, a literary rival, also chafed at the role of mere writer. "I have been running for President these last ten years in the privacy of my mind,"[9] Mailer

wrote in 1959. The novelist had to settle for the presidency of PEN American Center in 1984. He finished fourth in a primary field of five as candidate for mayor of New York City (fellow writer Jimmy Breslin, bidding for the presidency of the city council, was his running mate) in 1969 and never occupied the Oval Office except in the privacy of his mind. Richard Henry Dana ran for Congress from Massachusetts in 1868; Jack London for mayor of Oakland in 1901 and again in 1905; Upton Sinclair for governor of California in 1934; James Michener for Congress from Pennsylvania in 1962; Hunter S. Thompson for sheriff of Pitkin County, Colorado, in 1970; and David R. Slavitt for Massachusetts House of Representatives in 2004—none victoriously. As the bestselling author of a dozen books, Marianne Williamson was an anomaly among candidates for the Democratic nomination for president in 2020, but her New Age writings on meditation and spirituality would not be considered "literary." She failed to win a single delegate in the Democratic primaries and caucuses. In 2014, in a bid to represent California's Third Congressional District, she had finished fourth in a field of eighteen.

Poets might, as Shelley proclaimed, be the unacknowledged legislators of the world, or, in George Oppen's formulation, the legislators of the unacknowledged world. Yet they rarely enter legislatures or executive suites in an elected capacity. One writer who did was Václav Havel, the dramatist who was elected president of Czechoslovakia in 1989. He explained his commitment to public service by noting: "If the hope of the world lies with human consciousness, then it is obvious that intellectuals cannot go on forever avoiding their share of responsibility for the world and hiding their distaste for politics under an alleged need to be independent."[10] Michener, too, refused to regard writers as a privileged class exempt from participation in civic affairs: "I consider it insulting for any citizen to think that he is above politics,"[11] he wrote in the midst of canvassing votes within every square mile of Bucks County, Pennsylvania.

But the finest writers are connoisseurs of ambiguity, the negative capability that John Keats identified as Shakespeare's genius. And politics, particularly in our time, dissolves complexities into simplistic fables of good and evil, yes and no, blue and red. When a poet enters the electoral arena, something does not scan. The creed of democratic parity causes many voters to mistrust literary excellence. And Stephen Dedalus's dedication to a "pure" art that disdains the inevitably compromised—because it requires the art of compromise—realm of politics still shapes much of the discourse about belles lettres. "You talk to me of nationality, language, religion," says Joyce's haughty young

aesthete. "I shall try to fly by those nets."[12] In proud, Promethean alienation, many artists have disdained distractions from their lofty literary calling. "It's boring and distasteful," was Slavitt's verdict on his experience of running for office when he could have been writing more poetry.[13]

It might seem that, because the trade requires collaboration if not gregariousness, a playwright, at least, would be temperamentally more suited to cajoling voters and donors than a poet, whose Romantic traditions celebrate impecunious solitude in a garret. It is easier to imagine Arthur Miller than Emily Dickinson out shaking hands and kissing babies. The only significant electoral success among American authors was playwright Clare Boothe Luce, whom Connecticut voters sent to Congress twice, in 1942 and 1944. But neither Eugene O'Neill nor Lillian Hellman nor Edward Albee nor David Mamet nor August Wilson ever appeared on a ballot.

Despite a rich tradition of *littérature engagée*, for much of the past two centuries, writers have been adversaries of the dominant social values, rendering artistic and political sensibilities as immiscible as oil and Greenpeace. Three years before his election to the presidency of Senegal, Léopold Sedar Senghor acknowledged his ambivalence, his sense that literature and politics were pulling him in opposite directions: "I am torn between Europe and Africa, between politics and poetry, between my white brother and myself."[14] Are artists incapacitated from participation in civic life? Or are they merely undesirable except as artists? "All poets adore explosions, thunderstorms, tornadoes, conflagrations, ruins, scenes of spectacular carnage. The poetic imagination is not at all a desirable quality in a statesman," observed W. H. Auden,[15] who might have understood why Lyndon Johnson exclaimed "I don't want anything to do with poets,"[16] and George H. W. Bush insisted "I can't do poetry."[17] In a 1939 symposium for *Partisan Review*, Gertrude Stein dismissed the entire question: "Writers only think that they are interested in politics, they are not really, it gives them a chance to talk and writers like to talk but really no real writer is really interested in politics."[18] Or perhaps one life is simply too short for a person to excel in both writing and politics.

Stendhal famously observed that "politics, in a literary work, is like a pistol shot in the middle of a concert,"[19] but a literary worker in politics seems more like a blunderbuss. Writers in politics behave differently than do soldiers, lawyers, and stockbrokers. In the United States, they are an oddity. Though Senghor, a major figure in modern French poetry, served as president of Senegal for twenty years, it is hard to imagine Robert Frost or Maya Angelou or Elizabeth Alexander serving anything but an ornamental function at a

presidential inauguration, and it is ludicrous to envision Marianne Moore or Richard Wilbur addressing rallies out in the hustings. The Velvet Revolution propelled Havel, whose dissident plays had earlier earned him seven years in a Communist prison, into the presidential castle in Prague, but revulsion against McCarthyism did not thrust Tennessee Williams into executive office. And, though novelist Benjamin Disraeli became one of Britain's most notable prime ministers (and continued publishing fiction while in office), the closest that Nathaniel Hawthorne came to president was to room with one— Franklin Pierce—at Bowdoin College.

"Writers should be read—but neither seen nor heard," declared Daphne du Maurier, voicing a common belief that writers are better off casting ballots but not appearing on them.[20] According to Mario Vargas Llosa, "There is an incompatibility between literary creation and political activity."[21] In much of the world for much of the time, writers are more likely to be victims than agents of official power. Each November 15 since 1981, members of PEN throughout the world have been observing the International Day of the Imprisoned Writer to call attention to the scores of people whom various régimes incarcerate and even torture and kill for their writing. Government authorities murdered Ken Saro-Wiwa in Nigeria, David Bergelson in Russia, André Chenier in France, and Cicero in Rome. Forced from power and far from home, the ancient Chinese poet-statesman Qu Yuan killed himself. In his prison memoir *For a Song and a Hundred Songs: A Poet's Journey through a Chinese Prison* (2013), contemporary Chinese poet Liao Yiwu recalls a failed suicide attempt as the most terrible moment of his harrowing four years of incarceration. Icelandic poet Snorri Sturluson was assassinated when his political activities angered Norway's King Haakon IV. Modernist culture has cast the writer as adversary rather than instrument of the state. "An author's first duty," quipped Brendan Behan, "is to let down his country."[22] Robert Crawford concurred: "As far as politics is concerned, the poet's most important work is to fiddle while Rome burns."[23] However, as mayor of Fort-de-France and deputy to the French Assembly, Aimé Césaire did not let down his native Martinique, nor did William Butler Yeats betray his nation by serving as senator of the new Irish Free State, nor did José Echegaray after election to the Spanish Cortes, nor did Lennart Meri during his tenure as president of Estonia. Alphonse de Lamartine flopped in his bid for the presidency of France in 1848, but Luis Muñoz Marin, the first elected governor of Puerto Rico (1949–64), sustained the dream of Philosopher King.

Nevertheless, French *intéllectuels* and Russian intelligentsia defined them-

selves in opposition to the regnant régime, and, speaking truth to power, literary dissidents including Voltaire, Hugo, Emile Zola, Thomas Mann, and Aleksandr Solzhenitsyn upheld the role of the writer as rival sovereign. "For a country to have a great writer," wrote Solzhenitsyn, "is like having a second government. That is why no régime has ever loved great writers, only minor ones."[24] The moral authority of Nigeria has resided in Wole Soyinka and Chinua Achebe, not the kleptocracy in Abuja. The Liberal Party that Alan Paton founded foundered at the polls, but his 1948 novel *Cry, the Beloved Country* ultimately exerted more lasting influence than the South African pass laws promulgated by H. F. Verwoerd and P. W. Botha.

Some of the greatest writers of Latin America, including Julio Cortázar, José Martí, Manuel Puig, and César Vallejo, have suffered imprisonment and/or exile, but other authors have possessed powers beyond the ability to devise startling metaphors and ingenious plots. Rubén Darío, Jorge Isaacs, Gabriela Mistral, Miguel Angel Asturias, Pablo Neruda, Octavio Paz, and Alejo Carpentier have served their nations as diplomats, and poet Ernesto Cardenal served as Nicaragua's minister of culture, while novelist Sergio Ramírez Mercado was its elected vice president. Carlos Fuentes served as Mexico's ambassador to France, and his death, on May 15, 2012, was first announced on Twitter by Mexican president Felipe Calderón. Whereas Zora Neale Hurston was buried in an unmarked pauper's grave, Fuentes was memorialized in a state funeral attended by his nation's political elite. But it was another Latin American writer, poet Rigoberto López Pérez, who threw his nation's politics into turmoil, by assassinating the Nicaraguan dictator Anastasio Somoza García. Early in his career, in 1945, Jorge Amado was elected to the National Constituent Assembly, though his political candidacies ended abruptly when his Brazilian Communist Party was outlawed. When novelist Rómulo Gallegos was elected president of Venezuela in 1948, he considered it "a loan from letters to politics, with no fixed repayment date."[25] The troubled presidency of novelist Domingo Faustino Sarmiento in Argentina (1868–74) promised the possibility of reconciling civic responsibility with the life of the mind.

That was also the ambition of Mario Vargas Llosa, when he ran for president of Peru in 1990. Though opponents wrenched lurid passages from his fiction to quote out of context, he garnered a plurality of 29 percent in the first round of balloting, before losing the runoff to an obscure agronomist named Alberto Fujimori, who received 57 percent of the final vote. In *A Fish in the Water*, the memoir that he published in 1993, Vargas Llosa recalls the

arguments with which Octavio Paz had tried to dissuade him from entering politics: "incompatibility with intellectual work, loss of independence, being manipulated by professional politicians, and, in the long run, frustration and the feeling of years of one's life wasted."[26] Yet Vargas Llosa admits that it was in large part "the decadence, the impoverishment, the terrorism, and the multiple crises of Peruvian society" that drew him to the challenge of seeking "the most dangerous job in the world."[27] By running for president of his destitute, embattled nation, the author of *The Green House* (1968), *Conversation in the Cathedral* (1975), *Aunt Julia and the Scriptwriter* (1982), *The War of the End of the World* (1984), *In Praise of the Stepmother* (1990), and other books pursued the grandiose illusion "of writing the great novel in real life."[28] His noble ambition of using his talents to transform Peru came up against his discovery that "real politics, not the kind that one reads and writes about, thinks about and imagines (the only sort I was acquainted with), but politics as lived and practiced day by day, has little to do with generosity, solidarity, and idealism. It consists almost exclusively of maneuvers, intrigues, plots, paranoias, betrayals, a great deal of calculation, no little cynicism, and every variety of con game."[29]

"Writers and politicians are natural rivals," declared Salman Rushdie. "Both groups try to make the world in their own images; they fight for the same territory."[30] However, the fight is seldom conducted on equal terms, and it becomes complicated when a single figure is both writer and politician. "I am a poetician, not a politician," observed Yevgeny Yevtushenko, who was elected to the Russian Duma.[31] Is the hybrid species of poetician as mythical—and sterile—as a unicorn? A hybrid can be stronger than either of its progenitors, if it is not grotesque.

With very few exceptions—Blaga Dimitrova, the poet who was vice president of Bulgaria; Clare Boothe Luce; and Halide Edib Adivar, who served in the Turkish Parliament—most writers showing up on ballots have been male. Women, who gained suffrage in most countries barely a century ago, have in general been underrepresented among candidates for office, and it is perhaps no surprise that the women who have pioneered as politicians have come from more customary professions such as law and education rather than literature. Gender has been enough of a handicap to women who might have sought election that the added baggage of authorship would sabotage a campaign from its outset.

In the United States, the nation with the most elaborate and expensive system of electing leaders, traditions of frontier egalitarianism and pragmatic

Babbitry have combined to make the phenomenon of writers who run for office especially rare, as if literary mastery were in fatal conflict with the leveling culture of electoral democracy. In recent campaigns, "elitist" has been one of the most damaging epithets in the arsenal of political invective, and a literary sensibility was seen as a symptom of toxic oligarchical tendencies. Though his wife was a librarian, George W. Bush was manifestly uncomfortable with books and with the English language. His opponent John Kerry was forced to disguise his fluency in French, the language of effete, un-American aesthetes such as Baudelaire, Proust, and Dominique de Villepin, the poet who became prime minister. In Edmund Wilson's famous appropriation of the Philoctetes myth (more applicable to American than Greek culture; Sophocles, after all, served as a general in the Athenian army), the artist and society are locked into a relationship of mutual resentment. Real poets—at least those in the mold of Rilke and Verlaine—don't do photo ops. When Upton Sinclair, running as a Democrat on the EPIC ("End Poverty in California") platform, was defeated for governor in 1936, a rival explained that the novelist "was beaten because he wrote books."[32] During a nasty campaign, passages from Sinclair's fiction were quoted against him. However, the specific contents were scarcely relevant, since dedication to any kind of writing can be a liability in a political culture that favors slogans over complex thought and personalities over ideas. In exile in Italy long after his last electoral battle, Gore Vidal told an interviewer: "There is also something in the water—let us hope it was put there by the enemy—that has made Americans contemptuous of intelligence whenever they recognize it, which is not very often. And a hatred of learning, which you don't find in any other country. There is not one hamlet in Italy where you fail to find kids desperate to learn."[33] After his own disastrous run for office, David R. Slavitt, a novelist, poet, and translator, concluded: "The electorate is invincibly stupid."[34] To many literary folk, *vox populi* is an ill-informed rant.

Asked by the emperor for advice on governing, Confucius is said to have replied: "First purify the language."[35] Although good writers are temperamentally allergic to clichés, a modern electoral campaign requires formulaic statements delivered several times a day for successive weeks and months. How do voters respond when a "poetician" attempts to communicate in ways that embody those qualities most valued in literature—innovation, complexity, provocation? What happens to people whose profession demands verbal precision when the pressures of a campaign oblige them to deliver speech after numbing speech and to settle for slogans? "It is a low-grade poetry,"

complained Slavitt, "the art of clobbering people over the head."[36] In demo-
cratic cultures in which increasing emphasis is placed on the candidate one
would most choose to share a beer with, how do voters relate to literary art-
ists? Candidates who choose poetry over rhetoric are not likely to succeed on
the stump.

In 2004, Slavitt staged a quixotic quest for a seat in the Massachusetts
House of Representatives. The sixty-nine-year-old author of twenty-nine
novels, seventeen collections of poetry, and twenty-seven volumes of trans-
lation ran as a liberal Republican against a six-term incumbent in a solidly
Democratic district encompassing Cambridge and Somerville. Slavitt re-
sented as humiliating distractions the signature-collecting, hand-shaking,
sloganeering, and schmoozing required for success in electoral politics. On
an occasion when literary inspiration competed with the candidate's schedule,
poetry won. "I took the day off and did absolutely nothing in the way of cam-
paigning," he reports. "Instead, I wrote a poem with which I am well pleased.
All my life, my practice has been to suspend almost any other kind of activ-
ity if a poem has presented itself to me."[37] Slavitt explained his unconven-
tional candidacy in a letter to prospective constituents: "I am a social mod-
erate, a fiscal conservative, and a grown-up. That I am also a person of some
intelligence and culture does not, I think, absolutely disqualify me for office
in the State House."[38] Most voters in the Twenty-Sixth Middlesex District
of Massachusetts disagreed. Slavitt was routed by the incumbent, Timothy
J. Toomey, 87 percent to 13 percent. He took consolation from the fact that
his minuscule support, 1,680 votes, "is not a bad number for sales of a book of
poems."[39]

Free to resume his prodigious career as a writer, Slavitt immediately set
to work publishing translations of Euripides, Boethius, Lucretius, Sophocles,
Ausonius, and Ariosto; two volumes of original poetry; a memoir; a book of
essays; and a novel. But in the aftermath of defeat, he also produced a sar-
donic account, Blue State Blues (2006), of his misadventures in electoral pol-
itics. Its pages, he later claimed, redeemed the ordeal of running for office:
"The book, very early on, became the purpose, and I got the book written
and published. That's what I accomplished. The account of the effort is much
more interesting as a piece of political anthropology than was my actual cam-
paign in this benighted city and state."[40]

Vargas Llosa, too, returned to writing, prolifically, and expressed grati-
tude and relief over the decision by Peruvian voters not to burden him with
the responsibilities of the presidency. In addition to a steady stream of new

fiction, he, too, published a campaign memoir, *El pez in el agua* (1993; *A Fish in the Water*, 1994), that is suffused with melancholy over the irrationality of an electorate he had hoped to win over through the strength of his ideas. Though Voltaire located *Candide*'s Eldorado, an idealized kingdom of rational citizens, in the vicinity of Peru, the real Peru was resistant to the reign of a Philosopher King. "They voted the way people do in an underdeveloped democracy, and sometimes in the mature ones as well," Vargas Llosa complains about his fellow citizens, "on the basis of images, myths, heart throbs, or on account of obscure feelings and resentments with no particular connection to processes of reason."[41]

Through his EPIC movement, Sinclair also made his bid for governor a campaign of ideas, an educational effort to win voters over to "production for use," a plan by which state-owned cooperatives would provide constructive employment for the seven hundred thousand Californians who were out of work. His popularity as the author of *The Jungle* and many other novels drew attention to his candidacy at the top of the Democratic ticket, but it also aroused animosity. "What does Sinclair know about anything?" a hostile movie executive is reported to have asked his screenwriters. "He's just a writer."[42] Despite the often vicious attempts by powerful interests to discredit him and sabotage his efforts, Sinclair did surprisingly well at the polls. He received 37.6 percent of the vote, to Republican Frank Merriam's 48.7 percent; a third-party candidate, Raymond L. Haight, received 13.7 percent. Within three days of losing, Sinclair was busy writing what has become almost requisite for writers who run for office—a campaign memoir. Finished in five weeks, *I, Candidate for Governor and How I Got Licked* (1935), expresses relief that its author is free again to drive his own car, take walks, sleep with the windows open, and get back to writing novels. And, insisting that he ran in order to advance his ideas and not because he particularly wanted to be governor, Sinclair pronounces himself satisfied that he has accomplished his goal.

After losing, by only seventeen thousand votes, to a ten-term incumbent, James Michener, too, resumed a prodigious—and lucrative—writing career. In the memoir that he published thirty years later, *The World Is My Home* (1992), he is sanguine about his unsuccessful bid for public office: "Running for Congress was one of the best things I've done because campaigning in public knocks sense into a man. He begins to see his nation as a carefully assembled mosaic whose individual pieces require close attention."[43] Even during the campaign, Michener's equanimity distinguished him from Slavitt's bitterness, Vidal's cynicism, and Vargas Llosa's despair. Unlike them, he did

not resent the sacrifice of time and energy for writing. "If I were found worthy to participate in the government of my country," he declared, "I would be happy indeed. I would consider the work more important than the writing of another book, more significant than the making of another movie."[44]

Václav Havel actually won election to the highest office in his nation, serving as president from 1989 to 2003. To Vargas Llosa, he is an inspiring example of the difference that a conscientious writer can make to political culture:

> I think what he brought to politics in Czechoslovakia is something that a writer or an artist can offer: a moral perspective, more important than the purely political, and a new discourse—a discourse without the stereotypes and the wooden language that is the norm in political discourse. Václav Havel was the extraordinary case of the politician whose speeches you could read because they full of ideas, and there was something authentic there. He proved to the people that politics is not only about intrigue, maneuvering, and sordid appetites, but also about something in which idealism, ideas, creativity, and authenticity can take place, and that these can produce positive changes in society. the unique contribution that a writer can make to politics. I think it's a positive example of how not all writers are so ineffective in politics, as I myself, for example.[45]

Of course, literary candidates in North America have been even more ineffective than Vargas Llosa, a credible contender for president of Peru.

Like other writers who ran for office, Havel resumed his literary career after reemerging from politics. He also wrote with intelligence, candor, and self-effacing wit about the frustrations and satisfactions of running and serving. In his unconventional memoir *To the Castle and Back* (2008; *Prosím stručně*, 2006), Havel recalls the challenges, ranging from determining place settings at state dinners and obtaining a longer hose for the presidential garden to dissolving the Warsaw Pact and gaining entry into the European Union, that he had to negotiate. He credits his success to the contradictory qualities that are assets in writing for the theater: "I'm a sociable person who likes being with people, organizing events, bringing people together; a cheerful fellow, sometimes the conversational life of the party, one who enjoys drinking and the various pleasures and trespasses of life—and at the same time I'm happiest when alone and consequently my life is a constant escape into solitude and quiet introspection."[46]

Havel acknowledges that his foray into politics benefited from the exalted prestige accorded writers under the repressive régimes of Central and Eastern

Europe. By contrast, many American writers—e.g., Herman Melville, Emily Dickinson, Kate Chopin, Walt Whitman, Henry Roth, Zora Neale Hurston—have languished, and flourished, in obscurity. And the changing dynamics of culture are making the success of a poetician, in this country and elsewhere, less and less likely. In a 2006 interview published fifty years after he ran for Congress, Vidal quipped that he was once a famous writer but that "to speak of a famous writer is like speaking of a famous speedboat designer. Adjective is inappropriate to noun. How can a novelist be famous—no matter how well known he may be personally to the press?—if the novel itself is of little consequence to the civilized, much less to the generality?"[47] Literature, once the arbiter, if not center, of serious culture, is increasingly marginalized. Books as printed texts are an endangered species, and book-reading must now compete with a multitude of other activities. Authors have ceded their authority to masters of other media, mostly visual. In an age of endemic aliteracy, a Vidal campaign would have a very different resonance today than it had when he ran for Congress in 1960, before the advent of the internet, cable TV, cinematic multiplexes, Facebook, Twitter, and podcasts. Actors (Fred Gandy, George Murphy, Ronald Reagan, Arnold Schwarzenegger, Fred Thompson) and athletes (Bill Bradley, Jim Bunning, Jack Kemp, Jesse Ventura, J. C. Watts) are more likely to succeed in politics than are the wretches who write.

Benito Mussolini began his career as a writer, and the world would have been spared much grief had he stuck to that profession. And it would have been greatly impoverished had Iris Murdoch, like Jeffrey Archer, diverted her energies to standing for Parliament. However, writers are among the best and brightest of citizens, and the health of the commonwealth suffers when they are confined to the role of political advisor or quarantined in academe. It is possible to imagine authors as varied as William Dean Howells, George Bernard Shaw, Margaret Atwood, Carlos Fuentes, David Grossman, and Walter Mosley making constructive contributions as candidates as well as elected leaders without having to banish their muses. Of course, many other writers (Charles Bukowski, Hart Crane, Henry Roth, Henry James, Jack Kerouac, Sylvia Plath, Thomas Pynchon, J. D. Salinger) are temperamentally ill-suited to a campaign trail or a government office. They also serve who only sit and write.

When Literature Was Dangerous

2014

Writing to PEN USA from a prison cell in Nigeria in 1995, novelist and environ-
mental activist Ken Saro-Wiwa admitted: "I've often envied those writers in
the Western world who can peacefully practice their craft and earn a living
thereby."

Shortly after sending off his letter, Saro-Wiwa was hanged by the mili-
tary régime of General Sani Abacha. For many writers throughout the world,
marshalling words on a page still imperils their lives, not just their ability to
make a living. It is usually not so for an American, though Philip Roth once
expressed peculiar envy for authors in repressive societies who risk incarcer-
ation and even death. Returning from a trip to Prague when it was still con-
trolled by a Communist régime, Roth observed that "there, nothing goes and
everything matters; here everything goes and nothing matters."[1] Suppression
is the compliment that a dictatorship pays to the power of its writers.

By 1969, when he published the sexually explicit novel *Portnoy's Complaint*,
Roth was able to write freely because of a series of court decisions that effec-
tually put an end to the literary censorship that was routine in the United
States not long before. In the momentous 1933 case of *United States v. One
Book Called "Ulysses,"* Judge John M. Woolsey, ruling that James Joyce's uncon-
ventional novel was not "obscene," set a precedent that would eventually lead
to the lifting of virtually all restrictions on books that are not libelous or a
threat to national security. Today, when obscenity and profanity seem quaint
categories, at least in connection with fiction and poetry, the United States
Postal Service no longer seizes and burns books. Despite strenuous efforts,
even the president of the United States was powerless to prevent his disgrun-
tled former national security advisor, John Bolton, from publishing a book
that cast him in a negative light.

In 1923, a year after the publication of both *Ulysses* and his own landmark

poem *The Waste Land*, T. S. Eliot proclaimed Joyce's novel "the most import-
ant expression which the modern age has found; it is a book to which we are
all indebted, and from which none of us can escape."[2] Henry Roth acknowl-
edged his own debt to *Ulysses*, the most powerful influence on *Call It Sleep*
(1934), his masterly evocation of the American immigrant experience. Joyce's
novel was a profound revelation when Roth read it in 1925: "What I gained
was this awed realization that you didn't have to go anywhere at all except
around the corner to flesh out a literary work—given some kind of vision, of
course. In stream of consciousness I recognized that my own continual dia-
logue with myself could be made into literature. It was a tremendous impetus
toward writing."[3]

Roth was nineteen when he discovered *Ulysses*, and, since the book was
banned in most of the English-speaking world, he was able to read it only be-
cause his mentor and lover, Eda Lou Walton, smuggled a copy back from a
trip to Paris. However, the novel was loathed not only by government agents
and moral vigilantes, who seized and destroyed hundreds of copies, but also
by some authors who should have known better. Edith Wharton called
Ulysses "a turgid welter of pornography,"[4] and Virginia Woolf dismissed Joyce
as "a queasy undergraduate scratching his pimples"[5] and his novel as "an illit-
erate, underbred book."[6] D. H. Lawrence, who had his own problems with
censorship, pronounced the triumphant final chapter of *Ulysses* "the dirtiest,
most indecent, obscene thing ever written."[7]

Today, *Ulysses* is readily available and has long since been absorbed into
the modern canon. If reading about Leopold Bloom's progress through
Dublin on June 16, 1904, is still an epiphany, it no longer produces the fris-
son of handling forbidden fruit. After its own success in smashing all the
icons in the Temple of Literature, it can no longer be termed iconoclastic.
Ulysses is widely taught and, though not exactly airport fiction, still man-
ages to sell more than one hundred thousand copies a year.[8] And while it
continues to inspire detractors (in the August 6, 2012, *Guardian*, Brazilian
author Paulo Coelho snarled that "there is nothing there. Stripped down,
Ulysses is a twit"), it consistently tops or places near the top in polls of the
greatest novels of the twentieth century. So, a century after its publica-
tion, it is no longer necessary to argue for the book's claim to our atten-
tion. Nor can a contemporary reader dismiss it as impenetrable. "Does
nobody understand?" were Joyce's last words, as he lay dying in Zurich
on January 13, 1941. A recent search of the Modern Language Association
Bibliography that yielded 4,671 entries—dissertations, scholarly articles,

and monographs—on Joyce's novel suggests that someone understands, or at least claims to understand.

So, adding to the vast library of *Ulysses* commentary, Kevin Birmingham needs neither to explicate nor exculpate Joyce's once-embattled opus. Instead, he has produced what he calls "the biography of a book,"[9] an account of the genesis, suppression, and ascendancy of the quintessential modernist text. *The Most Dangerous Book: The Battle for James Joyce's Ulysses* tells the fascinating story of how *Ulysses* came to be written, prosecuted, acquitted, published, and read. For Birmingham, a lecturer at Harvard, Joyce's novel is as crucial to legal as it is to literary history. Its trajectory from reviled contraband to essential landmark of modernism illustrates profound changes in Western culture within the span of less than a century.

In 1918, chapters of the novel began appearing in *The Little Review*, a magazine of the international avant-garde based in Greenwich Village. Though its motto was "Making No Compromise with the Public Taste," its dedicated editors, Margaret Anderson and Jane Heap, were forced to compromise when threatened with prison over the "obscene" contents of their journal. Harriet Weaver, editor of *The Egoist* in London, faced similar legal problems. No American or British book publisher dared defy their country's censors by marketing an edition of *Ulysses*. However, despite her lack of any publishing experience, Sylvia Beach, the plucky proprietor of Shakespeare and Company, the legendary English-language bookstore in Paris, decided to bring the book out herself. Employing a printer in Lyon who did not speak English, she eventually placed between two hard covers the most innovative novel in modern English. However, getting it distributed and read was a challenge, since, goaded by the New York Society for the Suppression of Vice, customs and postal employees seized and destroyed copies that made their way to the United States. British authorities were equally zealous in enforcing an embargo against Joyce's allegedly smutty book. It was not until Judge Woolsey's decision on December 7, 1933, more than a decade after the first Paris edition, that Random House, an ambitious upstart that had acquired the rights from Beach, was able to publish *Ulysses* legally. It was not until 1936 that John Lane was able to publish and sell the novel in the United Kingdom.

The American Library Association, which designates the final week of September as "Banned Books Week," has no problem finding titles to fill its annual lists of books under siege. However, these are generally books that have been removed from particular libraries or schools, not the kind of total proscription imposed on *Ulysses* as well as *Lady Chatterley's Lover, The Well of*

Loneliness, Tropic of Cancer, Naked Lunch, Lolita, and other works that have since become staples of literary study. Sexual explicitness and offensive language are, according to the ALA's Office for Intellectual Freedom, the most frequently cited reasons for which books are now challenged, but neither now prevents a book from being published or sold. In 1857, by contrast, Charles Baudelaire was put on trial and forced to pay a fine of 300 francs for the "insult to public decency" that his volume of poetry *Les Fleurs du mal* was judged to be. However, it is hard to imagine any democratic country now imposing an interdiction on a mere volume of poems. It is true that publication in 1988 of Salman Rushdie's *The Satanic Verses* provoked a violent backlash and a ban. It is also true that, under pressure from Hindu activists who took offense at its portrayal of their religion, Penguin India withdrew Wendy Doniger's *The Hindus: An Alternative History* (2009) from sale. Nevertheless, E. L. James has had no trouble publishing and selling (and selling and selling) her raunchy erotic romance *Fifty Shades of Grey* (2011). In no small part because of Joyce and his patrons, publishers, lawyers, and devotees, the nations of North America and Western Europe no longer employ literary censors.

Yet anyone who, like Philip Roth, observes how peripheral literature has become to the common culture might regard the victory for freedom of expression as Pyrrhic. If everything goes, does anything matter? Books continue to be sold and read in large numbers, but they are simply not considered enough of a menace to be censored. However, books did matter to the General Intelligence Division, the precursor to the FBI, whose agents believed that provocative writers posed as much of a threat to the social order as the anarchists, syndicalists, and socialists they rounded up during the "Red Raids" following World War I. Birmingham's book is a case study in splenetic literary reception, and, like such other recent works as Rick Wartzman's *Obscene in the Extreme: The Burning and Banning of John Steinbeck's "The Grapes of Wrath"* (2008) and Peter Finn and Petra Couvée's *The Zhivago Affair: The Kremlin, the CIA, and the Battle over a Forbidden Book* (2014), it offers perverse nostalgia for a recent perilous past when books mattered so much that writing and publishing them risked arrest, when publishing demanded not only capital but courage as well. Like Edward de Grazia's magisterial survey of literary censorship, *Girls Lean Back Everywhere: The Law of Obscenity and the Assault on Genius* (1991), it is written from the vantage point of a time in which no one is sent to prison for profanity or lewdness anymore. "True liberty," wrote Norman Mailer in 1968, "consisted of his right to say shit in the *New Yorker*."[10] A couple of decades later, it became possible to take for

granted the liberty of planting that vulgarism and other notorious four-letter words in the *New Yorker* as well as less fastidious venues.

In typical hyperbole, Ezra Pound, who was instrumental in getting *Ulysses* written and published, proclaimed that with the advent of Joyce's novel: "The Christian era came definitely to an END."[11] Almost a century later, the fact that *Ulysses* is no longer shocking or even baffling signals the end, too, of the Joycean era. Birmingham's quaint tale of prigs and pagans reads almost as a farce whose antiquated premise is that depiction of human sexual experience is criminal. It became comedy of the absurd when Barnet Braverman, a friend of Ernest Hemingway, smuggled *Ulysses* into the United States by crossing the border from Windsor to Detroit carrying one copy day after day after day. Because of an 1895 Supreme Court ruling that "it is unnecessary to spread the obscene matter in all its filthiness upon the record," prosecutors could triumph in court by using mere paraphrase of what offended them.[12] By 1933, government officials were becoming leery of moral vigilantes clamoring for prosecutions, and civil liberties champion Morris Ernst might not have had his landmark case (and the lucrative fee he negotiated with Random House, 5 percent of sales of *Ulysses*) if he had not succeeded in convincing reluctant customs authorities to seize a copy. Arguing before a judge who was a connoisseur of furniture, clocks, pewter, and fine literature, he won his case with an ingenious strategy—though offensive, he contended, Joyce's novel was a masterpiece. Even Sam Coleman, the prosecutor, agreed with that assessment, though he insisted that its brilliance made the book even more dangerous. The only one who went to prison for publishing *Ulysses* was the hapless and larcenous Samuel Roth, a wannabe media mogul who was arrested for selling a pirated and botched edition.

Many of the prim typists hired by Beach in France quit in exasperation over Joyce's impossibly cluttered manuscripts or disgust over their bawdy contents. When the outraged husband of one typist discovered the smut that his wife was working on, he burned part of the "Circe" chapter. French typesetters were befuddled and irritated by the copious alterations that Joyce made to the galleys of his text. In contrast to the consternation of strangers, Nora Barnacle, Joyce's lifelong companion, his muse, and the inspiration for Molly Bloom, took no interest in his great book. Years after its legal publication, Joyce confided to his friend Frank Budgen: "My wife has been complaining because there is no light literature in our flat. She has never read *Ulysses* which, after all, is light, humorous stuff."[13]

For Joyce himself, the battle for *Ulysses* was neither light nor humorous. It was an excruciating ordeal. Moving from Dublin to Trieste to Zurich to

Paris, he was utterly dependent on the kindness of strangers to pay his family's bills. Those bills increased after his daughter Lucia was diagnosed with schizophrenia. Joyce's own debilities both impeded and impelled the writing of his book. He persevered despite the agonies of syphilis-induced iritis that left him on the verge of blindness and madness. "Joyce wrote an epic of the human body partly because it was so challenging for him to get beyond his own," notes Birmingham.[14] In the end, for all the commentary that has grown up around Joyce's once-forbidden novel, the final word on it—in it—is best left to Molly Bloom's exultant, concluding soliloquy: "yes I said yes I will Yes." The naysayers have been defeated; the battle for James Joyce's *Ulysses* has been won.

The publication of *Ulysses* was a cataclysmic event that shifted the tectonic plates of Western culture. Though Joyce's audacious feat is inimitable, it was also the most influential fiction of the twentieth century. Its particular attention to the quotidian, its representation of interiority, and its verbal playfulness defy duplication, at the same time that they altered the possibilities of fiction for such disparate writers as Samuel Beckett, Jorge Luis Borges, Italo Calvino, Alfred Döblin, William Faulkner, Malcolm Lowry, Gabriel García Márquez, Vladimir Nabokov, Flann O'Brien, Georges Perec, Thomas Pynchon, and Yaacov Shabtai. However, in less exalted realms of artistic achievement, the impact of *Ulysses* is most apparent in the linguistic freedom and sexual candor of the entries in any week's bestseller list. One dramatic difference between publishing in 1922 and 2022 will probably be that writers in democracies no longer get hauled into court or sent to prison for what they write. That is not to say that proscriptions on expression no longer exist; a racist outburst by Donald Sterling cost him ownership of the Los Angeles Clippers, and what has come to be called "cancel culture" has ostracized numerous actors, journalists, politicians, and writers for imprudent statements. Stringent social taboos still exist, but they pertain to race, religion, and politics more than obscenity and vulgarity. And they have migrated from the printed word to film, TV, and social media. A sequence of words in a book that might cause a titter among readers could produce a cultural calamity if tweeted on Twitter. The victory of *Ulysses* helped create a culture in which literature lacks urgency. Until January 1, 2012, when Joyce's works entered the public domain, the fiercest recent battles over *Ulysses* were those conducted by copyright lawyers for Stephen James Joyce, the author's grandson. While earlier efforts to ban the novel affirmed the power of the written word, later conflicts over control by the Joyce estate reduced his great novel to a commercial commodity.

Joyce, Camus, and Roth

Joyce for Ordinary Blokes

2009

On June 5, 2009, a first edition of James Joyce's Ulysses was sold in London for £275,000 (around $450,000), the highest price ever paid for a twentieth-century book. According to the dealer, Pom Harrington: "The book is unopened and unread, except for the famous last chapter which contains all the naughty bits." Another copy of *Ulysses*, in the John F. Kennedy Library in Boston, belonged to Ernest Hemingway, who said about Joyce: "I like him very much as a friend and think no one can write better, technically, I learned much from him." Yet, except for its first and final pages, that volume, too, remains uncut. Since its publication (and clandestine distribution, to foil the censors), in 1922, *Ulysses* has been widely admired as the greatest monument of modern fiction. In 1998, when the editorial board of the Modern Library compiled a list of the one hundred best English-language novels of the twentieth century, Joyce's great work ranked no. 1. It was inevitable that *Ulysses*, too, became grist for the current popularizing mill, the fad of finding practical applications in formidable literary classics.

Despite its unique prestige, it is a book more venerated than read. June 16, the day in 1904 on which *Ulysses* is set, is annually celebrated as Bloomsday throughout the world, with little more attention to the text than Fourth of July vacationers pay to the Declaration of Independence. Dense with abstruse allusions, syntactically challenging, and longer than *Moby-Dick* (214,681 words) or *Uncle Tom's Cabin* (180,710 words), *Ulysses* (268,822 words) seems, as Joyce himself jested in its even more forbidding successor, *Finnegans Wake*, "his usylessly unreadable Blue Book of Eccles." Uttered as he lay dying in Zurich on January 13, 1941, Joyce's last words are a challenge to anyone reading the master of literary modernism: "Does nobody understand?"

According to Haines, a visiting Englishman in *Ulysses* who disparages Stephen Dedalus's theory of *Hamlet*, "Shakespeare is the happy hunting

ground of all minds that have lost their balance." The same could be said of Joyce, who told his French translator, Jacques Benoît-Méchin: "I've put in so many enigmas and puzzles that it will keep the professors busy for centuries arguing over what I meant, and that's the only way of ensuring one's immortality." According to the *Modern Language Association International Bibliography*, *Ulysses* has generated 4,671 scholarly studies. By contrast, the MLA lists only 2,694 entries for Marcel Proust's masterwork *In Search of Lost Time*, and only 945 entries for *Mrs. Dalloway*, whose author, Virginia Woolf, dismissed *Ulysses* as "a misfire." In a diary entry for September 6, 1922, she wrote: "The book is diffuse. It is brackish. It is pretentious. It is underbred, not only in the obvious but in the literary sense."

Yet, while the Bloomsbury Cult, whose principal deity is Woolf, flourishes, it lacks the authority of the Church of Joyce, whose sacred text is *Ulysses*. Its hunters—happy or hapless, deconstructionists, feminists, postcolonialists, queer theorists, and others—tend to belong to the species *Homo joyceanus*, which rarely mates with other modernists. My university employs numerous specialists in modern literature, and, though they frequently teach *Dubliners* and *A Portrait of the Artist as a Young Man* and insist on keeping *Ulysses* on the MA required-reading list, none to my knowledge has taught *Ulysses* since the departure of our sole Joycean two decades ago.

In *Ulysses and Us: The Art of Everyday Life in Joyce's Masterpiece*, Declan Kiberd pronounces *Ulysses* "modernism's greatest masterpiece." But though the author is a professor of Anglo-Irish literature at University College Dublin, he aims to rescue the novel from academic captivity. The paradox that Kiberd begins with and, like Odysseus returning to Penelope, comes back to at the end is that "a book which set out to celebrate the common man and woman endured the sad fate of never being read by most of them." He provides insightful commentary on how *Ulysses* recapitulates and transcends *The Odyssey*, the Bible, *The Divine Comedy*, and *Hamlet*, but he is most intent on demonstrating that Joyce's book is positively Whitmanesque, an enduring epic of the people and for the people. *Ulysses*, he proclaims, is "an extended hymn to the dignity of everyday living," best appreciated by those who do that living.

In eighteen chapters, with gerundive titles such as "Waking," "Learning," "Eating," and "Ogling," Kiberd walks his reader through the eighteen episodes of the novel, an account of Stephen Dedalus's and Leopold Bloom's perambulations through 1904 Dublin. He is especially informative about the Irish context of a work that is set in the provincial capital a couple of generations

after the famine and after English supplanted Gaelic as the lingua franca, koine of the realm, in occupied Éire. And he has much to say about how a dialectic of animus and anima is embodied in Leopold Bloom's androgyny. But what distinguishes this study from the bulging midrash on Joyce's canon is Kiberd's central contention that *Ulysses* is the magnum opus of populism. Not only does Joyce lavish attention on the unexceptional activities—breakfasts and bowel movements—of unexceptional characters, but, Kiberd argues, common folk not unlike Leopold and Molly Bloom, Gerty MacDowell, and Ned Lambert, rather than credentialed intellectuals, are the novel's ideal readers. "The book was written to be enjoyed by ordinary men and women," he maintains. Nevertheless, even Nora Barnacle, the former chambermaid whom Joyce cherished precisely because she was not an intellectual, pronounced *Ulysses* "dirty" and asked her husband, "Why can't you write sensible books that people can understand?"

Late in the novel, we are told that Leopold Bloom "had applied to the works of William Shakespeare more than once for the solution of difficult problems in imaginary or real life." Reading *Ulysses* as a "book of wisdom," and contending that its author "insisted on the use-value of art," Kiberd adopts the same approach to Joyce himself. In doing so, he makes common cause with other recent books that attempt to apply literary classics to everyday behavior, from boardroom to bedroom. They include Robert A. Brawer's *Fictions of Business: Insights on Management from Great Literature* and Joseph L. Badaracco Jr.'s *Questions of Character: Illuminating the Heart of Leadership through Literature*. In *How Proust Can Change Your Life*, Alain de Botton interprets the French master's seven volumes as a self-help manual. And several writers attempt to draw practical tips from Shakespeare, prince of the literary pantheon. Among them are John O. Whitney and Tina Packer in *Power Plays: Shakespeare's Lessons in Leadership and Management*, Norman Augustine and Kenneth Adelman in *Shakespeare in Charge: The Bard's Guide to Leading and Succeeding on the Business Stage*, Paul Corrigan in *Shakespeare on Management*, and Jay M. Shafritz in *Shakespeare on Management: Wise Business Counsel from the Bard*.

Though Kiberd neglects to point out that *Ulysses* instructs us in how to cook pork kidneys and fill out racing forms, he does insist that "this is a book with much to teach us about the world—advice on how to cope with grief; how to be frank about death in the age of its denial; how women have their own sexual desires and so also do men; how to walk and think at the same time; how the language of the body is often more eloquent than any words;

how to tell a joke and how not to tell a joke; how to purge sexual relations of all notions of ownership; or how the way a person approaches food can explain who they really are."

Joyce himself claimed otherwise. In 1922 he complained to a fellow novelist, Djuna Barnes: "The pity is the public will demand and find a moral in my book—or worse they may take it in some more serious way, and on the honor of a gentleman, there is not one single serious line in it." Joyce was not entirely serious about that disclaimer, any more than Mark Twain was when he posted his famous warning at the beginning of *Huckleberry Finn*: "Persons attempting to find a motive in this narrative will be prosecuted; persons attempting to find a moral in it will be banished; persons attempting to find a plot in it will be shot." Nevertheless, such persons need to proceed with caution.

Ulysses is indeed a triumph of what Northrop Frye called "the low mimetic mode"; it elevates plebeian characters and banal actions to artistic consideration and, celebrating them, performs what Kiberd, in an aptly Catholic metaphor, calls "the sacrament of everyday life." But his exhortation that "it is time to reconnect *Ulysses* to the everyday lives of real people" is not in itself enough to overcome the paradox that the novel is read not by "real people," but only by students and scholars. Real men may or may not eat quiche, but the "real people" Kiberd seems to have in mind rarely, according to surveys by the National Endowment for the Arts, read any books, and when they do, the authors are more likely to be Stephen King, James Patterson, or Danielle Steel than James Joyce.

Moreover, despite the admirable lucidity of his own style, devoid of preening jargon and turgid syntax, Kiberd's erudite book—though issued by a trade publisher, W. W. Norton, and not a university press—is not likely to be read by the "real people" he sentimentalizes and patronizes. "Modern living," he complains, "has been devalued by gloomy intellectuals who failed to appreciate just how intelligent, cheerful, and resourceful people were in their daily lives." Henry David Thoreau's claim that the mass of men lead lives of quiet desperation might be excessively gloomy, but *nostalgie de la boue*, the impulse to romanticize the commonplace, is the most insidious form of snobbery. It does not in any case explain why the masses of intelligent, cheerful, and resourceful people are not reading *Ulysses*.

No amount of populist pep talk can camouflage the fact that *Ulysses* is a demanding book. "The demand that I make of my reader," Joyce told Max Eastman, "is that he should devote his whole life to reading my works." Few

readers are willing to meet that demand. Though "elite" has become one of the most damaging epithets in the arsenal of political invective, it is best to admit that Joyce's work—caveat for the masses—resists easy access. Membership in the self-selecting community that responds to Joyce's challenge is not a function of class, wealth, or race, but rather of stubborn ardor. Its readers are convinced of a correlation between arduousness of effort and aesthetic pleasure.

Furthermore, the difficulties of reading *Ulysses* are integral to its art; the experience of negotiating and assimilating its unexpected words and sentences is more important than any practical lesson a well-meaning guide might draw from it for us. While packaging Joyce as a universal mentor, Kiberd also sums up what we need to take from Homer's epic: "The wisdom to be gleaned from the *Odyssey* is clear enough: that there is nothing better in life than when a man and woman live in harmony and that such happiness, though felt intensely by the couple themselves, can never be fully described."

But life is short and art is long, and if that's all there is, why not just settle for Kiberd's summary instead of struggling through more than twelve thousand lines of Homer's challenging verse? Disguised as praise, books that offer practical uses for literary classics are in fact acts of iconoclastic arrogance. Proclaiming their fealty to the ordinary, they are driven by impatience with— even contempt for—the actual experience of reading extraordinary works.

Reading Shilts Reading Camus Reading a Plague

1993

> Was not Camus's only fault, apart from being too
> widely read, that he was right too soon?
> —Bertrand Poirot-Delpech

Even before his narrative begins, Albert Camus offers a cue on how to read The
Plague. He positions a statement by Daniel Defoe as the epigraph to the en-
tire work. Any novelist writing about epidemics bears the legacy of *A Journal
of the Plague Year*, the 1722 text in which Defoe recounts the collective story of
one city, in his case London, under the impact of a plague, and uses a narrator
so self-effacing that his only concession to personal identity is the placement
of his initials, H. F., at the end.

Camus's *The Plague* insists that it is the "chronicle"[1] of an "honest witness"[2]
to what occurred in Oran, Algeria, a physician named Bernard Rieux who is
so loath to impose his personality on the story that he conceals his identity
until the final pages. Rieux claims the modest role of "chronicler of the trou-
bled, rebellious hearts of our townspeople under the impact of the plague."[3]

The particular passage appropriated as epigraph to Camus's novel
comes from another book by Defoe, from the preface to the third volume
of *Robinson Crusoe*. And, for the reader of *The Plague*, it immediately raises
questions of representation: "It is as reasonable to represent one kind of im-
prisonment by another, as it is to represent anything that really exists by that
which exists not." Coming even before we meet the first infected rat in Oran,
the Defoe quotation is an invitation to allegory, a tip that the fiction that fol-
lows signifies more than the story of a town in Algeria in a year, "194_," delib-
erately kept indeterminate to encourage extrapolation.

"I had plague already, long before I came to this town and encountered it
here, which is tantamount to saying I'm like everybody else,"[4] says a healthy
Jean Tarrou, by which he suggests that the pestilence that is the focus of the
story is not primarily a medical phenomenon nor is it, like Camus's adversary,

quarantined in one city during most of one year, from April 16 to the following February. "I know positively—yes, Rieux, I can say I know the world inside out, as you may see—that each of us has the plague within him; no one, no one on earth is free from it," declares Tarrou.[5] Camus's novel invites its readers to recognize that they, too, are somehow infected, though the diagnosis seems more metaphysical than physical.

In 1941, a typhus outbreak near Oran resulted in more than seventy-five thousand deaths. However, that epidemic was clearly a source for rather than the subject of Camus's novel. *The Plague* is one of the most critically and commercially successful novels ever published in France. Well before the COVID-19 pandemic caused sales to skyrocket, it had managed to sell more than four million copies throughout the world and to inspire an army of exegetes. For the generation that grew up in the 1950s and 1960s, it was, like *The Catcher in the Rye*, *The Lord of the Flies*, and *Catch-22*, a book that was devoured although (and because) it was not assigned in school. But its appeal has not been as an accurate case study in epidemiology. Particularly in North America, where Oran seems as remote as Oz, readers have accepted Camus's invitation to translate the text into allegory. *The Plague* offered a tonically despairing vision of an absurd cosmos in which human suffering is capricious and unintelligible. The lethal, excruciating disease strikes fictional Oran indiscriminately, and when it does recede it does so temporarily, oblivious to human efforts at prophylaxis. Evoking Camus's philosophical treatise *The Myth of Sisyphus*, the health workers of Oran combat each case without ever being convinced that their labors accomplish anything.

In a famous letter addressed to Roland Barthes in 1955, Camus attempted to narrow down the terms of interpretation. He insisted that his 1947 novel be read not as a study in abstract evil but as a story whose manifest reference is to the situation of France under Nazi occupation: "*The Plague*, which I wanted to be read on a number of levels, nevertheless has as its obvious content the struggle of the European resistance movements against Nazism. The proof of this is that although the specific enemy is nowhere named, everyone in every European country recognized it. Let me add that a long extract from *The Plague* appeared during the Occupation, in a collection of the underground texts, and that this fact alone would justify the transposition I made. In a sense, *The Plague* is more than a chronicle of the Resistance. But certainly it is nothing less."[6]

Long after the liberation of France, readers, particularly those born after World War II, preferred to read *The Plague* as something more than

a chronicle of the Resistance, as the embodiment of a more universal philosophical vision. The novel was, in fact, even more popular in the United States, which did not experience the Nazi occupation, than in France, where Camus's aversion to torture and violence made him politically suspect by both the left and right. The absence of an immediate historical context encouraged younger Americans to read *The Plague* as a philosophical novel. So, too, did our inexperience with plagues. "Oh, happy posterity," wrote Petrarch in the fourteenth century, when more than half the population of his native Florence perished in the bubonic plague, the Black Death, "who will not experience such abysmal woe and will look upon our testimony as a fable."[7]

Before 1980, *The Plague* was facilely read as a fable. Polio had been vanquished, and the smallpox virus survived only in a few laboratories. Aside from periodic visitations of influenza, usually more of a nuisance than a killer, epidemics, before the outbreak of cholera in Peru in 1991 and later scourges of Ebola, West Nile, and Zika, had been as common in this hemisphere as flocks of auks. Those of us who first read *The Plague* during the era of the Salk and Sabin vaccines were hard put to imagine a world not yet domesticated by biotechnology, in which a mere bacillus could terrorize an entire city. We read *The Plague* not as the story of a plague, an atavistic nemesis that seemed unlikely to menace our own modern metropolises. The story was a pretext, an occasion for ethical speculation, in short an allegory without coordinates in space and time.

However, though published long before the first case of AIDS was diagnosed and thirty-five years before the acronym (for Acquired Immune Deficiency Syndrome) was even coined, *The Plague* assumed a new urgency when it became apparent that epidemics were not obsolete occurrences or quaint events confined to distant regions. In 2020, the global ravages of a novel coronavirus gave the novel renewed relevance, made it seem to Elisabeth Philippe, writing in the March 26, 2020, edition of *L'OBS*, "la Bible de ces temps tourmentés" (the Bible of these troubled times). But, four decades earlier, a 1981 article in the *New England Journal of Medicine* reported seven inexplicable cases of severe infection. Within ten years, AIDS was a global pandemic. Thirty-five years after its first diagnosis, infection with HIV (Human Immunodeficiency Virus) would be responsible for approximately thirty-nine million deaths worldwide. At first, AIDS seemed to target homosexual men, Haitians, and intravenous drug users, but, like Camus's plague, it was soon striking indiscriminately, without any regard to the social status of its hundreds of thousands of helpless, hapless victims. As in *The Plague*,

an anxious populace responded in a variety of ways but without any cure. It is no longer possible to read *The Plague* with the innocence of the existential aesthete.

Published in 1987, *And the Band Played On: Politics, People, and the AIDS Epidemic* is a detailed account of the onset and spread of AIDS and of the spectrum of reactions to it. What, to a student of Camus, is remarkable about Randy Shilts's book—which, selected for the Book of the Month Club, was a bestseller in both hardcover and paperback—is how much it has in common with *The Plague*. Not only does Shilts document the same pattern of initial denial followed by acknowledgment, recrimination, terror, and occasional stoical heroism that Rieux recounts during the Oran ordeal, but it is clear that Shilts had read Camus and had adopted much of the style and structure of *The Plague* to tell his story of an actual plague. Where Camus appropriates Defoe for the epigraph of his novel, Shilts mines Camus's *The Plague* for epigraphs to four of his nine sections: parts IV, V, VI, and VII. In part II, describing baffling new developments among homosexual patients, Shilts echoes Camus's absurdist myth of Sisyphus when he states: "The fight against venereal diseases was proving a Sisyphean task."[8] That same Greek myth, for which Camus is the modern bard, is alluded to two other times by Shilts—flippantly, in reference to AIDS victim Gary Walsh's "Sisyphean task"[9] of renovating his Castro District apartment and, more portentously, in reference to the "Sisyphean struggle"[10] against AIDS directed by Donald Francis, a leading retrovirologist at the Centers for Disease Control.

Camus's existential vision of a random universe in which adversity, though gratuitous and impossible to defeat, must nevertheless be opposed provides the subtext to Shilts's book, which, translated into six languages and even adapted to an NBC miniseries, remains the most influential text on AIDS. "I had written a book to change the world," explained Shilts in a 1988 *Esquire* memoir,[11] and he did. By alerting and prodding professionals and the general public to respond to the crisis, *And the Band Played On* can be credited with saving lives and altering attitudes and behavior. It is a work of committed nonfiction, though it is phrased and organized—with prologue, epilogue, epigraphs, and a roster of "dramatis personae"—novelistically, echoing Camus's novel in particular.

Early in *The Plague*, its still anonymous narrator attempts to establish his credibility by assuming the humble role of historian. He insists on his distaste for rhetorical flamboyance and literary contrivance, assuring the reader that "his business is only to say: 'This is what happened,' when it actually did

happen, that it closely affected the life of the whole populace, and that there are thousands of eyewitnesses who can appraise in their hearts the truth of what he writes."[12] Rather than his own eccentric fabrication, what follows, he assures us, is an impartial account adhering scrupulously to reliable sources. "The present narrator," says the present narrator, in an attempt at objective attachment from himself, "has three kinds of data: first, what he saw himself; secondly, the accounts of other eyewitnesses (thanks to the part he played, he was enabled to learn their personal impressions from all those figuring in this chronicle); and, lastly, documents that subsequently came into his hands."[13]

Like Camus's Rieux, Shilts also suppresses the first-person pronoun, camouflaging his own presence as both narrator and agent. While Rieux insists on the word "chronicle" to characterize a narrative that pretends solely to record verifiable facts as they unfold in time, Shilts acquired most of his information while reporting for a San Francisco newspaper that happens to call itself the *Chronicle*. A streetwalker and heroin addict named Silvana Strangis forms part of his story, and when he tells the reader that "a *Chronicle* reporter, tipped off by an emergency room attendant, knocked on Silvana's door,"[14] that reporter is presumably Shilts himself. When an unnamed San Francisco reporter goads epidemiologist James Curran into a statement about the dangers of gay bathhouses and then publishes his remarks, Bay Area gay leaders are irate. "The reporter, they agreed, suffered from internalized homophobia," states Shilts impassively, though it is apparent that that reporter is Shilts himself, both the chronicler and the chronicled—also, implicitly, maligned.

"This book is a work of journalism," declares Shilts in a documentational appendix. "There has been no fictionalization."[15] Like Rieux, he is anxious to deny invention, to demonstrate that everything in his chronicle is a transcription of his own observations, copious interviews with others, and public documents. Like Rieux, who incorporates the journal of Jean Tarrou for access to events the narrator did not directly experience, Shilts relies on the diary of graphic designer Matthew Krieger for insights into the illness of his lover Gary Walsh.

Early in *The Plague*, before the epidemic forces the authorities to seal Oran off from the outside world, Rieux sends his ailing wife to a sanatorium beyond the city. At the end of Camus's novel, just as the quarantine is being lifted from his ravaged city, Rieux learns that his wife has died in exile. As chronicler, the widowed doctor claims to be a faithful representative of his fellow citizens, but his preoccupation with the plight of lovers separated by the plague is surely a product of his own poignant and singular situation.

Similarly, though Shilts suppresses his personal identity and affects the impartial voice of History, his book is clearly the product of a particular sensibility. From its title to its final pages, *And the Band Played On* is an impassioned indictment of the indifference, vanity, and naivete that facilitated the catastrophe. Shilts quotes with scorn the characterization of AIDS as the "the gay plague,"[16] but his account of the disease makes it seem just that, as though the virus is as in love with homophilic men as they are with others of their orientation. Shilts acknowledges and emphasizes that the disease also strikes others, but the plight of gays receives the elephant's share of his attention and compassion.

Some critics have faulted the book for its slighting of other sorts of victims. Diane Johnson and John F. Murray, for example, noted in the *New York Review of Books* that "most of his examples are taken from homosexuals, encouraging the impression that AIDS is mainly a homosexual disease."[17] AIDS did in fact affect gays disproportionately, especially in the early years that Shilts chronicles. But behind the mask of Olympian omniscience is an author who has come out of the closet, and, though he reports on the hardships of the Haitians, blood recipients, and intravenous drug users, it is understandable that he empathizes with the gay victims whose lives he vividly dramatizes. A clinically detached chronicler might not write with such rage about the internecine squabbles within the largely gay Castro District that delayed effective action against their microbial enemy. "At the beginning of the pestilence and when it ends, there is always a propensity for rhetoric,"[18] says Tarrou to Rieux, who, writing after the pestilence, eschews the rhetoric and aspires to a zero degree of writing. Shilts is less scrupulous about restraining his language, and, amid the mass of statistics, writes in a style that one reviewer ridiculed as "overheated Sidney Sheldonesque prose."[19] Despite the pose of third-person chronicler, Shilts narrates with fervent urgency, from within a community in peril.

In the drab and dreadful universe that Camus depicts, the possibilities of heroism are severely constricted. Yet, recognizing that readers crave heroes, Rieux nominates the perversely named Joseph Grand, a low-level municipal clerk who does his job and dreams of writing perfect sentences: "Yes, if it is a fact that people like to have examples given to them, men of the type they call heroic, and if it is absolutely necessary that this narrative should include the 'hero,' the narrator commends to his readers, with to his thinking, perfect justice, this insignificant and obscure hero who had to his credit only a little goodness of heart and a seemingly absurd ideal."[20] Shilts likewise chooses

his heroes from among the meek: the health professionals who, often defying directives from more eminent leaders, persisted in their struggle against the new disease, and those victims of AIDS who managed to die with grace. While his book is often scornful of celebrities such as Robert Gallo or Margaret Heckler, it is the unsung sufferers who agreed to be interviewed whom Shilts salutes in the final sentences of his acknowledgments: "When I'd ask why they'd take the time for this, most hoped that something they said would save someone else from suffering. If there is an act that better defines heroism, I have not seen it."[21]

What Shilts has seen is the way crisis magnifies the grandeur of ordinary people. Recounting the arduous dedication of volunteers to the Gay Men's Health Crisis, Shilts quotes author Larry Kramer: "There are no heroes in the AIDS epidemics." But he concludes the paragraph with a rejoinder from Paul Popham, president of the GMHC: "There were heroes in the AIDS epidemic, he thought, lots of them."[22] Like Camus, Shilts admires the health workers who persist in their task without either pomp or victory. He is particularly impressed with Selma Oritz, the assistant director of the Bureau of Communicable Disease Control at the San Francisco Department of Public Health. He so admires her stubborn refusal to ignore anything marginal to her mission of saving lives that he twice precedes her name with the adjective "no-nonsense,"[23] an epithet that might apply as well to Camus's Rieux.

Within *The Plague*, a sharp contrast to the selfless dedication of characters such as Rieux and Grand is represented by Cottard, an opportunist who revels in others' misery because the quarantine enables him to profit from black-market contraband. Shilts's version of the egotist is Gaetan Dugas, the Canadian airline steward referred to as Patient Zero, for being a primary source of contagion in North America. Aware that he has contracted AIDS, Dugas refuses to curtail his hedonistic promiscuity, even allegedly gloating to some of his 2,500 sexual partners: "I've got gay cancer. I'm going to die and so are you."[24]

"There was venality, and there was also courage,"[25] declares Shilts, who writes with righteous wrath about the bathhouse managers who placed profits before lives and scientists who pursued careers rather than truth. Despite its guise as impartial chronicle, *And the Band Played On* is an exercise in moral indignation. Yet its narrator is as wary of moralism as is Rieux, who keeps his distance from Paneloux, the Jesuit priest who preaches two crucial sermons strategically and symmetrically positioned—in parts II and IV of Camus's five-part novel. In the first, Paneloux rails against the sinners of

Oran, portraying the plague as a scourge from God, an instrument of retribution for the depravity of the entire community. By the time of his second sermon, Paneloux's theodicy has been shaken by the experience of watching a blameless child die in agony, and he preaches that the plague is as unfathomable as the deity we must love without understanding. Shilts also depicts high-minded homilists who pretend to see a moral pattern to the plague of AIDS. "When you violate moral, health, and hygiene laws, you reap the whirlwind," proclaims the Reverend Jerry Falwell. "You cannot shake your fist in God's face and get away with it."[26] Elsewhere, invoking a Darwinian, rather than an Augustinian, moral code, Patrick Buchanan declares: "The poor homosexuals—they have declared war upon nature, and now nature is exacting an awful retribution."[27] Unlike Camus's Paneloux, neither Falwell nor Buchanan alters his attitudes within Shilts's book, and, though Shilts is highly critical of behavior that spreads the epidemic, *And the Band Played On* is the closest to the nonjudgmental stance toward suffering that Rieux expresses in response to Paneloux: "No, Father. I've a very different idea of love. And until my dying day I shall refuse to love a scheme of things in which children are put to torture."[28]

Though it purports to replicate verbatim extended stretches of dialogue and to represent the thoughts of its characters, *And the Band Played On* is of course not a novel. Camus invented Rieux, Tarrou, Grand, Paneloux, and Cottard, but Harry Britt, Selma Oritz, Michael Gottlieb, Cleve Jones, Bill Kraus, and Gary Walsh existed independently of Shilts's book. While Camus is virtually neoclassical in his decision to intensify his five-act drama by confining it to one cloistered city, Oran, within less than one revolution of the earth, Shilts's story is global and ranges among San Francisco, Kinshasa, New York, Paris, Atlanta, Vancouver, Copenhagen, Washington, London, and other locales for most of a decade. Rieux tells his tale in retrospect, after the plague has dissipated and the gates of Oran have swung open again, while Shilts writes in medias res, in the muddled midst of a deadly pandemic that would surely expand before it receded.

But both Camus and Shilts personify their plagues, depicting them as animate enemies aroused from sleep. Shilts explains that by the end of 1980, "slowly and almost imperceptibly, the killer was awakening."[29] In the final line of his chronicle, Camus's Rieux reminds us that any victory over the plague is only provisional: "that the plague bacillus never dies or disappears for good; that it can lie dormant for years and years in furniture and linen-chests; that it bides its time in bedrooms, cellars, trunks, and bookshelves; and that perhaps

the day would come when, for the bane and the enlightening of men, it would rouse up its rats again and send them forth to die in a happy city."[30]

Shilts's view of human arrogance toward natural adversity seems shaped not only by his research into the often cavalier or inept responses to AIDS but also by his reading of *The Plague*. His account of pneumocystic pneumonia, a disease that frequently results from a failure of immune systems, sounds remarkably like the final sentence of the Camus novel. Like Rieux, Shilts provides admonition against overconfidence, since the disease will never be definitely defeated: "*Pneumocystis* flared sporadically, eager to take advantage of any opportunity to thrive in its preferred ecological niche, the lung. The disease, however, would disappear simultaneously once the immune system was restored. And the little creature would return to an obscure place in medical books where it was recorded as one of the thousands of malevolent microorganisms that always lurk on the fringe of human existence, lying dormant until infrequent opportunity allows it to burst forth and follow the biological dictate to grow and multiply."[31]

The day would come, Rieux reminds us, when, *for the bane and the enlightening of men*, the plague, merely dormant, never dead, would strike again. It strikes again when Rieux relives the collective ordeal of Oran by writing about it. But just what sort of enlightenment is brought by that account or by the plague itself remains elusive. "A pestilence isn't a thing made to man's measure; therefore we tell ourselves that pestilence is a mere bogey of the mind, a bad dream that will pass away," admits Rieux, in a passage that Shilts chooses as epigraph to part V of his book. "But it doesn't always pass away, and from one bad dream to another, it is men who pass away."[32] Protagoras's confidence that "man is the measure of all things" posits a universe that is intelligible to and governable by human beings. Both Camus's plague and Shilts's AIDS arrive as a challenge to the humanist's presumption; they are inscrutable and invincible.

"The evil that is in the world always comes of ignorance, and good intentions may do as much harm as malevolence, if they lack understanding," Camus explains, in a passage from *The Plague* that Shilts appropriates as the epigraph to part VI: "On the whole, men are more good than bad; that, however, isn't the real point, but they are more or less ignorant, and it is this that we call vice or virtue; the most incorrigible vice being that of an ignorance that fancies it knows everything and therefore claims the right to kill. The soul of the murderer is blind; and there can be no true goodness nor true love without the utmost clear-sightedness."[33] Shilts, like Camus, presents himself

as a clear-sighted writer in a world where most prefer to close their eyes. He reveals how denial and temporizing by scientists, physicians, politicians, and victims squandered many lives: "One had the feeling that many concessions had been made to a desire not to alarm the public," observes Rieux about official policy toward the plague, and the description is so applicable to initial reaction toward AIDS as well that Shilts employs it as the epigraph to part IV.[34]

As a reporter, Shilts is especially critical of the failure of writers to dispel the widespread ignorance about the growing crisis. It is not just a partisan pride in the anomalous coverage provided by his own paper, the *San Francisco Chronicle*, that prompts Shilts to note that "in New York City, where half the nation's cases resided, the *New York Times* had written only three stories about the epidemic in 1981 and three more stories in all of 1982. None made the front page. Indeed, one could have liked to live in New York, or in most of the United States for that matter, and not even have been aware from the daily newspapers that an epidemic was happening, even while the government doctors themselves were predicting that the scourge would wipe out the lives of tens of thousands."[35]

In 630 pages densely packed with statistics and suffering, Shilts documents the evil that came from ignorance. *And the Band Played On* is offered to open our eyes or, to shift the metaphor, to stop the band so we might hear the sounds of torment. Camus leaves us with his plague in temporary remission, but in Shilts's final pages, AIDS is merely gaining momentum. Neither disease is near a cure. Yet both epidemics and both books leave us enlightened: about the limits of human understanding but the need to act on what we know. William Styron spoke for many American admirers when he praised Camus for his tonic recognition of a bleak cosmos: "Camus was a great cleanser of my intellect, ridding me of countless sluggish ideas and, through some of the most unsettling pessimism I have ever encountered, causing me to be aroused anew by life's enigmatic promise."[36] Stronger on enigma than promise, Shilts has nevertheless created a book designed to arouse.

Four Score and Philip Roth

2013

Growing old is easy. It's staying old that is a mortal challenge.

For those who began reading Philip Roth as he began writing, with pawky provocations such as *Goodbye, Columbus* (1959), *Portnoy's Complaint* (1969), and *The Breast* (1972), he remains the eternal enfant terrible of American letters. Yet Roth turned eighty on March 19, 2013. And Roth himself, as his friend Edna O'Brien stated publicly, "recently believed that the number eighty was a house number." A full house at the Newark Museum marked the occasion in a style that recalled the banquet years in Paris, when the French used to feed their living lions with elaborate meals and extravagant praise. For two days, scholars, friends, and other curious people descended upon the author's blighted native city to examine his legacy and wax Roth. When William Butler Yeats died, W. H. Auden observed that: "The words of a dead man / Are modified in the guts of the living." But Roth was still very much alive, and chewing over his written corpus might have seemed like gorging on a carcass that is not yet a cadaver.

Literary scholars have a habit of clustering in single-author societies, focusing their attentions on such canonical figures as Emily Dickinson, Henry James, Herman Melville, John Milton, and Edmund Spenser. There is even a Constance Fenimore Woolson Society, dedicated to the study of a nineteenth-century American novelist best known as a friend of James. Is the e. e. cummings Society chronically undercapitalized? Are those who join the Robert Frost Society rather than, say, the William Faulkner Society or the Cormac McCarthy Society haunted forever by the road not taken? Yes, there is a Philip Roth Society, founded in 2002, that publishes both a newsletter and the academic journal *Philip Roth Studies*. On March 18, Erev-Roth Day, it convened a daylong conference, Roth@80, at the Robert Treat Hotel, a ninety-six-year-old landmark named for Newark's founder; Roth specialists

would certainly recall fictional Robert Treat College, which Marcus Messner attends in *Indignation* (2008). Scholars from more than a dozen countries, some as far away as New Zealand, India, and Russia, delivered papers on the work and life of the birthday *bokher*. Topics covered included sex, humor, transgression, Jewishness, and death, as well as Roth's affinities with Saul Bellow, J. M. Coetzee, Franz Kafka, Grace Paley, Henry Roth, and William Shakespeare.

That this scholarly organization is not necessarily an adoration society was apparent in several presentations that emphasized Roth's obsession with controlling every detail of his reputation, from cover to dustjacket, from advertising to translation. He has gone through editors and publishers the way Bellow went through wives. A member of the John Updike Society noted that organizing *its* conference a few years earlier was much simpler, because its author was already dead. Not only did Roth insert himself into planning his birthday tribute, but he has exerted ventriloquial control over the biographical record. In 2004, denying anyone else encouragement and access, he anointed Ross Miller, a professor at the University of Connecticut, to be his authorized biographer. However, Roth later replaced Miller with Blake Bailey, the biographer of Richard Yates and John Cheever. Bailey was present for the birthday in Newark, but so were other would-be biographers who regard Roth's blessing as both an advantage and a handicap. Ira Nadel, a professor at the University of British Columbia who has published biographies of Leonard Cohen and David Mamet, insisted that the cunning creator of treacherous characters including Nathan Zuckerman, David Kepesh, and "Philip Roth" is deliberately setting traps and false trails for those who would write about him. Nadel intends to steer his own way through Roth's elusive life.

As befitted the setting of the conference and much of Roth's fiction, the largest city in New Jersey formed the subject of several presentations. Mark Shechner, a professor at the University of Buffalo who was born in Newark seven years after Roth, described their antebellum neighborhood, Weequahic, as a shtetl and recalled how the gangsters were Jewish and Yiddish was the lingua franca. Michael Kimmage, who teaches history at Catholic University, emphasized how Roth is repeatedly writing about a vanished urban space—his Atlantis, his Troy, his Jerusalem, a coherent Jewish community that, after Newark became the poster child for urban decay, exists solely in nostalgic retrospect.

That realization did not prevent the Roth scholars from piling into

three buses in order to tour "Roth's Newark." Conceived and operated by the Newark Preservation and Landmark Committee, the three-hour outing stopped at Stations of the Roth Cross—including his boyhood home at 81 Summit Avenue, the Newark Public Library (where Neil Klugman has a job in *Goodbye, Columbus*), and Weequahic High School (where, in *American Pastoral* [1997], Seymour "the Swede" Levov excels in three sports). At each stop, an appropriate passage was read aloud from one of the books. *Portnoy's Complaint* provided the chant recited in front of Weequahic High: "Ikey, Mikey, Jake and Sam, / We're the boys who eat no ham, / We play football, we play soccer— / And we keep matzohs in our locker! / Aye, aye, aye, Weequahic High!" The camera-toting scholars—mostly white and Jewish— and current students of Weequahic High—African American—gazed at each other in mutual fascination. The curtains were drawn at Roth's childhood home, a modest two-family building, but the current residents must be accustomed to the gaze of strangers, since it is visited occasionally by a Philip Roth tour, and a commemorative plaque has been affixed to the front. A nearby intersection has been renamed "Philip Roth Plaza." It is not clear whether the police escort, lights flashing, that accompanied the visitors throughout their tour was a function of Newark's crime rate or the esteem accorded literary scholars.

Among the 250 guests who gathered in the Billy Johnson Auditorium of the Newark Museum to honor the new octogenarian were some figures more famous than mere professors. Roth grew up rooting for the Brooklyn Dodgers and has Alexander Portnoy proclaim: "Oh, to be a center fielder, a center fielder—and nothing more!" So a baseball simile might score a run: the evening felt almost as if Hank Aaron, Mickey Mantle, Willie Mays, and Duke Snider all showed up to toast Ted Williams. Seated in the audience were Paul Auster, Don DeLillo, Siri Hustvedt, and David Remnick. On stage, Jonathan Lethem paid tribute to Roth's "torrential" voice. "The books are Jewish," he claimed, "because they won't shut up." Crediting a reading of *The Breast* with jump-starting his own writing career, Lethem claimed that Roth "closed the distance between Bellow and *Mad* Magazine." In clear Oxfordian cadences, Hermione Lee, a biographer of Virginia Woolf and Edith Wharton, stressed Shakespeare's presence in Roth's work. "There is something Shakespearean about the way he uses him," she added. Claudia Roth Pierpont, a staff writer for the *New Yorker*, noted the presence of music in Roth's fiction as well as the musicality of his prose but also, countering the canard that Roth is a misogynist, spoke affectionately about female characters of his who have seized hold

of her imagination. She reported how once, after complaining to Roth that one was just too perfect, he replied: "You should hear what she says about you."

Focusing on Roth's final novel, *Nemesis* (2010), French philosopher Alain Finkielkraut described the author as a diagnostician of "the pathology of explanation." His characters come undone when they refuse to accept life's contingency and insist on finding logic where there is none. According to Finkielkraut, Bucky Cantor, the protagonist of *Nemesis*, "is a martyr of the why." On a more personal note and with an Irish lilt, parrying persistent gossip that she and Roth were lovers, Edna O'Brien shared anecdotes from their enduring friendship. She offered no revelations about Roth's two disastrous marriages or any other liaisons. O'Brien insisted that, as a writer, he is "like a trapeze artist," and she praised his ebullience, precision, and gravity—his "artist's dissection of the hemorrhaging of faith and hope."

Then came forth Philip Roth, looking remarkably hale for eighty and all the rumors about ailments of the heart, the prostate, and the mind. Sitting at a table, his only concession to age and a bad back, he spoke deliberately and engagingly in the companionable voice that has drawn readers into thirty-one books and earned him enough literary prizes to shame the jurors in Stockholm. He praised Newark for shaping him and the realistic novel for its "passion for specificity," its "ruthless intimacy." Reaffirming his decision to retire from fiction, Roth teased the audience with a catalog of subjects he would no longer be turning words to get right. Then he proceeded to read seven pages from *Sabbath's Theater* (1995), the book he called his favorite. The passage, an aging Mickey Sabbath's thoughts while visiting the graves of his mother and father, is in itself a moving meditation on memory, love, and loss. The occasion made it much more poignant. Roth reminded us that the epigraph he had chosen for the novel, from *The Tempest*, is: "Every third thought shall be my grave." Everyone in the audience, even those whose suspicion and cynicism had been finely tuned by the work of that most devious of novelists, knew that they had been present for an extraordinary moment in American literary history. His revels now ended, the Prospero of Weequahic exited the stage.

In *Exit Ghost* (2007), the caretaker of Nathan Zuckerman's Berkshire home and his wife prepare a private dinner for the reclusive author to celebrate his seventieth birthday. When they ask Zuckerman what it is like to turn seventy, he replies: "Think seriously about 4000. Imagine it. In all its dimensions, in all its aspects. The year 4000. Take your time.... That's what it's

like to be seventy." On March 19, 2013, none of the 250 guests at the Newark Museum asked Roth publicly what it's like to be eighty. But he might have replied: 5773—the current year in the Hebrew calendar. He has repeatedly insisted that there is no future to serious novels. At least for the passionate readers gathered at the Newark Museum, it will be hard to imagine a literary season without a new book by Roth, and harder still to imagine the extinction of literary fiction. However, as his 1960 essay "Writing American Fiction" complained: "The American writer in the middle of the twentieth century has his hands full in trying to understand, and then describe, and then make credible much of the American reality. It stupefies, it sickens, it infuriates, and finally it is even a kind of embarrassment to one's meager imagination. The actuality is continually outdoing our talents." The second decade of the twenty-first century is no less exasperating, especially after one major American writer has relinquished the struggle.

Louise Erdrich has not yet given up on literary fiction, and, after Roth was escorted into the museum atrium by the Weequahic marching band, she delivered a benediction in Ojibwe. There was no *bracha*, but along with champagne and other pastries, hamantasch—unseasonal salute to the Jewish author's roots—was served. Then the cake was cut—a monstrous confection in the shape of books whose icing spelled out titles from the birthday boy's oeuvre. Philip Roth was gracious toward his well-wishers, but it was hard to read his smile as he slipped back out of Newark, retreating from the scene to let them eat cake.

Whither Reading

Arms and the Curriculum

2007

In the end, Fortinbras, who leads his foreign army into Elsinore in time to take control of Denmark, honors Hamlet with a soldier's burial. Yet, more scholar than soldier, the melancholy Dane brought military disaster to his kingdom. Reluctant to leave the University of Wittenberg for the frivolous royal court, Hamlet was more adept at metaphysics than national defense. The man who diagnosed himself as "sicklied o'er with the pale cast of thought" was no match for Fortinbras (Strong in Arms), the young Norwegian leader whose decisive actions were not impeded by reflection.

Reflecting on Hamlet's tragic failure, Ralph Peters, a retired lieutenant colonel in the US Army, warns that higher education handicaps a military officer. In an article in the July–August 2007 issue of the *American Interest* pointedly titled "Learning to Lose," Peters suggests that graduate schools pose a threat to national security. More than a little learning is a dangerous thing for those who put themselves in harm's way, according to Peters, who views the prince of Denmark as an object lesson in otiose intellectuality.

"The archetypal academic, theory-poisoned and indecisive, Hamlet should have stayed at the university in Wittenberg," he argues, "where his ability to prattle without resolution surely would have gained him early tenure." Warning that a PhD "is deadly," Peters concludes that "too much formal education clouds a senior officer's judgment, inhibits his instincts, and slows his decision making."

Peters wraps the ancient animus against mere book larnin' in modern battle ribbons. However, Gen. David H. Petraeus, commander of the US forces in Iraq, disagrees. In "Beyond the Cloister," a contrapuntal essay published in the same issue of the *American Interest*, he contends that "the most powerful tool any soldier carries is not his weapon but his mind." By stimulating and challenging that mind, advanced study, claims Petraeus, lifts military officers

"out of their intellectual comfort zones" and provides experiences "critical to the development of the flexible, adaptive, creative thinkers who are so important to operations in places like Iraq and Afghanistan." Petraeus does not insist that all scholars be soldiers, but he does suggest that if all soldiers (men and women) were scholars they would possess the sagacity and resiliency necessary for success.

If an army's sole objective is to deploy human engines of destruction, then the study of philosophy, history, literature, and the other liberal arts is at best a distraction, the effete pastime of a privileged elite. At worst, it is subversion. "I never expect a soldier to think, sir," scoffs an American rebel on trial for treason in George Bernard Shaw's *The Devil's Disciple*. Yet in medieval Japan, the culture of the warrior treasured cultured warriors—samurai skilled not only with swords and horses but also with poetry, calligraphy, and painting. After conquering Sindh for the British Empire, the erudite Charles Napier is said to have drawn on his command of Latin in a famously terse communication: "Peccavi" (I have sinned). However, if war is an assault against the very basis of civilization, then "cultured warrior" is, more than "military intelligence," an oxymoron. If war is hell, then the demons who prosecute it are repudiating the values of higher education. Even if war is a necessary evil, should not warriors get their job done as efficiently as possible? Who wants an oral surgeon pondering Kierkegaard while performing a root canal?

I teach at a public university in a city, San Antonio, that is home to several military bases. Active military, retired military, military reserve, National Guard, and dependents of all those abound, while the local economy battens on the defense budget. But I teach literature, a subject that, even in its bleakest moments, in the writings of Franz Kafka, Samuel Beckett, or Paul Celan, fixes its canon against mass slaughter. Though I do not teach to indoctrinate, it seems to me that intimate acquaintance with *The Iliad*, *The Aeneid*, *Troilus and Cressida*, *War and Peace*, *The Red Badge of Courage*, *All Quiet on the Western Front*, *Catch-22*, or *Slaughterhouse Five* inoculates a reader against infection by what Wilfred Owen—the poet who announced his subject as "War, and the pity of War" but died, in 1918, leading troops in combat—called the "Old Lie: Dulce et decorum est / pro patria mori." Much world literature exists to reconcile us to the fact that death is neither sweet nor proper nor avoidable. It is true that nationalistic epics such as *The Song of Roland* and *The Poem of the Cid* celebrate military prowess, but even those are weighted with a woeful awareness of loss. In fact, it is hard to think of any literary text

apart from the most simplistic jingoist effusion that does not in some way caution against the insolence of trifling with life.

My university offers army and air force ROTC programs, and I can tell when their students enroll in my courses, even if they do not come to class in uniform. Prompt with assignments and perfect in attendance, they are the only ones who call me "sir." Though they are usually avid learners, I sometimes wonder whether analyzing Petrarchan sonnets or parsing a novel's point of view is the most constructive use of their time and talent in the months before deployment to Afghanistan or Iraq. For their immediate futures, knowing how to handle an M203 grenade launcher is more crucial than knowing how to read Proust. However, since the imminence of bloodshed concentrates the mind, perhaps the minds of officers in training should be focused on the fundamental questions that are the province of philosophy and literature: What is the value of a life? What is truth? What is justice? What are our obligations to others and ourselves? Socrates famously insisted that the unexamined life is not worth living. Neither is it worth risking—if for no other reason than that we determine worth by examination.

The challenge of educating an American soldier assumed greater urgency after September 11, 2001. But it is really a more dramatic version of the persistent, perplexing question of what should constitute the core curriculum for any college student. What purpose is served by requiring future engineers, accountants, restaurateurs, and anesthesiologists—as well as soldiers—to study David Hume, *Mrs. Dalloway*, *The Divine Comedy*, and the Congress of Vienna?

Elizabeth D. Samet confronts such questions a bit differently than other professors of English. Every student who sits in one of her classes is preparing for a military commission. In *Soldier's Heart: Reading Literature through Peace and War at West Point*, Samet recounts her experiences during an eventful decade on the faculty of the US Military Academy. And she offers precious reflections on the place of the liberal arts in a soldier's education.

Because West Point cadets are required to take at least three engineering courses, all graduates receive a BS. However, the academy offers a choice of forty-three majors, including English. Founded in 1802, the academy has had a department of English, by act of Congress, since 1926. Samet, who received her doctorate from Yale and her BA from Harvard, is part of the 20 percent of faculty in all departments who are civilian PhDs. She answers to a department head who is an active-duty colonel, but her fascinating book is an attempt to answer a question posed by a groundskeeper soon after her arrival at

West Point: "Miss, what's your function?" What purpose is served by teaching literature to men and women preparing to serve in the wartime military?

Inspired in part by Ulysses S. Grant's eloquent *Personal Memoirs* and her own father's service in the Army Air Corps during World War II, Samet applied right out of graduate school for the job at West Point. She later published a poem, "Grant in Mexico," that imagines the Union general's conflicted thoughts during his earlier service in the Mexican War. Her first book, *Willing Obedience: Citizens, Soldiers, and the Progress of Consent in America, 1776–1898*, examines how the United States, a society founded on individual liberty, accommodated a military culture based on submission to command.

However, Samet, who moved to an apartment in New York City when living within West Point itself became too stifling, appears at first to be a poor fit for the military academy, an odd duck at a club for alpha males. A graduate of the all-girls' Winsor School, she recognizes that the academy, where only 15 to 17 percent of cadets are women, is a masculine, often misogynistic, world. And she harbors "deep sorrow and anger" over the current uses to which her cadets are put. She explains: "I remain unconvinced by any of the stated reasons given for the invasion of Iraq and dismayed by its civilian architects' apparently cavalier lack of foresight." She characterizes the abuses at Guantánamo and Abu Ghraib as "a crushing betrayal to military professionals."

Yet Samet does not use her position to proselytize for withdrawal, and she certainly does not pressure her students of war to chant, "I ain't gonna study war no more." Conscientious objection would be the logical extension of her beliefs about the conduct of this war, though some might call it treason. Samet includes Herman Melville's "Bartleby the Scrivener" and Jean Renoir's *Grand Illusion* ("the most powerful cinematic study of war") on her syllabi, but she does not follow Bartleby's rejectionist "I prefer not to" and refuse to collaborate with the military-educational complex. She provides private counsel to cadets conflicted about their responsibilities but does not consider tossing a monkey wrench into the war machine that she is, albeit indirectly, serving. She does not even consider opting out by jumping to an academic institution whose mission is not to create warriors.

Samet is smitten with the romance of West Point, its customs, traditions, and codes. After the alienation of graduate work at Yale, a temple of deconstruction, she was ready to join others in an honorable enterprise and relished the camaraderie of an illustrious national institution that values loyalty and dedication. "Having been coached by professionals to cultivate

ironic detachment," she explains, "I allowed myself to be seduced by esprit de corps—by the worth of community and commitment, and by the prospect of surrendering myself to a shared mission." Her students, selected from every state of the union as well as twenty foreign countries, are not the homicidal automatons a pacifist might imagine, and her colleagues impress her—and her reader—with their intelligence, vitality, and empathy. She is encouraged to teach the same texts that she would at any other institution, including works by Li Po, Michel de Montaigne, Siegfried Sassoon, and J. M. Coetzee, which might obstruct a cavalry charge. Samet is surely familiar with Falstaff's disdain for abstract honor. "What is honor?" he asks. "A word. What is that word, honor? Air. A trim reckoning! Who hath it? He that died o' Wednesday." Yet she embraces the West Point motto, "Duty, Honor, Country."

Nevertheless, slogans are no substitute for thought, and Samet retains the dialectical mind of an Ivy League academic. While attracted by the idealism of the men and women who pledge their lives to national service, she is also repulsed by a strain of anti-intellectualism she finds in military culture. She is troubled by the fact that English at West Point is a geographical afterthought, housed in Lincoln Hall, the academic building farthest from the barracks. Some of the most poignant pages in Samet's book describe her interactions with cadets past and present whose lives she has changed by guiding them not toward what to think but how to think. She regularly sends packages of books and magazines (one shipment included several issues of *Poetry*) to former students deployed in Iraq. She seems to have resolved, at least in her own mind, the ethics of working at an institution that sustains a war she deems unjustified. An officer corps of citizen-soldiers must be educated, not merely trained, and, to her, education is learning to recognize and cope with complexities.

To one first-year class of willing warriors, Samet assigned texts, including *Antigone*, *Prometheus Bound*, and *Narrative of the Life of Frederick Douglass*, on the theme of defiance. Her group of plebes was able to learn "that courage isn't simply a matter of leading charges: Sometimes it consists in speaking up, sometimes in stoic silence, sometimes in forging ahead, sometimes in circumspection, and sometimes in nothing less than preserving our own humanity." Literature is not an elegant ornament reserved for sentimental recitations at the officers' club. According to Samet, it provides its readers with "an ability to know more than one truth, to rest in uncertainty when uncertainty was required, and to change one's mind when the evidence demanded."

That ability is essential for newly commissioned lieutenants compelled to

make crucial battlefield decisions. As much as proficiency with an M16 rifle, it can determine survival. But the survival of the republic is also dependent on civilians who can think clearly and independently about contradictory matters, which is why liberal arts are central to all higher education. It is hard to imagine that anyone who has studied *King Lear*, including the excruciating scene in which Cornwall gouges out helpless old Gloucester's eyes, would commit, abet, or even abide the atrocities at Abu Ghraib. And close acquaintance with Henry James or Molière surely makes anyone better equipped to deal with the temptations and deceptions of everyday life. Nevertheless, as George Steiner famously pointed out, erudition is in itself ethically neutral. Fondness for German high culture did not deter some Nazi officials from abominable actions. As Steiner observed, "We know now that a man can read Goethe or Rilke in the evening, that he can play Bach and Schubert, and go to his day's work at Auschwitz in the morning." It is not what one reads or plays but how.

Examined closely, with an eye to the complex choices made by authors and characters, even mediocre books empower the reader. But, when reduced to an insignia of social status, a cultural trophy, even the greatest work is only words. Reciting classical verse was long a custom within the military aristocracy (George S. Patton read Homer in Greek, and Charles de Gaulle was partial to Horace in Latin), but poetry has loftier purposes than affirmation of caste. It may be that, as Wellington is said to have observed, "The battle of Waterloo was won on the playing fields of Eton." Future conflicts could be won—even deterred—in the classrooms of West Point's Lincoln Hall.

Education for Education's Sake

2008

That's what Stanley Fish wants, but is it possible?

To counter the old Platonic charge that poetry is mendacity, that conjuring worlds up out of words is lying, Sir Philip Sidney devised a clever strategy. The poet "nothing affirmeth, and therefore never lieth," contended Sidney, relieving literature of responsibility for veracity. At the beginning of his poem "Anecdote of the Jar," Wallace Stevens declares: "I placed a jar in Tennessee," but it would be ludicrous to demand eyewitness corroboration or photographic evidence. Stevens scholars do not waste their time excavating berms near Knoxville in search of shards of jars. While the poet appears to be making a statement, it is really a pseudostatement, subject to neither verification nor nullification. Although it liberated poetry, Sidney's gambit also trivialized it. If modern poetry, asserting its autonomy, says nothing, it says it to an evaporating pool of readers.

To counter widespread accusations that college instruction is mendacity, inaccuracy, indoctrination, or treason, Stanley Fish adopts a strategy similar to Sidney's. Declaring that "poetry is the liberal arts activity par excellence," he pushes back against pressures from trustees, legislators, corporations, students, parents, alumni, and other taxpayers who would deny the autonomy of higher education. Insisting that, like poetry, liberal-arts education "makes no claim to efficacy beyond the confines of its performance," Fish is in effect proclaiming that college teachers are pseudoprofessors; they profess nothing.

Fish sets out his philosophy of higher education in *Save the World on Your Own Time* (Oxford University Press). However, he anticipated both the style and substance of that book thirty-six years earlier, with *Self-Consuming Artifacts: The Experience of Seventeenth-Century Literature* (University of California Press, 1972), which includes novel approaches to works by Francis Bacon, John Bunyan, George Herbert, John Milton, and others. In "Literature

in the Reader: Affective Stylistics," an essay appended as a postscript, he of-
fered a prescription for the study of any text. According to Fish, the proper
task of criticism is to provide "*an analysis of the developing responses of the
reader in relation to the words as they succeed one another in time.*" The formula,
which he emphasized through italics, was breathtaking in its conceptual ele-
gance. It empowered readers to ignore centuries of disputation about inten-
tion, imitation, and effect. All one need—should—do is be attentive to the
developing responses of the reader. Of course, who "the reader" is provoked
robust discussion throughout the 1970s and 1980s. Fish himself attempted to
clarify the question by developing the concept of "interpretive communities."
But what his original formulation did was provide an algorithm for generat-
ing any meaningful observation about a text. Defining what the task of liter-
ary studies was, it insulated the discipline from responsibility for what it was
not.

Fish now offers a similarly severe definition of higher education. In *Save
the World on Your Own Time*, whose very title rejects the soapbox and the
pulpit as metaphors for the classroom, he exhorts liberal-arts professors: "Do
your job, don't try to do someone else's job, and don't let anyone else do your
job." That job is not, according to Fish, preaching, proselytizing, or election-
eering. It is not inculcating ethical, social, or political virtues. What it *is* can be
reduced to a binary formula repeated throughout the volume: (1) "introduce
students to bodies of knowledge and traditions of inquiry that had not pre-
viously been part of their experience; and (2) equip those same students with
the analytical skills—of argument, statistical modeling, laboratory proce-
dure—that will enable them to move confidently within those traditions and
to engage in independent research after a course is over." All the rest is distor-
tion, disruption, or at least distraction from what professors ought to do.

That is not to say that colleges should avoid any commerce with topics
that are timely, controversial, and political. But Fish says that they should ac-
ademicize them, by which he means something very like what Sidney meant
when he said that poetry affirms nothing. To do their job, professors should
be abstracting topics from their immediate networks of cause and conse-
quence, neutralizing them as occasions for political action. University study
of euthanasia, for example, means thorough scrutiny of the biology, history,
anthropology, philosophy, theology, and legality of mercy killing; but under-
standing, not advocacy, must be the goal. Any campaign to support or oppose
assisted suicide should be conducted on a professor's own time.

As he had when he reduced reader-response theory to a one-sentence

algorithm, Fish casts his central tenet about the proper task of higher education into italics: "*To academicize a topic is to detach it from the context of its real-world urgency, where there is a vote to be taken or an agenda to be embraced, and insert it into a context of academic urgency, where there is an account to be offered or an analysis to be performed.*" Fish does not deny the virtue of seeking social justice, world peace, environmental balance, or merely virtue, but he insists that, except as the object of study, those objectives have no legitimate place in a college classroom.

Like fin-de-siècle aesthetes who tried to liberate literature, painting, and music from any responsibility except to their own formal perfection, Fish celebrates the uselessness of the liberal arts. They are, he claims, "like poetry because they make no claim to benefits beyond the pleasure of engaging in them." However, to suggest, as Fish does, that college teaching, like music, should not be didactic is as perplexing as saying that music, like teaching, should not be musical. To do so, he must redefine teaching to exclude much of what has historically passed for pedagogy. And his strategy to immunize professors from the complaints of hostile outsiders ends up debilitating them. They should, he insists, embrace their uselessness.

The seductive beauty of Fish's formula is that it seems to dispose of many of the most vexing controversies in higher education. Although he concedes that a sizable majority of faculty members in the humanities and social sciences align with the left, ideological homogeneity is not a problem, as long as instructors are academicizing rather than politicizing. Ward Churchill, Lawrence H. Summers, Holocaust deniers, intelligent designers, Marxists, flat taxers, anti-Zionists—the question is not are they partisan, but rather do they, while teaching, analyze or proselytize? Disdaining the bromide that everything is political, Fish denounces English-composition courses that, using themes such as stem-cell research, capital punishment, and immigration, are instruments of indoctrination. He insists that it is possible—and desirable—to teach writing without content: "All composition courses should teach grammar and rhetoric and nothing else." (Fish himself confuses nominative and accusative cases when he writes about "the values favored by whomever is doing the indoctrinating.")

While maintaining that any topic is ripe for academicizing, inquiry rather than polemic, he also contends that topics that have receded historically lose their venom. He gives slavery as an example, but if an instructor at Ole Miss today asserted that Africans deserved shackles, those would surely be taken as fighting words, not scholarly hypothesis. Campaigning in the classroom for

an electoral candidate would clearly abuse professorial privilege (and prove counterproductive among resentful students), but the boundary between politics (the deployment of power) and analysis is more porous than Fish admits. What is offered for study can be as loaded as how we study it. Replacing Edmund Spenser and Henry James with Gloria Anzaldúa and Amiri Baraka on an MA reading list is not a neutral academic procedure.

Why support universities? The study of philosophy, history, and musicology cannot be justified on economic grounds; Latin scholars do little to boost the nation's gross domestic product. And Fish himself admits that liberal arts for liberal arts' sake is a hard sell. He recounts how, as dean, he was pointedly not invited to lobby the legislature. Yet he dismisses as sentimentality claims that higher education helps build moral character. Nevertheless, though one can cite ethical monsters who are connoisseurs of Thucydides and Proust, training in the disinterested search for truth surely inclines us to respect both the truth and the search. Commitment to that kind of training is one small way to save the world, on anyone's time.

New and Newer Directions

Publishing Books in the United States

2014

On the copyright page of every volume brought into the world by New Directions Press, a notice proclaims: "New Directions Books are published for James Laughlin." Though Laughlin died in 1997, at age eighty-three, the publishing house he founded continues the practice, a tribute to the role played by one extraordinary personality in shaping its list as well as much of the canon of twentieth-century literature. The panoply of fiction, nonfiction, poetry, and drama that Laughlin assembled—by Sherwood Anderson, Djuna Barnes, Robert Creeley, H.D., Henry Miller, Vladimir Nabokov, Ezra Pound, Gary Snyder, Wallace Stevens, Dylan Thomas, Nathanael West, Tennessee Williams, and William Carlos Williams, among hundreds of others— would constitute a solid education in modern literature in English. But he also foraged restlessly throughout the world and was the first to make Jorge Luis Borges, Paul Eluard, Shūsaku Endō, Federico García Lorca, and Boris Pasternak available to American readers. Laughlin extended the tradition of human dynamos, such as Frank Doubleday, James Harper, Henry Holt, and George Palmer Putnam, who drove book publishing in the United States. These strong-willed men dominated their companies and, by choosing and enthusing over what Americans get to read, the course of literary history.

After the opening logo of a lion (MGM), a mountain peak (Paramount), or a statuesque woman holding a torch (Columbia), few moviegoers pay much attention to the studio that produced the work they are watching. Yet, during the years when movies meant Hollywood, each of the major studios had its own distinct style. Cinephiles could enter a theater after the open- ing credits, and, merely by noting the cast, lighting, genre, and style, deduce that they were watching a production from MGM, Paramount, Columbia, Warner Brothers, 20th Century Fox, or Universal.

Similarly, few readers give much thought to the brand of the books they

read, though a connoisseur could, even without looking at the colophon, deduce from the typography, paper, author, and content, whether the publisher was Doubleday, Harper & Row, Houghton Mifflin, Knopf, Random House, Scribner, or Simon & Schuster. Today, more than half the books published in the United States are produced by five conglomerates. An increasing number of works arrive digitally, their editorial origins obscured. But the house that Laughlin built still stands apart.

Published by Farrar, Straus & Giroux (another firm with a legendary history of recruiting talent, including twenty-five Nobel laureates), Ian S. MacNiven's biography of Laughlin coincides with its subject's centenary. New Directions is also honoring the occasion with a new edition of *The Collected Poems of James Laughlin*. Though the inscription on Laughlin's tombstone suggests the man's own priorities—"James Laughlin / 1914–1997 / Poet / Publisher"—it is as a publisher that he made his most significant contributions to literary history, a history that, it is widely felt, has already entered a new era. Not only will we never again see the likes of Laughlin as well as such other formidable publishing buccaneers as Bennett Cerf, Pascal Covici, Alfred A. Knopf, Barney Rosset, and Roger L. Straus Jr., but e-books, print-on-demand, self-publishing, media conglomeration, the disappearance of bookstores, and the decline of reading have transformed the codex culture more profoundly than at any other time since Gutenberg.

MacNiven's absorbing biography of Laughlin follows by a year two other studies of publishing luminaries: Loren Glass's *Counterculture Colophon: Grove Press, the Evergreen Review, and the Incorporation of the Avant-Garde (Post*45)* (Stanford University Press, 2013), and Boris Kachka's *Hothouse: The Art of Survival and the Survival of Art at America's Most Celebrated Publishing House, Farrar, Straus, and Giroux* (Simon & Schuster, 2013). The story of Grove Press, which won landmark victories over the right to publish *Lady Chatterley's Lover, Tropic of Cancer,* and *Naked Lunch,* is very much the story of gutsy Barney Rosset; and Farrar, Straus & Giroux is primarily the story of the productive symbiosis of extrovert Roger L. Straus Jr. and introvert Robert Giroux. *The Lady with the Borzoi,* Laura Claridge's biography of Blanche Knopf, wife and publishing partner of Alfred A. Knopf Sr., was published in 2016 by FSG. These books arrive at a crepuscular moment appropriate for reflecting back on a vanishing world of publishing entrepreneurs. The explicit premise in the title of Al Silverman's memoir *The Time of Their Lives: The Golden Age of Great American Book Publishers, Their Editors and Authors* (2008) is that, having attained its greatest glory during the decades following

World War II, book publishing is currently in decline. That premise is both true and not true.

MacNiven takes the title of his biography, *"Literchoor Is My Beat,"* from a mockingly misanthropic letter that Laughlin sent to Pound. "The world is conducted by buffoons, ignoramy and nuts. I don't want to bother with it," MacNiven quotes Laughlin as writing to his old friend at Saint Elizabeth's Hospital, where the fascist sympathizer's confinement for insanity saved him from a trial for treason. "Literchoor is my beat." Laughlin is ridiculing the dandified notion of majuscular Literature and yoking it to the lowly notion of a gig. Within the exalted social circles in which Laughlin, the heir to a Pittsburgh steel fortune, grew up and against which he rebelled, poetry and publishing were not fit for a gentleman. However, family connections and money sent him to Choate and Harvard, where he fell in love with Greek and Latin. But, restless in a classroom, he decamped to Europe, where he served as a secretary to Gertrude Stein. Later, he spent several months studying at what he called "Ezraversity," under the tutelage of polymath Pound at the poet's home in Rapallo, Italy. In 1936, Laughlin returned to Harvard and also founded New Directions.

It helped that Laughlin, a twenty-two-year-old sophomore when he started New Directions, was able to draw on his family fortune. Though he was known for parsimonious advances to authors and for never taking a salary himself, he called on his Aunt Leila for periodic cash infusions when the company slipped into the red. He used her rural estate in Norfolk, Connecticut, as headquarters, until it became more practical to move to Manhattan. Never one of the behemoths of the industry, New Directions usually got by with seven to nine employees. Despite commercial success with Tennessee Williams (at five million copies, New Directions' best-selling author) and an illustrious backlist that provided a steady stream of revenue, a firm that pushes poetry and that, during the anti-German animosity of World War II, published Goethe and Kafka could expect deficits. Recognizing that publishing serious literature will continue to be a financially precarious activity, Laughlin bequeathed $500,000 to New Directions in his will.

Straus, a scion of both the Guggenheim and Straus dynasties, also came from money. So did Richard L. Simon, whose father made a fortune in feather and silk. Bennett Cerf, cofounder of Random House, benefited from a maternal grandfather who got rich marketing tobacco. Though Horace Liveright did not grow up wealthy, he was able to rely on his father-in-law, a tycoon in the paper industry, to bankroll his publishing career. It is possible

to come away from publishing with a small fortune, but only if you go into it with a large fortune, and the gentlemen publishers responsible for some of the most important books of the twentieth century enjoyed the luxury of being able to insulate themselves to some extent from market pressures. In its inaugural brochure, New Directions described itself as "concentrating on books of purely literary rather than commercial value."[1] From the outset, Laughlin conceived of his firm, which did not turn a profit until 1946, as the idealistic antithesis to the mercenary mammoths, especially the "editorial pigsties of Fourth and Madison Avenues."[2] In 1936, the address of Random House was 457 Madison Avenue.

The letter that M. Lincoln Schuster sent to Simon on May 20, 1923, outlining the mission of their new partnership, Simon & Schuster, begins by pledging to "publish good books—and only good books. Books that we have read and about which we are generally enthusiastic."[3] A similar objective is proclaimed by the venerable Little, Brown (founded in 1837, sold to Time Inc. in 1968 and then to French megapublisher Hachette in 2006). In its own self-description, the house proclaims: "To this day, Little, Brown remains committed to publishing fiction of the highest quality and nonfiction of lasting significance." Few publishers broadcast an intention to publish literature of the lowest quality or transient significance. Few would admit to an interest in anything but what Simon & Schuster—which began by publishing lucrative collections of crossword puzzles—calls "good books." However, each house has defined those terms in its own way. What Laughlin meant by "purely literary value" would have precluded him from dealing with the "good books" by and about movie stars, politicians, and athletes that have earned huge dividends for the big houses, enabling them to publish works that do not earn back the funds invested in them. Profits from E. L. James's *Fifty Shades of Grey*, which has sold more than thirty-five million copies in the United States, subsidized Random House's publication the following year of *Stay, Illusion*, a volume of poetry by Lucie Brock-Broido.

"Contemporary writing," wrote Laughlin, "the work that really expresses its time, is seldom accepted by the generation it mirrors."[4] Until writing is accepted, it needs to be made available by publishers willing and able to risk financial loss. Though he did publish Tang Dynasty poet Li Po and nineteenth-century German Heinrich Kleist, the fact that he chose New Directions as the name for his enterprise underlines Laughlin's principal interest in the contemporary avant-garde. As his business practice, according to *The Cantos of Ezra Pound* (New Directions, 1996), he adopted Pound's

famous motto: "MAKE IT NEW…Day by day make it new." Nevertheless, Laughlin, whose own poetry often echoes Catullus, chose Latin books for his leisure reading and was especially drawn to publish contemporary poets who shared his classical interests, such as H.D., Guy Davenport, Pound, and Kenneth Rexroth.

The strong personal bonds that Laughlin forged with several writers, including Thomas Merton, Kenneth Patchen, Pound, Rexroth, Delmore Schwartz, and Tennessee Williams, was an essential ingredient in the success of New Directions. Both Patchen and Schwartz took staff positions at ND, and Williams appointed Laughlin his literary executor. Cantankerous Pound liked to tease his younger friend by calling his firm "NUDE dye rectum."[5] Though Laughlin early on repudiated Pound's fascism and anti-Semitism, he remained a steadfast supporter and helped organize a campaign to release him from incarceration. The fact that the firm published fewer than thirty titles a year made it easier to claim that New Directions was synonymous with James Laughlin. After its amalgamation in 2018, Penguin Random House, with 250 divisions and imprints, publishes fifteen thousand titles a year, an output that no single member of the company—or the public—could possibly keep up with. Among megapublishers, the words of Nelson Doubleday are apt: "I publish books. I don't read them."[6]

Publishing and poetry did not exhaust Laughlin's energies. He was a world-class skier who traveled frequently and as far as New Zealand in quest of the perfect snowy slope. For many years, manuscripts had to compete for his attention with a spectacular ski resort in Alta, Utah, that he founded. He was also an avid philanderer, a tall, attractive, thrice-married alpha male for whom monogamy was erotic agony. The publishing business during its "Golden Age" was a bastion of privileged Y chromosomes, in which sexual adventurers such as Liveright and Straus pursued women as ardently as authors.

The period since the death in 1984 of Alfred A. Knopf, whom Laughlin called "the greatest thing in publishing that ever was," has been the best of times and the worst of times for books and publishing. Of making books there has been no end…yet. American publishing houses release close to three hundred thousand new titles each year. Laughlin came tardily and reluctantly—in 1955, with García Lorca's *Three Tragedies*—to the paperback format, though, especially with sales to the college market, it proved a boon to New Directions' bottom line. It is hard to imagine that he would rejoice in the fact that e-books constitute a rapidly growing share—now about 20 percent—of the business, and that, on handheld digital devices, literature is

experienced quite differently than it was when Laughlin fell in love with the classics as a student at Choate.

It is no longer necessary to rely on a family trust fund in order to do what Laughlin and Straus did. Digital technologies have made it easier to become a publisher or merely to publish one's own book. More than 1.65 million self-published books appeared in the United States in 2018, a jump of about 40 percent over just the previous year. Publication is no guarantee of recognition, and of the hundreds of thousands of new titles annually, a handful sell hundreds of thousands of copies, but the average book sells fewer than 250 copies a year. Moreover, according to a 2007 study by the NEA, only 47 percent of American adults read any work of literature, and the number of books they read, the time they spend reading, and their comprehension of what they read has been declining precipitously. If reading is in trouble, then publishing certainly is. Moreover, since reading correlates with civic participation and support for the arts, the decline of reading augurs a general cultural decline.

Laughlin was fiercely proud of being accountable to no one but his own sophisticated self, and, though New Directions has worked out a distribution arrangement with W. W. Norton (another high-minded literary firm that retains its own independence through employee ownership), it remains free of corporate control. However, he would not be pleased by the epidemic of mergers and buyouts that has transformed his industry. Small fish have been swallowed up by bigger fish, who have been swallowed up by even bigger fish...until they are all made to swim within the same corporate tank. Harper & Row, William Collins & Sons, Avon, Ecco, William Morrow, Thomas Nelson, and Zondervan were all combined under the rubric of HarperCollins, which in turn became part of the vast News Corp multimedia empire. They, along with Bertelsmann, CBS, Hachette, and von Holtzbrinck, are the superpowers of American publishing. In addition to cookbooks and celebrity memoirs, they sometimes publish literature of genuine distinction.

For all his adventurous, sophisticated taste, Laughlin's lists had glaring gaps. He found *Lolita* "too toasty,"[7] shunned the Beats, and rejected all of Samuel Beckett. New Directions missed out on the Latin American Boom as well as the flowering of African American, Jewish, and Latinx writing. However, a profusion of new, small presses—Archipelago, Black Sparrow, BOA, Coffee House, Copper Canyon, Dalkey Archive, Graywolf, Melville House, Milkweed, Open Letter, Restless, Sheep Meadow, Sun & Moon, among many, many others—ensures that publishing is no longer confined to Manhattan Island and has ceased to be the preserve of high-testosterone

legatees. Many of the new, frugal independents are, either by design or circumstance, nonprofit, which keeps them from signing the most famous authors but also liberates them to publish the poetry and innovative fiction that megacorporations ignore. Faced with diminishing institutional support for scholarly monographs and encouraged by LSU Press's surprise bestseller with John Kennedy Toole's *A Confederacy of Dunces* (1980), university presses—Georgia, Pittsburgh, Wesleyan, Yale—have turned to creative writing to balance their budgets.

The result is a literary marketplace that resembles cable TV—a plethora of choices and little consensus. As booksellers Amazon and Barnes & Noble attempt to muscle into publishing and tech companies keep refining devices to displace printed texts, only a fool would claim to know which are the enduring new directions.

Is a University without Literature
Like a Milkshake without an Olive?

2018

According to the Latin Vulgate, the authoritative version of the Bible for more than a thousand years, academic departments of literature might as well close up shop. Psalm 70:15 is able to praise the righteousness of the Lord, *"quia non cognovi litteraturas"*—because I have not known literatures. According to the fourteenth-century Wycliffe translation, the Psalmist can proclaim God's glory because "I knew not by literature, by man's teaching, but by God's revelation." Thus, an education in secular literature distracts us from important matters.

Though the word in the Hebrew original is *sifrut*, most commonly translated as *literature*, its root, *sfr*, also generates the verb for counting. So most modern translations render the line not as an attack on literature but as proclaiming that God's greatness exceeds man's ability to measure it. The King James Version, for example, reads: "My mouth shall shew forth thy righteousness and thy salvation all the day; for I know not the numbers thereof." In the most popular translations, literature is no longer impugned. Furthermore, its academic study is also salvaged if the phrase in the original Hebrew *"ki lo yadati sifrut"* (because I did not know literature) is understood, as it is by some biblical scholars, as an interpolation by the scribe, simply stating that he could not decipher part of the text he was trying to transcribe.

However, whether or not reading John Donne and Franz Kafka constitutes an obstacle to communion with the Deity, the study of literature in American colleges and universities has been suffering sustained, perhaps fatal, assault from other sources. When Calvin Coolidge, who spent part of his honeymoon translating Dante, was a student at Amherst, a college graduate was expected to be familiar with Homer, Dante, and Shakespeare. A few decades later, Lyndon Johnson was exclaiming: "I don't want anything to do with poets,"[1] and George H. W. Bush was insisting: "I can't do poetry."[2] Today,

the president of the United States does not read books, and even many English majors do not know the difference between Keats and Yeats. Though books—bound and unbound—abound, a cynic might conclude that writers outnumber readers. The academic study of literature is in crisis.

Departments of literature in American universities are often under-funded, understaffed, and demoralized. Concentrations in French, German, Russian, and other languages have been terminated, and those that remain have trimmed their offerings in literature. A major in Spanish might end up acquainted with the *Reconquista*, the Treaty of Guadalupe Hidalgo, and the ingredients of guacamole but ignorant of *La Celestina* and *Pedro Páramo*. In a 2017 article in the *Chronicle of Higher Education*,[3] Nina Handler reports that her own Roman Catholic institution, Holy Names University, is even elimi-nating the English major.

"Why should I be forced to read Ralph Ellison or Margaret Atwood?" asks the student who went to college to train to be a radiologist, tax accoun-tant, or volleyball coach. "You shouldn't," reply many colleges, anxious about applications, enrollments, and their bottom lines. Neglected in favor of STEM specialists, tenure-track scholars of literature—and their attendant horde of poorly paid, insecure adjuncts—must contend not only with dimin-ished resources and resentful students but also with a failure of nerve within their own discipline. Frustrated by their institutional impotence, they turn their hostility against one another. Literature has been displaced by mov-ies, TV, comics, pop music, and social media as the focus of "literary stud-ies." Mesmerized by the perplexities of the present, scholars have abrogated their role as custodians of the literary heritage. An undergraduate syllabus is as likely to include *Fifty Shades of Grey* as the poetry of Thomas Gray. As Yeats (not Keats) would put it, "Caught in that sensual moment all neglect / Monuments of unageing intellect." But there is something less sensual than consensual about this melancholy moment. Our collective decisions have brought it on.

In *The Hatred of Literature*, William Marx, a professor of comparative lit-erature at the University of Paris Nanterre, surveys the long history of antip-athy toward literature, from Plato to the present. Assessing what Socrates, in *The Republic*, calls "a long-standing quarrel between philosophy and poet-ry,"[4] Marx finds that it is not just philosophy that has been hostile toward imaginative writing. Alongside the history of literature, he outlines a parallel and parasitic tradition of anti-literature, of statements and actions that would deny authors their authority. Among the overlapping bases for anti-literature

that he traces, Marx finds that, in its earliest stages: "It is a question of power."[5] Plato felt compelled to banish poets from his ideal Republic because he wanted to free its citizens from the pernicious influence that the Homeric epics were continuing to exert over the lives of Athenians. If, as Percy Bysshe Shelley proclaimed, "Poets are the unacknowledged legislators of the world," there are many who would deny them the right to legislate.

It has also been a matter of truth. Plato dismissed poetry as a mere imitation of an imitation of eternal Forms. A poem about a bed merely represents a physical bed, which itself is but an imperfect version of the ideal, paradigmatic Bed. By the sixteenth century, in *An Apology for Poetry*, Sir Philip Sidney was able to summarize this enduring Platonic rejection of literature as rooted in the belief that it is "the mother of lies," as if fiction is synonymous with falsehood. In the modern university, the paragon of truth-seeker is housed and generously funded in the College of Sciences, not within the threadbare outposts of literary dilettantes. In 1959, C. P. Snow delivered his infamous "Two Cultures" lecture that claimed epistemological priority for the scientific mind over the humanistic imagination. Despite the glaring defects in Snow's argument that Marx points out, it still holds sway among trustees and politicians, who are inclined to disdain literary studies as, in contemporary parlance, "fake news."

To counter that charge, poets themselves have often denied any truth claims for their art; if poetry no longer professes veracity, it cannot be reviled for mendacity. Sidney's own defensive strategy was to contend that the poet—synecdoche for all creative writers—"nothing affirms, and therefore never lieth." Nevertheless, maintaining that literature says nothing is hardly likely to assuage critics who would banish it from the university. If, according to Archibald MacLeish's famous formula, "A poem should not mean / But be," it becomes natural to dismiss the poem as meaningless.

Morality is another historical basis for anti-literature that Marx traces. Because he mistrusted the passions, Plato denounced the literary fantasies that arouse them. Not only have the ranks of poets been filled by boozers, junkies, traitors, thieves, murderers, and other assorted psychopaths, but, warn the champions of anti-literature, their poetry infects readers with their vices. Puritans of various eras define vice differently, but what the fiery tomecides presided over by Savonarola and Hitler have in common is a fear that books can induce abnormality. In contemporary classrooms, notions of "political correctness" have led to trigger warnings and outright prohibitions. Purge Ovid's *Metamorphoses* from the curriculum because it seems to condone

rape, *Huckleberry Finn* because it uses the N-word, the *Divine Comedy* because it consigns Muhammad to the eighth circle of Hell. The avant-garde is, by etymology and definition, a frontal attack on conventional values. And, if much of modern literature is designed to shock, provoke, and destabilize, it seems hard to justify its study in an institution supported by the state or high-powered donors. It could be argued that the greatest literature is profoundly moral: that the overt eroticism of the Song of Songs is really an allegory for the love of God and that Jonathan Swift's suggestion that eating Irish babies solves the famine problem is really a satirical broadside against English Hibernophobia. However, it would be difficult to recuperate the works of the Marquis de Sade, William Burroughs, and Kathy Acker for use in courses filtered for morality.

A final case against literary studies is on the grounds of social utility. Cui bono? For whose benefit other than the insular industry of pedants is a monograph on Edmund Spenser? How does a seminar on Emily Dickinson prepare its participants to be productive citizens? The Battle of Waterloo might have been won on the playing fields of Eton, but certainly not in its Latin classes, and it is mandarin snobbery to think that an elite education in classical texts prepares one for leadership. Marx quotes a striking simile coined by the seventeenth-century French poet François de Malherbe to deny social responsibility: "*Un bon poète n'est pas plus utile à l'Etat qu'un bon joueur de quilles*" (A good poet is no more useful to the State than a good skittles player).[6] Nevertheless, if skittles had been an Olympic sport, its best practitioners might at least have brought glory to their nation, whereas some deny that poets even do that. Furthermore, modernists abjure any claim to social utility. "All art is quite useless," insisted Oscar Wilde, in the preface to *The Picture of Dorian Gray*. After Wilde, there might seem no use trying to defend the academic study of an otiose subject.

Anti-literature, however, is the tribute that its detractors pay to literature. The premise sustaining anti-literature is a belief that literature possesses power and is therefore worth attacking. It is unlikely that any nuclear nation aims its missiles at Togo. Poetry ceases to be hated when it ceases to seem threatening. Worse than antipathy, for the defenders of literature, is indifference. Marx concludes his book with the disturbing possibility that someday literature might merely be ignored and with the fervent wish that "the gods prevent that day from ever arriving."[7]

Perhaps that day has arrived. In 1870, when Charles Dickens's last (and unfinished) novel, *The Mystery of Edwin Drood*, was published, 20 percent

of Americans could not read it, on account of illiteracy.[8] Today, when literacy is almost universal in the United States, 26 percent of Americans report not having read even part of a book—print, electronic, or audio—during the past year.[9] Though fiction still outsells other literary genres, even the "literary novel," the kind that is studied in colleges, is becoming like ikebana, the exquisite art of floral arrangement, the rarefied specialty of a happy few connoisseurs. Before he ceased writing literary novels, at eighty, Philip Roth offered this prediction about the future of the species: "I think it's going to be cultic. I think always people will be reading them but it will be a small group of people. Maybe more people than now read Latin poetry, but somewhere in that range."[10] Can departments of English survive if their subject matter becomes as occult and cultish as origami?

However, Americans still read—tax forms, cereal boxes, and Twitter messages. Some even read Danielle Steel, though almost never Richard Steele. Merve Emre calls this material "paraliterature," and reading specialists contend that paraliterature can be an effective gateway drug for developing the reading habit. Start with a takeout menu, and it is on to Proust. In *Paraliterary: The Making of Bad Writers in Postwar America*, Emre is interested not only in the consumption of noncanonical texts but also in alternative methods of consumption. Seizing on Vladimir Nabokov's magisterial distinction between "good readers" (those who apply the techniques of close reading championed by New Criticism) and "bad readers" (for Emre's purposes, "individuals socialized into the practices of readerly identification, emotion, action, and interaction that Nabokov decried").[11] Emre examines bad reading in the middle of the twentieth century. At the same time that universities were enforcing techniques of studying texts as richly nuanced, autonomous verbal units, "bad readers" were not only perusing memoirs, diaries, committee reports, and other paraliterature. They were also using their readings in ways not sanctioned by the academy.

Emre is particularly interested in how extramural reading positioned the United States as a world power during the Cold War. She examines the internationalization of American Studies through the creation of a literary canon that enshrined Melville, Whitman, and James and was exported by passionate travelers. At home, such scholars as Alfred Kazin, F. O. Matthiessen, and Robert Spiller adhered to the academic orthodoxy of close, dispassionate reading, but, through study abroad programs, Fulbright grants, and the Peace Corps, the same scholars encouraged emotional responses to texts chosen not for their autonomous stylistic graces but to spread American ideals

and influence. Emre studies the "paranoid reading" performed by black nationalists such as John A. Williams, Richard Wright, and James Baldwin who sought to mobilize action against racism. She also examines a fascinating case of failed bad reading—a presidential commission that Dwight Eisenhower created in order to present an inspiring portrait of leading American authors to readers throughout the world. Called the People-to-People Initiative, it disintegrated amid bickering among participants including Saul Bellow, Edna Ferber, Donald Hall, John Steinbeck, and William Carlos Williams and the debilitating tippling of its chairman, William Faulkner.

To avoid extinction, disciplines must adapt and evolve. The Department of Astrology that Pope Leo X founded at the University of Rome in the early sixteenth century has long since disappeared, but astronomy has thrived by moving beyond geocentric and then heliocentric models. Feminism, critical race theory, ecocriticism, reader-response theory, New Historicism, queer theory, and other approaches have made the twenty-first-century English department quite distinct from the one that formalists dominated in midcentury. The demographics of instructors and students has also changed dramatically. Courses in travel writing, science fiction, cookbooks, and other paraliterary genres are commonly offered. Topics such as Bollywood, Black Lives Matter, and Food as Cultural Capital would have made fastidious William Wimsatt shudder. So would the department's presentism, its reluctance to look beyond the past century.

Necrophilia, mermaids, and Australian cinema are no doubt worthy topics in themselves, but since life is short and academic years not long enough, should they be supplanting Chaucer, Shakespeare, and Milton? It is hard to believe that *Game of Thrones*, or even the G. R. R. Martin fantasy novels on which the TV series is based, might serve as a gateway drug to a lifelong addiction to Virginia Woolf. Since its origins in Aristotle's accounts of Greek drama, literary studies has proven remarkably resilient. How far can it stretch before it ceases to be literary studies?

Reading's Next Chapter

2008

"Of making many books there is no end," declared Ecclesiastes, but an ancient bookmaker did not have to bet against websites, movies, TV shows, CDs, and videogames. Of reading many books did a rich life once consist, before other distractions were invented. But now the practice of scrutinizing page after page in splendid, concentrated isolation has begun to seem almost as quaint as blacksmithery.

The disappearance of books is as catastrophic as the extinction of French or Japanese; it would mean the loss of a mode of thinking and being. It is hard to imagine a world without books, though Ray Bradbury did, in his dystopian novel *Fahrenheit 451*, whose inhabitants are impoverished not just by the absence of books but by the ways of imagining made possible by books. More books are being produced and consumed than ever before, but they have relinquished their place at the heart of a culture in danger of cardiac arrest from overstimulation and under-rumination.

It used to be obligatory to read the leading novelists, but the authors themselves wax wistful about their dwindling hold on public attention. It is not so much that the novel is dead as that the sensibility that savors immersion in *Don Quixote* and *Anna Karenina* is moribund, displaced by one more attuned to a miniseries, feature film, or videogame derived from them. Philip Roth, a connoisseur of dying animals, called literature "one of the great lost human causes." He explained to an interviewer: "I don't think in twenty or twenty-five years people will read these things at all...there are other things for people to do, other ways for them to be occupied, other ways for them to be imaginatively engaged, that are I think probably far more compelling than the novel. So I think the novel's day has come and gone, really." However, all ways of being occupied are not equally valuable, and if the novel is—truly, finally—dead, so is a precious, irreplaceable mode of cognition. When the last

speaker of Flaubertese and Faulknerese disappears, the possibilities for conversing will be diminished.

Nevertheless, the belief that, as Anthony Powell put it in the title of a 1971 novel, "books do furnish a room" keeps dealers solvent selling books by the yard, for ornamentation. A recent survey by the National Association of Home Builders found that 63 percent of buyers desire a library, but what they apparently want is a room with a view—of elegant bindings. A *Wall Street Journal* report describes Terri Taylor, an interior designer in Tucson who scavenges for attractive tomes to adorn clients' bookcases. You can't tell a book by its cover, but Taylor never needs to turn a page: "She selects books to match color schemes rather than for their content. She once was ecstatic to find a stash of beautiful, leather-bound books at the bargain price of $20 apiece—never mind that they were written in German, a language her clients didn't read." The great books are indeed immortal, outliving their creators and their purposes as a kind of tchotchke for the upscale residential market.

You can usually tell when something is in trouble by the clamorous praise that it receives. Announcement of a landmark restaurant's demise precipitates a torrent of melancholy tributes from those who have not dined there in years. If fish could converse, water would be the topic only when the lake ran dry. Recent books about book culture are a symptom of its malaise. *How to Talk about Books You Haven't Read* concedes that the reading of serious literature has become marginalized and attempts to assuage its readers' guilt for skimming, discarding, or avoiding Virgil, Joyce, and Musil. The fact that Pierre Bayard's 2007 book became a best seller testifies to the decline in reading as well as widespread anxiety over that decline.

In 1934, when Henry Miller proclaimed that "every man with a bellyful of the classics is an enemy to the human race," he was deriding conventional wisdom that a steady diet of venerated books nourishes mind and soul. To many, it now seems more likely to induce acid reflux. But the film critic David Denby was not yet infected by the bibliophobia endemic to the coming age of Netflix and the iPod when, at forty-eight, he returned to his alma mater, Columbia University, to grapple with Plato, Sophocles, Dante, Shakespeare, Kant, Marx, Woolf, and others. Yet by 1996, when Denby published *Great Books* (Simon & Schuster), his portrait of the scholar as middle-aged matriculant, Columbia was one of the few institutions that still endorsed the notion that higher education is congruent with book learning, by offering a sequence of Great Books courses. In the title of his book, Alex Beam, a columnist for the *Boston Globe*, dubs the Great Books regimen *A Great Idea at the Time*.

Beam's awed but snarky study concludes that its time has passed. Still smarting from the smoke of the canon wars, a reader of his book can hardly deny, even while both applauding and lamenting, the evidence of biblioclasm. Free minds resist the tyranny of sanctified, required texts, even if they eventually discover and devour them on their own. The quickest way to foment a rebellion against spinach is to make the salubrious leaf obligatory.

Although the idea of a canon—essential writings that constitute required reading—goes back two millennia, to selection of the sacred texts that compose the Bible, Beam begins his study of the Great Books movement with Charles W. Eliot, the Harvard president who jettisoned rigid requirements for graduation in favor of a looser system of electives. Eliot was more indulgent as architect of a flexible curriculum than he proved to be as a publishing entrepreneur. Speaking to a working-class audience, he contended that a five-foot shelf of books was sufficient for enlightenment, that it could offer "a good substitute for a liberal education in youth to anyone who would read them with devotion, even if he could spare but fifteen minutes a day for reading." In 1909, at the end of his four-decade presidency, Eliot teamed with P. F. Collier and Sons to publish the *Harvard Classics*, a set of fifty-one volumes that, beginning with Benjamin Franklin and ending with Blaise Pascal, encompassed history, poetry, natural sciences, philosophy, biography, fiction, drama, education, religion, and political science. Catering to the insecurities of a nation that was emerging as a global power but that still looked to Europe for cultural authority, the unwieldy collection, dubbed "Dr. Eliot's Five-Foot Shelf," sold 350,000 copies within its first twenty years. With the imprimatur of the oldest and most prestigious university in the United States, the *Harvard Classics* were, fifty years after Samuel Smiles's *Self-Help*, a highbrow response to the insatiable American craving for personal improvement.

John Erskine, a professor of literature, reacted against the permissiveness of Harvard's undergraduate curriculum when he devised General Honors, the two-year seminar in the Great Books that, inaugurated in 1920, became a hallowed institution at Columbia. One of its early instructors, Mortimer Adler, also taught adult-education classes on "The History of Thought" that were offered free by the People's Institute in lower Manhattan. For Adler and many other Great Books evangelists, the canon was an instrument for the democratization of culture. They imagined a horde of voracious working-class autodidacts who, like Jack London's Martin Eden, would devour the world's written masterpieces. However, for Leo Strauss and his protégé Allan Bloom, study of the Great Books represented an antidote to the leveling relativism of

contemporary culture. "The substance of my being has been informed by the books I learned to care for," wrote Bloom in *The Closing of the American Mind*, and the books that he cared for, containing what Matthew Arnold might call "the best that was known and thought," were caveat for the masses. Reading them offered initiation into an aristocracy of the intellect.

Bloom taught at the University of Chicago, an academic enclave that eschewed football and other distractions from cerebration and that, during the twenty-two years that it was led by Robert Maynard Hutchins, as president (1929–45) and then chancellor (1945–51), became the leading champion of a Great Books curriculum. Hutchins, a charismatic patrician, hired Adler, a bookish Jewish striver, away from Columbia, and the unlikely pair, likened by Beam to Don Quixote and Sancho Panza, succeeded in cajoling reluctant, even hostile faculty members into making the mastery of canonized texts the core of an education at Chicago. At the same time, in collaboration with the *Encyclopaedia Britannica*, Adler and Hutchins pursued a populist mission by publishing a series of fifty-four volumes they dubbed the *Great Books of the Western World*. Consisting of 443 works, these are, in Beam's description, "icons of unreadability—32,000 pages of tiny, double-column, eye-straining type." The contents were ponderous, and the price was steep. Nevertheless, powered by Adler's hucksterism and an army of peddlers, the series became a hit and, in Beam's account, "joined the roster of postwar fads like drive-ins, hula hoops, and Mexican jumping beans." More than 1 million sets were sold, while the Great Books Foundation extended the franchise nationwide through more than 2,500 Great Books discussion groups. However, the fad has faded, and tiny Saint John's College, in Maryland, remains the last bastion of a pure Great Books curriculum.

It was only during a relatively brief span of history, when a burgeoning but insecure middle class affirmed its ascendency by possession and consumption of books, that reading could seem the custom of the country. More recently, the drive toward universal literacy has been succeeded by an embrace of aliteracy, the condition of those who can but do not read. In addition to noting a decline of 7 percent during the past decade in the reading of any book, the 2004 National Endowment for the Arts study "Reading at Risk" reported that less than half the adult population of the United States reads any literary books. However much they once were, most Americans are not now inclined to devote their leisure time to Aristotle, Goethe, and Proust, or even to Don DeLillo, Jhumpa Lahiri, and Junot Díaz.

For Wendy Griswold, though, that is no cause for alarm. "Today reading

is returning to its former, narrower social base: a self-perpetuating minority that I have called the reading class," she argues in *Regionalism and the Reading Class*, a book chiefly concerned with how that class—in Italy and Norway as well as the United States—constructs and enforces regional identity. According to Griswold, who holds appointments at Northwestern University and the University of Oslo, the reading class constitutes 25 to 33 percent of the population. Reading is an elite, prestigious practice, and members of the reading class wield disproportionate political, economic, and cultural power. If, as Griswold insists, "it appears that it is the more casual reading by occasional readers, not the extensive reading by avid readers, that is atrophying," then great books of the past retain a future. However, she does not exactly account for how fondness for local (probably living) authors necessarily expands to ancient ones. A Texan's enthusiasm for Larry McMurtry, Horton Foote, and Elmer Kelton does not necessarily lead to Euripides, Ovid, and Li Po.

Jay Parini is a congenial companion through some touchstone books. A professor at Middlebury College and an accomplished poet, novelist, and biographer, he focuses on thirteen books that he believes "changed America." One of those books is the 1936 self-help classic *How to Win Friends and Influence People*, which he confesses to having imbibed when he was young and lacking self-confidence. Though he is now discomfited by the book's hortatory hokeyness, Dale Carnegie's influence lingers in Parini's own straightforward, assertive style. Treating its readers as friends, *Promised Land: Thirteen Books That Changed America* aims to influence and mostly succeeds.

In addition to *How to Win Friends*, the titles that Parini names as most consequential are *Of Plymouth Plantation, 1620–47*; *The Federalist Papers* (1788); *The Autobiography of Benjamin Franklin* (1793); *The Journals of Lewis and Clark* (1814); *Walden* (1854); *Uncle Tom's Cabin* (1852); *Adventures of Huckleberry Finn* (1885); *The Souls of Black Folk* (1903); *The Promised Land* (1912); *The Common Sense Book of Baby and Child Care* (1946); *On the Road* (1957); and *The Feminine Mystique* (1963). Each receives a chapter, and, except for the puzzling placement of Henry David Thoreau's memoir of life in the woods before Harriet Beecher Stowe's abolitionist novel, the thirteen are treated in chronological order. Each chapter walks the reader through the book in question and offers a patient, informed discussion of its author, historical context, and repercussions. Parini concedes that "only *Walden*, *Huckleberry Finn*, and *On the Road* could be considered 'great' books as such." A more generous—or revisionist—assessment might also include *Uncle*

Tom's Cabin. But what interests Parini here are not necessarily works of great literary merit; *Moby-Dick, Leaves of Grass,* and *The Sound and the Fury* are notable omissions. Instead, each of his chosen books "changed America in some visible and profound way." According to him, they "helped to create the intellectual and emotional contours of this country. Each played a significant role in developing a complex value system that flourishes to this day." A tour through Parini's thirteen books is thus an examination of the preoccupations and myths that constitute American identity.

In Benjamin Franklin, for example, he finds Yankee buoyancy married to the urge for self-invention. Thoreau, Parini claims, "defines American independence," while "*Adventures of Huckleberry Finn* defines the American project, its strenuous search for liberty, equality, and the pursuit of happiness." Jack Kerouac's famous novel "identified, and helped to define, the notion of an American counterculture," while Betty Friedan's feminist manifesto "shifted the minds of countless women, drawing attention to the uncomfortable circumstances of their lives, forcing them to consider alternatives."

However, wavering between omelet and pullet, each chapter is uncertain about the priority of chicken and egg. Did the book change America or reflect it? Pace Lincoln, Stowe might not have been "the little woman who wrote the book that started this great war" as much as the one who voiced the contradictory passions of a society on the verge of violent schism.

Acknowledging the arbitrariness of his thirteen chapters, Parini offers an appendix of "One Hundred More Books That Changed America." Among these is *A Brief Relation of the Destruction of the Indies*, the 1552 account of Spanish atrocities against indigenous peoples written by Bartolomé de las Casas, who never set foot in what is now the United States. Also included is the French traveler Alexis de Tocqueville's *Democracy in America* (1835). Surely other books by other foreigners—the King James Bible, *The Spirit of Laws, The Wealth of Nations,* the Harry Potter series—changed America as profoundly as books by Americans. And although Parini received his doctorate from the University of Saint Andrews, he seems indifferent to the question of which thirteen books changed Scotland...or Brazil, Japan, or Canada.

His Americocentric approach invites a less provincial question: What are the books—*On the Origin of Species; The Communist Manifesto; Cry, the Beloved Country; The Gulag Archipelago?*—that changed the world? And if books can change the world, the world can surely change a book. *The Divine Comedy* today, post-Luther, post-Hiroshima, and post-9/11, is read differently than it was by Dante's contemporaries. *The Iliad* in an era of nuclear

proliferation and suicidal terrorists is not the same volume that stunned John Keats into silence.

In *Walden*, Thoreau asks: "How many a man has dated a new era in his life from the reading of a book?" A bibliophilic Johnny Appleseed, Andrew Carnegie planted new eras by seeding the landscape with libraries. Yet a century later, when Bill Gates wanted to change lives, he gave away computers. A century from now, a search for books that changed America may well seem quaint. Although *Roots* appears on Parini's supplementary list, the record-setting TV miniseries had more impact even than Alex Haley's best-selling book. *An Inconvenient Truth* is also included, though the movie more than the book opened eyes to global warming. As long as there is a reading class, it will be avid to read about works that rearrange the world, even if they are films.

The percentage of serious readers has probably not changed significantly during the past century. Most human beings continue to go about their lives oblivious of the Great Books, or even the mediocre ones. What has changed is not whether but how books are processed by the reading class. *The Republic*, *The Mahabharata*, and *The Canterbury Tales* were not created to be experienced on printed codices, and their translation to other, post-Gutenberg forms of delivery should alarm us only if, since something is always lost in translation, we end up discarding something we cannot begin to contemplate except through books. Let's hope that by then we won't have abandoned the book-based sensibility necessary to measure the magnitude of our loss.

Film Love, Language,
and Laurels

Kael and Farewell

1996

> To prove my out-of-it-ness once again, in my pantheon
> Pauline Kael never came close to replacing Edmund
> Wilson.
> —Joseph Epstein

The force of Joseph Epstein's quip derives from the fact that, following Edmund Wilson's death in 1972, Pauline Kael was, for many, the preeminent public intellectual in the United States. Untenured and untethered, she addressed the educated nonspecialist in a way that was accessible but rarely facile or banal. For most of her long tenure reviewing film at the *New Yorker*, from 1968 to 1991, she was probably the most respected working critic, on any beat, in North America. Kael's manifest zest for the task—what, three years after Parkinson's disease compelled her retirement from the *New Yorker*, she called "the best job in the world ("The Movie Lover" 133)—and her airy erudition engaged readers and commanded admiration. "You must use everything you are and everything you know that is relevant" (*I Lost It* 309), insisted Kael, the compleat critic for whom reviewing became a total expression of self.

She defined herself as a writer whose subject happened to be movies, and what is most memorable about her work—in thirteen volumes that have been honored with the National Book Award and other tributes—is, first, the vivacity and clarity of the prose. Kael was an enthusiast and champion of the American vernacular, even the vulgar, and she emerged, along with Robert Altman, Francis Ford Coppola, Brian De Palma, Arthur Penn, Martin Scorsese, and Steven Spielberg, when American cinema was experiencing a renaissance. "A few decades hence," she wrote in 1976, "these years may appear to be the closest our movies have come to the tangled, bitter flowering of American letters in the early 1850s" (*Reeling* 11). In part because of Kael, film became central to educated culture, and she helped to shape the terms and textures of the national conversation about the medium and our lives.

Edmund Wilson, an autodidactic polymath, a man of scattered letters who was equally illuminating on the Civil War, Proust, commercials, and

the Dead Sea Scrolls, remains a paragon of literary freelancers. But Norman
Mailer, the nonfiction stylist for whom prose is performance, who advertises
himself, in *The Armies of the Night,* by reiterating that "Mailer was as fond of
his style as an Italian tenor is of his vocal cords" (70), provides a closer ana-
logue to Kael's own writing. Reviewing Mailer's 1973 biography of Marilyn
Monroe, Kael might also be discussing herself: "His writing is close to the
pleasures of movies; his immediacy makes him more accessible to those
brought up with the media than, say, Bellow. You read him with a heightened
consciousness because his performance has zing. It's the star system in liter-
ature; you can feel him bucking for the big time, and when he starts flying it's
so exhilarating you want to applaud" (*Reeling* 218). With the casual intimacy
of its second-person pronoun, its tarting up of learned terms like "immedi-
acy," "accessible," and "consciousness" with demotic neologisms such as "zing"
and "buck," its valorization of exhilaration, and its tacit assumption that mov-
ies are the model of human pleasure, the passage is vintage Kael. And the as-
sessment it offers is as applicable to Kael's flamboyant style as to Mailer's.

A Kael review often begins in synecdoche, in a canny close-up on a small
but telling detail, such as the moment in *Shampoo* when Warren Beatty asks
Julie Christie: "Want me to do your hair?" After a defiantly preposterous hy-
perbole ("Jaws may be the most cheerfully perverse scare movie ever made,"
When the Lights 195), Kael teases out an ample exegesis through liberal use
of archly epic similes. "Seeing it," she writes of *The Thomas Crown Affair,* "is
like lying in the sun flicking through fashion magazines and, as we used to say,
feeling rich and beautiful beyond your wildest dreams" (*Going Steady* 136). A
merry reader along for the ride may well respond with "Cheers!"—a reaction
that Mailer, following a similar exhibition of verbal dexterity, sometimes in-
scribes within his own texts. Kael's pieces frequently conclude in sly bathos;
following a cataract of—largely negative—comments on *Raging Bull,* her
boisterous voice trails off with the savorless sentence: "An end title supplies a
handy Biblical quote" (*Taking It* 112).

Pauline Kael is perhaps the most exuberantly ludic figure in the history
of American criticism. Whether or not that claim is valid, it is itself a kind
of Kaelian superlative—the tentative assertion of very odd distinction. She
thus characterizes *Mon Oncle Antoine* as "probably the most plangent movie
ever made in and about Canada" (*Taking It* 421), as if the category admitted
of subtle gradations and numerous contestants. The contention that *Altered
States* is "probably the most aggressively silly picture since *The Exorcist*"
(*Taking It* 128) admits the possibility of another as well as of passively silly

pictures before *The Exorcist*. With just a soupçon of hesitation, she pro-
nounces *An Englishman Abroad* "probably the best hour of television I've ever
seen" (*State of the Art* 311), the early frames of *Iceman* "perhaps the greatest
opening shot I've ever seen" (*State of the Art* 160), and an exchange between
Ed Harris and Mary Jo Deschanel in *The Right Stuff* as "perhaps the wittiest
and most deeply romantic confirmation of a marriage ever filmed" (*State of the
Art* 65). When she declares that *The Trial of Billy Jack* "probably represents
the most extraordinary display of sanctimonious self-aggrandizement the
screen has ever known" (*Reeling* 504), that *Godfather II* "may be the most pas-
sionately felt epic ever made in this country" (*Reeling* 529), that *Last Tango in
Paris* "may turn out to be the most liberating film ever made" (*Reeling* 53), that
Carol Burnett "is probably the most gifted comedienne this country has ever
produced" (*Reeling* 126), that *The Iceman Cometh* is "perhaps the greatest the-
sis play of the American theater" (*Reeling* 271), and that *Days and Nights in the
Forest* "is perhaps the subtlest, most plangent study of the cultural tragedy of
imperialism the screen has ever had" (*Reeling* 200), Kael keeps her eyes wide
but her options open, barely.

The critic who proclaims that a dinner party in *My Left Foot* "may be the
most emotionally wrenching scene I've ever experienced at the movies" (*Movie
Love* 178), that Jeff Bridges "may be the most natural and least self-conscious
screen actor who ever lived" (*Reeling* 233), and that *Padre Padrone* "may be the
only fully conscious animistic movie ever made" (*When the Lights* 299) may
be the most hyperbolic of eminent authors since Dickens. So persistent is she
in devising a radical epithet for almost every movie and moviemaker that Kael
might be the most fervent enforcer of the law of the excluded middle. If not a
conscious mockery of puffery in an industry in which every new release is ei-
ther a blockbuster or an award-winner, her extravagant rhetoric does call at-
tention to itself and to criticism as performance. Kael speculated that her best
talent may be "a real gift for effrontery" (*Espen* 135), and that gift finds its most
gaudy wrapping in the audacious hyperboles that she repeatedly conceives.

Borrowing her own testy trope for the plethora of close-ups in *Downhill
Racer*, one could claim that the superlatives in Kael's prose "keep hitting one
like the Yo-Yos in 3-D movies" (*Deeper* 57). That is a veritably baroque com-
parison, and if there is any stylistic device in Kael's prose with more resilience
than her hyperboles, it is the mock-epic simile. "*The Pope of Greenwich Village*
is like a doughy plum cake with wonderful plums sticking out of it," she de-
clares and then, like a bard ecstatic over extending an analogy, adds: "The
plums are the performers" (*State of the Art* 201). Kael characterizes *One, Two,*

Three as "a comedy that pulls out laughs the way a catheter draws urine" (*I Lost It* 150), *Risky Business* as "a George Bernard Shaw play rewritten for a cast of ducks and geese" (*State of the Art* 40), and *Star Wars* as "like getting a box of Cracker Jack which is all prizes" (*When the Lights* 291). Sometimes she applies her gymnastic comparisons not to movies but to how to talk about movies, as when she declares that lambasting "a Ross Hunter production is like flogging a sponge" (*Reeling* 194), when she concedes that warning connoisseurs away from *How to Save a Marriage and Ruin Your Life* is "as superfluous as warning a gourmet against canned spaghetti" (*Going Steady* 21), or when she complains that "a critic with a single theory is like a gardener who uses a lawn mower on everything that grows" (*I Lost It* 309). Kael, as handy with a manure spreader as a lawn mower, does not confine herself to a single theory. She celebrates her nimbleness by concocting comparisons between wildly divergent terms. The similes are often so manifestly farfetched that the reader shares the thrill of giddy ingenuity.

Kael's bravura style is a creature of her guerrilla campaign against gentility. As staff reviewer for that most urbane of glossy weeklies, the *New Yorker*, she aroused fierce and continuing resistance from the magazine's decorous older guard, who resented both her raffish subject, movies, and her congruent, breezy style. Precipitating the most notorious of several rows that Kael has had in print with other critics, Renata Adler, a Knickerbocker loyalist, assailed Kael's flamboyant verbal art as "a form of prose hypochondria, palpating herself all over to see if she has a thought, and publishing every word of the process by which she checks to see whether or not she has one; it is also equally true that she can hardly resist any form of hyperbole, superlative, exaggeration" (Adler 34). Adler's account of Kael's histrionics is largely valid, though, for all its evident animosity, not necessarily damning. It had no demonstrable effect on Kael's work, though it might have confirmed the California woman in her outsider's determination to stun and wow proper New Yorkers. Her praise, during a 1989 interview, for exorbitance in 1930s movies also justifies her own verbal campiness: "Part of the fun for many of us—you see it now if you look at old movies of the '30s—is that extravagance of gesture, doing things to excess. Every emotion is made bright. And it helps us satirize ourselves, helps put our own emotions in perspective, because they are so overdramatized" (Sawhill and Frost 101).

Kael's first book, *I Lost It at the Movies*, a collection of pieces written before she moved east to join the *New Yorker* and when she could still mock its occasional reviewer John McCarten, announces Kael's insurgency against

the canons of critical respectability; she is as contemptuous of the entire tribe of movie reviewers, "a destructive bunch of solidly, stupidly respectable mummies—and it works either way, maternal or Egyptian" (*I Lost It* 72), as of Hollywood malarkey. She offers herself as a lively alternative to Bosley Crowther and Andrew Sarris and flaunts her mischievous manner as a weapon of rebellion. Edward Murray has analyzed the "Huck Finn complex" (Murray 131) that he finds in Kael's writing, as if her brazen hyperboles and similes were the whoppers of a wayward frontier child.

Kael, who never grew above five feet ("I think that the disjunction between my strong voice as a writer and my five-foot frame somehow got to people," "The Movie Lover" 134), grew up, far from Manhattan, as the youngest of five children. "One nice Jewish boy from Brooklyn on another" (*Reeling* 219) is the way she describes Mailer's treatment of Arthur Miller in *Marilyn*, but Kael herself must be understood in part as a nice Jewish girl from Petaluma. Of course, nice Jewish boys and girls often go out of their way to deny they are either nice or especially Jewish. Much of Kael's work must be read as a mid-century ordeal of civility, the record of cultural anxieties felt by a California Jewish woman avid for immersion in America and by an American wary of the residual authority of Europe.

Born in 1919 to Isaac Paul and Judith (Friedman) Kael, who had immigrated from urban Poland to rural northern California during the previous decade, she spent the first eight years of her life, before stock market losses forced the family to move to San Francisco, on a Sonoma County farm. In telephone conversations with this author, Kael noted that her alien family name was tamed and abbreviated by immigration officials but that she could not recall its original form. She also emphasized that her parents, who came from Warsaw, were "not shtetl Jews" and that English, certainly not Yiddish, was the language of their California household. Kael belongs to the cohort of assertive American Jews born during or shortly after World War I that includes not only Mailer, Miller, Bernard Malamud, and Leonard Bernstein, but also Diane Arbus, Betty Friedan, Lee Krasner, Grace Paley, and Beverly Sills. Created and dominated by European greenhorns including Samuel Goldwyn, Carl Laemmle, Louis B. Mayer, Harry and Jack Warner, and Adolph Zukor, motion pictures during Kael's childhood were the most conspicuously Jewish of American industries, and her own career as apologist and antagonist of the business can be seen as an arduous attempt by a second-generation Jew to negotiate a place for herself within American popular culture. Almost fifty when invited by William Shawn to join the *New Yorker*,

Kael ultimately managed, in fertile middle age, to become one of the foremost foes of Old World stuffiness, a champion of the youthful American vernacular. It is a compelling but not bewildering paradox that just as Jewish immigrants created the celluloid images of middle America that most forcefully defined the nation to itself and others, Pauline Kael became the Huck Finn of American critics. She launched her career as movie maven with a review of Chaplin's *Limelight* in an issue of San Francisco's *City Lights* for 1953, the same year that Saul Bellow reinvented Twain's Great American Novel as the adventures of a Chicago Jew named Augie March.

Despite her explicit admiration for the works of many foreign directors, notably Bernardo Bertolucci, Jean-Luc Godard, Jean Renoir, and Satyajit Ray, Kael devotes most of her attention to domestic releases and writes with a nativist mistrust of cinematic imports. Like Emerson in "The Poet," she demands a declaration of independence from the tyranny of the European Muse. Offering herself as a champion of local genius, Kael denies that American culture is an oxymoron and indeed argues for the superior vitality of New World art, as long as it remains true to its autochthonous inspirations. She reveres, and attempts to personify, Yankee irreverence. Rejecting Europe as the gauge of artistic achievement, particularly for something as quintessentially American as comedy, she notes that: "It's a bad joke on our good jokes that film enthusiasts here often take their cues on the American movie past from Europe, and so they ignore the tradition of comic irreverence" (*Citizen Kane* 15). Kael dared refuse to worship at the Swedish shrine of Ingmar Bergman. And she famously dismissed three fashionably ponderous new European films, *La Notte*, *Last Year at Marienbad*, and *La Dolce Vita*, as "the Come-Dressed-As-the-Sick-Soul-of-Europe Parties" (*I Lost It* 179), concluding her extended act of deflation by imagining a zestful American alternative to Antonioni, Resnais, and Fellini: "All we need to undermine and ridicule this aimless, high-style moral turpitude passing itself off as the universal human condition is one character at the parties—like, say, Martha Raye in *Monsieur Verdoux*—who enjoys every minute of it, who really has a ball, and we have the innocent American exploding this European mythology of depleted modern man who can no longer love because he has lost contact with life" (*I Lost It* 196).

Kael presents herself as a lively Raye among the mummies of Momus—no less American for her European lineage, indigenous for her Jewishness, or sophisticated for her girlhood on a West Coast farm. In 1953, when Kael began to publish and broadcast her thoughts about movies, the industry,

like the culture at large, was tyrannized by narrow definitions of national-
ity; blacklists and congressional committees were ostracizing studio employ-
ees judged insufficiently "American." But, in contrast to earnest native patri-
ots, Kael, a Jewish woman one generation removed from the Iron Curtain,
dared to equate Americanness with irreverence and to celebrate the impu-
dence of American popular culture, impudently. "We want the subversive ges-
ture carried to the domain of discovery" (*Going Steady* 120), she proclaimed,
to explain the kind of movies that she craved. But the recipe applies as well to
her own seditious style of commentary. Kael's fractious form of (Groucho)
Marxism threatened the Margaret Dumont primness that dominated discus-
sions of "culture." Diagnosing solemnity as "a crippling disease" (*Reeling* 324),
she went to battle against snobs, prudes, and censors to restore American
culture to robust health. During the era that the august *New Yorker* carried
Kael's essays—for several years in six-month cycles alternating with Penelope
Gilliatt's—she carried the subversive gestures of provocative prose into the
domain of discovery. Her final review appeared on February 11, 1991, barely a
year after the fall of the Berlin Wall, and, for almost four decades, her vigor-
ous celebrations of American pluck and cheek were as palpable a response to
the Cold War as were J. Edgar Hoover's xenophobia and Richard Nixon's jin-
goism. While her fans were as numerous and devoted as those of many movie
stars, Kael also provoked hostile letters—some scrawled anonymously and
ominously on their authors' own *New Yorker* stationery.

"Our movies are the best proof that Americans are liveliest and freest
when we don't take ourselves too seriously," she declares, as though thumbing
her nose at a HUAC inquisitor, early in her first book (*I Lost It* 82). If Europe
is the stern arbiter of manners, Kael finds greater strength in the social gau-
cheries to which untutored but affable Americans are prone: "We are bump-
kins, haunted by the bottle of ketchup on the dining table at San Simeon.
We garble our foreign words and phrases and hope that that least we've used
them right. Our heroes pick up the wrong fork, and the basic figure of fun
in the American theatre and American movies is the man who puts on airs"
(*Kiss Kiss* 67). Kael exults in deflating the air from pretentious productions,
particularly if they are from Europe. "There is more energy, more original-
ity, more excitement, more art," she insists (*I Lost It* 24), "in American kitsch
like *Gunga Din, Easy Living*, the Rogers and Astaire pictures like *Swingtime*
and *Top Hat*, in *Strangers on a Train, His Girl Friday, The Crimson Pirate,
African Queen, Singin' in the Rain, Sweet Smell of Success*, or, more recently,
The Hustler, Lolita, The Manchurian Candidate, Hud, Charade, than in the

presumed 'High Culture' of *Hiroshima Mon Amour, Marienbad, La Notte, The Eclipse,* and the Torre Nilsson pictures." Her favorite way of dismissing a movie is to pronounce the experience "logy." Writing about a Japanese import, Kaneta Shindo's *The Island,* she lambastes both the work and the pervasive premise that bombastic tedium is lofty art: "This work has been widely acclaimed as a masterpiece, largely I suspect because it is so ponderously, pretentiously simple. A lot of serious-minded people will think it must be art because it sure as hell isn't entertainment" (*Kiss Kiss* 357).

America at its best, she suggests, is sassy not stuffy, and its arts are characterized by audacity devoid of pomposity. In her vocabulary, pulp and trash ceased to be terms of abuse. It is because gentrification has betrayed its feral native roots that she attacks the choreography in *West Side Story*: "What is lost is not merely the rhythm, the feel, the unpretentious movements of American dancing at its best—but its basic emotion, which, as in jazz music, is the contempt for respectability" (*I Lost It* 147). For Kael, *Moby-Dick* is the great American novel precisely because its author was a barbarian: "Melville is not a civilized, European writer; he is our greatest writer because he is the American primitive struggling to say more than he knows how to say, struggling to say more than he knows" (*I Lost It* 238).

Because she takes delight in disorder, Kael opposes prigs and pedants— real and imaginary—in defense of both American culture and the movies. In *The Citizen Kane Book,* Kael champions the rumpled, flippant Herman J. Mankiewicz over grandiloquent Orson Welles as true auteur of the upstart movie on which both worked. She dismisses the exquisitely sophisticated John Simon as a patrician critic constitutionally unsuited to appreciate the commoners' art: "Movies are for everybody—except people with arctic temperaments" (*Hooked* xv). Kael cooks her own prose—enough to melt a polar cap. Rejecting the pretense of objectivity, she denies, by statement and example, the possibility of detachment from an art for which she feels such enthusiasm and of writing anything of value without enthusiasm. Convinced that pleasure is the motive for both movies and movie criticism, she exults in her own exuberance. At a time when books by D. H. Lawrence, Henry Miller, and Vladimir Nabokov were still banned because of erotic content, she celebrated the sensuality of movies. The notoriously sexual innuendoes in the titles to many of her books—e.g., *I Lost It at the Movies, Kiss Kiss Bang Bang, Deeper into Movies, When the Lights Go Down*—prepare the reader to encounter an unabashedly passionate critic.

When Kael began writing, cinema had not yet become an academic

discipline or a canonized art, and the United States, in contrast to its devastated wartime enemies and allies, felt itself a parvenu of nations, newly rich and powerful but more than a bit uncouth. Kael exulted in the crude vitality that she identified with both movies and America. "Vulgarity is not as destructive to an artist as snobbery," she wrote in the pages of the *New Yorker*, an illustrious institution whose luminaries continued to snub her, "and in the world of movies vulgar strength has been a great redemptive force, cancelling out niggling questions of taste" (*Deeper* 412–13). Kael's commitment to vulgarity (from *vulgus*, the people) extended to her preference for viewing movies with the general public rather than during private critics' screenings and to her tendency to incorporate audience reactions into her reviews. Like theater, moviegoing is for her a supremely social experience, in which collective reactions and later conversations are crucial elements.

Because the sharing of impressions is so integral to her experience at the Bijou, Kael has admitted that she would find it hard to maintain a close friendship with someone whose reactions differed fundamentally and frequently from her own (Sawhill and Frost 101). Many of her reviews commence with the comment a companion made while watching the movie or with what was said afterward at a party or a meal. In *Hooked* (292), she begins her analysis of a film performance by recounting a "late-night-overdrinks conversation" in which she and a friend concluded that Morgan Freeman is the greatest living American actor. Her disappointment over the relationship between Robert De Niro and Meryl Streep in *Falling in Love*—"They don't share any tastes; they don't enthuse over anything; they don't argue over a book, a movie, a painting, a building, or even TV" (*State of the Art* 279)—suggests that to her mind the clash of passions is essential to both moviegoing and love, if not mere friendship. "Being able to talk about movies with someone—to share the giddy high excitement you feel—is enough for a friendship" (*Movie Love* xii), she claims, implying that such sharing is also crucial to the full experience of a movie.

Kael did most of her reviewing before the advent of the VCR and long before streaming, which made every viewer a projectionist and further atomized audiences. But, because of continuous shows and seating, moviegoing was never the discrete communal event that live drama, whose audiences arrive and depart in unison, is. What is gloriously gregarious for Kael, though, is the fact that memories of movies have the power to shape conversations and connections among large numbers of people. "Who wants to be a crazy alone?" asks Kael during a parenthetical aside about Woody Allen.

"That leads to melancholy" (*Reeling* 329). In Kael's pharmacology, movies are an antidote to melancholy. And movie reviewing is a way to avoid being crazy alone, especially if you implicate your reader in almost every clause you write, as Kael does with her persistent use of "you" and "we." Reviewing *A Cry in the Dark*, Kael pretends to have seen each of us emerge from the dark theater: "You come out moved—even shaken—yet not quite certain what you've been watching" (*Movie Love* 33). She has lamented that the demands of writing to a deadline enjoined a solitary régime: "What began for me as a gregarious activity—talking about movies—became, at last, a monastic pursuit" ("The Movie Lover" 134). But, by peppering her prose with the second-person pronoun, she invents an interlocutor and avoids being crazy alone.

To Simone Weil, "the intelligence is defeated as soon as the expression of one's thoughts is preceded, explicitly or implicitly, by the little word 'we'" (27–28). The first-person plural both assumes and asserts complicity between writer and reader, one, complain her detractors, that Kael does not earn. Like the reflexive "you," "we" is indeed a way of camouflaging idiosyncrasy as collective norm. When Kael asserts, "When you were a kid, you wondered if your crayons would kill you if you ate them" (*Movie Love* 25), many of us will balk at the rum biographical assumption. We are not amused, as we are by most of her other acts of ventriloquism, by her talent for projecting a manic voice that presumes to speak for all.

In 1953, when Kael began broadcasting movie commentaries on Berkeley's noncommercial Pacifica radio station KPFA, the doctrine of impersonality still held sway in analyses of modern art, and New Criticism's dismissal from aesthetic consideration of everything but the text itself still dominated academic studies. But, from the first page of her first book, a caustic account of a visit to Hollywood, Kael dared to intrude into her discussions of movies. As though the stance of mandarin detachment were itself the dreary enemy against whom she fashions an answerable style. Kael sometimes proffers autobiography disguised as movie criticism. "I'm frequently asked why I don't write my memoirs," wrote Kael in a coda to her years at the *New Yorker* ("The Movie Lover" 134). Her terse response, "I think I have," suggests not only that writing about movies has been her life, that who touches those thirteen books touches the woman; it also acknowledges that personal information is scattered throughout her prose. Over the years, readers have learned about her student days as a philosophy major at the University of California, about the time she caught a glimpse of William Randolph Hearst, about the five-month sabbatical she took in 1979 to work for Paramount, about her

experience managing the Berkeley Cinema Guild and Studio, about her fondness for dance, jazz, and opera, about her daughter, and about her dog. Her three failed marriages are not discussed. During a review of *Hud* (*I Lost It* 78–94). Kael recalls her childhood on a Petaluma chicken farm and details about her father, who, she confides, was generous, kind, and Republican and frequented brothels. More tantalizing than anything she has to say about a particular epic of range wars or cattle drives is the improbable claim—reaffirmed during a telephone conversation (Kellman)—that: "My father went to a Western just about every night of his life that I remember" (*Kiss Kiss* 54). More intriguing than any of Kael's insights into *The Paper Chase* is her parenthetical recollection (*Reeling* 263) of having vomited after seeing a play directed by John Houseman. What is most memorable about her piece on *Shoeshine* (*I Lost It* 114) is the way it evokes a memory of the lovers' quarrel she had just before seeing the film. Kael informs us that she cannot remember the name of the prizefighter she once dated (*Kiss Kiss* 278), but she does note (*Hooked* 438) that the man who accompanied her to the theater in 1938 when she laughed so hard she fell out of her seat is now a judge.

Kael denies herself the privilege of Olympian judgment. Though she wears her erudition—in literature, music, art, dance, and, of course, movies, among other subjects—lightly, she frequently unveils the process of how she arrives at impressions. Readers get to witness the critic on deadline making sausage out of sweat. She also concedes, even boasts of, her derelictions. "There are people who can sit through any movie, but I'm a walker-outer" ("The Function of a Critic" 38), she wrote, early in a career in which she has probably deserted more movies than most have sat through. Thirty minutes seems to be the threshold of Kael's impatience. "I walked out after a half hour of my first Schlesinger film" (*Deeper* 369), she declares and, apropos of *Tora! Tora! Tora!*, virtually boasts that: "After a half hour I fell into a comatose state ... then sneaked away" (*Deeper* 186). What makes her assessment of Mailer's *Wild 90* as "the worst movie that I've stayed to see all the way through" (*Going Steady* 10) such an ambiguous reproach is our awareness of how often Kael does not stay to see a movie all the way through. To explain why she did not review *Betrayal*, she confesses: "Because I couldn't sit through it. My body wouldn't let me" (*State of the Art* 14).

Kael also concedes trouble sitting at the typewriter. She explains her absence from the January 16, 1971, *New Yorker* as justifiable hooky: "The new movies defeated me—I couldn't think of anything worth saying about them" (*Deeper* 292). Kael is nothing if not conscientious about her professional

delinquency. She flaunts her negligence in viewing and writing as though waywardness were further proof of vivacity. In contrast to steadfast drudges who test the patience of their readers also, Kael presents herself as the Huck Finn of reviewers, ready to light out for the territory ahead when civilization seems too tedious. She identifies going to the movies with childhood spontaneity, and when a visit to the theater becomes a grown-up duty, she is out of there. "Who the hell goes to movies for mature, adult, sober art, anyway?" (Kiss Kiss 42), she asks, and her own slightly naughty use of hell echoes Huck Finn's defiant "All right, then, I'll go to hell!" that both damns the boy and saves him.

Kael's theology appears to be cinematic, inspired by the varied visions that appear on giant movie screens. In 1976, long before Schindler's List and The Last Temptation of Christ exposed a strain of latent piety in their directors, Kael chided Steven Spielberg, Martin Scorsese, and other young filmmakers as amoral aesthetes for whom technique is its own value. "Film is their common religion" (When the Lights 203), she complains, though the same might be said of Kael herself, who finds a kind of sacramental beatitude in the rituals of sharing flickering images with other avid viewers. But, if virtue is its own reward, it is not what Kael seeks out in darkened movie houses: "If there is any test that can be applied to movies," she claims, as though endorsing a Blakean/Nietzschean élan vital that transcends pious categories of good and evil, "it's that the good ones never make you feel virtuous" (Hooked 197). The worst thing that Kael can find to say about James Agee, her most distinguished American predecessor as a movie reviewer, is that "his excessive virtue may have been his worst critical vice" (Going Steady 60).

Anyone who dismisses virtue as an important value is likely to lose patience with the 613 commandments of Talmudic law. The religion of Kael the reviewer hardly seems to be the Judaism of her ancestors. She is not the only modern Jew who prefers to spend her Friday evenings in a movie house rather than a synagogue. Examining Joan Micklin Silver's immigration drama Hester Street, she states that Jake, the protagonist, is trying to escape from "that oppressive messianic Jewish tradition, with its stress on worthwhile activities" (When the Lights 80). The casual, derisive remark confounds several threads of Jewish tradition, not all of which shared a stress on messianism or on worthwhile activities. Despite its faith in the imminent advent of Messiah, Hasidism, for example, is a populist movement whose emphasis on personal fervor and disregard for the pedantic niceties of the Law resemble Kael's own rebellion against the orthodoxies of secular high culture. She also confounds

Jewish tradition with Anglo-American Puritanism and Victorianism, the genteel, Gentile culture of "virtue" against which so much of Kael's prose is in open rebellion. Kael's references to Jewishness are either rare or anxious, in part because she, the critic as liberator, seems to identify the ancient religion with oppression. Kael sees Woody Allen (né Allen Konigsberg), not Eddie Cantor, Morris Carnovsky, Paul Muni, or Zero Mostel, not Molly Picon, Shelley Winters, or Barbra Streisand, as the most overtly Jewish of movie performers. "No movie star (not even Mel Brooks) can ever have been more explicit on the screen about his Jewishness than Woody Allen," she declares, despite the fact that Allen's third-generation Jewishness is distinctive and comic for how very attenuated and vexed it is. If to be Jewish is to be ill at ease, either in or out of Zion, then it might be asserted that no movie critic (not even Manny Farber) can ever have been more explicit in print about his Jewishness than Pauline Kael. "For Woody Allen, being Jewish is like being a fish on a hook" (*Taking It All In* 91), observes Kael, who does not acknowledge other, freer fish. She dubs *Interiors,* Allen's austere, Bergmanesque study of an emotionally constipated family of uncertain ethnicity, "the ultimate Jewish movie" (*When the Lights* 428). Ultimately, *Interiors,* whose characters could pass for patrician Protestants, can be said to be Jewish only in its scrupulous avoidance of identifiably Jewish characteristics.

However, despite Kael's (unfavorable) assessment of *Interiors* as the quintessential Jewish film, she elsewhere faults another somber Allen drama, *Another Woman,* for being purged of precisely that "Jewishness" that she claims gives life to Allen's comedies. "You can see in his comedies that he associates messy emotions with Jewishness and foolishness and laughter" (*Movie Love* 15), observes the naughty Jewish girl from Petaluma, who usually champions messy emotions, foolishness, and laughter but does not herself associate them with Jewishness. The critic who dubs *Intolerance* "the greatest film ever made in this country" (*Deeper* 403) is hardly an advocate of ethnic or religious tribalism. It comes almost as a noble repudiation of American Jewish sectarianism when Kael claims that "Casey at the Bat" is better poetry than anything by Paul Simon (*Deeper* 28) or when she distances herself from fugitives of the Holocaust. Kael disparages the new Jewish immigrants she encountered in the 1930s for attempting to perpetuate precisely those elitist European attitudes against which her own demotic, Capraesque Americanism would rebel: "As a schoolgirl, my suspiciousness about those who attack American 'materialism' was first aroused by the refugees from Hitler who often contrasted their 'culture' with our 'vulgar materialism' when

I discovered that their 'culture' consisted of their having had servants in Europe, and a swooning acquaintance with the poems of Rilke, the novels of Stefan Zweig and Lion Feuchtwanger, the music of Mahler and Bruckner" (*I Lost It* 78). Kael's nonmaterialistic alternative to Rilke, Zweig, Feuchtwanger, Mahler, and Bruckner would not be Rashi, the *Zohar*, Yehudah Ha-Levi, and Agnon but rather *Citizen Kane, Godfather II, Mean Streets, Nashville,* and *Last Tango in Paris.*

"I regard criticism as an art," Kael declared, defensively but proudly. For almost four decades, the kind of criticism she practiced was brilliant performance art. To correspondents who belittled criticism, she replied: "If you think it so easy to be a critic, so difficult to be a painter or film experimenter, may I suggest you try both? You may discover why there are so few critics, so many poets" (*I Lost It* 234). The answer is a bit disingenuous. Without an institutional base, who bothers to write movie criticism? By contrast, the country is filled with uncommissioned, and even unpublished, poets. However, it is also true that film, the people's medium, is the one art about which everyone has an opinion. Americans who would not presume to comment intelligently on a chamber concert, an exhibition of paintings, or even a novel feel no compunction about expressing their reactions to any movies shown in the local shopping mall. The number of professional reviewers has multiplied epidemically since Kael began more than forty years ago; virtually every general interest newspaper and magazine and radio and TV station now runs movie commentary, and regular commentators recruited have included Edward Koch, Yogi Berra, and sundry schoolchildren. The artistry in all this prose is not always apparent, even as it accentuates Kael's distinctive merits. Choosing to align herself more with the impassioned American vernacular of Mark Twain, Will Rogers, and H. L. Mencken than with the mandarin stance of T. S. Eliot, Kenneth Burke, and Cleanth Brooks, she provokes strong reactions—to the movies on which she reports and to her reports on those movies. You antagonize more readers more easily if you write about *The Song of Norway* than about a recital by a visiting Norwegian contralto. Many remember Kael as a cranky contrarian, the critic with particularly harsh remarks about popular or critical favorites, including *Awakenings, The Big Chill, A Clockwork Orange, Gandhi, Rain Man, Shoah, The Sting,* and *West Side Story.* A stint at *McCall's* came to an abrupt end when she was fired for panning one of Hollywood's greatest hits, *The Sound of Music.* She dared call it *"The Sound of Money."*

However, Kael's books are the archives of an unusually receptive sensibility. She was an early, lonely enthusiast for many important figures, including

Robert Altman, Bernardo Bertolucci, Jonathan Demme, Brian De Palma, Jean-Luc Godard, and Satyajit Ray. Her ardent prose can be credited with saving *McCabe and Mrs. Miller* and *Last Tango in Paris* from oblivion and with at least doing valiant battle on behalf of *Hour of the Star, Melvin and Howard*, and *Shoot the Moon*. In her later years on the job, Kael railed increasingly against the soullessness of contemporary corporate productions, but it is remarkable how much she still could find to praise; even in *Movie Love*, which covers eighty-five movies from 1988 to early 1991, not, a preface warns us, "a time of great moviemaking fervor" (xi), one reader counted thirty-three favorable reviews (Smirnoff 42). She completed her final weekly contribution to the *New Yorker* with a word of affirmation. On February 11, 1991, Kael's parting review concludes with a comment on Sarah Jessica Parker in *L.A. Story*: "She's the spirit of L.A.: she keeps saying yes" (*Movie Love* 328). Yes, like Molly Bloom's closing words, it is a fitting valediction for the American critic who did most to spread the democratic creed of movie love.

Works Cited

Adler, Renata. "The Perils of Pauline." *New York Review of Books* 27, no. 13 (Aug. 14, 1980): 26–35.

Epstein, Joseph (Aristides). "Nicely Out of It." *American Scholar* 62, no. 4 (Fall 1993): 487–96.

Espen, Hal. "Kael Talks." *New Yorker*, March 21, 1994: 134–43.

Kael, Pauline. *The Citizen Kane Book: Raising Kane.* Boston: Little, Brown, 1971.

Kael, Pauline. *Deeper into Movies.* New York: Bantam, 1974.

Kael, Pauline. *5001 Nights at the Movies.* Expanded ed. New York: Henry Holt, 1991.

Kael, Pauline. *For Keeps: 30 Years at the Movies.* New York: Dutton, 1994.

Kael, Pauline. "The Function of a Critic." *McCall's*, Feb. 1966: 34, 38, 172.

Kael, Pauline. *Going Steady.* New York: Bantam, 1971.

Kael, Pauline. *Hooked.* New York: Dutton, 1989.

Kael, Pauline. *I Lost It at the Movies.* Boston: Little, Brown, 1954.

Kael, Pauline. *Kiss Kiss Bang Bang.* New York: Bantam, 1969.

Kael, Pauline. *Movie Love.* New York: Plume, 1991.

Kael, Pauline. "The Movie Lover." *New Yorker*, March 21, 1994: 133–34.

Kael, Pauline. *Reeling*. New York: Warner, 1976.

Kael, Pauline. *State of the Art*. New York: E. P. Dutton, 1985.

Kael, Pauline. *Taking It All In*. New York: Holt, Rinehart and Winston, 1984.

Kael, Pauline. *When the Lights Go Down*. New York: Holt, Rinehart and Winston, 1980.

Kellman, Steven G. Telephone interviews with Pauline Kael, Sept. 8, 1993, April 30, 1994, and May 4, 1994.

Mailer, Norman. *The Armies of the Night: History as a Novel / The Novel as History*. New York: New American Library, 1968.

Murray, Edward. *Nine American Film Critics*. New York: Ungar, 1975.

Sawhill, Ray, and Polly Frost. "Kaleidoscope." *Interview* 19 (April 1989): 98–101, 130.

Smirnoff, Marc. "Pauline Kael: The Critic Wore Cowboy Boots." *Oxford American* 1, no. 1 (Spring 1992): 40–51.

Weil, Simone. *The Need for Roots: Prelude to a Declaration of Duties toward Mankind*. Trans. Arthur Wills. New York: Octagon, 1979.

Esperanto at the Movies

2009

American monolingualism is nowhere more insistent than at the movies. In Ridley Scott's medieval epic *Kingdom of Heaven* (2005), Saladin, played by Ghassan Massoud, negotiates with a hostile French Crusader in halting modern English. In Stanley Kubrick's *Spartacus* (1960), it is not Latin in which Tony Curtis, playing Roman slave Antoninus, delivers his lines, inflected by the Bronx. Like Marlene Dietrich, Catherine the Great grew up speaking German, but, despite all her accomplishments, the Russian monarch, who wrote her memoirs in French, never spoke English, as Dietrich does portraying her in Josef von Sternberg's *The Scarlet Empress* (1934).

The conventions of the Hollywood Western compel Native American characters to stammer their thoughts in pidgin English, even when conversing among themselves. Indian speak with forked tongue, when that tongue is tied by the studio chiefs. But Kevin Costner's *Dances with Wolves* (1990) stands out from the pack by conducting much of its dialogue in Lakota Sioux, with subtitles for the benefit of viewers who cannot comprehend the words of the Great Plains tribe. More typical is Delmer Davies's *Broken Arrow* (1950), whose narrator, Tom Jeffords (James Stewart), announces at the outset: "I was involved in the story and what I have to tell happened exactly as you see it—the only change will be that when the Apaches speak, they will speak in our language." Putting the words of an alien tongue into the mouths of characters not fluent in it seems like a minor concession to audience deficiency, until one tries to imagine *The Bridge on the River Kwai* (1957) if the script had obliged its British and American prisoners of war to communicate among themselves in Japanese. In *Waterloo* (1970), Rod Steiger's Napoleon speaks only the language of his Anglo-Saxon adversary.

At the beginning of the 1983 remake of *To Be or Not to Be*, the dark comedy of a Polish theater troupe trapped in wartime Warsaw, actors Mel Brooks

and Anne Bancroft exchange angry words, and the medium of their altercation is, appropriately, Polish. However, several minutes into the proceedings, a disembodied, Olympian voice announces: "Ladies and gentlemen, in the interests of sanity and clarity, the rest of this movie will *not* be in Polish." And Brooks and Bancroft immediately resume their squabble, in English. *To Be or Not to Be* thereby mocks the movie convention that demands suspension of linguistic disbelief; even as the actors use only English, we are asked to assume that their characters are really speaking something else. Although Hollywood was created largely by immigrants from Eastern Europe, the founding moguls made their movies talk almost exclusively in the language of their adopted country. As far as the studios have been concerned, if English was good enough for Jesus Christ, as it was in *The Robe* (1953), *The Last Temptation of Christ* (1988), and other biblical dramas (but notably not *The Passion of the Christ* [2004]), it was good enough for Moses, Alexander the Great, Christopher Columbus, Michelangelo, Wolfgang Amadeus Mozart, Marie Curie, Joseph Stalin, Oskar Schindler, Eva Perón, Bugs Bunny, and Darth Vader.

It was good enough for James Fenimore Cooper, Herman Melville, Emily Dickinson, Mark Twain, William Faulkner, and Toni Morrison, but the literature of the United States has also been written in many languages other than English. Texts in Arabic, Chinese, French, German, Hawaiian, Italian, Navajo, Norwegian, Polish, Russian, Spanish, Swedish, Vietnamese, Welsh, and Yiddish, among many others, also deserve a place in the American literary canon and have recently been attracting critical attention. However, the enormous costs of creating and marketing commercial feature films discourage linguistic variety. It is a safer investment to produce a script in English than Czech, Nahuatl, or Zulu, in fact than any alternative to the world's most popular second language. Cinematic imports in such common languages as Chinese, French, German, Italian, Japanese, and Spanish are generally consigned to art-house ghettoes, and even the most successful almost always fare better at the domestic box office when remade in English. According to IMDb, Coline Serreau's *Trois hommes et un couffin* qualified as a foreign hit in the American market when it grossed $2,052,466 in 1985. However, Leonard Nimoy's 1987 remake, *Three Men and a Baby*, took in $167,780,960 domestically. Cameron Crowe's *Vanilla Sky* (2001) earned $100,614,858 in the United States, far exceeding the $368,234 that the Spanish original, Alejandro Amenábar's *Abre los ojos*, earned during its American release in 1997.

Nevertheless, a small body of American feature films in languages other

than English does exist. During the 1930s, the first decade of talking movies, more than sixty features, including *Der Yiddishe Koenig Lear* (1935), *Yidl Mitn Fidl* (1936), and *Mirele Efros* (1939), were produced in the United States in Yiddish. Spanish-language productions included *El presidio* (1930), *El tenorio del harem* (1931), *¿Cuándo te suicidas?* (1931), *Contra la corriente* (1935), *Alas sobre el Chaco* (1935), *El día que me quieras* (1936), and *La vida bohemia* (1937). A smaller group, including *La Donna bianca* (1930), *La Vacanza del diavolo* (1931), and *Amore e morte* (1932), was made in Italian. More recently, Wayne Wang made *Chan Is Missing* (1982) in Cantonese and English, *Eat a Bowl of Tea* (1989) in Mandarin and English, and *The Joy Luck Club* (1993) in Cantonese, Mandarin, and English. Ham Tran filmed *The Anniversary* (2003) entirely in Vietnamese. *El Súper* (1979), *El Norte* (1983), *La Ciudad* (1998), and *Maria Full of Grace* (2004) were each made mostly in Spanish, as was *Hombres armados / Men with Guns* (1998), whose writer-director, John Sayles, taught himself the language and determined to create dialogue appropriate to his screenplay's setting, an unnamed Latin American country. Like *Dances with Wolves*, *The Godfather Part II* (1975) also makes use of English subtitles, during the extended flashback to Vito Corleone's childhood in Sicily, when he, quite naturally, speaks Italian. And not the least unusual feature of *The Passion of the Christ* is the fact that, in order to underscore the biblical story's authenticity, director Mel Gibson had his characters speak Latin and Aramaic throughout (though most would have been speaking Greek instead). In *Apocalypto* (2006), set in sixteenth-century Mesoamerica, Gibson has his characters speak Yucatec Maya.

Derived from Greek, the term *hapax legomenon* refers to a word or phrase that occurs only once in the recorded history of a language. And within the extensive archives of American film production the singular work that remains a cinematic *hapax legomenon* is a seventy-six-minute allegorical horror fantasy called *Incubus*. Written and directed by Leslie Stevens in 1965, it is said to be the only feature film ever made in Esperanto: "Incubus *estas la unusola filmo usona iam farita tute en Esperanto*," declares the website marketing its DVD. Thirty years after its release, *Incubus* was lost to American audiences because of negligence at a Los Angeles laboratory that was storing what its producer, Anthony Taylor, believed were all the existing prints. However, in 1996, he discovered one surviving copy at the Cinémathèque Française in Paris, where weekly midnight screenings had become a cult ritual. Following protracted negotiations to make a copy and take it out of France, Taylor restored the dilapidated print, superimposed English subtitles over the French

ones, and put the work back into circulation in the United States in 1999. A DVD was marketed in 2001, and the film was aired on the Sci Fi Channel in 2002. Still the only feature film ever made in Esperanto, the artificial language introduced by its inventor, Warsaw oculist Ludwig L. Zamenhof, in 1887, *Incubus* has acquired a devoted American following since its rediscovery. Though one reviewer, writing for fantasticadaily.com under the byline Mervius, dismissed the work as "dated, melodramatic, and silly," Keith Bailey, at badmovieplanet.com, called it "a visual feast" and "a weirdly compelling movie." At Daily-Reviews.com, Rick Luehr, assigning it four out of five stars, called *Incubus* "one of the most original films in American cinema history." Though *Entertainment Weekly* and Salon.com both reported on the return of *Incubus*, other prominent publications continued to ignore the film.

Because of its rationalized grammar, simplified phonology, phonetic orthography, and a familiar lexicon drawn from several natural languages, a working knowledge of Esperanto can be acquired with relative ease and speed. Zamenhof designed his linguistic system to facilitate universal adoption, in the hope that a world language would encourage global peace and justice; in Esperanto, the name of the language itself means "I hope." And the hope is that adoption of a common tongue would eliminate many of the causes of misunderstanding and oppression. "*Ni estas movado por la homa emancipiĝo*" (We are a movement for human emancipation), concludes *The Prague Manifesto* issued by the eighty-first World Esperanto Congress in 1996.

The Universal Esperanto Association estimates that ten million to fifteen million people speak the language, though other calculations place the figure as low as one hundred thousand. Scattered throughout the world, with concentrations in parts of Asia and Europe, the Esperanto population is relatively sparse in North America, hardly enough in one location to keep a movie theater filled for a week. Despite more than forty million Spanish speakers within the United States, attendance at Spanish-language films is anemic. In 2019, box office revenue in the United States for the Korean *Parasite* surpassed that of all previous films not produced in English. Yet its $22,633,689 gross pales in comparison to the $858,373,000 that *Avengers Endgame* took in during the same year. At least for the purposes of capitalizing on the North American market, releasing a film in Esperanto was even more perverse than releasing one in Spanish, however appropriate Zamenhof's artificial language might be to the themes of the *Incubus* screenplay.

Except for Stevens, who initiated and drove the project, the limited

population of Esperantists did not include anyone in the cast or crew of *Incubus*. Stevens had created and produced *The Outer Limits* and recruited several associates, including young William Shatner, for a movie that promised to be as strange as anything on that science fiction television series. Before production began, everyone was sent to "Esperanto Camp," a ten-day session of instruction by tutors in the language. Once shooting began, Stevens insisted that only Esperanto be spoken on the set, a restriction that one actor later claimed resulted in the dazed look visible on the faces of characters. Closer in style to Japanese Noh performance, the Symbolist theater of Maurice Maeterlinck or William Butler Yeats, and German Expressionist cinema than classic Hollywood naturalism, the film's hieratic acting, like Esperanto itself, strives to embody universal verities.

Set in the fictional village of Nomen Tuum (Latin for Thy Name, an invocation of the Lord's Prayer that immediately alerts the viewer to the presence of religious themes), the film dramatizes a fierce struggle by the forces of darkness to vanquish a human exemplar of virtue. In the opening sequence, Kia (Allyson Ames), a beautiful young succubus, entices a vain and lecherous man into death and damnation. It is her third conquest of the day, but Kia is not content. "I am weary of luring ugly souls into the pit," she complains to Amael (Eloise Hardt), an older succubus. "I want to find a saint and cut him down." The opportunity soon presents itself when she observes Marc (played by Shatner, a year before becoming Captain James T. Kirk in *Star Trek*) walking out of church. Accompanied by his virtuous sister, Arndis (Ann Atmar), Marc is a military hero still recovering from wounds incurred during courageous defense of his comrades. Amael warns Kia that Marc is a genuinely good man and not to underestimate the power of love to thwart her evil designs. "Then he has a soul worth fighting for!" insists Kia, eager to take on the challenge.

The rest of the film follows Kia's efforts to seduce and destroy Marc. Marc is indeed smitten by the ravishing stranger, but he resists her entreaties to follow her to the sea. Instead, Marc draws Kia, who falls helplessly in love with her prey, back inland, toward the church. Indignant that an unsuspecting succubus has been contaminated by goodness, Amael summons up the Incubus (Milos Milos) from subterranean depths. Along with a band of succubi, the Incubus sets out to retrieve Kia and wreak vengeance on Marc. Revenge takes the form of the demonic rape of Marc's sister, but the effort to deliver Kia leads to a climactic confrontation on the threshold of the church. Appropriating the form of a monstrous snarling goat, the Incubus engages in

mortal—and immortal—combat with Marc, a human agent of divine love. And loses.

Preposterous as realistic drama, *Incubus* must be read as psychomachia, an allegory of the struggle between the forces of light and the forces of darkness for possession of the soul. Aside from the language of its dialogue, the most remarkable feature of the film is its expressive black-and-white lighting and cinematography. Early in a career that would earn him three Academy Awards, for *Butch Cassidy and the Sundance Kid*, *American Beauty*, and *The Road to Perdition*, cinematographer Conrad Hall deliberately overexposed footage in the first half of the film, set in luminous daylight before the arrival of the Incubus. However, moments after Kia, pretending to be a lost traveler, arrives at the cottage that Marc shares with Arndis, an unexpected lunar eclipse darkens the frame, temporarily blinding Marc's sister. The rest of the film belongs to the night, to the powers of darkness that, like the succubi dressed in dark cassocks when they perform their black mass, set about to extinguish the radiance emanating from Arndis and Marc.

Examined in the light of day, *Incubus* is silly stuff, the kind of hokey dross that thrives on midnight screenings, when reason and discernment are asleep and the rowdy spirit of a youthful crowd proclaims collective carnival. To relish fully the film's campy bravura, it might help to experience it stoned, the condition of cast and crew, Hall claims in an interview on the DVD, throughout the ten days in May 1965 that it took to finish shooting. While they dominate contemporary geopolitics, Manichean oppositions of absolute evil and absolute good disappeared from serious art when chiaroscuro entered painting. Filmed in part at the Mission San Antonio in Monterey, California, *Incubus* is a postmodern invocation of pre-Reformation Christian motifs. On the DVD, Taylor, the producer, recounts how, in order to obtain permission to use the old Spanish Catholic mission, as well as the state park at Big Sur, Taylor, the producer, disguised the project, submitting a stealth script as an alternative to what they were in fact shooting. However, its title, *Religious Legends of Old Monterey*, might do as well for the finished work.

A pioneer of independent American cinema at a time when big studios still controlled production, distribution, and exhibition, *Incubus* was the last film released by Daystar, a company created by Taylor. Its budget was approximately $100,000, according to Taylor, who recalls how, unable to get his film screened in commercial theaters in the United States, Daystar soon went bankrupt. One of the practical reasons for the peculiar choice of language for *Incubus* had been the belief that the art-house market, accustomed

to presenting subtitled films from overseas, would be receptive. However, any expectation that Esperanto, the language of hope, might be good for business proved unfounded. Aside from a few festivals as well as France, where, without being canonized along with Jerry Lewis, it was hailed in *Paris Match* by novelist Julien Green as "the greatest fantasy film since *Nosferatu*," *Incubus* remained unseen for more than thirty years.

Hall's innovative camera work, with contributions from William Fraker (who later served as director of photography for more than forty productions, including, not surprisingly, *Rosemary's Baby*), is still worth viewing. When the succubus Kia, finding herself in a church, panics at the sight of Christian effigies, the camera rotates vertically 180 degrees as she dashes past, back out into the night. Another shot frames her in the distance, through the window of an abandoned house. The effect, in that as in other long shots and in the use of low angles, is to aestheticize the proceedings, reinforcing the use of black and white and Esperanto to lift the story into myth.

Translated into English, much of the dialogue is as wooden as the burning stick Marc uses to defeat the Incubus. "He has defiled you with love," Amael, disgusted by Marc's pious hold on Kia, declares. "Revenge, sister, revenge!" Figures in an allegory, the characters declaim instead of speaking. But, heard in Esperanto, an artificial language alien to movie soundtracks, the hackneyed, sententious lines are defamiliarized, their speakers deautomatized. What most distinguishes *Incubus* from the black mass of formulaic horror flicks is its use of Zamenhof's linguistic invention to make strange the bizarre clichés of demonic possession. In *What's Up, Tiger Lily?* (1966), Woody Allen dubbed incongruous English lines over the dialogue of a Japanese gangster movie, thereby defamiliarizing tediously familiar content. The unusual choice of language in *Incubus* likewise produces an alienation effect, though one that was not at least intended to be comic. Esperanto, which appears to be dubbed over Ames's voice and pronounced by Shatner with the French accent of his native Montreal, helps stylize what might have seemed the record of a self-indulgent troupe of actors camped at Big Sur. Anglophone viewers are even able to experience another layer of abstraction. In addition to the American version (with English subtitles blocked in over the French that Taylor was not able to remove), the DVD offers the variant that was a hit at the Cinémathèque Française—and an opportunity to experience *Incubus* through the distancing scrims of both an Esperanto soundtrack and French subtitles.

Nomen Tuum could be located in any wooded temperate region that

possesses a seacoast. The war that Marc has just returned from is never specified, nor is the army for which he fought. The year, too, is indeterminate; guileless siblings Marc and Arndis share a timeless fairy-tale cottage in a world in which the most advanced technological device is a church bell. Similarly, the use of Esperanto enables the story to elude the coordinates of space and time. Like the Incubus, it is otherworldly. Natural languages, by contrast, anchor their speakers in a particular culture and era. The modern English in which Stevens wrote his screenplay, before it was translated into Esperanto, would have undercut his aspirations to transcend the familiar. And the international cast he assembled, including narrator Paolo Cossa from Italy, Milos from Yugoslavia, Shatner from Canada, and others from various regions of the United States, would have emitted a distracting array of accents in English. However, Esperanto, like mathematics, is universal, and it is an appropriate medium in which to reenact the eternal clash of good and evil.

Viewing *Incubus* in the twenty-first century, as a lost cinematic curiosity, a newly opened time capsule from the 1960s, adds yet another layer of abstraction to the experience. Furthermore, the production that disguised itself as *Religious Legends of Old Monterey* has itself become legendary not only for its use of Esperanto and its disappearance from circulation for three decades. The infamous "curse of *Incubus*" now shadows the film, like one of the screenplay's own malevolent succubi. According to Shatner, who on the DVD seems to relish spinning supernatural tales about a supernatural movie (he also alleges that Gene Roddenberry intended to make *Star Trek* in Esperanto), an unknown hippie who wandered near the set in Big Sur was treated rudely by the cast and crew. In response, he pronounced a malediction on them all. The consequence—or at least, the aftermath—was not only the commercial failure of *Incubus* and the bankruptcy of Daystar. A few weeks after the film wrapped, Atmar committed suicide, and within the year, after appearing in *The Russians Are Coming, the Russians Are Coming*, Milos killed Barbara Ann Thompson, the estranged fifth wife of Mickey Rooney, and then himself. Later, Hardt's daughter was kidnapped and murdered. And Dominic Frontiere, who composed the eerie music for the film, spent nine months in prison on a charge of evading taxes for tickets to the 1980 Super Bowl he had scalped. Shatner and Hall thrived, but Stevens, whose marriage to Ames ended in divorce not long after completion of *Incubus*, died suddenly, of a blood clot, in 1998.

The cover of its DVD advertises *Incubus* as "the only film shot entirely

in the artificial language of Esperanto." The claim is belied by *Angoroj*, a crime drama set in Paris that was completed in 1964, a year before *Incubus*. Despondent over his failure to find a distributor for *Angoroj* (Esperanto for Agonies) and to recoup his substantial financial investment in it, filmmaker Jacques-Louis Mahé reportedly destroyed most of the prints. The film is not readily available, but, at only sixty-one minutes, would not qualify in any case as the first feature-length film in Esperanto.

A few more widely known movies have offered bit parts to Zamenhof's artificial language. In *The Great Dictator* (1940), Charlie Chaplin, mocking the anti-Semitism of his Hitler proxy, Adenoid Hynkel, flaunts Zamenhof's Jewish background by printing the signs in shop windows of the Tomania ghetto in Esperanto. (In *Mein Kampf*, Hitler denounced Esperanto as part of a global Jewish conspiracy, and his Nazi régime singled Esperantists out for elimination, killing all three of Zamenhof's children.) In *Gattaca* (1997), a dystopian drama about a totalitarian society in which genetic engineering eliminates individual freedom, the fact that the public address system issues official announcements in Esperanto, a medium created through linguistic engineering, intensifies the dread of sacrificing our humanity to technocracy.

Poetry and fiction have been published in Esperanto, which is said to have thus far produced a library of thirty thousand volumes. But it was mere whimsy when Elvis Costello issued the liner notes to his 1986 album *Blood and Chocolate* in Esperanto and Michael Jackson used Esperanto in his 1995 music video *Redeeming Eastern Europe*. (Recurring charges of pedophilia against the singer make even more bizarre its inclusion of children crying "*Mi amas vin, Michael Jackson*"—I love you, Michael Jackson.) And it seems unlikely that, at least in the United States, an Esperanto movie industry will arise from the impetus of *Incubus*. Motion pictures are a popular and populist art that affirms the messy specificities of culture and thrives on the vernacular. When Marlon Brando murmurs, "I could have been a contender," and Mae West suggests, "Let's get out of these wet clothes and into a dry Martini," the distinctive English words suggest details about who and where they are that a neutral language designed to be devoid of personal idiosyncrasies cannot provide. A vibrant Esperanto movie culture will not be possible until there is a critical mass of native speakers using variants of the language that reflect region, class, and historical moment.

Like the artificial smoke made to billow above the ground where demons menace Marc and Arndis, Esperanto in *Incubus* suggests something spooky; we experience otherworldly happenings to the accompaniment of the putative

world language. Goran Markovic intensifies the horror in his 1987 horror film *Vec Vidjeno* by inserting some Esperanto in addition to the Serbo-Croatian expected in its Belgrade setting. However, it is unlikely that many other horror or science fiction screenwriters will follow the example of *Incubus* and put all their dialogue into Esperanto, if only because Stevens has already tried it. Devices for *ostranenie*—making strange—are productive only as long as they have not themselves become familiar, and anyone familiar with the alienating effects of Esperanto in *Incubus* would surely begin to take the language for granted in other films. "Been there, done that" is the American idiom, whose closest equivalent in Esperanto might be the very title of Markovic's cinematic latecomer: *Vec vidjeno* (Esperanto for déjà vu). Unless Esperanto becomes a living language, *Incubus* is destined to remain what those who still speak Latin call *sui generis*.

All the Glittering Prizes

2006

Mourning the early death of poet Edward King, young John Milton confronted the apparent futility of the literary calling. In "Lycidas," he asks:

> Alas! what boots it with uncessant care
> To tend the homely slighted shepherd's trade
> And strictly meditate the thankless Muse?

Why, when recompense for most is uncertain and slight, do poets write?

"Writing," according to Georges Simenon, "is not a profession but a vocation of unhappiness." Why, then, would any sane adult elect that vocation? Milton answers:

> Fame is the spur that the clear spirit doth raise
> (That last infirmity of noble mind)
> To scorn delights, and live laborious days.

Milton managed to make himself the most famous English poet of his time, but he was operating blindly, without the elaborate edifice of stipends, prizes, and academies that today is used to create and conserve artistic reputations. If Milton were living at this hour, he would have received a MacArthur "genius" grant, won a Lannan Lifetime Achievement Award, and appeared on both *Fresh Air* and the *PBS NewsHour*. *Paradise Lost* would have been designated Denver's citywide reading assignment for November.

Poetry itself might be the record of the best and happiest moments of the happiest and best minds, but writing in our culture is a gladiatorial occupation, and authors establish their credentials by besting rivals for all the glittering prizes. The contemporary poet's public identity resides as much in honors won as poems published. Future obituaries are likely to summarize the accomplishments of Joyce Carol Oates by listing a few of the more than two

dozen major awards she has already garnered. Oscar Hijuelos, the author of *The Mambo Kings Play Songs of Love*, will always be known as the first Latino to win the Pulitzer Prize. In 1991, Nadine Gordimer acquired a permanent new epithet: Nobel Laureate.

James F. English, a professor at the University of Pennsylvania whose website cites one award for teaching and one for his undergraduate senior thesis, estimates that 1,100 literary prizes are bestowed annually in the United States, 400 in the United Kingdom. Throughout the world, the number of film awards, 9,000, is about twice the annual output of feature-length films. Accomplishment in theater, music, dance, painting, sculpture, photography, architecture, and other arts is similarly defined through lavish laureling. Intent on grabbing all the bays, can artists pause to smell the roses? In *The Economy of Prizes*, English counts more than one hundred award shows broadcast in the United States each year, though he claims, incorrectly, that, amid all the Grammys, Emmys, Tonys, and Golden Globes, literary award ceremonies "have yet to find their way onto television" (the National Book Awards and the National Book Critics Circle presentations are regularly aired on C-SPAN). He even itemizes 240 separate honors conferred on Michael Jackson from 1970 to 2003, and he reports on the Lichfield Prize, 5,000 pounds sterling for the best unpublished novel set in Lichfield, Staffordshire.

The widespread rituals of bestowing cultural accolades merit more than just anthropological interest. The works that win the awards are the ones that get taught in schools, hung in museums, played on the radio, screened in theaters, and absorbed into our individual and collective psyches. Prizes determine not just which might be the greatest novels and statues but also who we are as persons and societies. English notes that, though they were a feature of festivals in ancient Attica, prizes have proliferated without precedent during the past century. He points to 1901, when the Nobel Prize was inaugurated, as the start of the present era of formalized, juried praise-singing. Since arts competitions have become homologous with sporting events, it is no random coincidence that the first modern Olympics were staged in 1896, the year in which Alfred Nobel left his bountiful bequest. Contending that "the stunning rise" of prizes in literature in particular and the arts in general over the past hundred years "is one of the great untold stories of modern cultural life," English sets out to tell it. The result is not so much a single coherent story as a fascinating, irritating blend of information, anecdote, and theory.

A reasonable reaction to contemporary society's surfeit of tribute—to the

concoction of American Music Awards, American Comedy Awards, People's Choice Awards, Addys, MTV Movie Awards, Cable Ace Awards, ESPYs, Independent Spirit Awards, AVNS (Adult Video News Awards, for pornography), Golden Heart Awards (for romance writing), Mary Diamond Butts Awards (for work executed by means of threaded needle by an artist under forty who resides in Ontario), and others—is revulsion at the flatulence of ubiquitous congratulation. An award for everything and everyone maps out a Neverland of egalitarian excellence whose distinguished citizens are indistinguishable from those in Garrison Keillor's Lake Woebegone, where "all the women are strong, the men good looking, and all the children are above average." The chorus of encomia is making us tone deaf.

The pathology of cultural prizes is nowhere more apparent than in the one that takes the cake for hype, the Oscar. Its annual—widely imitated—ceremony is attended electronically by an immense global audience, and what viewers see is a tacky exercise in self-promotion. Not only have choices by the American Academy of Motion Picture Arts and Sciences often demonstrated egregious taste: *The Great Ziegfeld*, not *Modern Times* (1936); *How Green Was My Valley*, not *Citizen Kane* (1941); *The Greatest Show on Earth*, not *Singin' in the Rain* (1952); *Around the World in Eighty Days*, not *The Searchers* (1956); *Gigi*, not *Vertigo* (1958); *Oliver!*, not *2001: A Space Odyssey* (1968). But, more effectively than nitrate stock, the entire enterprise has corroded the art of cinema. Fixation on histrionic performances by potential best actors and actresses promotes a star system that undercuts collaborative creativity. The bundles spent by studios on campaigns to acquire an Oscar could finance dozens of finer films. Furthermore, since the advent of Oscar in 1928, it has become customary for audiences to stagger out of a theater buzzing not about a movie's themes or style but about its odds of earning that famous piece of sculptured kitsch. Because of Oscar, going to the movies has come to resemble a day at the races; we are there not to savor equine speed and grace but to handicap performances. It coarsens and cripples the experience if our primary focus is on assigning trophies.

In no field more than film have prizes so distorted the timetable of releases. It is not true that American movies repeat their opening credits at the end in order to accommodate the meager memory spans of Oscar voters, but a feature that is screened in the spring is usually out of sight, out of mind, and out of luck the following winter, when nominations are made. So studios reinforce amnesia by flooding the market with their best products between Thanksgiving and Christmas. Has any geneticist postponed publishing

research into the DNA code because the Nobel Prize for Medicine is announced in the fall? To a moviegoer, Oscar has redesigned the calendar more than anyone else since Pope Gregory XIII. Because of the familiar statuette, the cinematic year now consists of two months: January–October and November–December. We could call this chronological unit, technically, a loony year, and during most of it audiences, especially outside New York and Los Angeles, can count on motion pictures that merely take the prize for froth. Then suddenly, when frost forms on the windshield and turkeys are at risk, distributors glut the market with worthy releases, just in time to qualify for an Oscar nomination. The Academy Awards make the movie year seem like most basketball games; miss everything but the final two minutes, and you can still catch anything worth seeing.

But to complain about prizes is to participate in a conventional ritual of derision that, according to English, strengthens the very system of rewards that it assails. He documents how the most reputable prizes were born in scandal and how disparagement has been the bass obbligato accompanying them throughout their history. Composing in honorable obscurity for most of his career, Charles Ives insisted that "awards are merely the badges of mediocrity." Yet he accepted a Pulitzer seven years before his death. Choosing René Sully-Prudhomme over Leo Tolstoy in 1901 ensured that bile not champagne would launch the Nobel Prize for Literature. Controversy has been revived periodically not only with the consecration of dubious masters such as Henrik Pontoppidan, Pearl Buck, and Dario Fo but also the omission of canonical figures such as Mark Twain, Thomas Hardy, Henrik Ibsen, Marcel Proust, Virginia Woolf, Osip Mandelstam, James Joyce, Rainer Maria Rilke, Fernando Pessoa, Jorge Luis Borges, Léopold Senghor, Vladimir Nabokov, and Philip Roth. The first Bollingen Prize, awarded in 1949 to Fascist collaborator Ezra Pound, provoked such outrage that Congress withdrew official sponsorship. But, like other tarnished awards, the Bollingen battened on the battering it took from outraged critics.

Though not founded until 1969, the upstart Booker succeeded in becoming Britain's premier literary prize largely through a series of attention-grabbing scandals. In 1971, Malcolm Muggeridge resigned in disgust from the Booker jury, citing the dreadful quality of the works he was asked to judge. During the following year's award ceremony, John Berger condemned Booker Brothers, the agribusiness that sponsored the prize he was accepting, for exploiting black plantation workers in Guyana. And in 1973, J. G. Farrell used his acceptance speech to berate the dirty hands that were feeding him

a dinner and a prize for *The Siege of Krishnapur*. However, public furor delighted administrators of the Booker Prize, whose private correspondence had been expressing despair that their ambitions might wither in oblivion. The subsequently renamed Man Booker Prize then rerenamed the Booker Prize has thrived not despite but because of hostility to it. "Far from posing a threat to the prize's efficacy as an instrument of the cultural economy," writes English, "scandal is its lifeblood; far from constituting a critique, indignant commentary about the prize is an index of its normal and proper functioning." A brouhaha over sexual abuse that caused the Swedish Academy not to award a Nobel in 2018 has not appreciably diminished interest in the prize.

Similarly, refusals by George C. Scott and Marlon Brando to accept an Oscar and by Jean-Paul Sartre to accept a Nobel Prize merely reaffirmed the authority of the institutions they were attempting to reject. The same dynamic applies to mock-prizes. Just as parody is paying tribute with rolls of pennies instead of a check (acknowledged by Bill Clinton when he invited Gary Trudeau to a White House dinner), the Golden Raspberries, Golden Turkeys, Ig-Nobels, and other attempts at travesty are the drollest form of flattery. By inverting criteria for the established prizes, they reaffirm their values, boost their stock by making them a laughingstock. Presuming to single out the worst performers and worst movies of each year, the Razzies have taken special aim at actors with working-class backgrounds such as Sylvester Stallone, Madonna, and Burt Reynolds. English thus observes that "for all their self-proclaimed 'tackiness,' the Razzies are more committed to the policing of good taste than are the Oscars, as well as being more elitist in their effects."

English recounts how in 1974 Thomas Pynchon dispatched comedian "Professor" Irwin Corey to accept a National Book Award for *Gravity's Rainbow* on his behalf by delivering "an incomprehensible amalgam of awards-banquet platitudes, academic jargon, political rant, and pure nonsense." But he neglects the case of Stephen King, whose apotheosis in 2003 with a lifetime achievement award by the same institution provoked widespread disdain among many already skeptical about the artistic legitimacy of the NBA. Nor does he discuss foetry.com, the website whose mission has been to expose the conflicts of interest and fee scams rampant among poetry contests. Yet the organized practice of dispensing kudos is so resilient that it absorbs and exploits ridicule and obloquy. In fact, the culture of cultural awards is steeped in self-irony; it does not do to appear too earnest or avid about the business of dispensing and receiving honors. Prize judges and

their defendants are expected to maintain a delicate balance of reverence and disparagement.

Nevertheless, the vulgar breach of etiquette committed by Toni Morrison and her allies when they openly lobbied for a Pulitzer did not prevent *Beloved* from winning the prize in 1988. "The Pulitzer Prize in fiction takes dead aim at mediocrity and almost never misses," wrote William Gass, who was both juror and recipient of numerous awards, in an acerbic essay that takes dead aim at the entire institution of literary accolades. In 1993, when the K Foundation, shadowing the Turner Prize, known as "the Booker Prize for Art," awarded sculptor Rachel Whiteread £40,000 for having produced "the worst body of work in the preceding twelve months," it doubled the £20,000 bestowed minutes earlier by the Turner jury on the "best" artist: Rachel Whiteread. In a culture that confounds fair and foul, publicity and renown, the Turner Prize endures and thrives.

Much of the discussion in *The Economy of Prestige* is based on a financial metaphor. Drawing on Pierre Bourdieu's theory of symbolic capital, it treats prizes as the currency of artistic celebrity—"the most ubiquitous and awkwardly indispensable instrument of cultural transaction." English does not ignore the business of culture, the economics of producing, distributing, and consuming works of art. He notes the intricate infrastructure of fundraisers, judges, publicists, and other functionaries necessary to sustain a prize year after year. And he provides pointed information about the cash stipends for awards, the origins of the fortunes that endow awards, and the commercial operations of the awards industry. However, he is more interested in culture as a parallel economy, in the symbolic rather than monetary value of prizes. And he has much of interest to say about the globalization of the cultural economy, how in recent decades international awards have superseded national authority in a radical deterritorialization of prestige. He explains that the musical group Ladysmith Black Mambazo achieved its eminence, despite opposition from the South African apartheid régime, because Grammys, Golden Lions, and other symbolic currency effected the "conversion of local into global capital." An earlier example might be what happened in 1951, when the Venice Film Festival bestowed its Golden Lion on Akira Kurosawa's *Rashomon*. A prophet without honors in his native Japan, Kurosawa became a plutocrat in the global economy of prestige.

An accounting of esteem rather than financial assets provides the truest measure of an artist's estate. Richard Otway and Edgar Allan Poe died destitute, and Zora Neale Hurston was buried in a pauper's grave. But their

worldly insolvency has no bearing on their standing in the literary stock market. Despite enormous debts, Richard Sheridan received a spectacular funeral and was interred in Westminster Abbey. Yet, though the correlation between winning respect and selling books, films, or recordings is weak (English reports that it is strongest for porn awards), the symbolic capital of cultural homage sometimes does take the form of fungible commodities. The medal comprising the Nobel Prize traditionally contained seven ounces of pure gold, which meant that melting it down might have fetched more than $10,000, depending on the fluctuating price of gold. However, the economy of prestige has grown so bullish that it would now be far more profitable to sell a Nobel Prize in the secondary medals market than in the market for melted precious metal. In 2014, in order to finance further research, molecular biologist James Watson sold his Nobel medal for $4.76 million, though the buyer, Russian billionaire Alisher Usmanov, promptly returned it to Watson, as a donation. In a graph tracking the price of the Nobel Prize as a bar of gold versus a symbolic collectible, English identifies 1985 as the point of parity; since that time the collectible value has soared above $60,000, and the commodity value has fallen below $1,000. However, because the secondary market in cultural trophies is directly affected by symbolic significance, Ernest Hemingway's Nobel medal would presumably bring in more on eBay than Rudolf Eucken's. Yet, as the Book of Proverbs (22:1) declares: "A good name is more desirable than great riches, a good reputation than silver and gold." Prizes—whether the £100,000 IMPAC Literary Prize or the National Book Critics Circle Award, which nets the winner nothing but a certificate and a handshake—are one way for artists to acquire a good name.

His eyes on the prizes, English does not look at other forms of symbolic cultural capital, including honorary degrees, halls of fame, and presidential appointments. In 1976, Gore Vidal declined an invitation to be inducted into the National Institute of Arts and Letters, explaining: "I already belonged to the Diners Club." Yet membership in exclusive societies can count as much as prizes in the final reckoning of an author's rank. A Pulitzer Prize did not guarantee immortality to poet Margaret Widdemer (1919), playwright Hatcher Hughes (1924), or novelist Margaret Ayer Barnes (1931). And John Kennedy Toole's Pulitzer (1981) came posthumously, after the author of *A Confederacy of Dunces* died sans honors and sans contract, by his own hand. Publication within a Norton anthology is as effective as any prize in ensuring that an author's work gets read and revered. His selection as chairman of the National Endowment for the Arts did more to enhance Dana Gioia's

standing as a poet than his 2002 American Book Award. In the calculus of renown, publication of Philip Roth's complete fiction within the canonical Library of America counts for more than his two NBAs, two NBCCs, and solitary Pulitzer.

More than one hundred cultural prizes—including not only the Nobel and the architectural Pritzker but also the more recently established $200,00 Lannan Lifetime Achievement Award, the $200,000 Dorothy and Lillian Gish Prize, the £100,00 IMPAC Literary Prize, and the $100,00 Polar Music Prize—dispense more than $100,000 each to their recipients. The profusion of more modestly endowed awards defies the efforts of *Awards, Honors, and Prizes*, a two-volume, two-thousand-page reference work published by Gale, to keep pace. Even for a single honoree, Frank Gehry, time spent accepting more than 130 awards—including the Pritzker Architecture Prize, the Praemium Imperiale, American Academy of Arts and Letters Gold Medal, Dorothy and Lillian Gish Award, Wolf Prize, Royal Institute of British Architects Gold Medal, and Friedrich Kiesler Prize—must have required frequent diversions from his work designing buildings.

English traces the history of French book prizes—Goncourt, Renaudot, Femina, Médicis, Décembre—to reveal the Hegelian process by which prizes continually beget their antitheses. But he also notes a dynamic of moderation, "the tendency of awards to soften their strategies of differentiation over time, to begin to merge with the very prizes that had served as their originary antagonists." It is not uncommon for an award founded in fierce opposition to another to end up duplicating the choices of its older rival. In 1981, the Booker, the Whitbread, and the James Tait Black all went to Salman Rushdie's *Midnight's Children*. But despite the monstrous duplication, triplication, and suffocation in an overgrowth more reminiscent of kudzu than laurel and bay, English heralds a world of honors heaped on honors heaped on honors: "What we are looking at, even today, is a system ripe for further expansion."

However, by the logic of his own financial metaphor, the economy of prestige is overheated. A surplus of symbolic capital is producing a spiral of hyperinflation that devalues the currency of any single prize. The tens of thousands of awards constitute an economic bubble, if not a Ponzi scheme. "In the future everybody will be world famous for fifteen minutes," Andy Warhol, who was inducted posthumously into the Art Directors Hall of Fame, famously said. One way to accomplish this is to give everyone in the world

an award, reduce renown to mere celebrity, and venerate the laureate of the Bulwer Lytton Grand Prize of Bad Writing as we would a Nobel poet.

It is not uncommon to find supermarkets, factories, and real estate firms recognizing an "employee of the month." The Boy Scout merit badge is an emblem of achievement, as well as of an individual self that is prized. In a culture of self-reliance that honors personal accomplishment over either nature or nurture, many—particularly academics, artists, and military—measure out their lives in gold stars. Yet it is all about extinction. Even as the mortal poet faced oblivion, the sonnet was a gesture toward eternity. Prizes for sonnets are an even more desperate device to try to defy the grave. But it takes more than a Grammy to dupe Mr. Death. Like a plethora of prizes, death, it is said, is the eminent leveler.

Veracity and Velocity

The Truth about Bullshit

2005

"*The most essential gift for a good writer,*" *observed Ernest Hemingway in a 1958 Paris Review* interview, "is a built-in, shock-proof shit detector. This is the writer's radar, and all great writers have had it." Hemingway's touchstone evidently excludes James Fenimore Cooper and Sir Walter Scott from the ranks of the truly great. Though Mark Twain does not use the term, verbal *merde* is clearly what he meant in his infamous essay "Fenimore Cooper's Literary Offenses." According to Twain, *The Deerslayer* "has no invention; it has no order, system, sequence, or result...its humor is pathetic; its pathos is funny; its conversations are—oh! indescribable; its love-scenes odious; its English a crime against the language."

However, Hemingway, the author of "Hills Like White Elephants," a story written almost entirely in dialogue, shaved with Occam's razor and—though willing to use the word—did not bother to define exactly what he meant by "shit." To do so would presumably be to add to the megatons of excrement that litter literary history. Harry G. Frankfurt is less fastidious than Hemingway, though almost as terse. In *On Bullshit*, a mere eighty pages, Frankfurt, a professor of philosophy emeritus at Princeton University, takes on a task of conceptual analysis as formidable as cleaning the Augean stables. He sets out to define and explain bullshit, a slippery concept that has eluded philosophical inquiry. Though he acknowledges Max Black's 1985 study *The Prevalence of Humbug* and refers to Wittgenstein on nonsense and Saint Augustine on lying, Frankfurt offers his book-length essay as the first attempt at a true theory of bullshit. "My aim," he announces, "is simply to give a rough account of what bullshit is and how it differs from what it is not—or (putting it somewhat differently) to articulate, more or less sketchily, the structure of its concept."

Because of its vulgar title, *On Bullshit* likely both repels and attracts

reviews. Impatient with euphemisms and circumlocutions, Frankfurt avoids BS. Intent on philosophy more than philology, he cuts right to the quiddity of his categorical oddity. Despite making vague suggestions that the association of excrement with death might explain the etymology of bullshit, Frankfurt does not pause to wonder how feces came to be associated with drivel in so many other European languages—*Scheisse* (German), *godno* (Russian), *mierda* (Spanish), *merde* (French), *merda* (Italian)—or whether these terms differ in connotation. Nor does he ask whether Bengalis, Zulus, Berbers, Quechuas, Hmongs, and Navajos also use crap as a synonym for blather. Frankfurt makes no attempt at copro-taxonomy—i.e., did bovine poo, rather than the dung of camels, chickens, horses, giraffes, or elephants, become the paradigm of bluster only in cattle cultures like our own? The sheep population of New Zealand outnumbers its human beings, and we might find it instructive to determine whether flacks, hacks, and pols in Auckland are said to emit ovine scat.

Frankfurt betrays a dubious grasp of agronomy when he defines excrement as "matter from which everything nutritive has been removed"; if so, manure would hardly do to fertilize the soil. But if one accepts Frankfurt's premise that doo-doo is devoid of sustenance, then the shit of bulls can function as a fitting metaphor for verbiage without substance. Calling speakers "flatulent" or their speech "hot air" makes similar allusion to the physiology of digestion, as if Imodium could be the cure for poppycock (a word derived from the Dutch *kakken*, to defecate). Mendacity, however, might be more symptomatic of a defective heart than of gastric disorder. Frankfurt scrupulously distinguishes between lying, which is a focused effort to misrepresent the truth, and bullshitting, which is expansive, improvisational, and indifferent about veracity. Liars try to deceive us with something they know to be false, whereas the bullshitter "is unconcerned with how the things about which he speaks truly are."

In other (contradictory) words, the bullshitter does not give a shit. Liberated from the constraints of truth that still guide the liar, he or she exults in the freedom to fabricate. "Hypocrisy is a tribute that vice pays to virtue," quipped La Rochefoucauld: we bother to feign virtue only because we recognize its primacy. In Frankfurt's view, liars—obsessively attentive to what is sham and what is not—acknowledge truth by striving to distort it. They are therefore, he argues, less dangerous than bullshitters, whose nonchalance subverts our systems of authenticating claims. According to Frankfurt, "bullshit is a greater enemy of the truth than lies are."

Without admitting it, the Princeton philosopher has brought his reader back to what, in Book 10 of *The Republic*, Plato was already calling "the ancient quarrel between philosophy and poetry." Banishing the bullshitter from his own Republic on account of a defective epistemology, Frankfurt seems willing to pardon the liar, who at least knows truth from falsehood. Poets, however, are bullshitters, and, as Sir Philip Sidney noted, poets never lie, because they never affirm. Instead, they offer an alternative universe with no responsibility to accuracy. Is art therefore more repugnant than mendacity? The bullshit that Honoré de Balzac spreads across ninety volumes is pernicious only to censorious readers unwilling to suspend their disbelief. The reasonable reactions to a bullshitter at work are elation or indignation: we can admire the fecundity of unconstrained invention, or else be repelled by the insolence. Blind Homer expounding on the travels of Odysseus is bullshitting, though so are the batty Baron von Munchausen and those said to be afflicted with his peculiar psychosis.

However, unless the falsehood serves some higher purpose, moral opprobrium is the proper response to a liar. "There is a taint of death, a flavor of mortality in lies," says Joseph Conrad's Marlow. For the narrator of *Heart of Darkness*, at least, the stench of lies is more odious than the reek of bullshit: "It makes me miserable and sick, like biting something rotten would do."

"Why is there so much bullshit?" asks Frankfurt. While conceding he lacks evidence to prove it, he suggests that, more than in other times and places, contemporary American culture wallows in the taural-fecal substance. And he attributes the current bull market for bullshit in part to "various forms of skepticism which deny that we can have any reliable access to an objective reality, and which therefore reject the possibility of knowing how things truly are." Without any consensus on what constitutes objective reality, we are encouraged to manufacture wildly varying accounts. Fashionable manifestations of deconstructionism provide license for conceptual anarchy, or at least flaccid rhetoric.

Yet one can also argue that certain forms of skepticism, like Frankfurt's own, obstruct and expunge bullshit. A textual antidiarrhetic, *On Bullshit* could paralyze the bowels of the most garrulous reader, even an epigone of Jacques Derrida. Yet one other claim by Frankfurt seems itself to be but arrant bosh. He suggests that free societies encourage bullshit because of "the widespread conviction that it is the responsibility of a citizen in a democracy to have opinions about everything, or at least everything that pertains to the conduct of his country's affairs." Since the affairs of the United States have

become global, the American electorate would thus be impelled to generate more bullshit than any other population in history. However, it is impossible to examine the public discourse of Hitler's Germany, Stalin's Russia, and Mao's China without marveling at the copious quantities of rhetorical caca in which those societies wallowed. Dictators are able to spew balderdash without challenge from opposition parties, the press, or an informed populace. While there is no paucity of Americans—in talk radio, cable television, government, advertising, and academe—who are eager, as Samuel Johnson put it, to milk the bull, there are also many, like Harry G. Frankfurt, ready to remind us that advice to look for truth in bulls is really a bum steer.

Second Wind

2008

Jim Morrison, Janis Joplin, Sid Vicious, Kurt Cobain, and Tupac Shakur burned themselves out before they needed to make peace with the conventional wisdom that senectitude means decrepitude. "A person who has not made his great contribution to science before the age of thirty will never do so," declared Albert Einstein, who was still in his twenties when he developed the special theory of relativity, mastered quantum theory, and explained the photoelectric effect. Dead by thirty-five, Wolfgang Amadeus Mozart began composing when he was five; Arthur Rimbaud completed his contributions to poetry by nineteen.

However, even while adulating teenage golfers, divas, and gymnasts, we marvel at the longevity of Michelangelo, who was still designing Saint Peter's Church at ninety; Giuseppe Verdi, who was eighty when he composed *Falstaff*; and Johann Wolfgang von Goethe, eighty-one when he finally finished *Faust*. Particularly fragrant are flowers that bloom *only* late— "Grandma" Moses, who, beginning at seventy-eight, created more than one thousand paintings by the time of her death at 101; Akiba ben Joseph, a leading rabbinical scholar until his assassination at eighty-five, though an illiterate shepherd until forty; Virginia Hamilton Adair, who published her first book of poems, *Ants in the Melon* (1996), at eighty-three.

Beowulf and Moses took on their greatest missions late in life. At the root of our communal history are fables of discontinuity, a pattern of assertion, withdrawal, and resurgence. American history commences with a Potomac Cincinnatus: George Washington, who, relishing his retirement at Mount Vernon after waging a long, successful revolution, reluctantly returned to public service. "There are no second acts in American lives," quipped F. Scott Fitzgerald, ignoring the comeback career of the exemplary American life.

Second winds aerate music. Consider Arnold Schönberg, who at

thirty-nine concluded his experiments in atonality with ten years of silence but resumed composing a decade later with his revolutionary twelve-tone works. Giuseppe Verdi, who stopped writing operas at fifty-eight but came back at seventy-four, with *Otello*.

However, cinema is the art that has often gone with a second wind—pensioned spies summoned back into service, doddering jewel thieves tempted to don their gloves again for one final, spectacular heist, and aging veterans who report for one last mission. *The Wild Bunch* tells the story of a last big score—aging outlaws attempt to finance their retirement by robbing an army train. In *Lonesome Dove*, former Texas Rangers Gus McRae (Robert Duvall) and Woodrow Call (Tommy Lee Jones) set off on a final cattle drive from Texas to Montana.

Blinded, captive Samson destroyed his tormentors in a stunning, redemptive feat that, like Beowulf's encounter with the dragon, also brought his own life to an end. But, in his last major literary enterprise, blind John Milton concludes his account of Samson's culminating deed with the phrase "calm of mind all passion spent." Is this the promised end: the peace that passeth understanding that T. S. Eliot invokes in the final line of *The Waste Land*—"Shantih, shantih, shantih"? Belief that the culminating reward of long life is serene enlightenment accounts for the custom of collecting deathbed utterances as if they offered inklings of transcendent truth. Whig politician Charles James Fox was exemplary; he exited the world (in 1806) declaring: "I die happy." His enemies no doubt shared the satisfaction. The final statement of Joseph Conrad, a hypochondriac, was less beatific: "You know I am really ill this time." Lewis Carroll's was more practical: "Take away the pillows." In his parting words, Oscar Wilde declared: "This wallpaper is killing me; one of us has got to go." The wallpaper stayed.

If Art Is a Lie, Then Tell Me a Tale

2007

With scholarly treatises including "Freedom of the Will and the Concept of the Person" and Necessity, Volition, and Love, Harry G. Frankfurt established his credentials in academe. But in 2005, after publishing a book that was only eighty pages long, Frankfurt, a professor emeritus of philosophy at Princeton University, became an unlikely celebrity. He found himself for the first time on bestseller lists, and *The Daily Show with Jon Stewart.* The brevity of Frankfurt's book surely contributed to its popularity, but so did the beguiling bluntness of its title. *On Bullshit* was widely reviewed, though primmer publications refused to print the b-word in full. The subject seemed a perfect fit for the taural-fecal epoch of Kenneth Lay, James Frey, Barry Bonds, and Tom DeLay.

On Bullshit distinguishes between lies, deliberate attempts to distort the truth, and bullshit, which is produced by sublime indifference to truth. On the principle that lying is the tribute that mendacity pays to veracity, Frankfurt argues that bullshit is more insidious. Liars are attentive enough to truth to pervert it, but bullshitters are epistemological anarchists; they simply do not care to make the acquaintance of truth. However, like a jesting Pilate, Frankfurt never stays for an answer to the fundamental question: What is truth?

In *On Truth,* he offers not so much a sequel as a prequel or, in more formal terms, a prolegomenon to *On Bullshit.* At 112 pages, the newer book is, by comparison, downright bloated. Its primary purpose is not to define truth but to explain and acclaim its importance. Frankfurt has little patience for deconstructionists and other postmodernists who dismiss truth as subjective, relative, and illusory. He notes that the very claim that truth does not exist arrogates for itself a claim to truth. And he argues that the continuing existence of societies and individuals depends on truth. "We really cannot live without

truth," he insists, pointing out that living in truth is not simply a matter of living well but of surviving at all. Without a clear grasp of reality, cooks, engineers, and pharmacists become assassins.

Lies undermine community; society disintegrates when no one trusts others to tell the truth. And they harm each of us personally because they isolate us and interfere with our efforts to apprehend reality. "There is a taint of death, a flavor of mortality in lies," says Marlow, the narrator of Joseph Conrad's *Heart of Darkness*. "It makes me miserable and sick, like biting something rotten would do." Frankfurt rejects the notion of even benign lies—the oncologist who tries to ease a terminally ill patient's distress by diagnosing the flu. He declares that "it is nearly always more advantageous to face the facts with which we must deal than to remain ignorant of them. After all, hiding our eyes from reality will not cause any reduction of its dangers and threats; plus, our chances of dealing successfully with the hazards that it presents will surely be greater if we can bring ourselves to see things straight." What, then, should an abolitionist tell the bounty hunter who asks whether there is a fugitive slave in his house, a station on the Underground Railroad? Should homeowners have admitted to Nazi officers that they were hiding Jews in their attics?

Much of Frankfurt's discussion rests on murky metaphors. He writes that ignorance and error "leave us in the dark." Without truth, he contends, "We are flying blind. We can proceed only very tentatively, feeling our way." What precisely does this figurative language mean? Is Frankfurt himself not facing away from facts by indulging in figures of speech? He does not ignore poetic uses of language when discussing Shakespeare's *Sonnet 138*, in which two lovers flatter each other with false compliments. However, their love is enhanced by the fact that each knows that the other is indulging in hyperbole, and that each knows that the other knows that. But such blandishments cannot be termed lies, since they are not designed to deceive and indeed do not deceive. More problematic for Frankfurt's theory of truth is the fact that some kinds of truth telling, particularly in poetry and the other arts, do not involve "facing facts."

Frankfurt insists that facts are necessary for the exercise of reason, that rationality is what makes us human, and that our reasoning about reality teaches us limits. However, there are facts, and there are facts. Consider each of the following three propositions. Charles is the Prince of Wales. Hamlet is the Prince of Denmark. A prince is the son of a monarch. If each is a "fact," its claim to truth rests on very different grounds. Frankfurt's approach to truth,

to "facing facts," seems uncomfortable with fictions such as *Hamlet* and down-right inimical to the ambiguity that is the basis of literary art. His complaint that "contradictory thinking is irrational because it defeats itself" would seem to deny veridical value to William Wordsworth's paradoxical assertion: "The child is father of the man." Yet John Keats, who knew a thing or two about truth, and beauty, characterized the creative state as being devoid of "any irritable reaching after fact and reason." To face the complex truths about its vast subject, *On Truth* would need to be much longer than 112 pages, or else as compact as a sonnet.

Valedictions

Literary Silences

2005

*From 1965 until his death in 1996, Joseph Mitchell published nothing of signifi-*cance. That fact is in itself unremarkable, since most people never publish anything of significance. However, Mitchell had already proved himself a virtuoso of nonfiction and, pretending to be working on "An Oral History of Our Time," continued to show up daily at his office at the *New Yorker* throughout his last three decades.

Artistic abdications—seventeen-year-old Thomas Chatterton choosing arsenic over poetry, Glenn Gould withdrawing from public performance, Greta Garbo wanting to be alone instead of on camera—invite and defy interpretation. Whatever the cause, muted creativity—Arthur Rimbaud renouncing poetry at nineteen, Sor Juana Inés de la Cruz obeying her archbishop, Friedrich Hölderlin succumbing to inarticulate insanity for his final thirty-six years—cries out for discussion and explanation. Harper Lee spent most of her life known as a one-book author—the creator of one book, *To Kill a Mockingbird* (1960), beloved by millions. When, a few months before her death, Lee published another novel, *Go Set a Watchman* (2015), it was a major news event—and the source of widespread disappointment that a clearly inferior book (actually an earlier version of the same book) would sully her reputation as the author of one consummate book.

An aesthetics of silence would study how blank pages undermine language's pretensions to convey Truth. Myles Weber, more interested in the psychology, politics, and sociology of his central term, offers in *Consuming Silences: How We Read Authors Who Don't Publish* (2005) case studies in four American authors famous for their reticence—Tillie Olsen, Henry Roth, J. D. Salinger, and Ralph Ellison. Weber's book is a scholarly counterpart to *Stone Reader* (2003), a cinematic meditation on literary resignation in which director Mark Moskowitz documents his quest to discover what became of

Dow Mossman, whose first and only novel, *The Stones of Summer* (1972), had fascinated him thirty years earlier. Weber does not try to track down his elusive authors, except in their texts, and he is less interested in what renunciation means for the writer than in how readers make sense of undesired silence.

Weber presents Olsen, the author of *Tell Me a Riddle* (1961) and little else, as a cunning opportunist "whose entire career has been spent cultivating the notion that she was nearly prevented from telling *anything*." Despite abundant opportunities to write, Weber argues, Olsen carefully constructed an image of herself as a one-book author hobbled by housework and mothering: driven by self-pity, rationalization, and rage, she deliberately positioned herself as the darling of women's studies, an emerging discipline that in turn justified itself in part by using Olsen as an exemplary martyr.

But every silent writer is silent in his or her own way, and Weber's discussions of Roth, Salinger, and Ellison are not nearly as polemical, nor as consistent. To explain the sixty years between Roth's first novel, *Call It Sleep* (1934), and his second, *A Star Shines over Mt. Morris Park* (1994), he examines reasons the author himself provided—alienation from his Jewish roots and disaffection from Communist ideology. Weber accepts Roth's own final explanation, the shocking secret of incest with his sister, as key to understanding how guilt begot the longest writer's block in the American literary canon. Though my own biography of Roth is not the only work that takes account of this incest, Weber claims that most have refused to revise their reading of Roth's notorious silence, lest it transform a modernist masterpiece into "merely a tawdry narrative of personal shame."

When Ralph Ellison died in 1994, he had failed to complete a novel after *Invisible Man* (1952). Weber examines *Shadow and Act* (1964), *Going to the Territory* (1986), and other obiter dicta to study how an author can contrive essays, interviews, and letters to shape his critical reputation. Yet the use of such paratexts is not unique to one-book authors: William Wordsworth, William Faulkner, and Isaac Bashevis Singer each labored at being his own publicist, though none was as assiduous in offering advertisements for himself as Norman Mailer, who, in contrast to Ellison, measured the intervals between his books in months, not decades.

Over forty years of silence from J. D. Salinger, who at his death in 2010 had not appeared in print since 1965, with the tedious novella *Hapworth 16, 1924*, was unbearable to many. Eager to extend their apprenticeship to the author of *The Catcher in the Rye* (1951), acolytes, biographers, critics, and other kooks

attempted to invade his New Hampshire reclusion. But Weber, trusting the published tales and not the elusive teller, finds clues to Salinger's withdrawal in the published fiction itself. He chides "those in the literary community for whom the term 'silent author' is no mere oxymoron but a strict impossibility." *Qui tacet conturbat:* silence is disturbing—to readers who crave sequels and to critics who are trained to interpret everything, even and especially blankness. Despite Weber's disdain for exegetes of reticence, he fills 168 engaging pages with eloquent chatter and intrusive insight. The rest, of course, is silence.

Telling It All

Pandictic Art

1989

> You see, the only way to beat this thing is to leave
> absolutely nothing behind. I don't want to leave
> anything unsaid, undone ... not a word, not even a
> lonely, obscure, silly worthless thought. I want it all
> used up. All of it.
> —Michael Cristofer, *The Shadow Box*

> I'm trying to say it all in one sentence, between one Cap
> and one period. I'm still trying to put it all, if possible,
> on one pinhead.
> —William Faulkner

Of making books, there is no end, not even in the post-Gutenberg, post-Wiener era. Endless, too, is the ancient dream of a book to end all books—the encyclopedic bible that would subsume all previous and all possible statements. Stephane Mallarmé's grandiose statement that *"tout, au monde, existe pour aboutir à un livre"*[1] is only one of many, many manifestoes for a pandictic art, a single text that comprehends everything. In "La Biblioteca de Babel," Jorge Luis Borges imagines a measureless treasury of words coterminous with the world. However, he suggests, "There must exist a book that would be the cipher and the perfect compendium of all the rest." And he notes later, "Strictly speaking, one single volume should suffice: of ordinary format, printed in nine or ten body type, and consisting of an infinite number of infinitely thin pages."[2]

What we venerate as the Great Books of the World are, then, not so great—to the extent that there is more than one, and they leave room for a world. Balzac's worldly ambition was to compete with the Civil Register, *"faire concurrence à l'Etat-Civil,"*[3] and, at the end of the first paragraph of *Le Père Goriot*, he echoes, in English, the Shakespearean claim that "all is true."

Throughout the scores of volumes that constitute the unfinished cathedral of *La Comédie humaine*, Balzac's audacious project is to demonstrate that the truth is all, that the writer who would comprehend the universe must omit nothing. Perhaps *intelligenti pauca*, but not a few intelligent authors have been obsessed, like Whitman, with the goal of giving voice to multitudes by becoming polyphonic, nay omniphonic. This macrological urge is not unique to the age of entropy, but it is temperamentally at odds with the spirit of neoclassicism. Prescribing moderation and equilibrium, one of its champions, Nicolas Boileau, cautions: "*Souvent trop d'abondance appauvrit la matière*"[4] (Overabundance often impoverishes the matter). Yet Boileau's still, small voice cannot constrain the megaphonics of epos. Homer, *1001 Nights*, *Kalevala*, and Mahler have had their say, and, though *ars longa vita brevis*, their art is not noticeably brief. *Manas*, a Kirghiz folk epic, runs more than five hundred thousand lines, Rainer Werner Fassbinder's *Berlin Alexanderplatz* more than fifteen hours. Small may be beautiful, but large is sublime. Even Candide might gaze up from his modestly cultivated garden at the magnificent prospect of skywriting. The via media is as well traveled as the traditions of straying beyond it.

But both minimalism and maximalism are rejections of the notion of art as finite and balanced. And, like anorexia and bulimia, they are not so much antithetical to each other as different manifestations of the same absolutist impulse. Arthur Rimbaud proclaimed the advent of a universal language that would say everything, declaring: "This language will be of the soul for the soul, summing up everything, odors, sounds, colors, thought hooking up with thought and drawing together."[5] Yet he also completely abjured his verbal magic at the age of nineteen. Although Ezra Pound popularized the haiku and advocated the austerities of Imagism, his voluminous *Cantos* are not reticent. Samuel Beckett's garrulous narrators prolong their discourse in the name of silence, prattle on and on in order, they hope, to say it all and then be done. Conceptual artist On Kawara's *One Million Years* (1970), a ten-volume list of all the years humans have inhabited the earth, was created only four years before Bruce Harris's *The Nothing Book*, an edition of blank pages. Serialism, which, according to Pierre Boulez, "is based upon a universe that finds itself in perpetual expansion,"[6] is a product of the same transitorizing century that produced Malevich's *White on White* and Rodchenko's *Black on Black* and that condensed the Bible. How many epics can now stand on the head of a microchip? The liner notes to the Everest recording (S-3230) of John Cage's *Variations IV* (1964) describe the work as: "The kitchen-sink

sonata, the everything piece, the minestrone masterpiece of modern music, the universe symphony of everybody and everything. This is the world that technology offers us: instant communication with the entire experiential world, including the complete musical expression of the race and the entire possible aural universe (well, almost)."[7] Yet Cage is also best known as the creator of "4'33"" —four minutes and thirty-three seconds of silence, a 1952 composition that was outdone in 1971 by an MGM record album entitled *The Best of Marcel Marceau*. Perhaps Roland Barthes's notion of *l'écriture blanche*—the stylistic vacuum of "white writing"—is not antithetical to what in acoustics is called white noise—a blend of all sonic frequencies. (Someone once wrote a very big book about a white whale and everything else.) The equation macrology: bulima = micrology: anorexia is not merely bloated rhetoric but rather is appropriate to the metaphor of ingestion that pervades many of the most compulsive works themselves.

Rabelais dedicates his Gargantua to "*Beuveurs très illustres*" (most illustrious tipplers) and proceeds to celebrate indulgence with a copious text that seems to abstain from nothing that is human. Henry Fielding introduces his "comic epic in prose," *Tom Jones*, as if it were an opulent feast at which the reader is invited to partake; but we should not blame the author if the spread proves to be too much of a good thing—that, he explains, is why he posts the bill of fare in his very first chapter. Whether deliberately or not, the Marquis de Sade applies the same analogy to his massive intemperance tract *Les 120 Journées de Sodome*, warning his reader at the outset: "We have here the story of a magnificent meal where six hundred diverse dishes are offered for your delectation. Will you eat them all?"[8] With his oral obsessions and his compulsions about ingestion and excretion, Sade presents a bizarre case of the pandictic artist, one who reminds us at the beginning of the twenty-ninth of his 120 outrageous days that "*L'appétit vient en mangeant*"[9] (Appetite comes through eating). Convinced that continence is a crime, he fills thousands of pages in order to exercise that appetite ad nauseam. Hyperbole is the governing principle of *Les 120 Journées*, where the torrents of blood, semen, and excrement are not simply grotesquely excessive but are bids for the absolute. Sade's program in this distended text is to catalogue and depict every conceivable permutation of debauchery and transgression. Traditional frame narratives such as *1001 Nights*, *Il Decamerone*, *The Canterbury Tales*, and *L'Heptamèron* are macrological by suggesting an infinite regress of embedded stories. By parodying them in *Les 120 Journees*, Sade seeks to surpass them. If he had bothered to flesh out the book's scaffolding of 120 days during which,

along with plentiful digressions, four storytellers are each to tell 150 indelicate tales, the text would require far more than its present 500 pages. Like Joyce's even more ambitious macrology, the "usylessly unreadable" *Finnegans Wake*, it would demand a reader "with an ideal insomnia," one who, like the incarcerated Sade himself, is at liberty to gorge himself. As it is, the book does not so much conclude as merely stop; after just the thirtieth day, Sade merely outlines what else is to happen, making the bulk of this ponderous text as elliptical as it is apocalyptical.

The New Testament Apocalypse and doomsday books in general are pandictic, particularly if, like the fourteenth-century *Cursor Mundi*, they attempt to encompass not only the end of days but the beginning as well. Eschatology is, of course, common to the sacred writings of East and West. But, at least since Mary Shelley's *The Last Man* (1826), the secular genre of science fiction has been busy imagining a terminal disaster. However, such works join the company of the *Mahabharata*, Dante, and Beckett if they are not only about the end of the world but present themselves as the first and last word as well. If alpha and omega can be put within the bindings of one book, what need is there for another? Verbosity is textual tyranny. Balzac's celebrated ambition to complete with the pen what Napoleon (who, on Saint Helena, is said to have been a voracious reader) began with the sword suggests a political paradigm to the horde of characters and adjectives he organized. Coleridge's Ancient Mariner is totalitarian to the extent that he not only fills pages and hours with his own rime but that he assumes absolute control of the Wedding Guest's time. The *Congressional Record* is a vast miscellany of information and polemic published regularly by the legislative branch of the US government; those who would dutifully read the entirety of this diffuse document would themselves be left at a loss for words. Other governments are even more monopolistic in their measures to control public discourse, to say everything worth saying.

Fundamentalist cultures and sects that place their faith in one inspired Book as the summa of divine and human wisdom are rarely tolerant of other volumes on the shelf. Authoritarianism is a natural consequence of the belief that one author has said everything of value. When spatial artists aspire to infinity and temporal artists to eternity, the implications for the politics of aesthetic reception are extensive. Magna opera are characteristically demanding, and what they demand is a consumer willing to suspend disinclination and to accept someone else's longueurs. The title of Jules Romains's twenty-seven-volume roman-fleuve, *Les Hommes de bonne volonté*, is surely as accurate

a description of his patient readers as of his characters. Andy Warhol's six-hour film *Sleep* (1963) is deliberately oppressive to those who submit to its wearisome rhythms. His eight-hour *Empire* (1964) is aptly named not merely because it is a static view of the Empire State Building but because the impertinent film is itself an imperial gesture. John Barth has described a modern "Literature of Exhaustion," and it is so not simply in the sense of having said all there is to say; writers who, like Sade, Beckett, and Burroughs, would tell it all often explicitly court boredom. Ennui is erected into an aesthetic principle of Erik Satie's *Vexations*, an eighty-second piece repeated 840 times. The textual autocrat who would impose tedium is as domineering as the composer of a te deum is submissive. When Sade has one of his narrators offer this mock apology to her numbed auditors, it is symptomatic of his own verbal megalomania: "I can only beseech these gentlemen to be good enough to pardon me if I have perchance caused them any boredom by the monotony that is almost inevitable in such stories of the same sort."[10]

What has come to be called the Boom in contemporary Latin American fiction arose in reaction to the repressive régimes and to the stagnant cultures that dominated much of the Western hemisphere. The metaphor "Boom" identifies authors such as Julio Cortázar, José Donoso, Carlos Fuentes, Gabriel García Márquez, and Mario Vargas Llosa as explosive insurgents intent on detonating something overwhelming. Boom novelists do write spare prose, and one of them, Vargas Llosa, accounts for their difference from European and North American writers in terms of the Latin Americans' felt need to abandon their shabby environments entirely and to create complete alternative worlds. While literature is for others an extension of reality, for Boom writers, Vargas Llosa argued in 1970, it is a thorough substitution for reality. "This reality, which is still thought to be viable, does not awaken the same 'total' rejection [in Europeans and North Americans] which compels today's Latin American novelist to 'totally' replace reality with 'total' novels."[11] In *García Márquez: Historia de un deicidio*, a study that he published in the following year, Vargas Llosa likens the Colombian radical not to a mere tyrannicide but to a deicide. And the lesson of the Promethean Romantics was that the artist who displaces God had best be prepared to serve as the new demiurge.

In his tribute to the author of *Cien años de soledad*, Vargas Llosa again employs the term "total novel," by which he seems to mean two things: first, that the big books of Latin America are comprehensive syntheses of ostensible antinomies like fantasy and reality, universal and particular, ancient

and modern, and second, that these huge creations offer a complete alternative to the given world. "*One Hundred Years of Solitude* is a 'total' novel, a descendant of those maniacally ambitious creations that compete with reality as an equal, confronting an image of a vast and complete reality qualitatively equivalent. That totality earlier manifested itself in the heterogeneous nature of the novel that is, simultaneously, things that are believed antithetical: the traditional and the modern, local and universal, imaginary and realistic.... But *One Hundred Years of Solitude* is a total novel above all because it embodies the ideal of all divine usurpers: to describe a total reality, to confront the real reality with the image that is its expression and negation."[12] In his survey of contemporary fiction in the United States, Frederick Karl expands on García Márquez's notion of "total novel" and applies it to North American works as well: "It suggests a complete world made possible through artifact: a world of its own. Such 'total novels' would include, of course, Márquez's *One Hundred Years of Solitude*, possibly Grass's *The Tin Drum*, Pynchon's *Gravity's Rainbow*, Gaddis's *The Recognitions*, Barth's *Giles Goat-Boy*, with some hesitation Barth's *Letters* and McElroy's *Lookout Cartridge*."[13]

However, in the United States, such pandictic longings have long been embodied in the popular notion of "The Great American Novel," a single monumental book so capacious as to articulate the aspirations and the experiences of a vast, heterogeneous republic. The dream of a definitive national opus emerged following the Civil War; the United States now sprawled across a continent and became eager to declare its cultural independence from European models. In an 1868 editorial in the *Nation*, J. W. De Forest urged the creation of "a single tale which paints American life so broadly, truly and sympathetically that every American of feeling and culture is forced to acknowledge the picture as a likeness of something which he knows."[14] Rhapsodizing over it as the syncretic nation of all nations, Walt Whitman had earlier proclaimed: "The United States themselves are essentially the greatest poem."[15] And Whitman looked for one consummate writer capable of expressing the vibrant complexity of this brash new society. "The American poets are to enclose old and new for America is the race of races. Of them a bard is to be commensurate with a people. To him the other continents arrive as contributions....His spirit responds to his country's spirit...he incarnates its geography and natural life and rivers and lakes. Mississippi with annual freshets and changing chutes, Missouri and Columbia and Ohio and Saint Lawrence with the falls and beautiful masculine Hudson, do not embouchure where they spend themselves more than they embouchure into him."[16] Whitman's own

rambling poetic line, wide range of styles and subjects, prolix catalogues, and spacious persona throughout his expansive life's work *Leaves of Grass* qualify him as a candidate for the mantle of complete author. Other American poets, such as Hart Crane, Ezra Pound, William Carlos Williams, Charles Olson, and Allen Ginsberg, have, in the magnitude of their designs and rhetoric, also aspired to comprehensiveness.

But it is more often in fiction, in their quest for the elusive Great American Novel, that American writers have pursued the chimera of a single plenary text. "He who has such infinite power of suggestion and delicacy has absolutely no right to glut people on whole meals of caviar," complained F. Scott Fitzgerald about the verbose Thomas Wolfe to their mutual editor, Maxwell Perkins.[17] But the careers of authors such as Wolfe, Frank Norris, Theodore Dreiser, John Dos Passos, Henry Miller, Norman Mailer, William Gass, Thomas Pynchon, David Foster Wallace, and William T. Vollmann are unintelligible without an understanding of their ambition to create the total novel. If Balzac's goal was to rival the census bureau, Karl Ove Knausgård's, in his massive autobiographical hexalogy *Min Kamp* (*My Struggle*) (2009–11), was to be as exhaustive and tedious as a personal diary.

Miller, who wrote as many as forty-five pages in one day and who regularly took an afternoon nap in order to curb his extraordinary profusion of words, originally chose the title *The Last Book* for what came to be called *Tropic of Cancer*.[18] From Brooklyn to Paris, Henry, the author-hero of both *Tropic of Capricorn* and *Tropic of Cancer*, aspires to write The Great American Novel, "a book that would make a guy like Dreiser hang his head."[19] Miller does mock Henry's earliest attempts to "say everything all at once—in one book—and collapse afterwards."[20] But there is also awe in his later description of the ultimate work of literature that Henry and his friend Boris earnestly and brazenly dream of composing: "It is to be a new Bible—The Last Book. All those who have anything to say will say it here—anonymously. We will exhaust the age. After us not another book—not for a generation at least. Heretofore we had been digging in the dark, with nothing but instinct to guide us."[21] From *The Naked and the Dead* through at least *Ancient Evenings*, Norman Mailer, too, was obsessed with writing the pandictic work. As it would be not just a novel but the total novel, the conception is inherently competitive, as if the definitive book could incorporate and obviate all rivals. In *Advertisements for Myself*, Mailer refers to "the rumor that once I pointed to the farthest fence and said that within ten years I would try to hit the longest ball ever to go up into the accelerated hurricane air of our American letters. For if I have one

ambition above all others, it is to write a novel which Dostoyevsky and Marx; Joyce and Freud; Stendhal, Tolstoy, Proust and Spengler; Faulkner, and even old moldering Hemingway might come to read, for it would carry what they had to tell another part of the way."[22]

There is something stereotypically masculine in this agonistic dream of the big book that would outdo all and any others. Hemingway, who quipped that "all bad writers are in love with the epic,"[23] nevertheless had to reassure Fitzgerald about the relative size of his penis during a nervous moment in a Paris water closet.[24] The zealous effort of so many American males to create the supreme, nonpareil book dramatizes that anxiety of influence that makes of sons the mortal rivals of their fathers and their brothers. Much feminist theory would make of such fierce contentiousness a distinctively masculine trait, maintaining that Harold Bloom's paradigm of literary history is inherently phallogocentric.[25] Masculine achievements, it is argued, are the product of competition, feminine of collaboration. If so, the one work that will displace all others might seem a peculiarly masculine obsession. And yet Nathaniel Hawthorne resented the "d—d mob of scribbling women"[26] who dominated the nineteenth-century marketplace for writing much, not well. Gertrude Stein conceived of her one-thousand-page *The Making of Americans* as the total novel. As she repeats again and again in a triumph of battology, if not macrology: "This is then a beginning of the way of knowing everything in every one, of knowing the complete history of each one who ever is or was or will be living. This is then a little description of the winning of so much wisdom."[27] Stein's struggle to create an unmatched universal work might be explained by her attraction to androgyny, but what are we to make of the writer whom *The Guinness Book of World Records* acknowledges as the most prolific novelist of all time? With 904 books to her credit, South African Kathleen Lindsay (1936–73) easily surpassed such productive male rivals as Alger, Asimov, Balzac, Dumas, and Simenon. And any study of the metaphysics and psycho-pathology of the prodigious writer ought not to ignore such women as Barbara Cartland, Joyce Carol Oates, and George Sand. Hélène Cixous has argued that, while masculine sexuality is localized and the male libido finite, woman's jouissance is cosmic and unlimited.[28] According to Luce Irigaray, the female orgasmic economy is multiple and perpetual. "In contrast to simple man, Woman is sexually sensitive just about everywhere. She experiences pleasure just about everywhere. Even without speaking of the hysterization of her entire body, the geography of her pleasure is much more diversified, multiple in its differences, complex, subtle, than is imagined…

in an imaginary centered a bit too much on the same."[29] Irigaray, therefore, concludes that, unlike univocal male discourse, women's language is complex, multiple, and global. If there is any truth to the feminist polemic, women would, if given the opportunity, seem more likely successes at macrology than the determined men who have been vying with one another throughout the history of the arts. Perhaps they have simply been impeded by defensiveness over the ancient gender libel of garrulousness.

However, even the most impartial encyclopedia is, *sub specie aeternitatis*, provincial, doomed to being incomplete. Johann Samuel Ersch and Johann Gottfried Gruber were magnificent failures in their quest to encompass all knowledge; still unfinished, their *Allgemeine Encyclopädie der Wissenschaften und Künste* ceased publication in 1889, when only 167 volumes had been issued. Modern information retrieval technology has revived the dreams of one vast, perpetually accessible text. As early in the cybernetic revolution as 1937, a year after William Faulkner published, in *Absalom, Absalom!*, the 1,300-word tirade that *The Guinness Book of World Records* credits as the longest sentence in literature, H. G. Wells was calling for a *Permanent World Encyclopaedia*. The possibility of a total record was, he insisted, no longer a tall tale: "There is no practical obstacle whatever now to the creation of an efficient index to all human knowledge, ideas and achievements, to the creation, that is, of a complete planetary memory for all mankind. And not simply an index; the direct reproduction of the thing itself can be summoned to any properly prepared spot."[30] Computer technology and cultural interchange have made such supreme heteroglossia a virtual reality through the advent of the World Wide Web. A vast collective enterprise constantly expanding, self-correcting, and updating, the *Wikipedia*, currently offering more than 54 million articles in more than 300 languages, provides a compendium of human knowledge that Denis Diderot and Jean le Rond d'Alembert, assiduous editors of the *Encyclopédie*, a storehouse of Enlightenment learning, could only have fantasized.

However, if only because of the possibility of meta-discourse, of a larger text that would assimilate its predecessor, the poetics of prolixity is an exercise in defeat. The collation of every utterance would be no small thing, but it could always be prefaced with another. If, as T. S. Eliot and Northrop Frye have variously contended, the entire tradition, cumulative of individual contributions, is the culmination of the text, then there can be no genuine finale before the last syllable of recorded time. History, a collaborative text, is the ultimate, collective utterance, and that says it all.

Swan Songs

1999

When I was young, my fondest wish—beyond fleeting fantasies as cowboy, fire-man, or center fielder—was to be old. Oh, to be as ancient and oracular as Norman Thomas, who, at seventy-nine, spoke to my high school history club! Annealed by multiple defeats in a lost but lustrous cause, the Socialist-Who-Would-Have-Been-President stood before us: wispy, white-haired, almost saintly, purged of banality by the aura of longevity. Though I no longer re-member any words that Thomas said, I would have given fifteen larks to be that wise old owl. I longed for a gray beard, who could not yet shave.

Time is the catalyst that separates grape juice from vintage wine. After a certain age, even witless Dennis Rodman might rebound as a sage. When I was young, Albert Einstein, Pablo Picasso, Bertrand Russell, and Igor Stravinsky still walked the earth, and I longed to interrogate them about cosmic myster-ies. To clueless youth, seniority is sagacity; trust no one under seventy.

"What is the answer?" asked Gertrude Stein, dying. When Alice Toklas did not reply, Stein delivered her final thoughts: "In that case, what is the question?" To Platonists, there is revelation in every deathbed utterance, be-cause death, like birth, is closest to divinity. The child is father to the man, claimed Wordsworth, but the grandfather, reaching beyond this world, has something to teach each. Yet I am drawn to the parting words of the elderly, not because I believe in an afterlife but because the imminence of extinction may energize organisms it has not already enervated.

Eager to record the obituary dicta of moribund grandees, Victorian ladies and gentlemen used to attend their closing throes, hovering over the bedstead with pen and pad in hand. Even after careers of pedantry and prattle, all pro-fessors become emeriti in their parting breaths. And those who audit the con-cluding lecture expect something more inspirational than Giacomo Puccini's dying request for fresh water or Michael Jackson's final stage direction: "Let

me have some milk." Just before expiring, the hotel magnate Conrad Hilton advised: "Leave the shower curtain on the inside of the tub."

But Goethe had more in mind than opening the curtains when, fading, he proclaimed, "*Mehr licht!*" More light. Those minding Thomas Alva Edison were hardly disappointed when the incandescent inventor exited after observing, "It is very beautiful over there." However, Karl Marx's final words were a critique of final words. Admonishing his housekeeper, who stood by with pen and paper, eager to write down the famous man's ultimate utterance, he declared: "*Hinaus! Letzte Worte sind für Narren, die noch nicht genug gesagt haben*" (Go on, get out—last words are for fools who haven't said enough).

Dying in a Boston hotel, though, Eugene O'Neill was merely peeved, declaring: "I knew it! I knew it! Born in a hotel room and, goddamn it, dying in a hotel room." The playwright's adieu strikes me as entirely too clever to be improvisational. A masterpiece of studied spontaneity, the pronouncement must have been composed in advance, polished and preserved until precisely the right moment. But imagine the agony of a miscalculation! What if, after delivering the consummate final line, you live on for hours, weeks, even years—in mute mortification over premature valediction? What if you are so eager to attain wisdom that you long to skip the lengthy middle years of apprehension? There is nothing more preposterous than a fifteen-year-old's memoir...except the deathbed statement he devises in anticipation of the distinguished occasion.

The rest is silence.

I been there before.

It is a far, far better thing that I do, than I have ever done; it is a far, far better rest that I go to, than I have ever known.

...and yes I said yes I will Yes.

Isn't it pretty to think so?

And it was like a confirmation of their new dreams and good intentions when at the end of the ride their daughter got up first and stretched her young body.

They hand in hand with wand'ring steps and slow / Through Eden took their solitary way.

After all, tomorrow is another day.

I stop somewhere waiting for you.

A text's best line is often its last. Likening nature to a meticulous author, Cicero insisted that "it makes no sense to believe that she would be at great pains to map out the earlier parts of life and then, like a lazy playwright, give the last act a careless once-over." The Roman orator was assassinated in his early sixties, a bit too green to pass for a genuine sage. However, Cicero attributes to Cato the Elder, who died a century earlier at eighty-five, the mellow thoughts on aging that he records in *De Senectute*, the locus classicus of gerontophilia. It is a book designed to amplify the anguish of any youth impatient with our species' system of deferred enlightenment. Like Ecclesiastes, Cicero's Cato does note that "each season of life has an advantage peculiarly its own." But he argues that the best comes last, when, liberated from the demands of mating and attaining, the individual can think freely and serenely. "For it is among the old," Cato claims, "that thought, reason, and deliberation are to be found; if there had never been any old men, there would never have been any civilization at all." Sigmund Freud would certainly agree, while noting that the old are discontent. "I am not young enough to know everything," quipped Wilde, old enough to know that.

When raw, I craved nothing but ripeness. Adolescent anxiety over the puzzling imperatives of sexuality must have been a factor in my zeal to pass beyond baffling passion to wise serenity. Yet, even as I coveted the cognizance of Tiresias, he who foresuffered all, I recognized that not every ancient is oracular. Mel Brooks's two-thousand-year-old man substitutes boundless flippancy for omniscience. While envying Ernest Gaines's Miss Jane Pittman, Thomas Berger's Little Big Man, and Allan Gurganus's Oldest Living Confederate Widow, I conceded that certain specimens of human antiquity wheezed and groaned and reeked. They forgot my name, and their own as well. They seemed incapable of wonder or mischief or elation. Like Alberto Giacometti's wizened sticks, they offered an image of diminished possibility, of life scarcely distinguishable from extinction. "When he's forsaken," wrote Thomas Hood, "Withered and shaken, / What can an old man do but die?" He can write.

According to legend, and little else, Solomon wrote the Song of Songs in lusty youth, Proverbs in prudent middle age, and Ecclesiastes as the mellow fruit of his final years. To everything there is a season, quoth the Preacher, but I have always preferred his more seasoned sooth to the soupy drool of the Song of Songs or the gritless homily of Proverbs. If ancient Solomon had verily believed that all is vanity, he would never have bothered to lift quill to vellum. Yet tradition says he did, magnificently, autumnally, if only to bemoan

the futility of it all. Of making books there is no end, laments Ecclesiastes, but many of the brightest books are made in sight of the finish line.

"You are not required to finish" is the Talmudic dictum that Henry Roth appropriated as the epigraph to *Requiem for Harlem*, a novel that was published two years after its author's death in 1995, at the age of eighty-nine. *Requiem for Harlem* is one of five volumes, totaling 3,200 manuscript pages, that Roth, crippled by rheumatoid arthritis and deep depression, felt compelled to finish during his ninth decade. His crepuscular creativity, in the autobiographical fictional cycle he titled *Mercy of a Rude Stream*, is one of the most extraordinary episodes in twentieth-century American literary history.

"One might as well call it sleep. He shut his eyes." Those words close Roth's prodigious first novel. Published in 1934, when its author was twenty-eight, *Call It Sleep* soon fell out of print and into literary oblivion. By 1964, when the book was reissued to vast acclaim, Roth was subsisting in Maine, slaughtering waterfowl. Convinced that his artistry was dead, Roth had become an artist of death, the self-taught scourge of rural poultry. Abruptly rich and famous at the age of fifty-eight, he was not ready to resume a thwarted literary career. One might as well call it sleep, and Roth had given up. However, despite suicidal despondency after the death of his wife, Muriel, in 1990, he felt obliged to finish. In 1994, sixty years after *Call It Sleep* appeared, Roth published his second novel, *A Star Shines over Mt. Morris Park*.

It would be lovely to be able to say that, after enduring a legendary writer's block long enough to lodge all the grubs in Greenwich Village, Roth finally found serenity in the renewed flow of words. He did not. Narrated by an octogenarian novelist very like Roth himself, the autobiographical *Mercy of a Rude Stream*, which virtually revels in painful revelations of incest, is a lacerating exercise in self-contempt, and the series title's acronym, MORS, means death. *Apothanein Thelo*—I wish to die—is the motto, borrowed from the Cumaean Sibyl, that the ancient author within Roth's story hangs in his study in New Mexico. Roth's eighty-nine-year trajectory, from Galicia to New York to Maine to Albuquerque, was classically Greek in both abomination and cathartic redemption. His concluding, excruciating labor gave life to his self-loathing, even as it put to rest an old man's mortal pain. Sophocles, who wrote *Oedipus at Colonus* at eighty-one, could not have invented a more melancholy denouement.

"Some people are born posthumously," noted Friedrich Nietzsche. And some are reborn at eighty, the age at which Giuseppe Verdi composed *Falstaff*. Leopold von Ranke began his magisterial *History of the World* at eighty and completed its tenth volume just before his death at ninety-one.

For the posthumous artist (and does not every authentic artist aim to make contemporaries of posterity?), every book deserves the title of François de Chateaubriand's last, most awesome one, *Memoirs from Beyond the Tomb*. If the dead don't know, who does? Goethe was eighty-one when he finally finished *Faust*, and Thomas Hardy, who relinquished fiction at fifty, was eighty-five when he wrote his last, and lasting, poems. "All I have produced before the age of seventy is not worth taking into account," wrote the Japanese painter Katsushika Hokusai, at seventy-five. "At ninety I shall penetrate the mystery of things; at a hundred I shall certainly have reached a marvelous stage; and when I am a hundred and ten everything I do, be it a dot or a line, will be alive." When Hokusai died at ninety, in 1849, he left some mysteries unsolved.

A child's longing for enlightened senescence can masquerade as precocity. A tot who favors the late motets of Heinrich Schutz or who reads Thomas Mann, author of three major novels after seventy, is thought to be sagacious beyond his years. He might merely be a prig. But in a juventocracy, where an aged man is but a paltry thing, a faith in late eloquence might also serve as consolation for early disappointment. If I could not be Arthur Rimbaud, who had exhausted the possibilities of poetry by the age of nineteen, perhaps I could still be Miguel de Cervantes, nearly sixty when he began *Don Quixote*. If not now, then.

In the culture of the callow, though, novice achievement is the only kind that counts. Raymond Radiguet secured a place in French literature despite—because of?—the fact that, after writing two remarkable novels, he died at twenty. Sylvia Plath's case for canonization was not impaired by her failure to survive beyond thirty. John Keats wrote "On First Looking into Chapman's Homer" at twenty, and, dying at twenty-five, did not linger for a second look. The example of Thomas Chatterton, who began writing at twelve and poisoned himself at seventeen, inspired William Wordsworth to promulgate the Romantic Law of Artistic Decline: "We Poets in our youth begin in gladness; / But thereof come in the end despondency and madness." In literary matters, insist the Dionysians, never trust anyone over thirty; a seasoned hand might, like Wordsworth, be doddering.

Nor is the principle of creative atrophy confined to consumptive poets and self-consuming rock musicians. Much of the history of mathematics is a saga of prodigies who were over the hill before they had license to drive around it. Carl Friedrich Gauss made many of his crucial contributions to number theory before reaching twenty. The self-taught genius Srinivasa Ramanujan made his remarkable discoveries in function theory, power series, and number

theory long before his death at thirty-one. Facility in abstract thought demands not only the energy and audacity most abundant in robust youth but also detachment from the messy minutiae that accumulate with years. "A person who has not made his great contribution to science before the age of thirty will never do so," declared Albert Einstein, who was still in his twenties when he developed the special theory of relativity, mastered quantum theory, and explained the photoelectric effect. Yet for me, the rumpled old émigré of Princeton who, in oddly inflected English, spouted abstruse formulas and preached world peace was, until his death at seventy-six, the very prototype of the sage dispensing arcane truths. I yearned to grow up and grow old so that I, too, might decipher the cosmic design. Fathoming Charles Foster Kane's final utterance, "Rosebud," requires understanding all of the fictional tycoon's seventy-nine years. If wisdom is less purely conceptual than a matter of sifting and weighing experience, then there is a higher discipline to which persons under the age of sixty are not admitted. Talmudic pupils are cautioned about the perils of studying Cabala prematurely; trying to make sense of the mystical obscurities of the Zohar at too tender an age could shake the foundations of personal faith. Now, more than sixty years later, I believe less in Gatsby's green light, the orgiastic future that year by year recedes before us anyway, than in the lucency of twilight.

Altersstil is a term that, conceding majesty to seniority (and authority to German), art historians have applied to the distinctive style of aging masters. Jean-Michel Basquiat, done in at twenty-seven by a heroin overdose in 1988, might be the current rage, but others, who managed, sometimes despite crippling illness, to produce major pieces shortly before extinction at advanced ages, have never lost their savor. The monumental *Water Lilies* that arthritic Claude Monet executed months before his death at eighty-six are among the glories of modern painting. Ninety-two-year-old Frank Lloyd Wright was designing the Guggenheim Museum when he died. Donatello continued to create extraordinary work until his demise at eighty, as did Francisco Goya until eighty-two, Henri Matisse until eighty-five, Frans Hals until eighty-six, Titian and Louise Nevelson until eighty-eight, Rufino Tamayo until ninety-one, Georgia O'Keeffe until ninety-nine. Is there something, other than durable DNA, that they had in common? In *The Artist Grows Old* (1972), a discussion of geriatric creativity, Kenneth Clark identifies these characteristics: "A sense of isolation, a feeling of holy rage, developing into what I have called transcendental pessimism; a mistrust of reason, a belief in instinct." In a 1986 essay, Rudolf Arnheim contends that *Altersstil* is marked by looser

brushstrokes, a detachment from practical concerns, an abandonment of interest in causal connections. Though Ludwig van Beethoven left life at a mere fifty-seven, his final chamber music evokes the sublime lucidity of an artist old and wise enough to cast aside the trite. Any child can be morose, but "transcendental pessimism" is the unique achievement of advanced maturity. I prefer Beethoven's parting five quartets and the Grosse Fuge, op. 133 in B-flat major, to the sweetly ebullient String Octet, op. 20 in E-flat major, that Felix Mendelssohn composed when he was sixteen. "Man must suffer to be wise," proclaims the Chorus in Aeschylus's *Agamemnon*. Mere pain is not the same as suffering; it lacks longevity.

Though all testify to the telling truth that it ain't over till it's over, it is surely important to distinguish among different sorts of *Altersstil*. Some artists, like Igor Stravinsky and Richard Strauss, who were still composing when they died at eighty-nine and eighty-five, respectively, are steadily productive throughout a long career. The creative lives of others exhibit a beginning and an end, yet miss the middle: Henry Roth went sixty years between novels, and eighty-seven-year-old Helen Hooven Santmyer rushed into print with "...*And Ladies of the Club*" (1982) fifty-three years after her second novel, *The Fierce Dispute* (1929). Still others, like the narrator of Marcel Proust's consummate and consummating novel, redeem a long, squandered life by trysting with the Muse before an inevitable rendezvous with death. It was only after retiring, at fifty-nine, as headmistress of the Bryn Mawr School for Girls, that Edith Hamilton, productive until ninety-one, started to write her popular books on classical mythology and culture. An illiterate shepherd until he began his studies at forty, Rabbi Akiba ben Joseph managed, before his assassination at eighty-five, to become the leading architect of rabbinical Judaism. Though each is redolent of patient growth, the fragrance of a late bloomer surely differs from that of a seasoned perennial. Voltaire, prolific to the end, which came in his eighty-fourth year, represents a different type from that of Virginia Hamilton Adair, who published her first book of poems, *Ants on the Melon* (1996), when she was eighty-three. Yet each case admonishes the ne'er-do-well never to say ne'er; while the breath still lingers, so does the possibility of filling the air with something aromatic. As Tennyson's Ulysses proclaims:

> Old age hath yet his honour and his toil;
> Death closes all: but something ere the end,
> Some work of noble note, may yet be done,

Not unbecoming men that strove with Gods.

Though it wastes the brain, death does concentrate the mind. And I would not mind finding the kind of concentration that William Butler Yeats mustered in his final, passionate, gerontophobic poems.

Because they lack formal training and usually encouragement, so-called primitive artists often begin their labors after most people are retired. Grandma Moses created her more than one thousand canvases between her late seventies and her death at 101. William Edmondson, a son of slaves, began a sculpting career in his sixties; Morris Hirshfield, an immigrant Jewish tailor, taught himself to paint at sixty-five; the Englishman Alfred Wallis commenced painting at sixty-seven, only a decade before his death. In the previous century, the Japanese artist Sengai began at sixty-one and died at eighty-seven.

Several scholarly tomes—including W. A. Newman Dorland's *The Age of Mental Virility: An Inquiry into the Records of Achievement of the World's Chief Workers and Thinkers* (1908), Harvey C. Lehman's *Age and Achievement* (1953), and Hugo Munsterberg's *The Crown of Life: Artistic Creativity in Old Age* (1983)—attempt to create a science of geriatric achievement, computing the chronological mean of peak performance for men and women in dozens of fields. Lehman's empirical studies, for example, reveal an earlier prime for mathematicians and chemists than for geologists, biologists, and social scientists, and find that philosophers write their best books between thirty and thirty-nine. Detailed charts provide a graphic sense of the flow and ebb of human élan. Yet I learned more about late creativity from reading Rabindranath Tagore's deathbed poems or comparing the *Pietà* that Michelangelo was working on when he died, in his ninetieth year, with the one he executed more than six decades earlier.

Paris in the 1920s exhilarated Malcolm Cowley in his twenties, and he carved a literary career out of remembering it. But he also made a book, *The View from Eighty* (1980), out of outliving his cohorts; it is an eloquent reflection on the ravages of age whose very eloquence defies and denies those ravages. But just as Simone de Beauvoir's *The Second Sex* (1950) can be said to inaugurate contemporary literary feminism, her gloomy disquisition *The Coming of Age* (1970), published when she was sixty-two, anticipates recent personal writing on aging. I would call these volumes memoirs, except that they look not to the past and certainly not to an undependable future; rather they gaze—soberly, lucidly, tonically—at the shriveled present. Perhaps

because women tend to live longer than men and because conventions of beauty oppress older women more than they do their male contemporaries, the most engaging recent reflections on aging have been written by women. Flouting the old youth culture's mistrust of antiquity, the Turning-Seventy-Meditation has become a lively, if often crabby, contribution to current letters.

Though their subgenre lacks the fury of ancient Lear standing on the stormy heath, the elderly women who confront the ruthlessness of chronology forbid us to sentimentalize the aging process. In *At Seventy: A Journal* (1984), May Sarton is by turns peevish, envious, aching, and weary—though neither aching nor weary enough to prevent her from publishing a verse sequel, *Coming into Eighty: New Poems* (1994), exactly ten years later. In *Coming into the End Zone: A Memoir* (1991), Doris Grumbach uses the occasion of attaining the biblical limit of three score and ten to flaunt her aversions to photography, seasons, speed, travel, and people. In *The Last Gift of Time* (1997), Carolyn Heilbrun, who was Sarton's literary executor, reveals at age seventy-one how she violated her own resolution to die before seventy. "I find it powerfully reassuring now to think of life as borrowed time," she remarks. "I daily choose life more earnestly because it is a choice." We are, of course, all always dying, but when the memoirs of youngsters dominate the culture, I am grateful that some choose to spend their dwindled time wrestling with words. "Every time those of us in our last decades allow a memory to occur," contends Heilbrun, "we forget to look at what is in front of us." Nostalgia is a narcotic of the young; the old face what's left cold sober.

William Shakespeare, who abjured his own rough magic four years before his death at fifty-two, attests that what's left is not much. "When the age is in," contends Dogberry in *Much Ado About Nothing*, "the wit is out." Yet nonagenarian George Burns did not lack for wit when he promised a centenary comic gig that he, turning one hundred just before his death, was too ill to give. In *As You Like It*, Jaques prophesies that life will end "sans teeth, sans eyes, sans taste, sans every thing." What to make of a diminished thing is the compelling question posed by "The Oven Bird" of Robert Frost, a poet productive into his eighty-ninth year. Demographics indicate that it is a question confronting more and more of us. The population of the United States has never been older. Sixteen percent (52 million) were outliving three score years and five in 2018, and the percentage is expected to swell to 23 percent (95 million) by 2060. Extreme age is becoming almost common; from a total of 82,000 centenarians in the United States in 2016, the number is expected to jump to 589,000 by 2060.

Old age is my Walden Pond, to which I hope to go to live what's left deliberately, to front only the essential facts of life, and to see if I can learn what it has to teach—and find the means to reveal it. At fifty-two, when I began this essay, I was already old enough to know that gray is not always keener than green and that incontinence, not omniscience, is the likelier fate of marathon survivors. Granted immortality but not eternal youth, Tithonus was as miserable as the Struldbrugs, who lived in perpetual tedium on Jonathan Swift's Luggnagg. I nonetheless cling to the hope of rising to a gray eminence, a mature mountain from whose majestic summit few young climbers ever gaze.

Is there something morbid about a youngster's lifelong envy of the canny old? Even into middle age, I have rooted for the superannuated athlete, for heroic performances by Satchel Paige, George Blanda, George Foreman. While their faded bodies attract our sympathy, old underdogs can also teach young observers novel tricks. Now that no active major league baseball player possesses a birth date earlier than mine, my interest in the game has waned.

The separate commandments to "Honor thy father and thy mother" and "Know thyself" make sense in stable societies where parental identities are more certain than one's own. Most cultures inculcate respect for elders, if for no other reason than as a means of enforcing social control. Allocating power according to seniority is only slightly less arbitrary than allocating it according to skin tone, but at least mortality enforces term limitations on movie discounts. Most codgers, like most mere cinquanters, command respect as human beings more than as sages. However, the Elders of the Tribe, a group whose roster is perforce as fluid as a leaky bladder, are a special case of veterans who merit veneration. Norman Thomas was retired from the club more than fifty years ago, and other aged sages who departed in more recent years include Jacques Barzun, Saul Bellow, Ingmar Bergman, Elliot Carter, Freeman Dyson, John Kenneth Galbraith, Nadine Gordimer, Philip Johnson, Stanley Kunitz, Ursula K. Le Guin, John Lewis, Naguib Mahfouz, Nelson Mandela, Arthur Miller, Czeslaw Milosz, Toni Morrison, Albert Murray, Tillie Olsen, Aleksandr Solzhenitsyn, George Steiner, John Paul Stevens, Ruth Stone, Studs Terkel, and Eudora Welty. Still alive and vibrant, though, are Mel Brooks, Jimmy Carter, Lawrence Ferlinghetti, Frank Gehry, Ruth Bader Ginsburg, Tenzin Gyatso, Rolando Hinojosa, Dolores Huerta, Norman Lear, Cynthia Ozick, Gloria Steinem, Gerald Stern, and Desmond Tutu. That parliament of owls would be a brilliant legislature, a gathering of canny old birds that makes an exaltation.

Notes

That Goes without Saying

Epigraph. Interview with Robert Fripp in Rock and Folk, submitted by Daniel A. Kirk-dorffer, Elephant Talk, www.elephant-talk.com/wiki/Interview_with_Robert_Fripp_in_Rock_and_Folk.

1. Toru Takemitsu, *Confronting Silence: Selected Writings*, trans. and ed. Yoshiko Kakudo and Glenn Gasow (Berkeley, CA: Fallen Leaf Press, 1995), 17.

2. Lennard J. Davis, *My Sense of Silence: Memoirs of a Childhood with Deafness* (Urbana: University of Illinois Press, 2000), 15.

3. Maurice Maeterlinck, *The Treasure of the Humble*, trans. Alfred Sutro (New York: Dodd, Mead & Co., 1910), 7.

4. Martin Luther King Jr., "Loving Your Enemies," sermon delivered at Dexter Avenue Baptist Church, Birmingham, Alabama, November 17, 1957.

5. Blaise Pascal, *Pensées, Oeuvres complètes* (Paris: Gallimard/Pléiade, 1954), 1113.

6. John Cage, *Silence: Lectures and Writings* (Middletown, CT: Wesleyan University Press, 1961), 191.

7. Christina Rossetti, "Rest," in *The Complete Poems*, vol. I (Baton Rouge: Louisiana State University Press, 1979–90), 60.

8. Nelly Sachs, "Ein Spiel," trans. Michael Hamburger, in *O the Chimneys: Selected Poems, Including the Verse Play, ELI* (New York: Farrar, Straus & Giroux, 1967), 296, 297.

9. Nadezhda Mandelstam, *Hope against Hope: A Memoir*, trans. Max Hayward (New York: Atheneum, 1970), 42–43.

10. Adrienne Rich, *On Lies, Secrets, and Silence: Selected Prose 1966–1978* (New York: W. W. Norton, 1979), 11.

11. Betty Friedan, *The Feminine Mystique* (New York: Dell, 1983), 15.

12. Patricia Meyer Spacks, *Gossip* (New York: Alfred A. Knopf, 1985), 26.

13. Norman Mailer, *The Armies of the Night: History as a Novel / The Novel as History* (New York: New American Library, 1968), 38.

14. Alexander Pope, "Essay on Criticism," part II, lines 109–10.

15. Maeterlinck, *Treasure of the Humble*, 4.

16. Talmud, *Pirke Avot*, 1:15.

17. Lao Tzu, *Tao Te Ching*, trans. Stephen Mitchell (New York: Harper & Row, 1988), chapter 56.

18. J. D. Salinger, *Raise High the Roof Beam, Carpenters and Seymour: An Introduction* (Boston: Little, Brown, 2001), 78.

19. Thomas Merton, *No Man Is an Island* (Boston: Shambhala Publications, 2005), 276.

20. Karen Armstrong, *The Spiral Staircase: My Climb out of Darkness* (New York: Knopf, 2004), 284.

21. Richard Byrd, *Alone* (Washington, DC: Island Press, 2003), 85.

22. Henri Matisse, *Écrits et propos sur l'art* (Paris: Hermann, 1972), 235.

23. Rabindranath Tagore, "Sickbed 30," trans. Wendy Barker and Saranindranath Tagore, *International Poetry Review* 31, no. 2 (Fall 2005): 55.

24. Susan Sontag, "The Aesthetics of Silence," in *Styles of Radical Will* (New York: Farrar, Straus & Giroux, 1969), 12.

25. Ludwig Wittgenstein, *Tractatus Logico-Philosophicus*, trans. and ed. C. K. Ogden (Boston: Routledge & Kegan Paul, 1981), 188–89.

26. Deirdre Bair, *Samuel Beckett: A Biography* (New York: Simon & Schuster, 1978), 640.

27. Samuel Beckett, *Three Novels* (New York: Grove, 1965), 116.

28. Beckett, *Three Novels*, 114.

29. Samuel Beckett, *Dream of Fair to Middling Women*, ed. Eoin O'Brien and Edith Fournier (New York: Arcade, 1993), 193.

30. Beckett, *Three Novels*, 13.

31. Beckett, *Three Novels*, 121.

32. Iris Murdoch, *The Black Prince* (New York: Penguin, 1975), 414.

33. Charles Darwin, *Charles Darwin's Beagle Diary* (New York: Cambridge University Press, 1988), 351–52.

34. William Shakespeare, *The Tempest*, act III, scene 2, lines 135–36.

35. J. D. Salinger, *The Catcher in the Rye* (Boston: Little, Brown, 1951), 25.

36. Paul Auster, *The Book of Illusions* (New York: Henry Holt, 2002), 14.

37. Auster, *Book of Illusions*, 208.

38. Friedrich Hölderlin, "Da Ich Ein Knabe War ...," lines 26–27, in *Hyperion and Selected Poems*, ed. Erik L. Santner (New York: Continuum, 2002), 136.

39. Hannah Merker, *Listening* (New York: HarperCollins, 1994), 7.

40. Bonnie Poitras Tucker, *The Feel of Silence* (Philadelphia: Temple University Press, 1995), 10–11.

41. Tucker, *Feel of Silence*, xxi.

42. Ruth Sidransky, *In Silence: Growing up Hearing in a Deaf World* (New York: St. Martin's Press, 1990), 20.

43. David Wright, *Deafness* (New York: Stein & Day, 1969), 22.

44. Wright, *Deafness*, 22.

45. Thomas Carlyle, *Sartor Resartus* (New York: Oxford University Press, 1999), 166.

46. Max Picard, *The World of Silence*, trans. Stanley Goodman (Chicago: Henry Regnery, 1952), 221.

47. David Owen, "The Soundtrack of Your Life," *New Yorker*, April 10, 2006, p. 71.

Ut Coitus Lectio: The Poet as Lovemaker

1. Marjorie Rosen, *Popcorn Venus: Women, Movies, and the American Dream* (New York: Coward, McCann & Geoghegan, 1973).

2. Simon Karlinsky, "Great Contradictions," *New York Times Book Review*, July 16, 1978, p. 19.

3. John Garner, *On Moral Fiction* (New York: Basic Books, 1978), 83.

4. Gardner, *On Moral Fiction*, 84.

5. "Three Essays on the Theory of Sexuality" (1905), in *The Standard Edition of the Complete Psychological Works of Sigmund Freud*, vol. VII, trans. and ed. James Strachey (London: Hogarth Press, 1953), 156n.

6. John Hall Wheelock, "The Art of Poetry XXI," *Paris Review* 17, no. 7 (Fall 1976), 160.

7. *Robert Frost: Poetry and Prose*, ed. Edward Connery Lathem and Lawrance Thompson (New York: Holt, Rinehart & Winston, 1972), 394.

8. John Barth, *Chimera* (Greenwich, CT: Fawcett, 1972), 3.

9. Garrett Stewart, "Lawrence, 'Being,' and the Allotropic Style," *Novel: A Forum on Fiction* 9, no. 3 (Spring 1976): 136.

10. Jean-Paul Sartre, *Saint Genet: Actor and Martyr*, trans. Bernard Frechtman (New York: George Braziller, 1963), 550.

11. Oh, that some reader, my brother, to whom I speak
Through this pale and shining mask,
Might come and place a slow and heavy kiss
On this low forehead and cheek so pale,
All the more to press upon my face
That other face, hollow and perfumed.
Translated from the French by Ron Padgett and Bill Zavatsky, in Valéry Larbaud, *The Poems of A. O. Barnabooth* (Boston: Black Widow Press, 2008).

12. François de La Rochefoucauld, *Maxime #136*, in *Collected Maxims and Other Reflections* (New York: Oxford University Press, 2007), 38; Blaise Pascal, *Discours sur les passions de l'amour* (Paris: Grasset, 1911), 63.

13. Norman Mailer, "The White Negro: Superficial Reflections on the Hipster," in *Advertisements for Myself* (New York: G. P. Putnam's Sons, 1959), 341.

14. Quoted in Pierre Binet, *The Living Theatre* (New York: Horizon Press, 1971), 95.

15. Alex Comfort, *The Joy of Sex: A Gourmet Guide to Love Making* (New York: Simon & Schuster, 1972), 8.

16. George Steiner, *After Babel: Aspects of Language and Translation* (New York: Oxford University Press, 1975), 38–39.

17. William Shakespeare, *Twelfth Night*, act 3, scene 1, lines 14–15.

18. Vladimir Nabokov, *Lolita* (New York: Fawcett Books, 1955), 31.

Books and Ballots

1. Congressional Research Service, *Membership of the 113th Congress: A Profile*.

2. Bureau of Labor Statistics, *Occupational Outlook Handbook*, April 10, 2020.

3. Henry Kissinger, *White House Years* (Boston: Little, Brown, 1979), 1058.

4. "Literary Reading in Dramatic Decline, According to National Endowment for the Arts Survey," National Endowment for the Arts News Room.

5. Carlin Romano, *America the Philosophical* (New York: Knopf, 2012), 8.

6. Romano, *America the Philosophical*, 18.

7. Gore Vidal, "Laughing Cassandra," *Time*, May 1, 1976.

8. Gore Vidal, *Palimpsest: A Memoir* (New York: Random House, 1995), 334.

9. Norman Mailer, *Advertisements for Myself* (Cambridge, MA: Harvard University Press, 1992), 17.

10. Quoted by Carolyn Forché in William H. Gass and Lorin Cuoco, eds., *The Writer in Politics* (Carbondale: Southern Illinois University Press, 1996), 147.

11. James A. Michener, "Why I Am Running for Congress," *Saturday Evening Post*, 1962, p. 4.

12. James Joyce, *A Portrait of the Artist as a Young Man* (New York: Viking Press, 1968), 203.

13. Email to the author, October 27, 2009.

14. "Letter to Alain Badiou, February 20, 1957," quoted in Jacques Louis Hymans, *Léopold Sedar Senghor: An Intellectual Biography* (Edinburgh: Edinburgh University Press, 1971), 80.

15. W. H. Auden, "The Poet and the City," in *The Dyer's Hand and Other Essays* (New York: Vintage, 1990), 84.

16. Colman McCarthy, "An Investigation of the Soul," *Washington Post*, July 18, 1995, p. D21.

17. Ben MacIntyre, "When Rimbaud Meets Rambo," *The Times*, June 4, 2005, p. 24.

18. Gertrude Stein, "The Situation in American Writing," *Partisan Review* 6, no. 4 (Summer 1939): 41.

19. Stendhal, *The Charterhouse of Parma*, trans. Margaret Mauldon (New York: Oxford University Press, 1997), 414.

20. Connie Robertson, ed., *The Wordsworth Dictionary of Quotations* (Ware, Hertfordshire: Wordsworth Editions, 1998), 111.

21. Mario Vargas Llosa, *International Herald Tribune*, April 1, 1988, quoted in Robert Andrews, ed., *The Columbia Dictionary of Quotations* (New York: Columbia University Press, 1993), 534.

22. Brendan Behan, *Guardian*, 1960, quoted in Jonathon Green, ed., *The Cynic's Lexicon: A Dictionary of Amoral Advice* (London: Routledge & Kegan Paul, 1984), 20.

23. Quoted in Charles Simic, *Memory Piano* (Ann Arbor: University of Michigan Press, 2006), 232.

24. Aleksandr Solzhenitsyn, *The First Circle*, trans. Thomas Whitney (New York: Harper & Row, 1968), chap. 57.

25. Rómulo Gallegos, *Una posición en la vida* (Buenos Aires: Ediciones Centaures, 1977), 383.

26. Mario Vargas Llosa, *A Fish in the Water: A Memoir*, trans. Helen Lane (New York: Farrar, Straus & Giroux, 1994), 431.

27. Vargas Llosa, *Fish in the Water*, 41.

28. Vargas Llosa, *Fish in the Water*, 41.

29. Vargas Llosa, *Fish in the Water*, 87.

30. Salman Rushdie, *Imaginary Homelands: Essays and Criticism 1981–1991* (New York: Penguin, 1992), 14.

31. Yevgeny Alexandrovich Yevtushenko, "A Time for Summing Up," in *Voices of Glasnost: Interviews with Gorbachev's Reformers*, ed. Stephen F. Cohen and Katrina Vanden Heuvel (New York: Norton, 1991), 261.

32. Richard Rapaport, "The Great Gorino," *Los Angeles Times*, May 7, 2006, p. W.28.

33. Steve Perry, "The Undoing of America: Gore Vidal on War for Oil, Politics-Free Elections, and the Late, Great US Constitution," *City Pages*, March 23, 2005.

34. Email to the author, October 27, 2009.

35. F. David Peat, *The Blackwinged Night: Creativity in Nature and Mind* (New York: Basic Books, 2000), 125.

36. David R. Slavitt, *Blue State Blues* (Middletown, CT: Wesleyan University Press, 2006), 267.

37. Slavitt, *Blue State Blues*, 41.

38. Slavitt, *Blue State Blues*, 31.

39. Slavitt, *Blue State Blues*, 334.

40. Email to the author, October 27, 2009.

41. Vargas Llosa, *Fish in the Water*, 81.

42. Upton Sinclair, *I, Candidate for Governor: And How I Got Licked* (Berkeley: University of California Press, 1994), 170.

43. James A. Michener, *The World Is My Home: A Memoir* (New York: Random House, 1992), 188.

44. Michener, "Why I Am Running for Congress," 4.

45. Gass and Cuoco, *Writer in Politics*, 80.

46. Václav Havel, *To the Castle and Back*, trans. Paul Wilson (New York: Vintage, 2008), 336.

47. Gore Vidal, *Point to Point Navigation: A Memoir 1964–2006* (New York: Doubleday, 2006), 2.

When Literature Was Dangerous

1. Philip Roth, *Shop Talk: A Writer and His Colleagues and Their Work* (Boston: Houghton Mifflin, 2001), 53.

2. Jeffrey Segall, *Joyce in America: Cultural Politics and the Trials of Ulysses* (Berkeley: University of California Press, 1993), 1.

3. Steven G. Kellman, *Redemption: The Life of Henry Roth* (New York: W. W. Norton, 2005), 89.

4. Edith Wharton, letter to Bernard Berenson, January 6, 1923, in *The Letters of Edith Wharton*, ed. R. W. B. Lewis and Nancy Lewis (New York: Scribner, 1980), 461.

5. Edward de Grazia, *Girls Lean Back Everywhere: The Law of Obscenity and the Assault on Genius* (New York: Random House, 1992), 26.

6. De Grazia, *Girls Lean Back Everywhere*, 223.

7. D. H. Lawrence, *The Letters of D. H. Lawrence*, ed. James T. Boulton and Keith Sagar (New York: Cambridge University Press, 2002), 7.

8. Kevin Birmingham, *The Most Dangerous Book: The Battle for James Joyce's Ulysses* (New York: Penguin, 2015), 339.

9. Birmingham, *Most Dangerous Book*, 2.

10. Norman Mailer, *The Armies of the Night* (New York: New American Library, 1968), 38.

11. Birmingham, *Most Dangerous Book*, 222.

12. Birmingham, *Most Dangerous Book*, 167.

13. Brenda Maddox, *Nora: The Real Life of Molly Bloom* (Boston: Houghton Mifflin, 2000), 376.

14. Birmingham, *Most Dangerous Book*, 258.

Reading Shilts Reading Camus Reading a Plague

1. Albert Camus, *The Plague*, trans. Stuart Gilbert (New York: Modern Library, 1948), 272.

2. Camus, *Plague*, 272.

3. Camus, *Plague*, 125.

4. Camus, *Plague*, 222.

5. Camus, *Plague*, 229.

6. Albert Camus, "Letter to Roland Barthes," January 11, 1955, in *Lyrical and Critical Essays*, ed. Philip Thody, trans. Ellen Conroy Kennedy (New York: Vintage, 1970), 339.

7. "Letters to Socrates," Francesco Petrarca, *Rerum Familiarium Libri I–VIII*, trans. Aldo S. Bernardo (Albany: SUNY Press, 1975).

8. Randy Shilts, *And the Band Played On: Politics, People, and the AIDS Epidemic* (New York: St. Martin's Press, 1987), 18.

9. Shilts, *Band Played On*, 411.

10. Shilts, *Band Played On*, 482.

11. Randy Shilts, "Talking AIDS to Death," *Esquire*, June 1988, p. 142.

12. Camus, *Plague*, 6.

13. Camus, *Plague*, 13.

14. Shilts, *Band Played On*, 509.

15. Shilts, *Band Played On*, 607.

16. Shilts, *Band Played On*, 97.

17. Diane Johnson and John F. Murray, "AIDS without End," *New York Review of Books* 35, no. 13 (1988), 61.

18. Camus, *Plague*, 107.

19. Mark Caldwell, "The Literature of AIDS: Sensationalism, Hysteria, and Good Sense," *Dissent* 37 (1990), 342.

20. Camus, *Plague*, 126.

21. Shilts, *Band Played On*, 126.

22. Shilts, *Band Played On*, 558.

23. Shilts, *Band Played On*, 186.

24. Shilts, *Band Played On*, 165.

25. Shilts, *Band Played On*, 318.

26. Shilts, *Band Played On*, 347.

27. Shilts, *Band Played On*, 311.

28. Camus, *Plague*, 126.

29. Shilts, *Band Played On*, 217.

30. Camus, *Plague*, 278.

31. Shilts, *Band Played On*, 34–35.

32. Camus, *Plague*, 217.

33. Camus, *Plague*, 337.

34. Shilts, *Band Played On*, 113.

35. Shilts, *Band Played On*, 191.

36. William Styron, "Camus Was a Great Cleanser of My Intellect," *Lear's*, August 1990, 74.

New and Newer Directions: Publishing Books in the United States

1. Ian S. MacNiven, *"Literchoor Is My Beat": A Life of James Laughlin, Publisher of New Directions* (New York: Farrar, Straus & Giroux, 2014), 107.

2. MacNiven, *"Literchoor,"* 122.

3. Herbert Mitgang, "Simon & Schuster History on Display," *New York Times*, March 30, 1982, section 1, p. 13.

4. MacNiven, *"Literchoor,"* 81.

5. MacNiven, *"Literchoor,"* 90.

6. Boris Kachka, *Hothouse: The Art of Survival and the Survival of Art at America's Most Celebrated Publishing House, Farrar, Straus and Giroux* (New York: Simon & Schuster, 2013), 285.

7. MacNiven, *"Literchoor,"* 300.

Is a University without Literature Like a Milkshake without an Olive?

1. Colman McCarthy, "An Investigation of the Soul," *Washington Post*, July 18, 1995, p. D21.

2. Ben MacIntyre, "When Rimbaud Meets Rambo," *The Times*, June 4, 2005, p. 24.

3. Nina Handler, "Facing My Own Extinction," *Chronicle of Higher Education*, December 7, 2017.

4. Plato, *The Republic of Plato*, trans. Francis MacDonald Cornford (New York: Oxford University Press, 1945), 339.

5. William Marx, *The Hatred of Literature* (Cambridge, MA: Belknap Press), 32.

6. Marx, *Hatred of Literature*, 95.

7. Marx, *Hatred of Literature*, 189.

8. "National Assessment of Adult Literacy," National Center for Education Statistics, https://nces.ed.gov/naal/lit_history.asp.

9. Andrew Perrin, "Who Doesn't Read Books in America?," Pew Research Center, www. pewresearch.org/fact-tank/2016/11/23/who-doesnt-read-books-in-america/.

10. Perrin, "Who Doesn't Read?"

11. Merve Emre, *Paraliterary: The Making of Bad Writers in Postwar America* (Chicago: University of Chicago Press, 2017), 3.

Telling It All: Pandictic Art

Epigraph 1. The Shadow Box (New York: Drama Book Specialists, 1977), 46.

Epigraph 2. Letter to Malcolm Cowley, November 1944, *The Faulkner-Cowley File* (New York: Viking, 1968), 15.

1. "Le Livre, instrument spirituel," in *Oeuvres complètes*, ed. Henri Mondor and G. Jean-Aubry (Paris: Gallimard, 1945), 378.

2. Jorge Luis Borges, *Obras Completas, 1923–1972* (Buenos Aires: Emece, 1974), 469 and 471 (my translations); "Avant-Propos," in *La Comédie humaine*, ed. Marcel Bouteron (Paris: Gallimard, 1951), 1:6.

3. Honoré de Balzac, avant-propos to *La Comédie humaine*. Cited in André Gide, *Romans et récits*, ed. Pierre Masson, vol. 1 (Paris: Gallimard, 2009), 118.

4. "L'Art poétique," Chant III, *Oeuvres complètes*, ed. Françoise Escal (Paris: Gallimard, 1966), 175 (my translation).

5. Letter to Paul Demeny, April 17, 1871, *Oeuvres complètes*, ed. Antoine Adam (Paris: Gallimard, 1972), 252 (my translation).

6. Quoted in Joan Peyser, *Boulez* (New York: Schirmer, 1976), 26.

7. Eric Salzman, quoted in *John Cage*, ed. Richard Kostelanetz (New York: Praeger, 1970), 150–51.

8. *Oeuvres complètes du Marquis de Sade*, vol. 13 (Paris: Cercle du livre précieux, 1967), 61 (my translation).

9. *Oeuvres complètes du Marquis de Sade* , vol. 13, 324.

10. *Oeuvres complètes du Marquis de Sade* , vol. 13, 344 (my translation).

11. "The Latin American Novel Today," *Books Abroad* 44 (Winter 1970), 16.

12. Gabriel García Márquez, *Historia de un deicidio* (Barcelona: Barral, 1971), 479 (my translation).

13. Frederick Karl, *American Fictions: 1940–1980: A Comprehensive History and Critical Evaluation* (New York: Harper and Row, 1983), 379.

14. J. W. De Forest, "The Great American Novel," *Nation* 6 (January 9, 1868), 28.

15. Walt Whitman, preface to the 1855 edition, *Leaves of Grass: Comprehensive Reader's Edition*, ed. Harold W. Blodgett and Sculley Bradley (New York: Norton, 1968), 709.

16. Whitman, *Leaves of Grass*, 711.

17. Letter of April 17, 1935, *The Letters of F. Scott Fitzgerald*, ed. Andrew Turnbull (New York: Scribner's, 1963), 262.

18. See Jay Martin, *Always Merry and Bright: The Life of Henry Miller* (Santa Barbara, CA: Capra Press, 1978), 250, 254.

19. Henry Miller, *Tropic of Capricorn* (New York: Grove, 1961), 87.

20. Miller, *Tropic of Capricorn*, 34.

21. Henry Miller, *Tropic of Cancer* (New York: Grove, 1961), 24.

22. Henry Miller, *Advertisements for Myself* (New York: Putnam's, 1959), 477.

23. Ernest Hemingway, *Death in the Afternoon* (New York: Scribner's, 1964), 54.

24. Ernest Hemingway, *A Moveable Feast* (New York: Scribner's, 1964), 190.

25. See Annette Kolodny, "A Map for Misreading: Or, Gender and the Interpretation of Literary Texts," *New Literary History* 11 (1980): 451–67; Joanne Feit Diehl, "'Come Slowly: Eden': An Exploration of Women Poets and Their Muse," *Signs* 3 (1978): 572–87.

26. Letter to William D. Ticknor, 19 January 1855, *Letters of Hawthorne to William D. Ticknor 1851–1864* (Washington, DC: NCR, 1972), 75.

27. Gertrude Stein, *The Making of Americans* (New York: Harcourt, Brace, 1934), 217.

28. Hélène Cixous, "Le Rire de la meduse," *L'Arc* 61 (1975): 39–54, translated by Keith and Paula Cohen as "The Laugh of the Medusa," *Signs* 1 (1976): 875–93.

29. Luce Irigaray, *Ce Sexe qui n'en est pas un* (Paris: Editions de Minuit, 1977), 28 (my translation).

30. H. G. Wells, *World Brain* (Freeport, NY: Books for Libraries Press, 1971), 86.

CREDITS

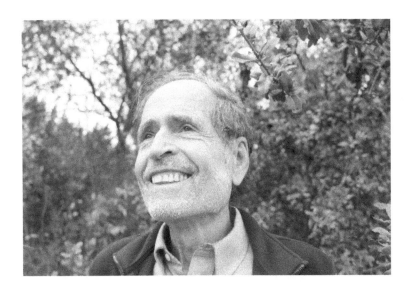

STEVEN G. KELLMAN is a professor of comparative literature at the University of Texas at San Antonio, where he has taught since 1976. He is the author of *Nimble Tongues: Studies in Literary Translingualism, The Restless Ilan Stavans: Outsider on the Inside, The Translingual Imagination, Loving Reading: Erotics of the Text, The Self-Begetting Novel,* and *Redemption: The Life of Henry Roth,* which received the New York Society Library Award for Biography, as well as hundreds of essays and more than a thousand reviews. Among his other honors are National Book Critic Circle's Nona Balakian Citation for Excellence in Reviewing, the Gemini Ink Literary Excellence Award, and the San Antonio Public Library Foundation's Arts and Letters Award. He lives in San Antonio.

CPSIA information can be obtained
at www.ICGtesting.com
Printed in the USA
JSHW030422251020
8977JS00002B/2

9 781595 349347